MEDIEVAL TEXTS

GENERAL EDITORS

V. H. Galbraith, R. A. B. Mynors and C. N. L. Brooke

EADMERI
VITA SANCTI ANSELMI

THE LIFE OF ST ANSELM
by
EADMER

Eadmeri monachi Cantuariensis
Vita Sancti Anselmi
archiepiscopi Cantuariensis

Thomas Nelson and Sons Ltd
London Edinburgh Paris Melbourne Toronto and New York

The Life of St Anselm
Archbishop of Canterbury

by

Eadmer

Edited with Introduction, Notes
and Translation by

R. W. Southern
*Chichele Professor of Modern History,
University of Oxford*

Thomas Nelson and Sons Ltd
London Edinburgh Paris Melbourne Toronto and New York

THOMAS NELSON AND SONS LTD
Parkside Works Edinburgh 9
36 Park Street London W1
117 Latrobe Street Melbourne C1

THOMAS NELSON AND SONS (AFRICA) (Pty) LTD
P.O. Box 9881 Johannesburg

THOMAS NELSON AND SONS (CANADA) LTD
91–93 Wellington Street West Toronto 1

THOMAS NELSON AND SONS
18 East 41st Street New York 17, N.Y.

SOCIÉTÉ FRANÇAISE D'ÉDITIONS NELSON
97 rue Monge Paris 5

———

© R. W. Southern, 1962

CONTENTS

Introduction		ix
I The Growth of the *Vita Anselmi*		ix
Manuscripts		xiii
Editions		xxiv
II Language, Punctuation, Spelling		xxv
Abbreviations		xxv
Latin Text	*verso*	1–171
English Translation	*recto*	1–171
Appendix		172
Index		175
Table of Manuscripts showing the Development and Diffusion of the work		viii

SINCE the publication of the first volume eleven years ago this Series has been directed by two general editors, Professor V. H. Galbraith and Professor R. A. B. Mynors. Recently Professor Mynors has been compelled, owing to heavy demands on his time, to lighten the burden of his work, and so Professor C. N. L. Brooke has taken over part of his share of the editorial work.

The great pains which Professor Mynors has taken for the Series deserve the warm gratitude of his colleagues, of all students of medieval Latin literature and of the publishers: his stature as Latinist and palaeographer have enabled him to set a new standard of precision in presenting medieval Latin texts. It is sad to record that he has to withdraw from full direction, but he has not withdrawn altogether from the enterprise. It is pleasant to be able to say that he remains an advisory editor, and that the Series will continue to have the advantage of his guidance.

PREFACE

THE work which follows is not a literary masterpiece, but it is the first intimate portrait of a saint in our history, by an observant pupil and ardent disciple. This is its great merit, and it is one which no criticism of detail can either diminish or enhance. Those who would see it in this light have no need of an introduction: *tolle, lege*, is all the advice they need. But it is also a fragment of a great religious and intellectual experience, which had its fullest expression in the time of Anselm and Eadmer. To place the work, and the life it records, in this setting demands labour and patience; and in this context the failures, and even the moments of bathos, are almost as important as the splendours and achievements. The introduction and footnotes are intended to provide some pointers to the historical scene of which this record is a part. Necessarily they are concerned with details, and many of the larger aspects of the subject have had to be dealt with elsewhere. In the present volume everything is subordinated to the presentation of the text and the matters which arise immediately from it. But in the volume, *St Anselm and his Biographer*, to which I frequently refer, I have allowed myself a larger liberty. The two books are quite distinct, but Eadmer's own words in describing his two attempts to portray his master may (I should like to think) be applied to them: *nec illud istius, nec istud illius pro mutua sui cognitione multum videtur indigere. Plane tamen actus eius scire volentibus, nec illud sine isto, nec istud sine illo sufficere posse pronuntio.*

I shall not repeat here what I have said in the other work about the debt which I owe to other scholars for their help in the preparation of both of them. But it is fitting that I should express my gratitude to the editors and publishers of this series for their patience and generosity in allowing me to apportion my matter as I thought best; and to the owners and custodians of the manuscripts mentioned below, who have allowed me every facility I could desire. R. W. S.

TABLE OF MANUSCRIPTS SHOWING THE DEVELOPMENT AND DIFFUSION OF THE WORK

I SHORT VERSION c. 1112–1114

II LONG VERSION c. 1114–1125

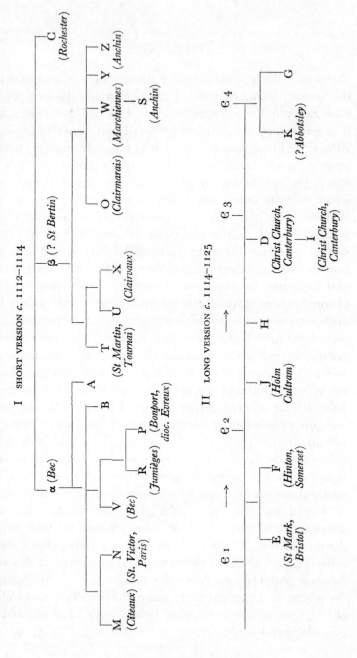

INTRODUCTION

I

THE GROWTH OF THE *VITA ANSELMI*: THE MANUSCRIPTS AND EDITIONS

THE relations between St Anselm and his biographer have been described in a companion volume to this edition.[1] It will therefore suffice here to say that Eadmer first met Anselm in 1079. He was at that time a young man of about nineteen and had been a monk of Christ Church, Canterbury, from infancy. Anselm was forty-six and had recently become abbot of Bec. It was in this capacity that he was visiting the estates of his abbey in England, and on the way he took the opportunity of paying a visit to his friends at Canterbury. The incident and the impression which it made on Eadmer are fully described in the text which follows.

It was probably another thirteen years before the two men met again. This was a very brief meeting, but in the following year, 1093, Anselm became archbishop of Canterbury; and from this time until Anselm's death in 1109 they were constantly together.

Eadmer must have begun early to write down what he saw and heard in the archbishop's company; and before long he profited by Anselm's habit of talking about his past to form the plan of writing a full biography. The work had advanced some considerable distance—probably the greater part of its present length—when it was detected by Anselm. The immediate effect of this was that Eadmer obtained the archbishop's help in the correction of the work, but further reflection

[1] *St Anselm and his Biographer* (Birkbeck Lectures, 1959-60), Cambridge University Press, 1962.

brought a revulsion of feeling and Anselm ordered its destruction. This Eadmer was constrained to carry out, but not before he had made a copy to which we owe the survival of the work. This incident is described by Eadmer (see p. 150) and I have conjectured that it took place in or shortly after 1100, and that though Eadmer preserved what he had already written he did not add to the work during Anselm's lifetime. This would account for the very full treatment of the years down to 1100 and the almost complete absence of personal detail or vivid narration in the years which followed. It was only after Anselm's death that Eadmer was encouraged by his friends to finish the work.

The earliest demand for the work seems to have come from those Continental churches where Anselm was known, and this is clearly reflected in the manuscript tradition. It seems probable that all the existing copies of the work which were produced on the Continent during the Middle Ages can be traced ultimately to two centres and to two manuscripts now lost which belonged to them. One group (α) almost certainly comes from Bec; the other (β)—a larger group—was spread throughout Flanders and Northern France, and may plausibly be connected with St Bertin, a house with which Canterbury had close associations and where Anselm was well-known. It was in this area that the work achieved its greatest popularity, and in the course of the twelfth century descendants of β found their way to Anchin, Marchiennes and Clairmarais, and through these Cistercian houses to Clairvaux. Meanwhile in England the work made its way forward very slowly. So far as we can now judge the first church outside Canterbury to receive a copy was Rochester; then a house in the South-West, possibly Malmesbury or Glastonbury, got a copy. Other English monasteries must have been supplied in Eadmer's lifetime but a glance at the diagram on p. viii will show that the English demand was languid compared to that in some parts of the Continent. Of the copies now known to exist, seventeen were made on the Continent and descend from the two earliest

exemplars; only seven come from English sources outside Canterbury, and these all stem from recensions of a later date than those known abroad.

This slow dissemination of his work gave Eadmer a chance to alter it, and probably no copy was ever made under his direction without some alteration. Most of these alterations are concerned with trifling details of phraseology and the order of words, and they now seem scarcely worth the trouble of revision. Eadmer evidently possessed to the full the author's itch for improvement and he had unusual opportunities for gratifying it during the years when, as precentor, he was in charge of the monastery's books. Some of his alterations, however, have more importance than these trifling word-changes; they affect the general intention of the work and the judgement on some of Anselm's actions. The book was written in the first place for private reading and edification, and when it first appeared in the world it still seems to have had this intention. Eadmer did not search at all diligently for the miraculous incidents proper to a saint's life and he passed over in silence the visions of his glory reported from various sources after his death. But quite soon the question of Anselm's beatitude became an issue to be debated rather than an assumption to be made. It was an issue which found the community at Christ Church divided. There were those, and perhaps the majority, who felt that Anselm had done less than his duty in preserving the privileges of his cathedral: they contrasted him, much to his disadvantage, with Lanfranc both as a manager of their estates and as an advocate of their primacy. These considerations no doubt had an adverse effect on any claim to saintliness which might otherwise have been entertained. Anselm had his devotees and his detractors both within and without the walls of the monastery. There were those who thought that Eadmer had written too much, others who thought he had written too little to justify the claims of the late archbishop to miraculous powers. Once launched on the world the *Life* became in a small way a centre of controversy, of friendly suggestions for improvement, and no

doubt also of unfriendly comment. It was difficult to know what to think about Anselm, and Eadmer himself described the perplexity of a young monk who did not know whether to pray for Anselm or to solicit his prayers for himself. Even Eadmer had to revise his opinion about the effectiveness of Anselm's stand for ecclesiastical principle in Henry's reign, and to admit that the victory of ecclesiastical liberty was far from complete. But on one point he did not waver: his conviction that he had been dealing with a saint became increasingly articulate. He saw St Anselm as the legitimate successor to St Wilfrid and St Dunstan in their sufferings and exiles and miracles. This conviction found expression in the changing form of the *Life* as it slowly became a work adapted for public use, taking its place in the series of saints' lives in the great lectionary of the Cathedral which was possibly one of the fruits of Eadmer's period of office as precentor. The transition took place by stages: first there was the division of the work into chapters, which probably facilitated public reading; then the addition of two posthumous miracles; finally the addition of a whole book of miracles similar to that which Eadmer had subjoined to his lives of St Dunstan and St Oswald; phrases were altered for the sake of greater edification, and small details of punctuation and word-order were amended to improve the rhythmical effect. The force of Eadmer's enthusiasm and diligence, which had found satisfaction in the original work of composition until it was checked by Anselm's prohibition, now busied itself with a multitude of small details until in about 1125 the now elderly and infirm biographer put down his pen and announced that he would make no further additions to his work.

It must be confessed that we know, or with a certain amount of labour can find out, almost too much about the growth of the *Vita Anselmi*. The most laborious devotion flags under the accumulating burden of Eadmer's second thoughts. The complicated story is, however, worth following in some detail, because it provides a good illustration of the conditions in which a medieval text came into existence, and also because the his-

tory of the work is a reflection of Eadmer's life and that of the community of Christ Church, Canterbury, in the first quarter of the twelfth century.

This development of the text over a space of about twelve years can be traced in the surviving MSS, which may be classified as follows:

The Manuscripts

I

The α group of MSS represents the earliest stage in the development of the work after Anselm's death. Its main characteristics were:

1. It was divided into two books corresponding to the periods before and after Anselm became archbishop of Canterbury, but there were originally no divisions into chapters within each book. Although most manuscripts of this group introduce chapter divisions there is no common agreement about the place at which these divisions should be made, and they may be presumed to be the additions of later scribes.

2. The work ended with an account of the burial of Anselm (below p. 145), and Eadmer disclaimed any intention of adding an account of the visions which had been seen after his death.

3. The text omitted an incident (below p. 131) which had been witnessed by a companion of Anselm in exile, the monk Alexander, but not by Eadmer himself. It will be seen that some of the manuscripts which I include in this class contain the incident in a confused or at least unusual form and the explanation (I suggest) is that the original copy omitted the incident, but it was later supplied and inserted on a loose sheet of parchment: this would explain the fact that the passage is omitted in MN, misplaced in A, distinguished from the rest of the work in B, and abbreviated in VRP. It is only in M and N that the incident is wholly omitted, but the peculiarities of the insertion in the other manuscripts seem to require an explanation such as the one I have suggested.

The manuscripts of this group are the following:

V Vatican Reginensis 499, 15th C. from Bec. Despite
its late date this is the most important manuscript of the group.
It was evidently copied at Bec, no doubt using material in the
library of the monastery, and it forms a unique collection of
material relating to the history of the house similar in purpose
to the contemporary Canterbury MS Lambeth 159 described
below. The pieces relating to Anselm are:

1. ff.73-122 Eadmer's *Vita Anselmi*. Alexander's anecdote
is told in an abbreviated form (see below p. 131). In addition
there are two additions to the *Life* which were probably made
at Bec, for they only appear in this manuscript and in the two
(RP) most closely associated with it. These additions are: i. A
sentence stating that Anselm studied at Avranches before going
to Bec (below p. 8). ii. An anecdote of Anselm's childhood
(below p. 172) which follows the *Life* on f.160 with the heading:
*Ista pagina debet esse ante prologum sancti Anselmi, sed scriptor oblitus
est eam*. In RP, which derive from the same exemplar as V, the
anecdote comes before the Prologue, as directed. From this it
appears that the story was on a loose piece of parchment in the
parent copy: it was probably a recollection of Anselm's talk
added at Bec by one of his former friends, perhaps Boso or
Riculfus, whom Eadmer quotes as authorities for some of his
information about this period of Anselm's life.

2. ff.122ᵛ-124ᵛ. A poem consisting of 151 hexameters des-
cribing two miracles of St Anselm briefly reported in the *Vita
Anselmi*, i, 32 and ii, 31. The poem is printed in *P.L.* 158,
119d-124b. Martène, who first printed these verses (*Amplissima
Collectio*, VI, 983) suggested that they were written by Eadmer,
for they follow the *Life* without a break. But it is clear that the
author had not seen the village of Liberi where Eadmer had
stayed with Anselm (see below p. 106), for he describes it as
non procul a muris Romanae urbis, which it cannot, however loosely,
be said to be. Like the additions to Eadmer's work already
noted, these verses are no doubt the work of a monk of Bec.

3. ff.124ᵛ-125. Two epitaphs on St Anselm (*P.L.* 158,
141b-142b). The first of these epitaphs is also found in B.

4. ff.158-9ᵛ. Further verses on Anselm with the heading
*Dum Becci quondam velut hospes forte maneret, Augensis Petrus opus
istud metrificavit* beg. 'Contigit Anselmum de Roma iam
redeuntem...' (printed by A. Poncelet, *Cat. Cod. hag. lat. Bibl.
Vat.* 1910, pp. 527-9).

5. f.160. The anecdote of Anselm's childhood already
noted (see below p. 172).

6. f.160ᵛ. Sayings of Anselm belonging to the time when
he was abbot of Bec (printed *P.L.* 158, 1051-2).

R Rouen U 102, 12th C. from the Abbey of Jumièges.

P Paris Bibl. Nat. lat. 1864, 13th C. from the Abbey of
Bonport (dioc. Evreux).

R and P, as has already been remarked, were copied from
the same exemplar as V, but they are inferior copies.

B Paris Bibl. Nat. lat. 5348, 12th-13th C. The *Vita
Anselmi* in this manuscript is incomplete at the beginning and
end but the composition of those parts of the MS which are
missing can be discovered from a 14th C. list of contents. The
Vita Anselmi here appears in the midst of a large assortment
of material on English saints, but a connection with Bec is
suggested by the occurrence (unfortunately on a missing quire)
of the *Vita Herluini Abbatis* before the *Life* of Anselm; also by
the inclusion of the Epitaph on Anselm which is otherwise
only found in V (*P.L.* 158, 141b). There are some marginal
symbols of annotation (the letter ·a· between two dots) which
are particularly frequent in manuscripts with Canterbury, and
probably also Bec, affiliations. As for the text of the *Vita Anselmi*
the most striking feature is that there are no divisions into chap-
ters until the scribe comes to Alexander's anecdote. This is
distinguished by a large capital A, and when it ends the scribe
begins afresh with a large capital R (see below p. 131). It seems
evident from this that the anecdote was an insertion, probably
brought into the text from a loose sheet of parchment.

A Paris Bibl. Nat. lat. 2475, 12th-13th C. Like B, this

manuscript also contains a considerable amount of material relating to English saints (Lives of St Cuthbert, St Elphege, St Oda of Canterbury, St Edmund, St Alban, St Bede). The *Vita Anselmi* follows a collection of Anselm's works, *De Incarnatione Verbi*, *De Processione Spiritus Sancti*, *Monologion*, *Proslogion* (which breaks off with the note: *Hunc librum ideo totum hic non scripsimus quia habenus eum in quodam parvo libello, in quo et orationes eius continentur*). The text of the *Vita Anselmi* has several peculiar faults, of which the strangest is the misplacing of Alexander's anecdote. It is included quite absurdly in the middle of (what is now) Book 2 chapter 20: it was only after writing the whole passage that the scribe realised his mistake and made an effort to give sense to his text (see below, p. 91)—a clear indication that the passage was on a loose sheet of parchment in his exemplar. A feature of this manuscript is that each of the saints' lives it contains is followed by a poem. The verses which follow the *Life* of Anselm have been printed in *P.L.* 158, 142b-c.

M Dijon 653, 14th C. from Cîteaux.

N Paris, Arsenal 938, 13th C. from St Victor, Paris.

M and N are the only two manuscripts which entirely omit the Alexander anecdote. They are however both very corrupt and they are of no help in establishing the text.

The β group of manuscripts is the largest and most homogeneous of all. As we have seen, it bears witness to the popularity of the *Life* in Flanders and the neighbouring district in the twelfth century. The manuscript from which the family springs has not survived but its characteristics can be distinguished without difficulty. The text is in the main identical with that of class α manuscripts, but the division into chapters has now been accomplished more or less on the lines finally adopted, and the Alexander anecdote is firmly embedded in the text. For the rest there are some common errors which must go back to the parent manuscript, but the text as a whole is of no special interest. The manuscripts of this class are:

O St Omer 716 ff.163-190ᵛ. 12th C. from the Abbey of Clairmarais, a Cistercian house near St Omer. The *Life* of St Anselm is added at the end of the second volume of the great lectionary of the abbey, where it is out of sequence for liturgical purposes. The text is preceded by a list of chapter headings which are also found incompletely in Z. These headings do not correspond either with the chapter divisions in the text or with the chapter headings which Eadmer introduced in later recensions of his work. They are evidently an independent attempt by an unknown librarian to meet the need for dividing the text in a readily intelligible way.

S Douai 352 ff.115-146ᵛ. 12th C. from Abbey of Anchin. The text is copied from Z until this breaks off; it then follows another unidentified MS for the remainder of the work.

T MS of Comte Guillaume de Hemricourt de Grunne, 12th C. from St Martin of Tournai. This manuscript probably preserves the characteristics of the original with more fidelity than any other member of the group. It is a small volume containing only the *Life* in a format suitable for private reading. Each of the two books is preceded by a full-page illumination depicting the author at work. Since Tournai was the home of Baldwin, Anselm's steward, it might well have received a copy of the *Life* straight from Canterbury; but this cannot have been the origin of the present manuscript, which is closely related to the β family, and too late in date (apart from other considerations) to be the parent of the whole group. The text was first studied and collated by Ph. Schmitz in *Revue Bénédictine*, XL, 1928, 225-34; the miniatures have been studied by A. Boutemy in *Revue Belge d'archéologie et d'histoire de l'art*, XIII, 1943, 117-22. Boutemy dates the manuscript 1150-75, and if this is correct (as seems most likely) it cannot be, as Schmitz thought it was, the manuscript which was at Tournai in 1142.

U Copenhagen Royal Library Gl. kgl. S 182 fol. ff.1-30. 12th C., French (probably Cistercian).

B

W Douai 840 ff.182ᵛ-206ᵛ. 12th C. from the Abbey of Marchiennes. The *Life* here forms part of a larger collection of saints' lives.

X Troyes 6. 12th C. from Clairvaux.

Y Paris Arsenal 314 ff.97-116ᵛ. 12th C.

Z Douai 878 ff.109-114. 12th C. from the Abbey of Anchin. The scribe never completed the MS but broke off at the bottom of f.114 recto with the words *ad pristinam sanitatem revocati* (p. 22 below). He treated the text in an arbitrary way, breaking it into short chapters and giving a title and number to each chapter. These do not correspond with those which Eadmer himself later introduced.

The following MSS, which I have not seen, also probably belong to this family and come from the same area as most of its other members:

Brussels Royal Library 9119, 12th C. (see Schmitz, *Revue Bénédictine*, 1928, XL, 231-2). The *Vita Anselmi* here appears among a large collection of saints' lives and is followed by these verses:

Extitit Anselmus vir laude per omnia dignus,
Claruit in clero, fuit illi fortior ordo;
Monacus egregius, fuit abbas postea summus,
Anglorum praesul sapiens et religiosus.

Brussels Royal Library, Phillipps 330, 13th C. fragment from S. Maria de Villari in Brabant (see *Cat. cod. hag. bibl. Brux.* pt 1, vol. II, pp. 268-73).

II

At some date after the first recension but before 1114, Eadmer —without as yet adding anything material to the work—carried out an extensive revision which chiefly affected the later chapters of the *Life*. The reasons for his discontent with several of these chapters can only be conjectured, but he was evidently very dissatisfied with his method of recounting two incidents,

of which he was not himself a witness. One of these was the story told him by Alexander which, as we have seen, had only been included as an afterthought; the other was a somewhat stupid story of a member of the household of Ralph, abbot of Séez, who had reviled Anselm. These chapters were extensively corrected without adding much, if anything, to the sense. A similar, though much less drastic, revision is to be seen also in some of the other chapters. Most of these corrections are purely stylistic; a few are made in explanation of points which had been left obscure in the first recension. Why had Anselm's companions not questioned Abbot Hugh of Cluny more closely about his prophecy concerning the death of William Rufus? How had Eadmer heard the story of the strange experiences of the inn-keeper at Florence who slept in Anselm's bed? Why had Eadmer himself not been present at the miracle witnessed by Alexander? One can imagine that it was in reply to questions such as these that Eadmer added the sentences on pp. 124, 130, and 132. One of the corrections however reflects the sense of the inadequacy of the political settlement achieved by Anselm which evidently became current in the years after his death. In his first recension, Eadmer had spoken of the 'victory for the liberty of the church' achieved by the archbishop in 1107: to this description Eadmer now added the qualifying phrase *quodam modo*, 'to a certain extent' as we might say (p. 140).

There is only one manuscript which testifies to this stage in the development of the text:

C Corpus Christi College, Cambridge, 318, ff.140-296. 12th C. from Rochester Cathedral. This MS also contains the Life of Herlwin, abbot of Bec, by Gilbert Crispin, printed by J. A. Robinson, *Gilbert Crispin*, 1911.

<div align="center">III</div>

By the time the exemplar from which C is copied was written the text had been considerably altered in small details, and in most respects, so far as it went, it was in the state in which Eadmer finally left it. At the time when he was making these

alterations he must also have been contemplating the additional chapters at the end of the book. The first additions he made were chapters 69-71 which relate two posthumous miracles and add a protestation of accuracy, together with the names of some of his informants. The occasion for the addition of these chapters is not difficult to imagine. Eadmer tells us that he was forced to make the additions because of the love towards Anselm which still animated some of his companions; but the hostility which animated other members of the community was probably an even more compelling motive. The question of the sanctity of the late archbishop was evidently one which was agitating and dividing the community at Canterbury, and these chapters were a contribution to a burning issue to which Eadmer would return later. These chapters were added while Ralph, Anselm's successor in the archbishopric, was still bishop of Rochester, hence before 1114 (see p. 147). A note, however, in a late but reliable Canterbury manuscript(I) informs us that Ralph enjoined the addition of the further chapter (72), where the touching story of Eadmer's disobedience to which we owe the preservation of the whole work is told, and he could scarcely have done this before he became archbishop. It seems likely, therefore, that these additions were made about the time when Ralph became archbishop in 1114. The work was thus brought to a definite and fitting close. For the ending of the text after chapter 71 we must rely on the note in MS I, but for the state of the work with the additional chapters 69-72 we have the following manuscripts:

Є 1-2 Corpus Christi College, Cambridge, 371, in its first state (Є1) and with its earliest corrections (Є2). This manuscript from Christ Church, Canterbury was certainly Eadmer's personal copy of his works and was probably written with his own hand. It its earliest state it may be dated about 1115, and it contained a complete collection of Eadmer's works at this date. In the following years he added new works and corrected his earlier ones, including the *Vita Anselmi*. That these corrections were made on a number of separate occasions can be shown

partly by a comparison with other manuscripts and partly by the evidence of the changes in the structure of this manuscript. I have numbered these stages in the alteration of the work Є1 to Є4. For practical purposes, however, Є1 and Є2 can be combined: Є1 is the long form of the work down to Book II chapter lxxii, as it was first written in this manuscript; but the changes in the text which constitute Є2 must have been made almost immediately because many of them already appear in C, which has the shorter and earlier form of the text. It would therefore appear that the increase in length and revision of textual details were part of a single process. The following are the other manuscripts which show the text in the same state of development as Є1-2:

E St John's College, Oxford 165 ff.35ᵛ-77, early 13th C., from the Hospital of St Mark, Bristol. This MS has the following inscription: *Liber sancte Marie Bristoll' ex dono Savarici de Lya presbiteri, hac conditione quod si executores Roberti de Thornbir' presbiteri eum iusto titulo exigant reddatur eis.* Thornbury was a castle about twelve miles north of Bristol. Although the manuscript is comparatively late, it is of great interest because the *Life* is found together with a collection of Anselm's prayers which has some unique features, and may well go back to a recension earlier than the definitive Canterbury edition of Anselm's works of about 1120 contained in MS Bodley 271.

F London, Lambeth Palace 410, 15th C., from the Charterhouse of Hinton, Somerset. In most points the text of this manuscript agrees with that of E and it was probably copied from the same exemplar. In view of the West Country origin of both these manuscripts, it is tempting to suggest that the parent copy came from Malmesbury, for William of Malmesbury certainly knew both the *Life* and Prayers of St Anselm as well as Eadmer's *Historia Novorum* in the form in which it was current before 1120. At Glastonbury, which might be considered another possible source, there is no trace of any of these works in the Catalogue of 1248.

J Harvard University Library, Latin MS 27. Late
12th C., from the Cistercian abbey of Holm Cultram, Cumber-
land. The manuscript also contains the *Lives* of the Cluniac
saints Maiolus, Odilo and Odo.

<div align="center">IV</div>

Eadmer's final corrections and additions to the *Life* are of
three kinds:

1. Further textual emendations in the body of the work;
2. The compilation of a list of chapter headings describing
 the contents of each chapter;
3. The addition of a separate collection of miracles either
 performed after Anselm's death or, in one case, only
 recently recollected.

The textual changes were evidently made for each copy as
required but they are very slight. The addition of chapter
headings is probably, like the collection of miracles, to be con-
nected with the aim of making the book suitable for public
reading. Eadmer must have attached importance to this work
because a series of rejected headings exists, written in the same
hand and on parchment of the same size as his personal manu-
script: it was probably originally designed for Є, but for some
reason not thought suitable. The book of miracles completes
the process of bringing the life of Anselm into line with those of
the earlier English saints. It was finished after the death of
Archbishop Ralph on 20 October 1122, but probably not long
after this event, since he was still alive in one of the last miracles
in the book. The last two miracles would seem to have been
added to Eadmer's manuscript piecemeal as they came to hand,
and at the end there is a touching picture of the controversies
amidst which Eadmer laid down his pen. On the one hand
there was the frequenting of Anselm's tomb by those who sought
counsel and aid from one whom they looked on as the latest of
the Canterbury saints; on the other, there were the detractors
and those who thought Eadmer had written too much; between
the two parties there were those who were puzzled. Among

them Eadmer felt himself an old man. He may have meant it literally when he says that his trembling fingers forced him to lay down his pen, for the last pages of his manuscript are written by a different hand from that which wrote the bulk of the book. He had done what he could: if anything else was to be added he would not be responsible—*Ego hic finem imposui*. With these words he brought his long labour to an end.

The manuscripts of the work in this state are:

Є3-4 CCCC 371 in its latest state. Є3 represents the state of the work as it existed in about 1123: this was later altered by a single correction (see p. 110*n*) which I call Є4.

H London, British Museum Cotton Tiberius D iii, ff.13-44. A collection of saints' lives of 12th-13th C. (See W. Levison, *M.G.H. SS*, VII, 1920, p. 600.) The manuscript is badly burnt and cannot be collated completely. It contains both the *Life* and *Miracles*, the former in a slightly earlier stage of development than D and I (see below esp. p. 24*n*.).

D London, British Museum Harleian 315, ff.16-39ᵛ, *c.* 1125 from Christ Church, Canterbury. The beginning and end of the *Life* are lost, but MS I is probably a copy of D and preserves what is missing from this manuscript. The text is one of almost faultless accuracy and agrees with Є3 (i.e. Є with all its corrections except one single last alteration) in every respect including spelling and punctuation. The now mutilated manuscript once formed part of a very large collection of saints' lives in seven volumes, of which only fragments now remain. Harl. 315 preserves part of the volume for the period from 2 April to 28 June, and other portions of this volume are in MSS Nero C vii ff.27-79 and Harl. 624 ff.84-143. (See N. R. Ker, *Medieval Libraries of Great Britain* (1941), p. 22.)

I London, Lambeth Palace 159 ff.117-160. This important manuscript, containing a collection of materials for the history of Christ Church, Canterbury, was made in 1507 by Richard Stone, a monk of Christ Church. Richard Stone was a

true descendant of Eadmer in his interest in the antiquities of Christ Church and in his veneration for Anselm, whom he describes (f.176) as *sanctus patronus meus*. His special interest in Anselm led him to make some additions to Eadmer's text (see below pp. 144ff.) and to add to his manuscript other material which he found at Canterbury, viz. John of Salisbury's Life of Anselm compiled in 1163 with a view to canonisation, of which this is the only known copy, and a poem on Anselm, beg. *Tange Syon cytharam*, which he found in MS D. The text of the *Life* is a very careful copy of D. It omits the *Capitula* and the compiler has provided chapter headings of his own, which I have not thought it worth while to print. Taken as a whole the manuscript is one of the best witnesses to the late flowering historical and hagiographical interests at Christ Church shortly before the Dissolution.

K London, Lambeth Palace 163, 13th C. (On f.5 there is the inscription *Abboldesle cathedralium* which may give a clue to its provenance.)[1] This MS contains a careful copy of the complete work (chapter headings, *Life* and *Miracles*) in its final form.

G London, British Museum Harleian 3846, 15th C. An indifferent text of the final form of the *Life* omitting chapter headings and *Miracles*.

THE EDITIONS

1. *Fratris Edineris Angli de Vita D. Anselmi archieposcipi Cantuariensis lib. II nunquam antehac aediti*. Antverpiae, excudebat Joannes Gravius anno MDLI.

This first edition is stated by the printer to have been taken from an *antiquissimum exemplare*. Its readings are very close to those of Y, and the manuscript was therefore probably one of the numerous twelfth century copies of the *Life* which circulated in Flanders and the neighbouring country. A few of the barbarisms have been smoothed away, for example *adit* is printed

[1] *Abboldesle* is a possible medieval form of Abbotsley, co. Huntingdon. The church was a valuable one, assessed at £24 a year in 1291, and it may well have had a library.

for *vadit* (i, 5) and *restitutus* for *redonatus* (i, 4), but in the main the text is a careful reproduction of the original.

2. *Acta Sanctorum*, Aprilis, ii, 866-93. (1675)

The text of 1551 was evidently used as a basis for this edition, but it was corrected with the help of another manuscript or manuscripts of the same general type. The resulting text is essentially of the β type, but the details in various ways were treated with a freedom which would make it difficult to tell exactly what manuscript was used.

3. F. Liebermann, *Ungedruckte Anglo-Normannische Geschichts-quellen*, 1879, printed the *Liber Miraculorum* (above) for the first time, using MSS H, K and Є.

4. Martin Rule, *Eadmeri Historia Novorum in Anglia et opus-cula duo De Vita Sancti Anselmi et quibusdam miraculis eius*, Rolls Series, 1884.

Rule printed for the first time the long form of the complete text with the *Miracles*. He was the first editor of the *Life* to make use of the English manuscripts and especially of the essential MS Є, which formed the basis of his text. His text is very good, but his account of the Continental manuscripts and of the development of the text is confused and incomplete.

In the text printed below I have followed, as any editor must, Eadmer's final version in Є, and in the footnotes the readings of earlier recensions which go back to Eadmer himself are printed in capital letters. For the rest, only those variant readings are given which help to illustrate the relations between the various main groups of manuscripts or the main witnesses within each group.

II

LANGUAGE, PUNCTUATION, SPELLING

Of the place of the *Vita Anselmi* in the development of bio-graphical writings and of Eadmer's own idea of his work I have spoken elsewhere, but it is necessary here to say something about

his language and the aids to clarity of expression which he employed. It is evident at once to anyone who reads the work that Eadmer wrote a clear and straightforward Latin which is easy to understand. The earliest editor of this work in 1551 noted that this 'aureus libellus' was written 'inculto et simpliciore stilo', but adds:

> Haud quaquam reiiciendus est hic noster tractatus, quod rudiori atque inornato sermone collectus sit: graphice enim depingit veram boni praesulis et pastoris imaginem atque exemplar.

To be simple and to be vivid were achievements greater than might appear at first sight. The Latin scholarship of England immediately before the Conquest had been painfully limited, and ambitious writing both in England and elsewhere meant bombast, complication and confusion. The writing of Osbern, Eadmer's older contemporary at Canterbury, who was himself in revolt against the puffed-up style of his predecessors, is rich in illustrations of the vices against which he himself reacted. The earliest life of Edward the Confessor and the voluminous writings of Goscelin illustrate one side of the foreign influences in England after the Conquest: they are coruscating with false gems in intricate and obscure settings. By contrast Eadmer is distinctly plain. It was perhaps not the least of Lanfranc's services to England to have introduced an unambiguous and unornamental style of writing to the monasteries which came under his direct influence. His letters provide some of the best examples of this style of writing. By contrast, Anselm's style though often sparkling is somewhat mannered, and he makes a freer use of the then fashionable devices of rhyme, assonance and antithesis than was good for less talented writers. These habits, which replaced the crude obscurities of an earlier period, marred the writing of many of Eadmer's contemporaries. It was the weakness of Latin as a vehicle of communication that being always learnt as a foreign language and lacking the control of popular usage, it was capable of being twisted into fanciful shapes following the whim of the

author or the fashion of an esoteric group. To write naturally came only from discipline and a fine balance of mind, and this praise must be conceded to Eadmer as it must also be allowed to Lanfranc. Behind Lanfranc there was a monastic tradition, at this time best exemplified at Cluny, which produced a small literature notably free from the vices of literary embellishment; and behind Cluny there was the long tradition of public reading in church, chapter and refectory which, in the absence of a popular control, formed the effective discipline to which the written word was subjected. Not everything that Eadmer wrote was designed for public reading; but everything that he wrote was deeply influenced by the standards imposed by the expectation of public scrutiny by men whom long habit must have made connoisseurs of the spoken word. From an early stage in the development of the *Vita Anselmi*, Eadmer must have expected it to be read in public, and many of the changes which he introduced in its later recensions were clearly intended to improve it from this point of view.

One of the points which public reading will naturally make a writer pay particular attention to is the rhythm of his sentences and the marking of this rhythm by an appropriate punctuation. The mere fact of public reading would make this necessary quite independently of any fashions or tastes of the time, but there was a special reason for attention to these details at the time when Eadmer wrote. To judge from the surviving literature of the twelfth century, the human ear seems then to have been capable of enduring and taking pleasure in an emphatic reiteration of rhyme and rhythm which is most painfully monotonous and obtrusive to modern taste. Eadmer was a very modest performer in these literary tricks: he had all the more reason therefore to manage his effects with care and to lose nothing which painstaking craftsmanship could emphasise or make explicit.

It must always be a problem to know how far we should go in gathering up the fragments of the past. It might seem better to leave the minutiae of language to a decent obscurity. Yet

we are pursued by the thought: *Sermo symbolum mentis*.[1] There
is something to be learnt even about Anselm's theology in ob-
serving the form in which he cast his sentences and the linguis-
tic effects at which he aimed. When something is clear it seems
a pity to leave it obscure; and when something was once im-
portant which is no longer congenial, we close a door which
may lead to an understanding of larger matters if we pass it by.
We have this work as Eadmer wrote it, and as he took great
care that it should appear to the world; and as the earliest
copyists likewise were scrupulous to see that it should appear to
the world. It seems best to take the very little extra trouble
required to see it through their eyes.

In doing this, the first puzzle the modern reader is likely to
find is in the system of punctuation. Eadmer used (in addition
to the question mark which needs no comment) these punc-
tuation marks:

1. *Medial stops.* In appearance these are the same as our
full-stop, but placed above the line. Most Canterbury scribes,
however, of a generation later than Eadmer would have put the
stop on the line and have meant the same thing by it: Eadmer's
practice is a survival from an earlier age. This mark was used
both as a full-stop at the end of a sentence and as the most
common mark of punctuation within the sentence. At first
sight this may seem a very confusing practice, but in practice
it is not so, for when used as a full-stop, it is always (and only
then) succeeded by a capital letter. It is an essential part of the
system that capitals at the beginning of words are only used at
the beginning of a sentence.[2]

In the course of the sentence, the medial stop is used to
indicate a break where there is a rough equality between what
goes before and after. The most clear instance of this equality

[1] R. Klibansky, *Magistri Eckardi super Oratione Dominica*, 1934, p. vi,
where there are some interesting remarks on the subject of linguistic peculi-
arities.

[2] In printing the text, the modern practice with regard to capital
letters for proper names has been followed, and the medial stop has been
replaced by commas and semicolons in the middle of sentences. With this
modification Eadmer's punctuation has been reproduced.

is where the sentence is held together by *et, ac, atque, sed,* or *-que,* whether understood or expressed:

Traditur litteris · discit · et in brevi plurimum profuit ·

This may be looked on as the normal use of the medial point within the sentence, but by extension it is also used wherever there is no need for a variation in the pitch of the voice. Where, for instance, the main clause is followed by a subordinate clause and the sentence sinks gradually to its close, the medial point, or a succession of medial points, is the right punctuation. It denotes, as Roger Bacon later said, a *pausatio parum flexa*[1]:

Monachus ut ne quidem minima sui ordinis contemnerent admonebat · contestans quia per contemptum minimorum · ruerent in destructionem et despectum omnium bonorum ·

2. ⸴ Whereas the medial point is used to show that the pitch of the voice is to be kept steady, the symbol ⸴ indicates that the sentence is left in suspense and that a rise in pitch is required immediately before this mark. Thus Eadmer uses this symbol when a dependent clause precedes the main clause, and especially when he has begun the sentence with his favourite present participle construction or with an ablative absolute:

Quam assequi cupiens ⸴ venit ad quendam sibi notum abbatem · rogans illum ut se monachum faceret ·

3. The third mark of punctuation which Eadmer uses, though only sparingly and often apparently as an afterthought, is a symbol (⸵) which appears to have been just recently coming into use in his time. This mark is used within a subordinate construction where ⸴ would be used in the main part of the sentence. Thus we have:

Cum constet solos malos in inferno torqueri · et solos bonos in caelesti regno foveri ⸴ patet nec bonos in inferno si illuc intrarent ⸵ posse teneri debita poena malorum · nec malos in caelo si forte accederent ⸵ frui valere felicitate bonorum ·

In other words ⸵ is a weak form of ⸴, used in places where

[1] *Opus Tertium,* ed. J. S. Brewer, *Rogeri Bacon Opera inedita,* R.S. p. 248.

Eadmer at an earlier date would probably have used a medial stop or none at all.

It is noticeable indeed that this mark is very much more frequent in the book of Miracles than in the Life and that in the Life it is at least sometimes added after the text had been completed. It is possible therefore that this refinement was being introduced in the scriptorium at Canterbury in the years between about 1110 and 1125.

Perhaps the structure of Eadmer's sentences can best be expressed by an image: each sentence resembles a stretch of country which is either flat or hilly. If it is flat, the stages are marked by a succession of medial points. If it is hilly, the point where it rises to a peak is marked by ⸵ and a subordinate peak by ⸴. Both in rising and declining the sentence may be punctuated by medial points, but the symbol ⸵ is reserved for a relaxing of tension when an upward is replaced by a downward movement:

> Quam assequi cupiens ⸵ venit ad quendam sibi notum abbatem · rogans illum ut se monachum faceret · Sed abbas voluntate ipsius agnita ⸵ quod petebat inscio patre illius ne offenderet animum eius facere recusavit · At ille in suo proposito perstans ⸵ oravit deum quatinus infirmari mereretur · ut vel sic ad monachicum quem desiderabat ordinem susciperetur ·

Eadmer's prose is melodious, though perhaps limited in its resources, and the punctuation is designed to emphasise the melody. But one cannot read much of Eadmer without seeing that though the punctuation helps the ear, it is primarily directed to the understanding and is a coherent system even without reference to the exigencies of reading aloud.

This system of punctuation, and possibly one might say the diction and literary culture of which it was a product, would seem to have reached a state of perfection in the early twelfth century. To trace its future modifications and partial collapse would require more work than has yet been done on the subject. But it is worth noting that, whereas the system of punctuation

used by Eadmer would still have been normal in the middle and possibly also in the later years of the twelfth century, by 1271 when Roger Bacon gave an elaborate account of punctuation in his *Opus Tertium* the system of the previous century had fallen into decay. Bacon described the marks of punctuation and their effect on the control of the voice in a way that Eadmer would have understood; but the practice he recommends is diametrically opposed to that of Eadmer and his contemporaries, and would have made nonsense of their whole intention.[1] No doubt the rise of a technical literature together with a decline in the production of works intended primarily for monastic purposes and for communal reading had something to do with the decay of a once well understood procedure.

It will be clear from what has been said that Eadmer used a complete and intelligible system of punctuation, which had the merit of emphasising the points in a sentence which required attention. The system paid more attention to the needs of the reader than to strict logic or grammar. It was therefore especially suitable for prose relatively weak in grammatical construction, and strong in rhythmical effects and other devices for easing the path of the reader and catching the attention of the listener.

The system which Eadmer employed did not in its integrity long outlast the golden age of Benedictine monasticism which was coming to an end in Eadmer's own day. It was a product of the centuries which followed the Carolingian revival; and it must not be thought that it came into existence without an

[1] *Opus Tertium*, pp. 248-56. Roger Bacon's work was written in 1267. A generation earlier, however, the system used by Eadmer is very exactly described by Thomas of Capua in a passage quoted by E. A. Lowe, *Beneventan Script*, 1914, p. 229 *n*: 'Tres distinctiones considerantur existere, quarum prima *comma*, secunda *colon*, tertia *periodos* appellatur. Comma est punctum cum virgula superius ducta, scilicet cum adhuc sensus suspensus remanet auditori. Colon est punctum planum cum animus auditoris necesse non habet aliud expectare, et tamen aliquid addi potest. Periodos est punctum cum virgula inferius ducta, cum animus auditoris amplius non expectat nec amplius quaerit discere intentionem proponentis.'
In Eadmer, the second and third of these *distinctiones* are medial stops, but the latter is followed by a capital letter.

effort. The old system devised in the late classical period had been quite different, and it was as a result of its breakdown that the system used by Eadmer and his contemporaries had been developed. To complete the picture a few words on this development may not be out of place.[1]

The classical system of which traces remain in some of the earliest English manuscripts is described in the treatise of Donatus on the art of Grammar.[2] He described a threefold punctuation of sentences marked by stops in descending order of importance, thus: · · . The first of these stops (the *distinctio*) marked the end of a sentence; the second (the *media distinctio*) marked a point about midway in the sentence where breath could be taken; the third (the *subdistinctio*) marked a breathing point where little of the sentence remained. This system was the one recommended by Cassiodorus who held it in high esteem as an aid to reading. 'These stops', he said, 'are like paths of meaning and lanterns to words, as instructive to readers as the best commentaries.'[3] Bede seems to have used this system of punctuation in his *Historia Ecclesiastica* as can be seen in the best of the early manuscripts, testifying in this way as in others to the care with which the teaching of antiquity was followed at Jarrow in the eighth century.[4] But at best it was a mechanical system which gave the reader little or no help in managing his voice or in bringing out the structure of the sentence. Moreover the fine distinction between stops at different levels was too complicated for unpractised or hasty scribes who were often unable to decide which was intended. They therefore tended to compromise on a medial stop as an almost universal mark of punctuation. This process of simplification, or

[1] There is no general study of medieval systems of punctuation, but valuable remarks and references will be found in the following works on which I have drawn largely: E. K. Rand, *Survey of the Manuscripts of Tours*, I, pp. 29-31; E. A. Lowe, *Beneventan Script*, 1914, pp. 228-9; W. Wattenbach, *Anleitung zur lateinischen Palaeographie*, 4th edit. 1886, p. 87.

[2] *Ars Grammatica*, i, 5 (Keil, *Grammatici Latini*, IV, p. 372).

[3] *Institutiones*, i, 15 (ed. R. A. B. Mynors, pp. 48-9).

[4] See the Leningrad manuscript of the *Historia Ecclesiastica* ed. in facsimile by O. Arngart, *Early English Manuscripts in Facsimile*, II, 1952.

more properly of confusion, can be followed in the very earliest manuscript of Bede, written only two years after his death.[1] This simplification is the more understandable since another text book, the *Etymologies* of Isidore, which rivalled Donatus and Cassiodorus in popularity, gave a quite different account of the use of the *subdistinctio* and *media distinctio* within a sentence. Two generations after Bede's death very little of the ancient doctrine seems to have been extant, if we may trust Alcuin's scathing comments on the scribes he found at Tours: 'although distinctions and sub-distinctions are the finest ornaments of sentences, yet their use has almost fallen into abeyance because of the rusticity of the scribes.'[2] In other words, only the indiscriminate medial point remained.

Despite Alcuin's efforts the ancient system of Donatus and Cassiodorus never seems to have made much headway again, although simplified versions of the system appear here and there. Much more important than these however is a system which has been noted in at least one manuscript made under Alcuin's directions. In this system only two stops were recognised, marking the distinction between a pause made in the course of the sentence where the pitch of the voice was sustained, and that at the end of the sentence where the voice was lowered: these movements of the voice were appropriately indicated by a rising (:') and a descending (;) stroke.[3] These symbols derive ultimately from musical notation, and they are an indication of the strong influence which the liturgy exercised on punctuation as on the other branches of the art of writing.

The history of these changes has never fully been worked out, but enough has been said to show that even in so diminutive a branch of the art of writing Eadmer was a careful crafts-

[1] On this manuscript, Cambridge University Library Kk, 5, 16, see E. A. Lowe, *Codices Latini Antiquiores*, II, no. 139, who writes of the punctuation, 'the medial point is apparently used for most pauses: the rest is added.' What is added appears to be the new system of punctuation described below.

[2] *Ep.* (*M.G.H. Ep.* IV, p. 285) quoted by Rand, *Survey of the Manuscripts of Tours*, I, p. 29.

[3] For this and related manuscripts, see Rand, *op. cit.* I, p. 30.

man using tools which were the product of a long period of experiment and effort. In this history some great names appear, and it is strange to find such men as Cassiodorus and Alcuin using words of exaggerated respect in speaking of a system of punctuation. The system which they strove to maintain disappeared and was replaced by one better adapted to the special needs of monastic communities in which reading meant primarily public reading, and public reading came near to chant. This was the tradition in which Eadmer wrote.

The reproduction of Eadmer's spelling cannot be justified so confidently as his punctuation. His spelling is a testimony to the state of the language in a great monastic house at the beginning of the twelfth century, but Eadmer could not have defended it on any theory. He spelt as well as he could, but he made mistakes which he would have been glad to avoid if he had known better. He took considerable care here as he did in every other branch of the craft of writing; and with the exception of a few uncertainties he is very consistent. He still carefully distinguished, as he would not have done half a century later, between *e* and *ae* or (as he generally wrote it) *ę*. Since he took care to make the distinction, it is interesting that he consistently shortened the vowel in *seculum, emulus,* and *estimo,* for example, as we still do in the words derived from them. These spellings and the assimilation of *m* to *n* before *qu* (*nanque, cunque*) must represent the pronunciation of his day. Whether these forms are worth preserving is doubtful; but there seemed no good reason for altering them, so they have been retained in the printed text which follows.

ABBREVIATIONS

Anselm's letters are referred to as follows *Ep.* 1 [i, 1]. The first number is the number in the edition of Dom Schmitt; the second is the number in Gerberon's edition, reproduced in Migne, *Patrologia Latina*, vols. CLVIII-CLIX.

Anglia Sacra	Henry Wharton, *Anglia Sacra*, 2 vols., 1691.
A.S.C.	Anglo-Saxon Chronicle (references are to C. Plummer, *Earle's Two Saxon Chronicles Parallel*, Oxford, 2 vols., 1892, 1899).
Bouquet	*Recueil des historiens des Gaules et de la France*, ed. M. Bouquet and others, 1738-1904.
C.S.E.L.	*Corpus scriptorum ecclesiasticorum latinorum*, Vienna, 1866-
E.H.R.	*English Historical Review.*
Fl. Wigorn.	*Florentii Wigorniensis monachi chronicon ex chronicis*, ed. B. Thorpe, 2 vols., 1848-9.
G.P.	William of Malmesbury, *Gesta Pontificum Anglorum*, ed. N. E. S. A. Hamilton, Rolls Series, 1870.
G.R.	William of Malmesbury, *Gesta Regum Anglorum*, ed. W. Stubbs, Rolls Series, 2 vols., 1887-9.
H.N.	Eadmer, *Historia Novorum in Anglia*, ed. M. Rule, Rolls Series, 1884.
Mansi	*Sacrorum conciliorum nova et amplissima collectio*, ed. J. D. Mansi.
M.A.R.S.	*Mediaeval and Renaissance Studies*, ed. R. W. Hunt and R. Klibansky, 1941-
Memorials of St Dunstan	*Memorials of St Dunstan*, ed. W. Stubbs, Rolls Series, 1874.

M.G.H. SS.	*Monumenta Germaniae historica. Scriptores rerum Merov.*
Muratori	*Rerum Italicarum Scriptores*, ed. L. A. Muratori (New edition, ed. G. Carducci and V. Fiorini, 1900-).
Ordericus Vitalis	Ordericus Vitalis, *Historia Ecclesiastica*, ed. A. le Prévost and L. Delisle, 5 vols., 1838-55.
P.L.	J. P. Migne, *Patrologiae Latinae cursus completus.*
Porée	A. Porée, *Histoire de l'Abbaye du Bec*, 2 vols., 1901.
Regesta	*Regesta Regum Anglo-Normannorum*, vol. 1, 1913, ed. H. W. C. Davis and R. J. Whitwell; vol. 2, 1956, ed. Charles Johnson and H. A. Cronne.
R.S.	Rolls Series (Chronicles and Memorials of Great Britain and Ireland during the Middle Ages).
Schmitt	F. S. Schmitt, *S. Anselmi Cantuariensis Archiepiscopi Opera Omnia*, 1938-
V.A.	Eadmer, *Vita Sancti Anselmi.*
Vita Herluini	Gilbert Crispin, *Vita Herluini* in J. A. Robinson, *Gilbert Crispin, Abbot of Westminster*, 1911, pp.87-110.

LATIN TEXT
and
ENGLISH TRANSLATION

INCIPIT PRÆFATIO[a] SEQUENTIS OPERIS[b]

Q̃UONIAM MULTAS et antecessorum nostrorum tempori-
bus insolitas rerum mutationes nostris diebus in Anglia
accidisse et coaluisse conspeximus, ne mutationes ipsæ
posterorum scientiam penitus laterent, quædam ex illis
succincte excepta,[c] litterarum memoriæ tradidimus.[1] Sed
quoniam ipsum opus[d] in hoc maxime versatur, ut ea
quæ inter reges Anglorum et Anselmum archiepiscopum
Cantuariorum facta sunt, inconcussa veritate designet,
quæque omnibus puram illorum historiam scire volen-
tibus tunc temporis innotescere potuerunt licet inculto
plano tamen sermone describat, nec adeo quicquam in
se contineat quod ad privatam conversationem, vel ad
morum ipsius Anselmi qualitatem, aut ad miraculorum
exhibitionem pertinere videatur, placuit quibusdam fami-
liaribus meis me sua prece ad hoc perducere, ut sicut
descriptione notarum rerum posteris, ita designatione
ignotarum satagerem tam futuris quam et præsentibus
aliquod officii mei munus impendere. Quos eo quod
offendere summopere cavebam, dedi operam voluntati

In the textual notes, the readings of earlier recensions which go back to
Eadmer himself are printed in CAPITAL LETTERS. Other variants are in-
cluded only if they illustrate the relationship of various manuscripts.

[a] PROLOGUS αβ
[b] SEQUENTIS OPERIS *on erasure in* ℭ. *Instead of this phrase, most MSS read:*
in Vita Domni (*or* Sancti) Anselmi Cantuariensis Archiepiscopi.
[c] succincte excerpta VRPEJ; succincte penitus excerpta U; succincte
penitus et excerpta X.
[d] OPUS IPSUM αβ

I

HERE BEGINS THE PREFACE

SINCE WE have seen many strange changes in England in our days and developments which were quite unknown in former days, I committed to writing a brief record of some of these things, lest the knowledge of them should be entirely lost to future generations.[1] This work was chiefly concerned to give an accurate description of those things which took place between the kings of England and Anselm archbishop of Canterbury. It described in rough and unadorned language events which were open to the inspection of any contemporary who wished to know the truth about them, but it left out anything which seemed to belong merely to Anselm's private life, or to his character, or to the setting forth of his miracles. It therefore seemed good to some of my friends to induce me to undertake another work, that, as by my former description of well-known events I had rendered some service to future generations, so now by the description of little-known events I should do the same both for the future and for the present generation. Since I was greatly afraid of offending these friends, I have tried to carry out their wishes to

[1] Eadmer here refers to his *Historia Novorum in Anglia*.

I

eorum pro posse morem gerere. Opus igitur ipsum De Vita et Conversatione Anselmi Archiepiscopi Cantuariensis titulatum, taliter Deo adjuvante curavi disponere, ut quamvis aliud opus quod præsignavimus ex majori parte de ejusdem viri conversatione subsistat.' ita tamen in sua materia integræ narrationis formam prætendat, ut nec illud istius, nec istud illius pro mutua sui cognitione multum videatur indigere. Plene tamen actus ejus scire volentibus.' nec illud sine isto, nec istud sine illo sufficere posse pronuncio.

EXPLICIT PRÆFATIO[a]

[a] PROLOGUS αβ

the best of my ability. I have therefore entitled this work *The Life and Conversation of Anselm, Archbishop of Canterbury*, and, by God's help, I have attempted so to order matters that, although that other work which we first wrote is largely concerned with the way of life of this one man, yet its material is arranged in the form of a complete narrative, so that neither of the two works stands much in need of the other for its understanding. I give warning however that readers of the former work cannot fully understand Anselm's actions without the help of this work, nor can readers of this work do so without the help of the other.

HERE ENDS THE PREFACE

INCIPIT LIBER PRIMUS DE VITA ET CONVERSATIONE ANSELMI CANTUARIENSIS ARCHIEPISCOPI[a]

i. *De vita et moribus parentum Anselmi Cantuariensis archiepiscopi*[b]

INSTITUTA VITÆ et conversationis Anselmi Cantuariensis archiepiscopi litterarum memoriæ traditurus,' primo omnium vocata in auxilium meum summa Dei clementia et majestate,'; quædam brevi dicam de ortu et moribus parentum ejus, ut hinc lector advertat de qua radice prodierit, quod in studiis nascituræ prolis postmodum fulsit. Pater igitur ejus Gundulfus, mater Ermenberga vocabatur.[1] Utrique juxta seculi dignitatem nobiliter nati, nobiliter sunt in Augusta[2] civitate conversati. Quæ civitas confinis Burgundiæ et Longobardiæ.' Ermenbergam in se edidit, Gundulfum in Longobardia natum civem sui ex advena fecit. Conjuncti sunt lege conjugali ambo divitiis non ignobiles, sed moribus ex quadam parte dissimiles. Gundulfus enim seculari deditus vitæ, non adeo curam suis rebus impendere, sed habita frequenter ab re distribuere, in tantum ut non modo largus

[a] *The MSS have a wide diversity of title. The common formula in* αβ *is* INCIPIT VITA DOMNI (or SANCTI) ANSELMI ARCHIEPISCOPI.

[b] *The chapter headings were one of Eadmer's latest additions to his work: they are found only in* Є *and* K. *There is a set of rejected headings for the first book, probably in Eadmer's own hand, in MS C.C.C.C.341. The scribes of* SZI *have added two independent sets of chapter headings which certainly do not go back to Eadmer. In its earliest form the work does not appear to have any division into regular chapters but only into two Books.*

THE LIFE AND CONVERSATION OF
ANSELM ARCHBISHOP OF CANTERBURY

BOOK I

i. *Concerning the life and character of the parents of Anselm archbishop of Canterbury*

BEING NOW about to commit to writing an account of the life and conversation of Anselm, archbishop of Canterbury, I first invoke the help of God's great mercy and majesty. I shall then say something briefly about the place of Anselm's birth and the character of his parents, so that the reader may know from what root came the qualities which later shone forth in the child. His father, then, was called Gundulf; his mother Ermenberga[1]; both of them of noble birth, so far as worldly dignity goes, and living spaciously in the city of Aosta.[2] This city is on the border of Burgundy and Lombardy, and Ermenberga was born there. Gundulf was a Lombard by birth and became a citizen of Aosta by adoption. Though they were both affluent, and bound together in marriage, yet they were somewhat different in character. Gundulf was given up to a secular way of life, was careless of his goods and lavish in his munificence, so that he was regarded by some not

[1] For Anselm's family, see *St Anselm and his Biographer*, pp. 7-11

[2] The city of Aosta and the whole valley as far as the customs station at Bard was at this time within the kingdom of Burgundy, and was in process of being added to the growing power of the House of Savoy. (C. W. Previté Orton, *The Early History of the House of Savoy, 1000-1233*, Cambridge 1912, pp. 89-91)

atque beneficus, verum etiam prodigus atque vastator a nonnullis estimaretur. Ermenberga vero bonis studiis serviens, domus curam bene gerens, sua cum discretione dispensans atque conservans.' bonæ matris familias officio fungebatur. Mores erant probi et irreprehensibiles, ac juxta rectam considerationem ratione subnixi. Hæc fuit vita ejus, in hac dum vixit permansit, in hac finem vitæ sortiri promeruit. Gundulfus autem circa diem obitus sui spreto seculo monachus factus, monachus defunctus est.

ii. *Qualiter ipse Anselmus adhuc puerulus per visum viderit se jussu Dei nitidissimo pane refici*

At Anselmus filius horum.' cum puer parvulus esset, maternis prout ætas sua patiebatur colloquiis libenter animum intendebat. Et audito unum Deum sursum in cælo esse, omnia regentem, omnia continentem.' suspicatus est utpote puer inter montes nutritus cælum montibus incumbere, in quo et aulam Dei esse, eamque per montes adiri posse. Cunque hoc sepius animo volveret.' contigit ut quadam nocte per visum videret se debere montis cacumen ascendere, et ad aulam magni regis Dei properare. Verum priusquam montem cœpisset ascendere.' vidit in planitie qua pergebat ad pedem montis mulieres quæ regis erant ancillæ segetes metere, sed hoc nimis negligenter faciebant et desidiose. Quarum puer desidiam dolens atque redarguens.' proposuit animo se apud dominum regem ipsas accusaturum. Dehinc monte transcenso.' regiam aulam subit,ᵃ Deum cum solo suo dapifero invenit. Nam familiam suam ut sibi videbatur quoniam autumnus erat ad colligendas messes

ᵃ subiit EJ

only as generous and good-hearted, but even as prodigal
and spendthrift. Ermenberga however was prudent and
careful in the management of her household, both
spending and saving with discretion, and performing
well the offices of a mother of a family. Her ways were
upright and blameless and in a true sense guided by
reason. Such was her life; so she persevered till death;
so she was found worthy to die. But Gundulf, almost
on the day of his death, turned from the world and
became a monk, in which condition he died.

ii. *How Anselm while yet a boy saw himself in a vision fed
with the whitest of bread at God's command*

Now Anselm, their son, when he was a small boy lent
a ready ear to his mother's conversation, so far as his
age allowed. And hearing that there is one God in
heaven who rules all things and comprehends all things,
he—being a boy bred among mountains—imagined that
heaven rested on the mountains, that the court of God
was there, and that the approach to it was through the
mountains. When he had turned this over often in his
mind, it happened one night that he saw a vision, in
which he was bidden to climb to the top of the mountain
and hasten to the court of the great king, God. But
then, before he began to climb, he saw in the plain
through which he was approaching the foot of the
mountain, women—serfs of the king—who were reaping
the corn, but doing so carelessly and idly. The boy was
grieved and indignant at their laziness, and resolved to
accuse them before their lord the king. Then he
climbed the mountain and came to the royal court,
where he found God alone with his steward. For, as he
imagined, since it was autumn he had sent his household

miserat. Ingrediens itaque puer a domino vocatur. Accedit, atque ad pedes ejus sedet. Interrogatur jocunda affabilitate quis sit vel unde, quidque velit. Respondet ille ad interrogata, juxta quod rem esse sciebat. Tunc ad imperium Dei panis ei nitidissimus per dapiferum affertur, eoque coram ipso reficitur. Mane igitur cum quid viderit ante oculos mentis reduceret.' sicut puer simplex et innocens se veraciter in cælo, et ex pane Dei refectum fuisse credebat, hocque coram aliis ita esse publice asserebat. Crevit ergo puer, et ab omnibus diligebatur. Mores etenim probi in eo erant, qui magnopere illum diligi faciebant. Traditur litteris, discit, et in brevi plurimum proficit.

iii. *Qualiter ut monachus fieret, a Deo petierit ut infirmaretur, et exauditus sit*

Necdum attigerat ætatis quintum decimum annum.' et jam qualiter secundum Deum vitam melius instituere posset mente tractabat, idque concepit apud se, nichil in hominum conversatione monachorum vita prestantius esse. Quam assequi cupiens.' venit ad quendam sibi notum abbatem, rogans illum ut se monachum faceret. Sed abbas voluntate ipsius agnita.' quod petebat inscio patre illius ne offenderet animum ejus facere recusavit. At ille in suo proposito perstans.' oravit Deum quatinus infirmari mereretur, ut vel sic ad monachicum quem desiderabat ordinem susciperetur. Mira res. Ut enim Deus declararet, quantum etiam in aliis de suæ pietatis auditu confidere posset.' preces illius exaudivit, ac illi

to collect the harvest. The boy entered and was sum-
moned by the Lord. He approached and sat at his
feet. The Lord asked him in a pleasant and friendly
way who he was, where he came from and what he
wanted. He replied to the question as best he could.
Then, at God's command, the whitest of bread was
brought him by the steward, and he refreshed himself
with it in God's presence. The next day therefore,
when he recalled to his mind's eye all that he had seen,
like a simple and innocent boy he believed that he had
been in heaven and that he had been fed with the bread
of God, and he asserted as much to others in public.
So the boy grew and was loved by all. His ways were
upright and made him greatly to be loved. He went
to school, he learnt his letters and in a short time made
great progress.

iii. *How, in order to become a monk, he asked God for an
illness, and his request was heard*

He had not yet reached the age of fifteen, when he
began to revolve in his mind how he could best form his
life according to God's will, and he came to the con-
clusion that there was nothing in the life of men superior
to the life of a monk. In his desire to follow this life,
he came to an abbot who was known to him and asked
him to make him a monk. But the abbot, when he
discovered what he wanted, refused to do as he wished
without his father's knowledge, for fear of offending him.
Then Anselm, persisting in his resolve, prayed that God
might find him worthy of some sickness, so that thus if
by no other means he might be received into the mon-
astic order as he desired. Wonderful to relate, God
heard his prayer and sent him straightway a consider-

protinus validam corporis debilitatem immisit. Acriter
igitur infirmatus ad abbatem mittit, mortem se timere
pronunciat, orat ut monachus fiat, præfato timore ob-
stante non fit quod postulat. Et hoc quidem quantum
ad humanum spectabat examen. Cæterum Deus quem
futura non fallunt." servum suum ipsius loci conversatione
noluit implicari, propterea quod alios quosdam in sinu
misericordiæ suæ reconditos habebat, quos ut postmodum
claruit magis per illum ad suam voluntatem in posterum
disponebat informari. Post hæc sanitas juveni redit,
quodque tunc nequibat, in futuro se per gratiam Dei
facturum mente proponit.

iiii. *Quod quia pater suus ei nimis infestus fuit.' patriam exierit*

Exinde cum corporis sanitas, juvenilis ætas, seculi pro-
speritas ei arrideret." cœpit paulatim fervor animi ejus a
religioso proposito tepescere, in tantum ut seculi vias
magis ingredi, quam relictis eis monachus fieri cuperet.[1]
Studium quoque litterarum in quo se magnopere solebat
exercere." sensim postponere, ac juvenilibus ludis cœpit
operam dare. Veruntamen pia dilectio et diligens pietas
quas in matrem suam habebat." nonnichil eum ab istis
restringebant.[a] Defuncta vero illa." ilico navis cordis ejus
quasi perdita anchora in fluctus seculi pene tota dilapsa
est. Sed omnipotens Deus prævidens quid de illo fac-
turus erat, ne animam suam pace transitoria potitus

[a] restringebat αЄ1

[1] Gilbert Crispin calls Anselm *ecclesiae Augustensis clericus* (*Vita Herluini*,
p. 103). As one of Anselm's closest friends he was well placed to know the
truth, and his words suggest that Anselm was designed for a secular ecclesi-
astical career. If my conjecture about his family background is correct
(*St Anselm and his Biographer*, p. 9), this would be in keeping with the
traditional interests of his family.

able weakness of body—thus making known to him how much in other things also he might be confident of being heard with pity. Being thus sharply attacked by illness, he sent to the abbot, told him that he feared he was going to die and begged to become a monk. Again the abbot's fear prevented what he asked: or rather it did so, so far as the human eye could see. But God, who knows the future and is not deceived, did not wish his servant to be tied up in the habits of that place, because in the bosom of his mercy he had certain other men tucked away, whom—as later became clear—he designed in the future to be formed according to his will by Anselm's help. After this the youth regained his health, and he resolved that with God's help he would in the future do what he was at that time unable to perform.

iv. *How he left his native land because of his father's great hostility to him*

From that time, with health of body, youth and worldly well-being smiling upon him, he began little by little to cool in the fervour of his desire for a religious life—so much so that he began to desire to go the way of the world rather than to leave the world for a monastic life.[1] He gradually turned from study, which had formerly been his chief occupation, and began to give himself up to youthful amusements. His love and reverence for his mother held him back to some extent from these paths, but she died and then the ship of his heart had as it were lost its anchor and drifted almost entirely among the waves of the world. But Almighty God, foreseeing what he was going to make of him, stirred up for him a hateful and domestic strife, lest in

D

perderet." infestum ei et intestinum bellum generavit;
hoc est animum patris ejus acerbo contra illum odio
inflammavit, in tantum ut æque aut certe magis ea quæ
bene, sicut quæ perperam faciebat insequeretur. Nec
aliqua poterat patrem humilitate lenire, sed quanto illi se
exhibebat humiliorem." tanto illum sibi sentiebat asperi-
orem. Quod nimis intolerabile cernens, et ne deterius
quid inde contingeret timens." elegit potius paternis rebus
et patriæ abrenunciare, quam patri suo vel sibi quam-
libet infamiam ex sua cohabitatione procreare. Paratis
itaque iis quæ necessaria erant in viam ituris." patriam
egreditur, uno qui sibi ministraret clerico comitatus.
Cunque dehinc in transcensu montis Senisii[1] fatigaretur,
et laboris impatiens corpore deficeret." vires suas nivem
mandendo reparare temptabat. Nec enim aliud quo
vesceretur præsto fuit. Quod minister illius advertens."
doluit, et ne forte quid edendum haberetur in sacculo
qui asino illorum vehebatur." diligenter investigare cœpit,
et mox contra spem panem in eo nitidissimum repperit.[2]
Quo ille refectus." recreatus est, et viæ incolumis redonatus.

[1] It is noticeable that Anselm did not cross the Alps by the nearest
route from Aosta, by the St Bernard Pass, but went southwards and crossed
by Mont Cenis. It is possible that family connections guided him in his
choice, for we know that his sister and her family were closely connected
with the monastery of Chiusa at the foot of the Mont Cenis Pass.

[2] No doubt the use of the adjective *nitidissimus* here is intended to
inspire a sense of the miraculous, and probably to refer back to the same
phrase in chapter 2.

enjoying a transitory peace he should lose his soul. That is to say, he stirred up in his father's mind so keen a hatred against him that he persecuted him as much, or even more, for the things he did well as for those which he did ill. Nor could he soften his father by any degree of humility, but the more humble he showed himself towards his father, the sharper did he feel his father's anger towards him. When he saw that this was becoming more than he could bear, he feared that worse might come of it, and he chose rather to renounce both his patrimony and his country than to bring some disgrace upon either himself or his father by continuing to live with him. He gathered together those things which were necessary for the journey, and left his country, with a clerk as his companion and servant. As they were crossing Mount Cenis,[1] he grew weary and his strength failed him, being unequal to the toil. He tried to revive himself by eating snow, for there was nothing else at hand which he could eat. His servant was grieved to see this and began to make a careful search in the bag which was carried on the ass's back to see if by chance there was anything to eat. Soon, against all expectation, he found some bread of exceptional whiteness[2] and, having eaten and been refreshed, Anselm set out once more on the road with renewed strength.

v. *Quod Lanfrancum virum prudentissimum adierit, et ejus discipulatui subditus, quomodo ubi monachus fieret deliberaverit*

Exactis dehinc partim in Burgundia, partim in Francia ferme tribus annis.' Normanniam vadit,*ᵃ¹* quendam nomine Lanfrancum, virum videlicet valde bonum, præstanti religione ac sapientia vere nobilem videre, alloqui, et cohabitare volens. Excellens siquidem fama illius quaque percrebruerat, et nobilissimos quosque clericorum ad eum de cunctis mundi partibus agebat.² Anselmus igitur viro adito, eumque singulari quadam sapientia pollere agnito.' ejus se magisterio subdit, eique post modicum familiaris præ cæteris discipulis fit. Occupatur die noctuque in litterarum studio, non solum quæ volebat a Lanfranco legendo,³ sed et alios quæ rogabatur studiose docendo. Propter quæ studia cum corpus vigiliis, frigore et inedia fatigaret.' venit ei in mentem quia si aliquo monachus ut olim proposuerat esset.' acriora quam patiebatur eum pati non oporteret,ᵇ nec tunc sui laboris meritum perderet, quod nunc utrum sibi maneret non perspiciebat. Hoc ergo mente concepto.' totam

ᵃ VRP *here add*: Abrincam ipsius provinciae urbem petit ubi aliquandiu moratur (demoratur RP). Post haec venit (et *add.* RP) Beccum magistrum ᵇ oportere βΘE

¹ The addition here made by MSS VRP, which represent a Bec tradition, provides a new piece of evidence for the importance of Avranches as a teaching centre in the middle of the eleventh century. Lanfranc is likewise said to have been taught at Avranches before going to Bec, though the information is first found in the *Life* ascribed to Milo Crispin, which cannot be dated earlier than the first half of the twelfth century (*P.L.* 150, 29-30).

² Gilbert Crispin thus describes the crowd of pupils who gathered at Bec at this time to study under Lanfranc, and the result for the prosperity of the monastery: 'Accurrunt clerici, ducum filii, nominatissimi scholarum Latinitatis magistri; laici potentes, alta nobilitate viri multi pro ipsius amore multas eidem ecclesiae terras contulere. Ditatur ilico Beccensis locus ornamentis, possessionibus, personis nobilibus et honestis: interius religio atque eruditio multum accrescere, exterius rerum omnium necessariarum subministratio coepit ad plenum abundare' (*Vita Herluini*, p. 97). Lanfranc's

v. *How he went to Lanfranc, a man of great prudence, and became his pupil; and how he deliberated where to become a monk*

After passing almost three years from this time, partly in Burgundy and partly in France, he went to Normandy[1] to see, to talk to, and stay with a certain master by the name of Lanfranc, a truly good man and one of real nobility in the excellence of his religious life and wisdom. His lofty fame had resounded everywhere and had drawn to him the best clerks from all parts of the world.[2] Anselm therefore came to him and recognised the outstanding wisdom, which shone forth in him. He placed himself under his guidance and in a short time became the most intimate of his disciples. He gave himself up day and night to literary studies, not only reading with Lanfranc those things which he wished,[3] but teaching carefully to others the things which they required. While he was thus wearying his body with late nights, with cold and with hunger because of his studies, he began to think that if he had become a monk somewhere, as he formerly intended, he would not have had to put up with anything more severe than what he was now suffering, nor would he then lose the reward of his labour, which he was quite uncertain of retaining in his present state. When this had once entered his

was clearly an 'external' school, in the sense that his pupils did not normally intend to become monks. For schools of this kind, which were not encouraged by strict monastic reformers, see E. Lesne, *Histoire de la Propriété Ecclésiastique en France*, tome v: *Les Écoles*, 1940, pp. 433-41.

[3] The phrase *a Lanfranco legendo* implies the regular study of a text under a master who commented on the difficult words and passages. Cf. Anselm *Ep.* 64 [i, 55] to the monk Maurice: 'Audivi quod legas a domno Arnulfo . . . Si autem nihil tibi legit et tua hoc est negligentia, displicet mihi, et volo quatenus ut fiat, quantum potes satagas, et praecipue de Virgilio et aliis auctoribus quos a me non legisti.'

intentionem suam ad placendum Deo dirigere cœpit, et
spernendo mundum cum oblectaminibus suis.' revera
cupit fieri monachus. Quid plura? Cogitat ubi melius
perficere queat quod facere desiderat, et ita secum tractat,
'Ecce' inquit 'monachus fiam. Sed ubi? Si Cluniaci vel
Becci.' totum tempus quod in discendis litteris posui,
perdidi. Nam et Cluniaci districtio ordinis, et Becci
supereminens prudentia Lanfranci qui illic monachus
est.' me aut nulli prodesse, aut nichili valere compro-
babit.[1] Itaque in tali loco perficiam quod dispono, in
quo et scire meum possim ostendere, et multis prodesse.'
Hæc ut ludens ipsemet referre solebat, secum medita-
batur. Addebatque, 'Necdum eram edomitus, necdum
in me vigebat mundi contemptus. Unde quod ego ut
putabam fretus aliorum caritate dicebam.' quam dam-
nosum esset non advertebam.' Postmodum autem in se
reversus,[2] 'Quid?' inquit, 'Essene monachus hoc est,
velle scilicet aliis præponi, præ aliis honorari, ante alios
magnificari? Non. Illic igitur deposita contumacia
monachus deveni, ubi sicut æquum est cunctis propter
Deum postponaris, cunctis abjectior habearis, præ cunc-
tis parvipendaris. Et ubi hoc esse poterit? Equidem
Becci. Ibi siquidem nullius ponderis ero, quandoquidem
ille ibi est qui præminentis sapientiæ luce conspicuus,
cunctis sufficiens, cunctis est honorabilis et acceptus.

[1] This is an important passage for the comparison of the monastic disci-
pline at Cluny and Bec—a comparison which is not at all easy to substan-
tiate from contemporary sources. The notorious fulness of the monastic day
at Cluny can be studied in detail shortly before the middle of the eleventh
century in the customs of Farfa (B. Albers, *Consuetudines Monasticae*, I, 1900,
pp. 4-136). But it is not clear how these customs differed, or in what ways
they were more onerous than those of Bec, for the nearest approach to what
may be presumed to have been the customs of Bec is in the monastic consti-
tution of Lanfranc for Christ Church, Canterbury. But since these regula-
tions were compiled 'ex consuetudinibus eorum cenobiorum quae nostro
tempore maioris auctoritatis sunt in ordine monachorum' (p. 1), the cus-

head, he began to turn his whole intention to pleasing God; and, despising the world and its pleasures, he desired in very truth to become a monk. And what then? He turned over in his mind where he could best bring to pass what he desired, and he argued thus with himself: 'Well then, I shall become a monk. But where? If at Cluny or at Bec, all the time I have spent in study will be lost. For at Cluny the severity of the order, and at Bec the outstanding ability of Lanfranc, who is a monk there, will condemn me either to fruitlessness or insignificance.[1] Let me therefore carry out my plan somewhere where I can both display my knowledge and be of service to others.' He often used playfully to recount these thoughts of his, and he would add: 'I was not yet tamed, and there was not yet in me any strong contempt of the world. Hence when I said this, as I thought, out of love for others, I did not see how damnable it was.' But after a while he came to himself.[2] 'What?' he said. 'Is this being a monk —to desire to be set over others, to receive more honour and glory than others? Far from it. So put aside your rebelliousness and become a monk in that place where, rightly and for God's sake, you will be lowest of all, and where you will be most insignificant and be held in less esteem than all others. And where can this be? At Bec, of course. For there I shall be of no weight, so long as he is there who is conspicuous by the light of his pre-eminent wisdom, who is adequate to all calls, and who is honoured and acceptable to all. There I

toms of Bec were not their 'only, or even the principal source'. See D. Knowles, *The Monastic Constitutions of Lanfranc*, 1951, pp. xii-xiii.

[2] Luke xv.17

Illic ergo requies mea[1], illic solus Deus intentio mea, illic solus amor ejus erit contemplatio mea, illic beata et assidua memoria ejus felix solamen et satietas mea.' Hæc cogitabat, hæc desiderabat, hæc sibi provenire sperabat.

vi. *Quod consilio Lanfranci et Maurilii Rotomagensis archi-episcopi monachus factus sit*

Raptabatur quoque mens ejus per id temporis in alias sectandæ semitas vitæ, sed vis desiderii ejus in hanc quammaxime declinaverat. Sciens itaque scriptum esse, 'Omnia fac cum consilio et post factum non pænitebis'.[2] nolebat se alicui uni vitæ earum quas mente volvebat inconsulte credere, ne in aliquo videretur scripturæ præceptis non obœdire. Amicos insuper multos habens, sed cui se totum in istis committeret consiliarium unum de mille[3] videlicet præfatum Lanfrancum eligens.' venit ad eum, indicans voluntatem suam ad tria pendere, sed per ejus consilium ad unum quod potissimum judicaret duobus relictis se velle tenere.[a] Quæ tria sic exposuit ei.[b] 'Aut enim' inquit 'monachus fieri volo, aut heremi cultor esse desidero, aut ex proprio patrimonio vivens.' quibuslibet indigentibus propter Deum pro meo posse exinde ministrare si consulitis cupio.'[4] Jam enim pater illius[c] obierat, et tota hæreditas illum[d] respiciebat. 'In his' inquam 'tribus voluntatem meam domine Lanfrance fluctuare sciatis, sed precor ut me in horum potissimo stabiliatis.' Differt Lanfrancus sententiam ferre, suadet-

[a] tendere MN [b] EI EXPOSUIT αβ [c] eius β [d] AD ILLUM αβ

[1] cf. Ps. cxxxi.14 (Vulg.)
[2] Ecclus. xxxii.24: Fili, sine consilio nihil facias, et post factum non poenitebis.
[3] Ecclus. vi.6

shall have rest,[1] there God will be to me all in all, there
His love will be the only subject of my contemplation,
the blessed and unremitting memory of Him will there
be my sweet solace and satisfaction.' These were his
thoughts, these his desires, these his hopes for the future.

vi. *How he became a monk on the advice of Lanfranc and
Maurilius, archbishop of Rouen*

Sometimes also at that time he was attracted by other
walks in life, but on this chiefly were his desires fixed.
Knowing therefore that it is written, 'Do all things with
counsel, and when they are done you will not repent,'[2]
he was unwilling to commit himself unadvisedly to any
one of the walks of life on which his thoughts were
turned, lest he should seem in anything to disobey the
commands of Holy Scripture. He had many friends
besides Lanfranc, but when he came to choose that one
counsellor in a thousand[3] on whom he could rely utterly
in these matters, he chose Lanfranc. He came to him
and told him that he was undecided between three
courses of action, but that he would hold to the one
which Lanfranc judged best and reject the other two.
He expounded to him the three aims, as follows[4]: 'I
want,' he said, 'either to be a monk, or to dwell in a
hermitage, or to live on my family estate, ministering so
far as I can to the poor, in God's name, if you advise it'
—for his father had died by this time and all the inheri-
tance had come to him. ' Know then, my lord Lanfranc,
that these are the three things between which my will
fluctuates; but I beg that you will stablish me in the
one which you think best.' Lanfranc hesitated to give

[4] For the significance of this choice, see *St Anselm and his Biographer*,
pp. 27-9.

que negotium ad venerabilis Maurilii[1] Rotomagensis episcopi*a* audientiam magis referre. Acquiescit Anselmus consilio, et comitatus Lanfranco pontificem petit. Tanta autem vis devotionis pectus Anselmi tunc possidebat, tantumque veri consilii*b* Lanfranco inesse credebat./ ut cum Rotomagum petentes per magnam quæ super Beccum est silvam pergerent, si Lanfrancus ei diceret, 'In hac silva mane, et ne dum vixeris hinc exeas cave'./ proculdubio ut fatebatur imperata servaret. Pervenientes ergo ad episcopum./ adventus sui causas ei exponunt, quid inde sentiat quærunt. Nec mora. Monachicus ordo præ cæteris laudatur, ejusque propositum omnibus aliis antefertur. Anselmus hæc audiens et approbans./ omissis aliis, seculo relicto Becci factus est monachus, anno ætatis suæ vicesimo septimo.

vii. *Qualiter prior factus una nocte divinis intentus per medios parietes corporali intuitu viderit quæ ultra fiebant*

Regebat eo tempore cœnobium ipsum domnus abbas Herluinus nomine, vir grandevus, et magna probitate conspicuus. Qui primus ipsius loci abbas./ monasterium ipsum a fundamentis de suo patrimonio fecerat.[2] Sepedictus autem Lanfrancus./ gradum prioris obtinebat. Anselmus vero novus monachus factus./ studiose vitam aliorum religiosius viventium emulabatur; immo ipse sic religioni per omnia serviebat, ut quisquis religiose in tota ipsa congregatione vivere volebat, in ejus vita satis in-

a archiepiscopi VRP *b* consilio TUX

[1] Maurilius, archbishop of Rouen, 1055-67; previously a monk of Fécamp and author of a prayer ascribed to St Anselm in many manuscripts (*Or.* xlix, *P.L.* 158, 946; see A. Wilmart, *Auteurs spirituels*, pp. 480-1).
[2] The story of Herlwin and the foundation of Bec in 1034 has often been

an opinion and advised rather that the matter should
be taken to be heard by the venerable Maurilius, arch-
bishop of Rouen.[1] Anselm acquiesced in this plan, and
together with Lanfranc he went to the archbishop. By
this time Anselm's devotion to Lanfranc was so great,
and his belief in the value of Lanfranc's advice so strong,
that if while they were going to Rouen through the
great wood which lies above Bec Lanfranc had said to
him 'Stay in this wood and see that you never come
out so long as you live', without a doubt, as he used to
say, he would have obeyed the command. They came
then to the bishop, explained the reason for their coming,
and asked him what he thought about it. Without
hesitation the monastic life was extolled beyond the
others, and the monastic profession recommended before
all others. Anselm heard and approved. Then, setting
aside all else, he left the world and became a monk at
Bec, being then in his twenty-seventh year.

vii. *How he was made prior, and how one night while engaged*
in holy meditation he saw through a wall with his physical sight
the things which were taking place on the other side of it

The monastery was ruled at this time by an abbot, Dom
Herlwin by name, a man of great age and well-known
for his upright life. It was he who had built the monas-
tery from its foundations on his own patrimony, and
he was its first abbot.[2] Lanfranc, whom we have often
mentioned already, held the office of prior. And now
Anselm, being a new monk, set himself to imitate the
lives of the more religious among the monks. Indeed
he so performed every religious duty, that if anyone in

told—most fully in Porée, *Histoire de l'Abbaye du Bec*, I, 1901, pp. 30-45; to the
sources there quoted should be added the *Vita Herluini* by Gilbert Crispin.

veniret quod imitaretur. Et ita per triennium de die in diem semper in melius proficiens.ʲ magnus et honorandus habebatur. Venerabili autem Lanfranco in Cadomensis cœnobii regimen assumpto.ʲ ipse prioris officio functus est.¹ Sicque Deo serviendi ampliore libertate potitus.ʲ totum se, totum tempus suum in illius obsequio expendere, seculum et cuncta negotia ejus ab intentione sua funditus cœpit amovere. Factumque est ut soli Deo cælestibusque disciplinis jugiter occupatus.ʲ in tantum divinæ speculationis culmen ascenderit, ut obscurissimas et ante suum tempus insolutas de divinitate Dei et nostra fide quæstiones Deo reserante perspiceret ac perspectas enodaret, apertisque rationibus quæ dicebat rata et catholica esse probaret. Divinisᵃ nanque scripturis tantam fidem habebat, ut indissolubili firmitate cordis crederet nichil in eis esse quod solidæ veritatis tramitem ullo modo exiret. Quapropter summo studio animum ad hoc intenderat, quatinus juxta fidem suam mentis ratione mereretur percipere, quæ in ipsis sensit multa caligine tecta latere. Contigit ergo quadam nocte ut ipse in hujusmodi mente detentus ante nocturnas vigilias vigilans in lecto jaceret, et meditando secum rimari conaretur quonam modo prophetæ præterita simul et futura quasi præsentia olim agnoverint, et indubitanter ea dicto vel scripto protulerint. Et ecce cum in his totus esset, et ea intelli-

ᵃ Divinis . . . luce perfusus (cap. 8) om. MN

¹ The dates of the events described in these sentences cannot be established with certainty, but the following scheme best fits the known facts: 1059 Anselm's arrival at Bec; 1060 his monastic profession; 1063 appointment of Lanfranc as abbot of Caen and of Anselm as prior of Bec. For the conflicting evidence see Porée, I, pp. 118-20, where reasons are given for adopting the chronology given above. The best of these reasons is the authority of Anselm himself: writing in August 1093 he says, 'Sic enim vixi iam per triginta tres annos in habitu monachico—tribus scilicet sine praelatione, quindecim in prioratu, totidem in abbatia annis . . . ' (Ep. 156,

the whole community wished to lead a religious life, he
had in Anselm a pattern which he could follow. So,
for three years, he grew daily in stature, and was held
in honour and esteem. Then when Lanfranc was taken
away to govern the monastery at Caen, Anselm suc-
ceeded to the office of prior.[1] Having thus obtained a
larger liberty for the service of God, he began to devote
his whole self and his whole time to serving God, and
he put the world and all its affairs entirely behind him.
And so it came about that, being continually given up
to God and to spiritual exercises, he attained such a
height of divine speculation, that he was able by God's
help to see into and unravel many most obscure and
previously insoluble questions about the divinity of God
and about our faith, and to prove by plain arguments
that what he said was firm and catholic truth. For he
had so much faith in the Holy Scriptures, that he firmly
and inviolably believed that there was nothing in them
which deviated in any way from the path of solid truth.
Hence he applied his whole mind to this end, that
according to his faith he might be found worthy to see
with the eye of reason those things in the Holy Scriptures
which, as he felt, lay hidden in a deep obscurity. Thus
one night it happened that he was lying awake on his
bed before matins exercised in mind about these matters;
and as he meditated he tried to puzzle out how the
prophets of old could see both past and future as if they
were present and set them forth beyond doubt in speech
or writing. And, behold, while he was thus absorbed
and striving with all his might to understand this

[iii, 7]). The allowance of a year between Anselm's arrival at Bec and his
taking the habit is no more than a plausible conjecture.

gere magnopere desideraret.ᴶ defixis oculorum suorum
radiis vidit per medias maceries oratorii ac dormitorii
monachos quorum hoc officium erat pro apparatu matu-
tinarum altare et alia loca æcclesiæ circumeuntes, lumi-
naria accendentes, et ad ultimum unum eorum sumpta
in manibus corda pro excitandis fratribus schillam[1] pul-
santem. Ad cujus sonitum conventu fratrum de lectis
surgente.ᴶ miratus est de re *a* quæ acciderat. Concepit
ergo apud se Deo levissimum esse prophetis in spiritu
ventura monstrare, cum sibi concesserit quæ fiebant per
tot obstacula corporeis oculis posse videre.

viii. *Quali modo de moribus hominum, virtutibus ac vitiis*
 disseruerit, et quibus exercitiis vitam suam instituerit

Hinc perspicaciori interius sapientiæ luce perfusus.ᴶ mores
omnis sexus et ætatis ita discretionis ratione monstrante
penetravit, ut eum palam inde tractantem, adverteres
cuique sui cordis arcana revelare. Origines insuper et
ipsa ut ita dicam semina atque radices necne processus
omnium virtutum ac vitiorum detegebat, et quemad-
modum vel hæ adipisci, vel hæc devitari aut*b* devinci
possent luce clarius edocebat.[2] Tantam autem omnis
boni consilii vim in eo elucere cerneres, ut pectori
ejus spiritum consilii præsidere non ambigeres. Quam
promptus vero atque assiduus in sanctis exortationibus
fuerit.ᴶ supervacuum est dicere, cum illum semper in

 a de re est VRP *b* atque β

 [1] *scilla*: the small bell used as a first signal for Nocturns or Matins. See
Regularis Concordia, ed. T. Symons, 1953, p. 13, *n.* 3, where the three signals
of increasing urgency are described. The word is used in *The Monastic
Constitutions of Lanfranc*, ed. D. Knowles, p. 4: 'Cum appropinquaverit tem-
pus horae terciae, pulsetur a secretario modice signum minimum quam
skillam vocant.'
 [2] Anselm was one of the first medieval thinkers to give serious attention

problem, he fixed his eyes on the wall and—right through the masonry of the church and dormitory—he saw the monks whose office it was to prepare for matins going about the altar and other parts of the church lighting the candles; and finally he saw one of them take in his hands the bell-rope and sound the bell[1] to awaken the brethren. At this sound the whole community rose from their beds, and Anselm was astonished at the thing which had happened. From this he saw that it was a very small thing for God to show to the prophets in the spirit the things which would come to pass, since God had allowed him to see with his bodily eyes through so many obstacles the things which then were happening.

viii. *How he discoursed about virtues and vices and the habits of men; and the spiritual exercises on which he formed his life*

Being thus inwardly more clearly illuminated with the light of wisdom and guided by his power of discrimination, he so understood the characters of people of whatever sex or age that you might have seen him opening to each one the secrets of his heart and bringing them into the light of day. Besides this he uncovered the origins and, so to speak, the very seeds and roots and process of growth of all virtues and vices, and made it clearer than light how the former could be attained and the latter avoided or subdued.[2] And you might have seen such power in every form of good counsel shine forth in him, as to leave no doubt that the spirit of counsel ruled in his heart. It is needless to say how ready and how assiduous he was in holy exhortations, for it is said that, being himself indefatigable, he wore

to the classification of the virtues and the results of his speculations are to be seen in various places, especially in *De Similitudinibus*, caps. 1-40. For this work and its sources, see *St Anselm and his Biographer*, pp. 221-6.

ipsis infatigabilem omnes ferme audientes constet fati-
gasse, quodque dicitur de sancto Martino 'ejus ori nun-
quam Christus defuit, sive justitia, vel quicquid ad veram
vitam pertinet'.'[1] incunctanter confirmemus sine men-
dacio posse dici de illo. In his leve est lectorem adver-
tere, eum de mensa Domini non sine quodam præsagio
per visum jam olim nitido refectum pane fuisse. De
corporalibus ejus exercitiis, jejuniis dico, orationibus
atque vigiliis, melius estimo silere quam loqui. Quid
nanque de illius jejunio dicerem, cum ab initio prioratus
sui tanta corpus suum inedia maceraverit, ut non solum
omnis illecebra gulæ penitus in eo postmodum extincta
sit, sed nec famem sive delectationem comedendi pro
quavis abstinentia utpote[a] dicere consueverat aliquando
pateretur? Comedebat tamen ut alii homines,[2] sed
omnino parce, sciens corpus suum sine cibo non posse
subsistere. In orationibus autem quas ipse juxta deside-
rium et petitionem amicorum suorum scriptas edidit, qua
sollicitudine, quo timore, qua spe, quo amore Deum et
sanctos ejus interpellaverit, necne interpellandos docu-
erit.' satis est et me tacente videre.[3] Sit modo qui eis pie[b]
intendat, et spero quia cordis ejus affectum suumque
profectum in illis et per illas gaudens percipiet. Quid
de vigiliis? Totus dies in dandis consiliis sepissime non
sufficiebat, addebatur ad hoc pars maxima noctis. Præ-

[1] Sulpicius Severus, *Vita S. Martini*, cap. 27: 'nunquam in illius ore
nisi Christus, nunquam in illius corde nisi pietas, nisi pax, nisi misericordia
inerat' (C.S.E.L., ed. C. Halm, p. 137).
[2] cf. Athanasius, *Vita S. Antonii*: 'Edebat tamen utpote homo' (*P.L.* 73,
146; and see below p. 78).
[3] The earliest of Anselm's writings were his Prayers and Meditations,
and it was through them that he first became known in the monastic world
outside Bec. For the collection of Prayers and Meditations, see Schmitt,
vol. III, and the numerous articles by Dom A. Wilmart there quoted (especi-

out almost all his listeners, and without any exaggeration
we can unhesitatingly affirm of him, what was said of
St Martin, that 'the name of Christ, or of justice or
whatever else belongs to the way of true life was always
on his lips'.[1] So the reader can easily see that there
was something prophetic in that early vision of his
in which he was fed with pure bread from the Lord's
table.

About his bodily discipline—I mean his fasts, his
prayers, his vigils—I think it is better to be silent than
to speak. For what should I say about the fasts of one
who from the time when he became prior so emaciated
his body with fasting that not only from this time were
all the lusts of the belly utterly extinguished, but even
as he used to say, neither hunger nor pleasure in eating
were induced by any amount of abstinence? Of course
he ate like other men,[2] knowing that his body could not
be supported without food, but he ate most sparingly.
As for his prayers, which at the desire and request of his
friends he wrote and published, anyone can see without
my speaking about them with what anxious care, with
what fear, with what hope and love he addressed him-
self to God and his saints, and taught others to do the
same.[3] If the reader will only study them reverently, I
hope that his heart will be touched, and that he will
feel the benefit of them, and rejoice in them and for
them. And what of his vigils? Very often the whole
day did not suffice for giving good counsel, but he added
thereto the greater part of the night. By night also he

ally his introduction to A. Castel, *Méditations et prières de saint Anselme*, 1923,
and the papers collected in A. Wilmart, *Auteurs spirituels*. For the early
diffusion of these works between 1071 and 1077, see *Ep.* 10 [iv, 121], 28
[i, 20], 55 [i, 46], 70 [i, 61]. For their place in Anselm's development see
St Anselm and his Biographer, pp. 34-47.

terea libros qui ante id temporis nimis corrupti ubique
terrarum erant nocte corrigebat[1]; sanctis meditationibus
insistebat; ex contemplatione summæ beatitudinis et
desiderio vitæ perennis immensos lacrimarum imbres
effundebat; hujus vitæ miserias, suaque si qua erant et
aliorum peccata amarissime flebat, et vix parum ante
nocturnas vigilias sepeque nichil somni capiebat. Talibus
studiis vita ejus ornabatur. Qualiter autem erga sub-
ditos se habebat.ᶦ det Deus ad emulationem prælatorum
posse quid vel modicum dici.

ix. *Quod quorundam odium contra se in sinceram dilectionem*
converterit

Cum primum igitur prior factus fuisset.ᶦ quidam fratres
ipsius cœnobii facti sunt emuli ejus, videntes et videndo
invidentes illum præponi, quem juxta conversionis ordi-
nem judicabant sibi debere postponi.ᵃ Itaque turbati
aliosqueᵇ turbantes scandala movent, dissentiones pari-
unt, sectas nutriunt, odia fovent. At ipse cum iisᶜ qui
oderunt pacem erat pacificus,[2] et detractionibus eorum
reddebat officia fraternæ caritatis, malens vincere mali-
tiam in bono, quam a malitia eorum vinci in malo.[3]
Quod miserante Deo factum est. Siquidem illi animad-

ᵃ subponi β ᵇ alios VRP ᶜ his Aβ

[1] The correction of corrupt texts is an activity very characteristic of this
phase of monastic development. St Dunstan's earliest biographer says of
him 'summum studium fuit ut . . . etiam mendosos libros, dum primam
orientis diei lucem contueri potuit, erasa scriptorum falsitate corrigeret'
(Stubbs, *Memorials of St Dunstan*, p. 49). The Bec tradition of this activity
on Lanfranc's part is preserved in Milo Crispin: *Vita Lanfranci* (ed. Giles, I,
p. 310): 'Et quia scripturae scriptorum vitio erant nimium corruptae, omnes
tam Veteris quam Novi Testamenti libros, necnon etiam scripta sanctorum
Patrum, secundum orthodoxam fidem studuit corrigere. Et etiam multa
de his quibus utimur nocte et die in servitio Ecclesiae ad unguem emen-
davit; et hoc non tantum per se, sed etiam per discipulos suos fecit.'
Evidence for Lanfranc's work as a corrector is to be found in MSS
Alençon 136 and Le Mans 15, and probably anonymously in several other

corrected the books, which in all countries before this time were disfigured by mistakes[1]; he occupied himself in holy meditations; and in his contemplation of the final blessedness and in his desire for the life everlasting he shed profuse tears. He wept most bitterly for the miseries of his life, for his own sins (if such there were) and for those of others, and he slept hardly at all—often not at all—before matins. These were the activities with which his own life was adorned. Now let me, with God's help, say something however briefly about his conduct toward those under him, as an example to other prelates.

ix. *How he converted the hatred which some felt for him into genuine love*

At first then after he became prior some of the brethren of the monastery were his enemies, being envious at seeing him, whom in seniority of profession they judged ought to have come after them, preferred before them. Being thus upset, they upset others; they spread scandal, they made dissensions, they formed cliques and fostered hatreds. But to those who hated peace, he showed himself peaceful.[2] He repaid their detractions with the offices of brotherly charity, preferring to overcome evil with good rather than, in wrong-doing, to be overcome by their wickedness.[3] In this purpose, by God's mercy,

manuscripts. There is no similar evidence of Anselm's activity in correcting manuscripts. The probable reason for this is that the manuscripts on which Lanfranc worked were valued for their marginal annotations, and were therefore copied; Anselm was not a commentator and his work on correcting texts therefore never won wide recognition.

[2] cf. Ps. cxix.7 (Vulg.)
[3] cf. Rom. xii.21

vertentes eum omnimodis pure ac simpliciter in cunctis
actionibus suis incedere, neque quod jure blasphemari
posset in illo residere.' mala voluntate in bonam mutata,
dicta ejus et facta in bono emulari cœpere. Verum ut
clareat quo pacto id provenerit.' unum ex ipsis exempli
gratia ponam, quatinus agnito quo dolo Anselmi a sua
pravitate sit mutatus.' qualiter et alii per eum correcti
sint perpendatur.

x. *Qualiter quendam adolescentem Osbernum nomine a pravitate
vitæ correxerit, et quid moriens viderit ei mortuus intimaverit*

Osbernus quidam nomine, ætate adolescentulus, ipsius
erat monasterii monachus.[1] Ingenio quidem sagax, et
artificiosis ad diversa opera manibus pollens.' bonam in
se bonæ spei materiam præferebat. Sed mores qui in eo
valde perversi erant ista multum decolorabant, et in-
super odium quod omnino more canino contra Anselmum
exercebat. Quod odium quantum ad se Anselmus non
magnipendens, sed tamen mores illius*a* concinere saga-
citati ingenii ejus magnopere cupiens.' cœpit quadam
sancta calliditate puerum piis blandimentis delinire,
puerilia facta ejus benigne tolerare, multa illi quæ sine
ordinis detrimento tolerari poterant concedere, in quibus
et ætas ejus delectaretur, et efrenis animus in mansuetu-
dinem curvaretur. Gaudet puer in talibus, et sensim a
sua feritate ipsius demittitur animus. Incipit Anselmum

a illius *om.* VRP

[1] Some of Anselm's earliest letters were written under the immediate
impact of Osbern's death, which probably took place in 1071 (*Ep.* 4, 5
and 7). In the list of monks of Bec, the name of Osbern is separated by a
single name from those of Lanfranc (nephew of the archbishop), Wido,
Hernaldus and Giraldus, who were the last monks before the removal was
made to the new monastery in October 1073 (Porée, 1, p. 630). The young
Lanfranc probably came to Bec about Easter 1072. New professions were
not frequent at this time (on an average only two or three a year), but it is

he succeeded, inasmuch that they—perceiving that he walked purely and innocently in all his ways and that there was nothing in him for which he could rightly be reproached—changed their evil intention to a good one, and began in well-doing to emulate his words and deeds. In order to make it clear how this happened, I shall take one of them as an example; and by seeing how he was turned from his evil ways by Anselm's guile, we may gather how others also were corrected by him.

x. *How he corrected the evil life of a certain young man called Osbern, who died and told him what he had seen after death*

There was a certain monk of the monastery, Osbern by name, in years little more than a boy.[1] He was distinguished by the keenness of his mind and by his skill in different kinds of handiwork, and he had the stuff in him which held out good promise for the future. But his good qualities were much disfigured by his really difficult character, and also by the mordant hatred with which he pursued Anselm. Anselm took little notice of the hatred on his own account, but he greatly desired to bring his character into conformity with the brightness of his intellect. He began with a certain holy guile to flatter the boy with kindly blandishments; he bore indulgently his boyish pranks, and—so far as was possible without detriment to the Rule—he allowed him many things to delight his youth and to tame his unbridled spirit. The youth rejoiced in these favours, and gradually his spirit was weaned from its wildness. He began to love Anselm, to listen to his advice, and to

clear that Osbern's profession can scarcely be earlier than 1070, and 1071 is more likely; his death must have followed it within a short space of time.

diligere, ejus monita suscipere, mores suos componere.
Quod ille intuens;' præ cæteris eum familiariter amplec-
titur, nutrit, fovet,ᵃ et ut semper in melius proficiat
omnibus modis ortatur et instruit. Dehinc paulatim ei
quæ concesserat puerilia subtrahit, eumque ad honestam
morum maturitatem provehere satagit. Non frustratur
pia sollicitudo ejus, proficiunt in juvene ac roborantur
sacra monita ejus. Ergo ubi de firmitate boni studii
adolescentis se posse confidere animadvertit;' mox omnes
pueriles actus in eo resecat, et siquid reprehensionis eum
admittere comperit;' non modo verbis, sed et verberibus
in eo acrius vindicat. Quid ille? Æquanimiter cuncta
sustinet, confirmatur in proposito omnis religionis, fervet
in exercitio discendæ omnis sanctæ actionis, suffert pati-
enter aliorum contumelias, opprobria, detractiones, ser-
vans erga omnes affectum sinceræ dilectionis. Lætatur
pater in his ultra quam dici possit, et diligit filium sancto
caritatis igne plusquam credi possit. Sed cum ipse, ut
flens referebat, eum ad magnum æcclesiæ fructum pro-
ficere speraret;' ecce gravi corporis infirmitate præripitur,
lectoque recipitur. Videres tunc bonum patrem, felicis
juvenis amicum lecto jacentis die noctuque assidere,
cibum et potum ministrare, omnium ministrorum super
se ministeria suscipere, veri amici morem in omnibus
gerere. Ipse corpus, ipse animam ejus studiosissime
refovebat. Appropinquanti autem ad exitum;' familiari
præcepit alloquio, quatinus post obitum suum si possibile

ᵃ fovet *om.* VRPMN

refashion his way of life. When Anselm saw this, he showed a more tender affection to him than to any other; he nursed and cherished him, and by his exhortation and instruction he encouraged him in every way to improve. Then slowly he withdrew the concessions made to his youth, and strove to draw him on to a mature and upright way of life. Nor was his pious care in vain: his holy counsels took firm root in the youth and bore fruit. When therefore he saw that he could confidently rely on the firmness of the young man's good intent, he began to cut away all childish behaviour in him, and if he found in him anything worthy of blame, he punished him severely not only with words but also with blows. And how did he stand it? He bore everything patiently, he was strengthened in every religious endeavour, he was eager to learn every form of religious exercise, he patiently endured the reproaches, the insults, the detractions of the others, and preserved towards all an attitude of unfeigned love. His spiritual father rejoiced in these things more than can be said, and, inspired by the holy fire of charity, he loved his son more than you could believe possible. But, as he used to relate with tears, just as he was hoping that the young man would bring much profit to the church, he was seized with a serious bodily infirmity and confined to his bed. Then might you have seen the good father (happy youth to have such a friend!) sitting by the sick-bed day and night, giving him his food and drink, taking upon himself the burden of every form of service, in everything showing himself a true friend. Most diligently he looked after his body, and his soul likewise. And as the time of his departure drew near, he enjoined him as a friend to give him knowledge of his state after

foret sibi suum esse revelaret. Spopondit et transiit.
Corpus defuncti ex more lotum, vestitum, in feretro com-
positum, in æcclesiam delatum est.¹ Circumsederunt
fratres, psalmos pro ejus anima decantantes. Anselmus
vero, quo liberius pro eo preces funderet,᾿ in secretiorem
æcclesiæ locum secessit. Qui cum inter ipsas lacrimas ex
gravi cordis mestitudine corpore deficeret, et paululum
oculos in somnum deprimeret,᾿ vidit in spiritu mentis
suæ quasdam reverendi vultus personas candidissimis
vestibus ornatas domum in qua idem Osbernus vitam
finierat introisse, et ad judicandum circumsedisse. Verum
cum judicii sententiam ignoraret, eamque sollicitus nosse
desideraret,᾿ ecce Osbernus adest, similis homini ad se ᵃ
cum aut ex languore aut ex nimia sanguinis minutione
fuerit exanimatus redeunti. Ad quem pater, 'Quid est,
fili? Quomodo es?' Cui ille hæc verba respondit, 'Ille
antiquus serpens ter insurrexit in me, et ter cecidit in
semetipsum, et ursarius Domini Dei liberavit me.' Quo
dicto,᾿ Anselmus oculos a somno levavit, et Osbernus non
comparuit. En obœdientiam mortuus vivo exhibebat,
quam vivens viventi exhibere solitus erat. Quod si quis-
piam audire voluerit,᾿ qualiter hæc obœdientis verba
defuncti ipse Anselmus fuerit interpretatus,᾿ brevi accom-
modet aures. 'Ter' inquit 'antiquus serpens insurrexit
in eum.᾿ quia de peccatis quæ post baptismum priusquam
a parentibus ad servitium Dei in monasterium offerretur
commiserat illum diabolus accusavit; de peccatis etiam

ᵃ ad se *om.* VRPMN

¹ This brief description of the arrangements following the death of a
monk should be read within the framework of the elaborate instructions
preserved in Lanfranc's *Constitutions* (pp. 120-31). The body was washed,
dressed in the monastic habit and taken into the church. Thenceforward
until the burial it was never left: 'numquam enim sine psalmodia corpus
esse debet, excepto quando in choro aliquid communis officii celebratur'
(p. 125).

death, if it were possible. He promised, then died. As
the custom is, the body of the dead brother was washed,
dressed, laid out on a bier and brought into church.[1]
The brethren stood round chanting psalms for his soul,
while Anselm withdrew to a more private part of the
church where he might more freely pour out prayers for
him. While he wept, his body was worn down with the
great sorrow of his heart, and he slowly closed his eyes
in sleep. As he slept he saw in his mind's eye certain
persons of venerable appearance, clothed in the whitest
robes, enter the building where Osbern had died, and
sit around in judgement. He still did not know the
result of the judgement, and earnestly desired to know,
when suddenly Osbern appeared like a man coming
round from a faint or from an excessive bleeding. To
whom the Father: 'Well, son, how it is with you?' And
he replied, in these words: 'Thrice the old Serpent rose
up against me, and thrice fell back, and the bear-keeper
of the Lord God set me free.' When he had spoken,
Anselm awoke, opened his eyes, and Osbern had dis-
appeared. Such was the obedience which the dead
youth showed towards the living man, whom he had
been accustomed to obey in this life. And if there is
anyone who wishes to know how Anselm himself inter-
preted the words spoken in obedience to his wishes by
the dead youth, let him pay attention for a moment.
'The old Serpent,' he said, 'rose up against him thrice
because the devil accused him, firstly, of the sins which
he had committed after his baptism and before he was
offered by his parents to the service of God in the
monastery; secondly, he accused him of the sins which

quæ post oblationem parentum ante suam professionem
fecerat illum accusavit; de peccatis nichilominus quæ
post professionem ante obitum suum egerat illum accu-
savit. Sed ter cecidit in semetipsum.' quia peccata quæ
in seculo constitutus admiserat per fidem parentum
quando eum Deo obtulerunt deleta invenit, et peccata
quæ postmodum in monasterio degens ante suam pro-
fessionem fecerat in ipsa professione deleta invenit; pec-
cata etiam quæ post professionem ante obitum suum
egerat per veram confessionem et pœnitentiam deleta
atque dimissa in ipso ejus obitu confusus invenit, sicque
malignas versutias suas quibus eum ad peccandum illexe-
rat, justo Dei judicio in se ad cumulum suæ damnationis
retorqueri ingemuit. Et ursarius Domini Dei liberavit
eum. Ursarii Dei, boni angeli sunt. Sicut enim ursarii
ursos.' ita angeli malignos demones a saevitia sua coercent
et opprimunt, ne nobis noceant quantum volunt.'[1] Post
hæc Anselmus ut sanctæ dilectionis munus quod vivo
impenderat mortuo non negaret.' per integrum annum
omni die missam pro anima ejus celebravit.[2] Quod si ali-
quando a celebratione ipsius sacramenti impediebatur.'
eos qui missas familiares[3] debebant suam pro anima
fratris missam dicere faciebat, et ipse missas eorum dum
opportunum erat ante missam sui defuncti alia missa
persolvebat. Itaque per singulos dies totius anni, aut

[1] This passage from *Cui ille haec verba respondit* (*And he replied in these
words*) is reproduced considerably altered and abbreviated in *De Similitu-
dinibus*, cap. 192.

[2] Lanfranc's *Constitutions* (p. 127) laid down that on the day of the
funeral all who could do so should say a mass for the dead brother; in
addition the corporate mass (*missa matutinalis*) was said for him. After that,
thirty masses were to be said for him, one on each of the succeeding thirty
days. Anselm's dedication of 365 masses to his friend was therefore a re-
markable act of friendly piety which must have attracted the attention of
the whole community.

[3] The phrase *missa familiaris* is here, as in Lanfranc's *Constitutions*, p. 22,

he had committed between his oblation by his parents
and his profession; thirdly, he accused him of the sins
which he had committed between his profession and his
death. But thrice he fell back because he found that
the sins into which he had fallen while he was still in the
world had been blotted out by his parents' faith in
offering him to God; and the sins which he afterwards
committed while living in the monastery before his
profession, he found blotted out in that profession; and
the sins of which he was guilty after his profession and
before his death, he found to his confusion wiped out
and remitted by true confession and penitence on his
death-bed. And so the Serpent lamented that the
wicked cunning with which he had drawn him on to
sin was by God's just judgement turned back on his own
head to the heaping up of his own damnation. Then:
'the bear-keeper of the Lord God set him free'. The bear-
keepers of God are the good angels. For just as bear-
keepers tame and restrain the savagery of bears, so do
the good angels prevent the evil demons from injuring
us as much as they wish.'[1]

After Osbern's death, Anselm did not withhold from
his dead friend the offices of that holy love which he
had bestowed upon him while he was alive. Each day
throughout an entire year he celebrated a mass for his
soul.[2] And if he was ever prevented from celebrating
that sacrament, he procured one of those who had the
duty of saying votive masses[3] to say one for the soul of
his brother, and he repaid this service as opportunity
arose, by saying another mass before the one for his dead
friend. And so, every day for a whole year, he either

used in the sense of *missa pro familiaribus* (i.e. for friends or benefactors), not
in the more usual sense of private mass.

ipse pro illo missam celebravit, aut ab alio celebratam
alia missa mutuatus est. Super hæc missis circumquaque
epistolis.' pro anima sui Osberni orationes fieri petiit et
obtinuit.[1] Hæc fratres videntes, et socordiam sui cordis
redarguentes.' se miseros et infelices, Osbernum beatum
prædicant ac felicem, qui talem amorem, talem meruit
invenisse subventionem. Ex hoc ergo singuli quique
corpore et animo se subdunt Anselmo, cupientes in ami-
citiam ejus hæreditario jure succedere Osberno. At ille
in conversione ipsorum Deo gratias agens.' omnibus
omnia factus est, ut omnes faceret salvos.[2]

xi. *Ratio quare juvenibus ut proficerent plus cæteris intenderit*

Veruntamen adolescentibus atque juvenibus præcipua
cura intendebat, et inquirentibus de hoc rationem sub
exemplo reddebat. Comparabat ceræ juvenis ætatem,
quæ ad informandum sigillum apte est temperata. 'Nam
si cera' inquit 'nimis dura vel mollis fuerit.' sigillo im-
pressa ejus figuram in se nequaquam ad plenum recipit.
Si vero ex utrisque duritia scilicet atque mollitie discrete
habens sigillo inprimitur.' tunc forma sigilli omnino per-
spicua et integra redditur. Sic est in ætatibus hominum.
Videas hominem in vanitate hujus seculi ab infantia
usque ad profundam senectutem conversatum, sola ter-
rena sapientem, et in his penitus obduratum. Cum hoc
age de spiritualibus, huic de subtilitate contemplationis
divinæ loquere, hunc secreta cælestia doce rimari, et

[1] For example, the letters quoted above (*Ep.* 4, 5 and 7); but from
Eadmer's words we must suppose that Anselm also sent round a notice to
neighbouring monasteries announcing Osbern's death and soliciting their
prayers.

[2] cf. 1 Cor. ix.22

said a mass for him himself, or borrowed one said by another and repaid it. Besides this, he sent letters in all directions asking, and procuring, that prayers should be made for the soul of his Osbern.[1] When the brethren saw all this, they blamed him for giving way to weakness declaring that it was they who were wretched and miserable, and Osbern who was happy and blessed in finding such love and aid. From this time therefore several of them devoted themselves body and mind to Anselm's service, hoping to succeed to Osbern's place in his affections, but he, though he thanked God for their change of heart, 'became all things to all men, that he might save all.'[2]

xi. *The reason for his giving more attention to the training of young men than of others*

Nevertheless his chief care was for the youths and young men, and when men asked him why this was, he replied by way of a simile. He compared the time of youth to a piece of wax of the right consistency for the impress of a seal. 'For if the wax,' he said, 'is too hard or too soft it will not, when stamped with the seal, receive a perfect image. But if it preserves a mean between these extremes of hardness and softness, when it is stamped with the seal, it will receive the image clear and whole. So it is with the ages of men. Take a man who has been sunk in the vanity of this world from infancy to extreme old age, knowing only earthly things, and altogether set in these ways. Converse with such a man about spiritual things, talk to him about the fine points of divine contemplation, show him how to explore heavenly

perspicies eum nec quid velis quidem posse videre. Nec
mirum. Indurata cera est, in istis ætatem non trivit,
aliena ab istis sequi didicit. Econtrario consideres pue-
rum, ætate et scientia tenerum, nec bonum nec malum
discernere valentem, nec te quidem intelligere de hujus-
modi disserentem. Nimirum mollis cera est et quasi
liquens, nec imaginem sigilli quoquo modo recipiens.
Medius horum adolescens et juvenis est, ex teneritudine
atque duritia congrue temperatus.[1] Si hunc instruxeris.'
ad quæ voles informare valebis. Quod ipse animadver-
tens.' juvenibus majori sollicitudine invigilo, procurans
cuncta in eis vitiorum germina extirpare, ut in sanctarum
exercitiis virtutum postea competenter edocti, spiritualis
in se transforment imaginem viri.'

xii. *Quomodo pontifex Rotomagensis ei et in prioratu persistere,
et majorem prælationem si injungeretur non abjiceret imperaverit*

Sed cum inter hæc eum diversa diversorum negotia fati-
garent, et nonnunquam illius mentem a sua quiete tur-
barent.' consilium super his a supradicto venerandæ
memoriæ archiepiscopo Rotomagensi Maurilio postula-
turus, Rotomagum venit. Cunque sui adventus causam
pontifici exponeret, ac inter verba pro amissa status sui
tranquillitate vehementissime fleret.' ab onere prælationis
quod sibi fatebatur importabile, ut relevari mereretur
magnopere cœpit rogare. At ille sicut vir magnæ sancti-
tatis, 'Noli' inquit 'mi fili karissime quod quæris quærere,

[1] This passage from *Videas hominem* (*Take a man*) is copied almost ver-
batim in *De Similitudinibus*, cap. 176.

mysteries, and you will find he cannot see the things you wish him to. And no wonder. He is the hardened wax; his life has not moved in these paths; he has learnt to follow other ways. Now consider a boy of tender years and little knowledge, unable to distinguish between good and evil, or even to understand you when you talk about such things. Here indeed the wax is soft, almost liquid, and incapable of taking an image of the seal. Between these extremes is the youth and young man, aptly tempered between the extremes of softness and hardness.[1] If you teach him, you can shape him as you wish. Realising this, I watch over the young men with greater solicitude, taking care to nip all their faults in the bud, so that being afterwards properly instructed in the practice of holy exercises they may form themselves in the image of a spiritual man.'

xii. *How the archbishop of Rouen ordered him to persevere in the office of prior and not to refuse a greater office if it were put upon him*

But, besides being occupied in these ways, he was harassed by the varied business of many people which drove away at times his peace of mind. On this he sought the advice of Maurilius (who has already been mentioned) the archbishop of Rouen of worthy memory, and for this purpose he went to Rouen. When he had explained the purpose of his journey to the archbishop and had vehemently and with tears deplored his lost tranquillity, he began to beg most earnestly to be relieved of the burden of his office, which he declared to be insupportable to him. But the archbishop, like the very holy man he was, said: 'My dearest son, do not, I beg you, persist in this request, and do not seek

nec te a subvectione aliorum tui solius curam gerens velis
retrahere. Vere etenim dico tibi me de multis audisse
multosque vidisse, qui quoniam causa suæ quietis proxi-
morum utilitati per pastoralem curam invigilare nolu-
erunt.' per desidiam ambulantes semper de malo in pejus
profecerunt. Quapropter ne tibi quod absit hoc idem
contingat.' per sanctam obœdientiam præcipio, quatinus
prælationem quam nunc habes retineas, nec eam nisi
tuo jubente abbate quomodolibet deseras, et siquando
fueris ad majorem vocatus.' eam suscipere nullatenus
abnuas. Scio enim quod in hac quam tenes non diu
manebis, verum ad altiorem prælationis gradum non
post multum proveheris.' Quibus auditis.' 'Væ' inquit
'misero michi. In eo quod porto deficio, et si gravius
imponitur onus reicere non audeo?' Repetit præsul
edictum, et ut primo jubet ne transgrediatur.

xiii. *Quam affectuosam sollicitudinem sanis ac infirmis im-
penderit*

Dehinc Anselmus ad monasterium reversus.' talem se
cunctis exhibuit, ut ab omnibus loco carissimi patris
diligeretur. Ipse enim mores omnium et infirmitates
æquanimiter sufferebat, et unicuique sicut expedire sci-
ebat necessaria suggerebat. O quot in sua jam infirmi-
tate desperati, per piam sollicitudinem ejus sunt ad
pristinam sanitatem revocati. Quod tu Herewalde de-
crepite senex in teipso percepisti, quando gravatus non
solum ætate sed et valida infirmitate, ita ut nichil tui
corporis preter linguam haberes in potestate.' per manus

to withdraw yourself from helping others to devote your care to yourself alone. For I tell you truly that I have heard of many and I have seen many who fell into sloth and went from bad to worse because they sought their own quiet and refused to devote themselves to pastoral care for the benefit of others. God forbid that such a thing should happen to you. Wherefore I order you by holy obedience to retain the office which you now hold, and on no account to lay it down except by the order of your abbot; and if you are ever called to a higher office you are by no means to decline it. For I know that you will not long stay in the office which you now hold, but you will be promoted within a short time to a higher charge.' On hearing this, Anselm said, 'Wretched man that I am. I stumble under the load which I carry, and if a heavier one is laid upon me, may I not dare to throw it off?' The archbishop repeated his instruction and ordered him as before not to disobey it.

xiii. *How he watched over both the healthy and the sick with affectionate care*

Anselm returned to the monastery, and from this time his conduct towards all men was such that all loved him as if he were a very dear father. For he bore with equanimity the habits and infirmities of them all, and to each, as he saw what was expedient, he supplied what was necessary. How many, whose infirmity seemed desperate, were recalled by his pious care to their former state of health! You, oh Herewald, a broken-down old man, experienced this in your own person. You were weighed down not only with age but also with a serious infirmity, so that you had no control over any part of your body except your tongue. You were fed by his

F

illius pastus, et vino de racemis per unam in aliam ejus manum expresso de ipsa ejus manu bibens es refocilatus, ac pristinæ sanitati redonatus. Neque enim alium aut aliunde potum sumere poteras, qui tibi cordi esset ut referebas. Ipse quippe Anselmus in usu habebat infirmorum domum frequentare, singulorum fratrum infirmitates diligenter investigare, et quod infirmitas cujusque expetebat singulis absque mora seu tedio sumministrare. Sicque sanis pater et infirmis erat mater, immo sanis et infirmis pater et mater in commune. Unde quicquid secreti apud se quivis illorum habebat, non secus quam dulcissimæ matri illi revelare satagebat. Veruntamen sollers diligentia juvenum hoc præcipue exercebat.

xiiii. *Qualiter languidus juvenis solo intuitu ejus curatus sit*

De quorum numero quidam in ipso conventu hoc apud se proposuerat, quatinus nulla occasione unquam suam manum suis genitalibus membris admoveret. Cui proposito invidens diabolus·' tantum in eisdem membris dolorem et angustiam eum fecit sentire·' ut se juvenis nullo modo ferre valeret. Sentiebatur etenim caro ipsa tanti ponderis esse, acsi quædam plumbi gravissima moles eum ad ima trahens*a* in illa sui corporis parte penderet. Cunque in habitu suo anxietatis magnitudinem dissimulare non posset·' requisitus ab Anselmo quid haberet, rem celare non potuit. Admonitus itaque ut modum egritudinis admota manu probaret·' verecundatus recusavit, timens ne propositum violaret. Tunc Anselmus assumpto secum quodam grandævo fratre et religioso·'

a DETRAHENS αβ

hand, and you drank from his hand the juice of some grapes which he squeezed from one hand into the other; and as you drank you were refreshed and restored to your former health. For, as you would relate, you had no heart for any other drink or any other manner of drinking. It was, in fact, Anselm's custom to spend time in the infirmary, making careful enquiries about the illnesses of all the brethren, and bringing to each of them without hesitation or unwillingness whatever his illness required. And so, while he was a father to those who were well, he was a mother to the sick: or rather, he was both father and mother to the sick and the sound alike. Hence any of them with any private trouble hastened to unburden himself to him, as if to the gentlest of mothers, and this was particularly the case with earnest and zealous young men.

xiv. *How he cured a sick youth simply by looking at him*

There was one such young man in the monastery who had resolved on no account to put his hand on his genital organs. The devil's spite was stirred by this resolve, and he made the young man feel such pain and anguish in those members that he found the burden intolerable. For his flesh felt so heavy that it was as if a great weight of lead were attached to that part of his body drawing him downwards. He could not prevent his great anxiety showing itself in his appearance, and when Anselm asked him what was the matter, the cause could not be concealed. He was advised to place his hand on the ailing place to discover what manner of trouble was there; but this, for shame, he refused to do, fearing to break his vow. Then Anselm took with him one of the brethren, a very old and pious man, and led

juvenem languidum in secretiorem locum ducit, utpote modum infirmitatis illius agniturus, et auxilium pro possibilitate laturus. Quid amplius? Caro sanissima reperitur, et admodum mirati sunt. Evestigio quippe omnis illa diabolica vexatio cadit, nec in hujusmodi fatigat ulterius juvenem, quem*a* Anselmi perpendentis omnia esse munda mundis[1] ex paterna pietate prodiens simplex aspectus a tanta clade fecit immunem.

xv. *Quomodo monachus in extremis positus a duobus lupis per eum erutus sit*

Præterea quidam ex antiquioribus ipsius cœnobii fratribus, qui veteri odio plurimum erat infestus Anselmo, nec ullatenus poterat super eum respicere simplici oculo.' infirmitate pressus ad extrema perductus est. Cum itaque fratres meridiana hora in lectis ex more quiescerent.' ipse in domo infirmorum in qua jacebat cœpit miserandas voces edere, et quasi quorundam horrendos aspectus subterfugere gestiret, pallens et anxie tremens vultum suum delitescendo hinc inde commutare. Territi fratres qui aderant, quid haberet percunctantur. At ille, 'Geminos immanes lupos me inter brachia sua compressum tenere, et guttur meum impressis dentibus jam jam suffocare videtis, et quid michi sit quæritis?' Quo audito.' unus ex monachis Riculfus[2] nomine ad Anselmum qui tunc in claustro emendandis libris intendebat concitus perrexit, et ei extra claustrum educto quid*b* circa infirmum

a quem . . . immunem: QUEM SIMPLEX ANSELMI ASPECTUS A TANTA CLADE FECIT IMMUNEM. αβϵιCEFJH *b* quod TUX

[1] Titus i.15
[2] In the list of monks of Bec, Riculfus has twelfth place after Anselm; he therefore became a monk about 1065. He is once mentioned in Anselm's correspondence as the bearer of a message from Gundulf bishop of Rochester (*Ep.* 107: the date is uncertain). As sacrist (*see below*) his duties included

the ailing youth aside to a private place so that he might discover what was the nature of his disease and give him such aid as he could. And what was the sequel? His flesh was found altogether sound, and they were not a little astonished. Immediately all this trouble caused by the devil ceased and never again was the young man vexed in this way: the mere fact that Anselm, inspired by a fatherly pity and reflecting that to the pure all things are pure,[1] had looked on him freed him from so great a distress.

xv. *How he freed a dying monk from the attack of two wolves*

Besides this, there was the case of one of the older brethren of the monastery who hated Anselm with a long-standing hatred and looked on him with a jaundiced eye. He was lying sick and almost on the point of death, and, while the brethren were spending the midday hour as usual resting on their beds, he began to cry out piti-fully in the infirmary where he lay. He was pale and trembling with apprehension, moving restlessly and attempting to hide his face, as if to ward off some horrible spectres. The brethren who were with him were terri-fied, and asked him what was the matter. To which he replied: 'You see two huge wolves holding me tight in their arms with their teeth in my throat so that I suffocate, and do you ask me what is the matter?' When he heard this, one of the monks, Riculfus by name,[2] went in haste to Anselm, who was busy in the cloister correcting books. He took him out of the cloister and told him what had happened to the sick brother. Anselm

seeing that the horarium was correctly observed (see *Constitutions of Lanfranc*, p. 82).

fratrem ageretur patefecit. Jussus ergo Riculfus ad
egrum rediit, et Anselmus in secretiorem locum solus
secessit. Post modicum domum in qua frater se male
habebat ingrediens.' levata manu signum sanctæ crucis
edidit, dicens, 'In nomine Patris et Filii et Spiritus
Sancti.' Ad quod factum statim eger conquievit, et
exhilarato vultu.' intimo cordis affectu Deo gratias agere
cœpit. Dicebat enim quod Anselmo ostium ingrediente,
et extensa manu signum sanctæ crucis edente.' viderit ex
ore illius flammam ignis in modum lanceæ procedentem,
quæ in lupos jaculata eos deterruit, et celeri fuga dilapsos
procul abegit. Tunc Anselmus ad fratrem accedens,
atque cum eo de salute animæ suæ secretius loquens.' ad
pœnitudinem et confessionem omnium in quibus se
Deum offendisse recordari valebat[a] cor ejus inclinavit.
Paterna dehinc auctoritate a cunctis absolutum.' dixit
eum hora qua fratres ad nonam surgerent præsenti vitæ
decessurum. Quod et factum est. Nam monachis a
lecto surgentibus.' ipse ad terram depositus est, et illis
circa ipsum sub uno collectis.' defunctus est.

xvi. *Qualiter Riculfus monachus Anselmum orantem globo*
viderit circumseptum

Præfatus Riculfus secretarii officio in ipso cœnobio funge-
batur. Hic quadam nocte dum tempus et horam qua
fratres ad vigilias excitaret per claustrum iens observaret.'
forte ante ostium capituli pertransivit. Introspiciens
vero.' vidit Anselmum in oratione stantem, ingenti
splendentis flammæ globo circumcinctum. Miratur, et

[a] *Here B begins.*

told Riculfus to return to the sick man, and he himself
went aside alone to a private place. Then after a while
he entered the building in which the sick brother lay,
and raising his hand he made the sign of the holy Cross,
saying 'In the Name of the Father, and of the Son and
of the Holy Ghost.' Upon which the sick man im-
mediately became quiet and, with cheerful face and
heart-felt emotion, began to give thanks to God. For
he said that when Anselm came in the door and raised
his hand to make the sign of the Cross, he saw a tongue
of flame come out of his mouth as if it were a lance
hurled at the wolves, which frightened them away and
drove them off till they vanished in rapid flight. Then
Anselm went up to the brother and talked to him pri-
vately about this soul's health, inclining his heart to
penitence and to the confession of everything in which
—so far as he could remember—he had offended God.
Thereupon with fatherly authority he absolved him
from all his sins and told him that he would depart this
life at the time when the brethren rose for nones. And
so it came to pass. For when the monks rose from their
beds, he was laid on the ground and, when they had
all gathered round, he died.

xvi. *How a monk called Riculfus saw Anselm praying in the
midst of a ball of fire*

This Riculfus, whom I have mentioned, held the office
of sacrist in the monastery. One night, when he was
walking through the cloister waiting for the moment
when he would waken the brethren for vigils, he hap-
pened to pass the door of the chapter house. He looked
in and saw Anselm standing in prayer in the midst of a
great ball of blazing light. He was amazed and could

quod videbat quid novi prætenderet ignorabat. Estimabat enim Anselmum ea hora sopori potius quam orationi occupatum. Otior itaque dormitorium ascendit, ad lectum Anselmi vadit, sed eum ibi nequaquam invenit. Regressus igitur hominem in capitulo repperit, sed globum ignis quem reliquerat non invenit.

xvii. *Quod piscis quem tructam vocant insolitæ magnitudinis sicut prædixerat ad victum ejus captus sit*

Alio quodam tempore eidem Anselmo mandatum ab uno de principibus Normanniæ est꞉ quatinus ad se in Angliam transire volentem, cum pro aliis negotiis, tum ut sua prece iter illius per marina pericula tueretur, veniret. Ascendit, abiit. Jam dies mutui colloquii in vesperam declinabat, et principem de hospitando Anselmo nulla cura tenebat.ᵃ Quod ubi Anselmo innotuit꞉ nichil super re cuiquam locutus, accepta licentia loco decessit. Eunti autem, et quo diverteret incertum habenti, Beccus enim longe aberat꞉ occurrit unus de monachis Becci, volens illuc ire, quo eum sciebat principis colloquio detineri. Interrogat igitur illum Anselmus quo tendat, ac deinde, quid consilii de suo hospitio ferat. Respondit, 'Et quidem pater hospitium qualecunque non longe habemus, sed quod vobis et fratribus preter panem et caseum apponatur nichil habemus.' At ille subridens꞉ 'Bone vir' ait 'ne timeas. Immo citus præcede, et misso reti in vicinum amnem statim invenies piscem qui sufficiet omnibus nobis.' Ille accepto mandato prævolat, accitoque piscatori quid Anselmus jusserit

ᵃ DETINEBAT αβ

not tell what this vision might portend, for he thought that
Anselm would have been asleep at that hour rather than
occupied in prayer. So he went quickly up to the
dormitory and walked to Anselm's bed; but he found
no trace of him there. Then he returned and found him
in the chapter house, but without the ball of fire which
had been there when he left him.

xvii. *How a trout of unusual size was caught for his supper
as he had foretold*

On another occasion, one of the barons of Normandy
was about to cross over to England, and he wished to
discuss business with Anselm and to have the protection
of his prayers in the perils of a sea voyage. So he sent
to ask Anselm to come to him; and Anselm rose up and
went. Their talk lasted until evening but the baron
took no trouble about providing Anselm with a lodging.
When Anselm noticed this, he said nothing about it to
anyone, but took his leave and departed. On his way,
while he was uncertain where to lodge—for Bec was a
long way off—he met one of the monks of Bec going to
the place where he knew Anselm was engaged in his
conversation with the baron. Anselm asked him where
he was going, and then whether he could give him any
advice about a lodging. He replied: 'We certainly,
Father, have some sort of a lodging not far from here,
but we have nothing we can offer you and the brethren
except bread and cheese.' Anselm smiled and said,
'My dear man, don't worry, but go on quickly, let down
a net into the river which is close at hand, and you will
quickly catch a fish sufficient for us all.' On this com-
mand he flew on ahead, called a fisherman, told him
what Anselm had ordered, and begged and prayed and

intimat, ac velocius rete in fluvium jactet, jubet, hortatur, et obsecrat. Admiratus ille parere petenti moratur, ridendum potius quam attemptandum quod dicebat fore pronuncians. Tandem tamen a fratre coactus contra spem rete jecit, et ilico tructam insolitæ magnitudinis cum alio quodam pisciculo cepit. Territus piscator ad factum et obstupefactus.' asseruit se jam per viginti annos recessus aquæ illius rimasse, et nunquam hujusmodi tructam in ea reperire potuisse. Parata igitur et viro apposita.' juxta verbum ejus sibi et suis copiose suffecit, et superabundavit.

xviii. *Quod viro qui eum hospitio receperat juxta verbum ejus sturio unus improvise allatus sit*

Alia vice vir quidam nomine Walterus*ᵃ* cognomine Tirellus[1] eundem hominem per terram suam transeuntem detinuit, nolens eum a se impransum dimittere. Verum cum ipse de penuria piscium conquereretur, et quod tanto viro ac monachis ejus nisi vilia quædam non haberet quæ apponerentur.' alludens dixit*ᵇ* Anselmus,

ᵃ WALTERUS NOMINE αβ　　　　　*ᵇ* DIXIT EI αβ

[1] Walter Tirel was a man with widely scattered interests in France and England. In France he had lands in Normandy and Picardy, and was a vassal of the count of the joint counties of Pontoise, the French Vexin, and Amiens. In England he had lands in Essex and was a vassal of Richard fitz Gilbert, the founder of the house of Clare, whose daughter he married. He was lord of Poix, about fifteen miles from Amiens, and this passage suggests that he also had lands further north in the area of the river Authie. As husband of Adeliza of Clare he belonged to the group of families most closely associated with Bec, and this is sufficient to account for his familiarity with Anselm. The following genealogical table illuminates several incidents in Anselm's life.

ordered him to cast his net into the river as quickly as possible. The fisherman was astonished and made some delay in yielding to this demand, saying that it sounded more like a joke than something to be carried out. At last however the monk prevailed on him and without any hope he cast in his net. Immediately he caught an unusually large trout with another little fish. The fisherman was frightened and amazed at what had happened, and said he had explored the recesses of that river for twenty years and had never been able to find in it a trout like that. The fish was prepared and placed before Anselm, and as he had predicted there was ample for himself and his brethren, and to spare.

xviii. *How, as he had predicted, a sturgeon was unexpectedly brought to a man who was entertaining him*

On another occasion, a certain man called Walter Tirel[1] stopped Anselm when he was passing through his lands and was unwilling to let him go until he had had a meal. When he lamented that, owing to the shortage of fish, he had only very wretched fare to offer so great a man and his monks, Anselm jokingly said to him: 'Here is a

	Count Gilbert of Brionne (Lord of Herluin, founder of Bec; benefactor
Walter Giffard	of Bec)

Rohese = Richard fitz Gilbert of Tonbridge or Clare (founder of St Neot's as a cell of Bec; tenant and constable of the archbishop of Canterbury)

| Gilbert fitz Richard of Tonbridge, etc. | Richard, monk of Bec; abbot of Ely 1100. d. 1107 | Rohese=Eudo Dapifer d. 1121; buried at Bec | Adeliza = died at Conflans, a cell of Bec | Walter Tirel, lord of Poix; tenant of Richard fitz Gilbert in Essex |

Many other members of the family were similarly connected with Bec, either as benefactors or monks. For fuller details, see J. H. Round, *Feudal England*, 1895, pp. 468-79; D. C. Douglas, *The Domesday Monachorum of Christ Church, Canterbury*, 1944, pp. 39-41; Ordericus Vitalis, iv, 90. For Walter Tirel's part in the murder of William Rufus see below p. 126, *n*. 3.

'Sturio unus en tibi defertur, et animus tuus de deliciarum inopia queritur?' Ridet ille, fidem iis quæ audiebat præbere nullatenus valens. Evestigio autem verborum Anselmi duo ex hominibus viri attulerunt sturionem unum prægrandem, quem in fluminis Altyæ*a* ripa dixerunt a pastoribus suis inventum, sibique transmissum. Si spiritum prophetiæ in his viro affuisse quis dubitat, gestæ rei veritas quid sit tenendum declarat.

xix. *De libris quos fecit, et quid de illo quem Proslogion titulavit primo contigerit*

His temporibus scripsit tractatus tres, scilicet *De Veritate*, *De Libertate Arbitrii*, et *De Casu Diaboli*.[1] In quibus satis patet ubi animum fixerit, quamvis ab eis quæ aliorum cura expetebat, talium rerum consideratione nullo se modo subtraxerit. Scripsit et quartum, quem titulavit *De Grammatico*. In quo cum discipulo quem secum disputantem introducit disputans,' cum multas quæstiones dialecticas proponit et solvit, tum qualitates et qualia

a IN RIPA FLUMINIS ALTYAE αβ

[1] Eadmer has already mentioned Anselm's Prayers and Meditations (cap. viii). In this chapter he puts together what he knows about all the other works completed before Anselm became archbishop. By implication he ascribes all these works to the period before 1078 when Anselm became abbot of Bec. But only the *Monologion* appears to have been written before this date, and it was followed after a short interval by the *Proslogion* (see below). The other works mentioned in this chapter were all written (at least in their finished form) in the 1080s, but the evidence is lacking which would allow any exact dating. Eadmer lists them in the order in which they appear in Anselm's preface to the *De Veritate*, and this does not mean that they were written in this order: all that Anselm says is that he wrote them *diversis temporibus*, and no doubt they were the result of teaching over many years. The following letters may be mentioned as containing some evidence for the writing of these treatises, though their evidence is neither very clear nor easily datable: *Ep.* 109 [ii, 17] to Hugo archbishop of Lyons

sturgeon being brought to you, and your spirit complains at the lack of delicacies, does it?' Walter laughed and had no confidence in these words. But no sooner had Anselm spoken than two of Walter's men brought along an immense sturgeon which, they said, some of his shepherds had found on the bank of the river Authie and had sent back to him. If anyone doubts whether Anselm was inspired by a spirit of prophecy in these incidents, the plain facts of the case show what is to be believed.

xix. *Concerning the books which he wrote, and what first happened to the one which he called the Proslogion*

At this period, he wrote three treatises: *On Truth, On the Freedom of the Will*, and *On the Fall of the Devil*.[1] It is quite clear from these where his interest lay, although his occupation with these things never led him by any means to withdraw himself from the business arising out of his care for others. Also he wrote a fourth treatise *On the Grammarian*, as he called it. This treatise was in the form of a disputation with a disciple, whom he introduced as the other disputant, and in it he both propounded and solved many dialectical questions, and also defined and expounded the different ways in which

(after 1082 and possibly as late as 1086) implies that Anselm has no other works to send him except the *Monologion* and *Proslogion*, but that he has other works in prospect; *Ep.* 97 [ii, 8] (? 1080-85) contains a long passage which is almost the same as a passage in the *De Casu Diaboli*, and from the way in which Anselm refers to this passage ('scriptum illud quod de ea questione, quomodo scilicet, cum malum nihil esse dicatur, nomen eius aliquid significet') it seems almost certain that the treatise as we now have it had not yet been written. For a general survey of the evidence, see F. S. Schmitt, 'Zur Chronologie der Werke des hl. Anselm', in *Revue Bénédictine*, XLIV, 1932, pp. 322-50.

quomodo sint discrete accipienda exponit et instruit.[1]
Fecit quoque libellum unum quem *Monologion* appel-
lavit.[2] Solus enim in eo et secum loquitur, ac tacita
omni auctoritate divinæ scripturæ quid Deus sit sola
ratione quærit et invenit, et quod vera fides de Deo
sentit, invincibili ratione sic nec aliter esse posse probat
et astruit. Post hæc incidit sibi in mentem investigare
utrum uno solo et brevi argumento probari posset id
quod de Deo creditur et prædicatur, videlicet quod sit
æternus, incommutabilis, omnipotens, ubique totus, in-
compræhensibilis, justus, pius, misericors, verax, veritas,
bonitas, justitia, et nonnulla alia, et quomodo hæc omnia
in ipso unum sint.[3] Quæ res.' sicut ipse referebat mag-
nam sibi peperit difficultatem. Nam hæc cogitatio
partim illi cibum, potum et somnum tollebat, partim et
quod magis eum gravabat intentionem ejus qua matu-

[1] A large part of the *De Grammatico* (which Anselm describes as a
'Tractatus non inutilis, ut puto, introducendis ad dialecticam') is taken up
with a discussion of the difference between accidents (*qualia*) such as white,
and *qualitates* or *substantiales differentiae* such as whiteness, and it is to this
discussion that Eadmer refers. Anselm's treatise presupposes a knowledge
of Aristotle's *Categories* and Boethius's commentary on this work, and in his
brief summary Eadmer uses language which seems to show an acquaintance
at least with Boethius (cf. *P.L.* 64, 239).

[2] The *Monologion* appears to have been completed in 1077 when Anselm
sent it (*Ep.* 72 [i, 63]) to Lanfranc for censorship. At this time it had no
name and Lanfranc was invited, if he approved the work, to suggest one.
In the event Lanfranc's approval was less than lukewarm and he made no
suggestion about a title. Meanwhile Anselm seems to have called it pro-
visionally an *Exemplum meditandi de ratione fidei* (MS Paris lat. 13413 = Dom
Schmitt's 1st Recension), and in this form it circulated anonymously. Then
by 1083 to 1084, Anselm had given the work, which was now getting a wider
circulation, a more definitive title as *Monoloquium de ratione fidei* (*Ep.* 100
[ii, 11]); but almost at once he struck out the last three words and changed
the *Monoloquium* into the linguistically more elegant and homogeneous form
Monologion (*Ep.* 109 [ii, 17]), by which it was subsequently known. Eadmer's
description of the scope of the work is quite accurate, as Anselm's first sen-
tence makes clear: 'Si quis unam naturam, summam omnium quae sunt,
solam sibi in aeterna sua beatitudine sufficientem, omnibusque rebus aliis
hoc ipsum quod aliquid sunt aut quod aliquomodo bene sunt, per omni-
potentem bonitatem suam dantem et facientem, aliaque perplura quae de
deo sive de eius creatura necessarie credimus, aut non audiendo aut non

qualities and *qualia* are to be regarded.[1] He also composed another small book, which he called the *Monologion*[2] because in this he alone spoke and argued with himself. Here, putting aside all authority of Holy Scripture, he enquired into and discovered by reason alone what God is, and proved by invincible reason that God's nature is what the true faith holds it to be, and that it could not be other than it is. Afterwards it came into his mind to try to prove by one single and short argument the things which are believed and preached about God, that he is eternal, unchangeable, omnipotent, omnipresent, incomprehensible, just, righteous, merciful, true, as well as truth, goodness, justice and so on; and to show how all these qualities are united in him.[3] And this, as he himself would say, gave him great trouble, partly because thinking about it took away his desire for food, drink and sleep, and partly—and this was more

credendo ignorat: puto quia ea ipsa ex magna parte, si vel mediocris ingenii est, potest ipse sibi saltem sola ratione persuadere.'

[3] Eadmer's account of the origin of the *Proslogion* and of Anselm's difficulties in composing it is one of his most valuable contributions to the history of Anselm's philosophical development: it could only come from Anselm himself. His description of the scope of the work raises some difficulties. Eadmer evidently did not look on the work primarily as a proof of the *existence* of God but as a proof that the attributes of God are such as the Christian faith holds them to be. In a sense he was justified in this, because Anselm's philosophical outlook, strictly speaking, excluded the possibility of God's non-existence. The existence of the word 'God' guaranteed the existence, in some form, of God. The question was: did this existence belong only to the world of ideas or to the world of external realities as well. It was the latter of these two possibilities that Anselm set out, in the first place, to prove to be the true one; he then demonstrated the other attributes of God—truth, eternity and so on. It is the first stage of his argument (occupying only the first three out of twenty-six chapters of the treatise) which has given Anselm his place in the history of philosophy: the remainder has been, from the point of view of Anselm's own thought, unduly neglected. By contrast, Eadmer, being no philosopher, unduly neglected the first stage in the argument and, in his brief resumé, concentrated on the remainder. For further discussion on these points see *St Anselm and his Biographer*, pp. 57-66.

tinis et alii servitio Dei intendere debebat perturbabat. Quod ipse animadvertens, nec adhuc quod quærebat ad plenum capere valens.' ratus est hujusmodi cogitationem diaboli esse temptationem, nisusque est eam procul repellere a sua intentione. Verum quanto plus in hoc desudabat.' tanto illum ipsa cogitatio magis ac magis infestabat. Et ecce quadam nocte inter nocturnas vigilias Dei gratia illuxit in corde ejus, et res patuit intellectui ejus, immensoque gaudio et jubilatione replevit omnia intima ejus. Reputans ergo apud se hoc ipsum et aliis si sciretur posse placere.' livore carens[1] rem ilico scripsit in tabulis,[2] easque sollicitius custodiendas uni ex monasterii fratribus tradidit. Post dies aliquot tabulas repetit a custode. Quæruntur in loco ubi repositæ fuerant, nec inveniuntur. Requiruntur a fratribus ne forte aliquis eas acceperit, sed nequiquam. Nec enim hucusque inventus est, qui recognoverit se quicquam inde scivisse. Reparat Anselmus aliud de eadem materia dictamen in aliis tabulis, et illas eidem sub cautiori custodia tradit custodi. Ille in secretiori parte lectuli sui tabulas reponit,[3] et sequenti die nil sinistri suspicatus.' easdem in

[1] *livore carens*: The phrase comes from one of the most famous of the poems in Boethius *De Consolatione Philosophiae* (lib. iii, met. 9) and the idea here expressed (which is found in many medieval writers) that the author in giving his ideas to the world is acting with generosity and showing a freedom from envy which might cause him to keep his thoughts to himself, is to be understood in the context of that poem. God is there praised as the source of all creation, impelled by no external cause, but moved by his own goodness, *livore carens*, to communicate his image to others. The author is in a similar position; and at a time when the written word became public property and brought no profit to the author, the analogy is not as far-fetched as might at first appear.

[2] *tabulis*: The use of wax tablets for first drafts and rough notes was universal at this time and very many examples can be quoted of their use in monasteries. The tablets were in the form of a diptych folded to protect the wax face and were worn in the girdle at the right-hand side attached to a cord; cf. the description of Odo of Cluny as a young man: 'duas solum tabellas manu bajulans, scribendi officio aptissimas, fabrili opere ita connexas, ut possent patefieri, non tamen disiungi, quibus scholastici dextro

grievous to him—because it disturbed the attention which he ought to have paid to matins and to Divine service at other times. When he was aware of this, and still could not entirely lay hold on what he sought, he supposed that this line of thought was a temptation of the devil and he tried to banish it from his mind. But the more vehemently he tried to do this, the more this thought pursued him. Then suddenly one night during matins the grace of God illuminated his heart, the whole matter became clear to his mind, and a great joy and exultation filled his inmost being. Thinking therefore that others also would be glad to know what he had found, he immediately and ungrudgingly[1] wrote it on writing tablets[2] and gave them to one of the brethren of the monastery for safe-keeping. After a few days he asked the monk who had charge of them for the tablets. The place where they had been laid was searched, but they were not found. The brethren were asked in case anyone had taken them, but in vain. And to this day no-one has been found who has confessed that he knew anything about them. Anselm wrote another draft on the same subject on other tablets, and handed them over to the same monk for more careful keeping. He placed them once more by his bed, in a more secret place,[3] and the next day—having no suspicion of any mischance—

femore solent uti' (*Vita S. Odonis*, i, 14; *P.L.* 133, 49). It would seem to have been a common practice, as here, for the author to make his own draft on wax tablets and for a scribe to transfer this to parchment. Eadmer, however, seems to have been his own scribe, as were William of Malmesbury and Ordericus Vitalis. Two generations later William of Newburgh complains that having written a draft of his work on the Song of Songs on wax tablets he could find no-one to copy it and had to do it himself (C. H. Talbot, in *Analecta S. ordinis Cisterciensis*, VI, 1951, p. 223 *n.*).

[3] Since the dormitory would not be divided into cubicles, the reference here must be to some cupboard or chest beside the monk's bed in which he could place the tablets.

pavimento sparsas ante lectum repperit, cera quæ in
ipsis erat hac illac frustatim dispersa. Levantur tabulæ,
cera colligitur, et pariter Anselmo reportantur. Adunat
ipse ceram, et licet vix.ʲ scripturam recuperat. Verens
autem ne qua incuria penitus perditum eat.ʲ eam in
nomine Domini pergamenæ jubet tradi. Composuit
ergo inde volumen parvulum, sed sententiarum ac sub-
tilissimæ contemplationis pondere magnum, quod *Pros-
logion* nominavit.¹ Alloquitur etenim in eo opere aut
seipsum aut Deum. Quod opus cum in manus cujusdam
venisset, et is in quadam ipsius operis argumentatione
non parum offendisset.ʲ ratus est eandem argumenta-
tionem ratam non esse. Quam refellere gestiens.ʲ quod-
dam contra illam scriptum composuit, et illud fini ejus-
dem operis scriptum apposuit.² Quod cum sibi ab uno
amicorum suorum ᵃ transmissum Anselmus considerasset.ʲ
gavisus est, et repræhensori suo gratias agens, suam ad
hoc responsionem edidit, eamque libello sibi directo sub-
scriptam, sub uno ei qui miserat amico remisit, hoc ab eo
et ab aliis qui libellum illum habere dignantur petitumᵇ
iri desiderans, quatinus in fine ipsiusᶜ suæ argumenta-
tionis repræhensio, et repræhensioni sua responsio sub-
scribatur.

ᵃ A QUODAM AMICO SUO αβ ᵇ petiturum β
ᶜ ipsius operis VRP

¹ The stages in the naming of the *Proslogion* are very similar to those in
the naming of the *Monologion*, and are described by Anselm in the Proemium
to the *Proslogion*. The work, completed probably in 1078, was at first
called *Fides quaerens intellectum* and circulated anonymously; then by about
1083 it had become *Alloquium de ratione fidei* (*Ep.* 100 [ii, 11]), and shortly
afterwards (for the same reasons which operated in the case of the *Monologion*)
simply *Proslogion* (*Ep.* 109 [ii, 17]).

² This refers to the reply by Gaunilo, monk of Marmoutier near Tours,
and to Anselm's rejoinder, which are attached to the *Proslogion* in most
manuscripts. Nothing is known about Gaunilo except that he was the
author of this strong refutation of Anselm's argument. In assessing the

he found them scattered on the floor beside his bed and the wax which was on them strewn about in small pieces. After the tablets had been picked up and the wax collected together, they were taken to Anselm. He pieced together the wax and recovered the writing, though with difficulty. Fearing now that by some carelessness it might be altogether lost, he ordered it, in the name of the Lord, to be copied onto parchment. From this, therefore, he composed a volume, small in size but full of weighty discourse and most subtle speculation, which he called the *Proslogion*,[1] because in this work he speaks either to himself or to God. This work came into the hands of someone who found fault with one of the arguments in it, judging it to be unsound. In an attempt to refute it he wrote a treatise against it and attached this to the end of Anselm's work.[2] A friend sent this to Anselm who read it with pleasure, expressed his thanks to his critic and wrote his reply to the criticism. He had this reply attached to the treatise which had been sent to him, and returned it to the friend from whom it had come, desiring him and others who might deign to have his little book to write out at the end of it the criticism of his argument and his own reply to the criticism.

level of philosophical development in the great Benedictine houses of this period, it is significant that a monk, unknown except for these few pages of argument, should at once have pointed out the main difficulty in accepting Anselm's argument in words which are as trenchant as, and in some details strikingly similar to, those of Kant.

xx. *Epistola quam scripsit Lanzoni qui postmodum fuit prior Sancti Pancratii apud Laewes*

Inter hæc scripsit etiam quamplures epistolas, per eas nonnullis ea quæ secundum diversitatem causarum sua intererant procurare mandans, et nonnullis consilium de negotio suo quærentibus pro ratione respondens. Et quidem de iis quæ diversæ causæ scribi cogebant, mentionem facere supersedemus. Quid autem consilii cuidam Lanzoni[1] noviter apud Cluniacum facto monacho per unam mandaverit.' huic operi inserere curavi, quatinus in hac una cognoscatur, quid de aliis perpendatur. Scribit itaque inter alia sic:

> Ingressus es karissime professusque Christi militiam, in qua non solum aperte obsistentis hostis violentia est propellenda, sed et quasi consulentis astutia cavenda. Sepe nanque dum tironem Christi vulnere malæ voluntatis aperte malivolus non valet perimere.' sitientem eum poculo venenosæ rationis malivole callidus temptat extinguere. Nam cum monachum nequit obruere vitæ quam professus est odio.' nititur eum conversationis in qua est subruere fastidio. Et licet illi monachicum propositum tenendum quasi concedat.' tamen quia hoc sub talibus aut inter tales, aut in eo loco incepit, illum stultum nimis imprudentemque multimodis versutiis arguere non cessat. Ut, dum illi persuadet incœpto Dei beneficio ingratum existere.' justo judicio nec ad meliora proficiat, nec quod accepit teneat, aut in eo inutiliter persistat. Quippe dum incessanter laboriosis cogitationibus de mutando, aut, si mutari non valet, saltem de improbando initio meditatur.' nunquam ad finem perfectionis tendere conatur. Nam quoniam illi fundamentum quod posuit displicet.' nullatenus illi structuram bonæ vitæ superedificare libet.

[1] The letter here quoted in part (*Ep.* 37 [i, 29]) is the most important of Anselm's letters on the monastic life and Anselm himself, as archbishop, advised a monk of Canterbury to read it (*Ep.* 335 [iii, 103]). To judge from its position in the collection of Anselm's letters it was written in 1072-3. Anselm had already, probably in 1070-1, addressed to Lanzo and his friend Odo an exhortation suitable for beginners in the monastic life (*Ep.* 2 [i, 2]). Lanzo, having been a monk of Cluny for some years, became the first prior of the Priory of Lewes in 1077, and died in 1107 (see *Sussex Archaeological Collections*, xxxiv, 1886, p. 125; William of Malmesbury, *G.P.*, p. 207, and *G.R.*, pp. 513-16).

xx. *The letter which he wrote to Lanzo who was afterwards prior of St Pancras at Lewes*

Meanwhile he also wrote many letters, in some of which he sought to obtain for his correspondents those things which their varying business required, and in others he sent reasoned replies to people seeking his advice about their affairs. As for those which he was obliged to write for business reasons, we will pass them over in silence. On the other hand I have taken care to insert in this work a letter of advice which he sent to a certain Lanzo[1] when he had recently become a monk at Cluny, so that from this one letter you may see what is to be thought about the rest. This is part of what he wrote:

Beloved, you have entered and taken the oath in the army of Christ, in which you are not only to resist the open violence of the enemy when he attacks you, but also to beware of his wiles when he seems to wish you well. For often when the Evil One cannot openly destroy the recruit of Christ by corrupting his will, he tries to snuff out his life by craftily and malevolently offering him a cup of poisoned reason when he is thirsty. For when he cannot crush a monk by making him hate the life which he has professed, he tries to undermine him by scruples about the circumstances in which he finds himself. He appears to be willing to grant that he must be loyal to the monastic profession, but he never ceases in all kinds of ingenious ways to suggest that he was foolish or imprudent to undertake it under such superiors, or among such companions, or in such a place. And so, being persuaded into ingratitude for the benefits which God had begun towards him, a just judgement decrees that he shall neither go on to better things, nor yet retain what he has received, nor be useful in his present way of life. For while his mind is perpetually occupied with thoughts of removal, or—if he cannot remove—with dissatisfied reflections on the beginning he has made, he gives up all attempt to reach the goal of perfection. While he is displeased with the foundation he has laid, no superstructure of a

Unde fit ut quemadmodum arbuscula si sepe transplantetur, aut
nuper plantata in eodem loco crebra convulsione inquietetur, ne-
quaquam radicare valens ariditatem cito attrahit, nec ad aliquam
fructus fertilitatem provenit;' sic infelix monachus si sepius de loco
ad locum proprio appetitu mutatur, aut in uno permanens frequenter
ejus odio concutitur;'[1] nusquam amoris stabilitus radicibus ad omne
utile exercitium languescit, et nulla bonorum operum ubertate
ditescit.[2] Cunque se nequaquam ad bonum sed in malum proficere
si forte hoc recogitat perpendit;' omnem suæ miseriæ causam non
suis sed aliorum moribus injustus intendit, atque inde se magis ad
odium eorum inter quos conversatur infeliciter accendit. Qua-
propter quicunque cœnobitarum forte propositum aggreditur;' ex-
pedit ei ut in quocunque monasterio professus fuerit, nisi tale fuerit
ut ibi malum invitus facere cogatur;' tota mentis intentione amoris
radicibus ibi radicare studeat, atque aliorum mores aut loci con-
suetudines si contra Divina præcepta non sunt;' etiam si inutiles
videantur dijudicare refugiat. Gaudeat se jam tandem invenisse
ubi se non invitum sed voluntarium tota vita mansurum omni
transmigrandi sollicitudine propulsa deliberet, ut quietus ad sola
piæ vitæ exercitia exquirenda sedulo vacet. Quod si sibi videtur
majora quædam ac utiliora spirituali fervore appetere, quam illi
præsentis monasterii institutionibus liceat;' estimet aut se falli sive
præferendo paria paribus, vel minora majoribus, sive præsumendo
se posse quod non possit; aut certe credat se non meruisse quod
desiderat. Quod si fallitur;' agat gratias divinæ misericordiæ qua
ab errore suo defenditur. Ne sine emolumento aut etiam cum
jactura locum vel vitæ ordinem mutando inconstantiæ levitatisque
frustra crimen subeat, aut majora suis viribus experiendo;' fatigatus
deterius in priora aut etiam in pejora prioribus deficiat. Si autem
vere meliora illis quæ in promptu sunt nondum meritus optat;'
patienter toleret divinum judicium quod ulli aliquid injuste non
denegat. Ne per impatientiam judicem justum exasperans;' mere-
atur quod non habet non accipere, et quod accepit amittere, aut

[1] The passage from *cum monachum nequit obruere* (*when the Evil One*) to
odio concutitur (*hatred for it*) with minor alterations forms chapter 177 of
De Similitudinibus.

[2] cf. *Vitae Patrum*, Lib. v, Libellus vii, 36: 'Dixit senex: Sicut arbor
fructificare non potest, si saepius transferatur, sic nec monachus frequenter
migrans potest fructificare' (*P.L.* 73, 902).

good life can be built upon it. And—just as a young tree cannot take root, soon withers, and brings no fruit to perfection if it is often transplanted, or if its roots are frequently disturbed when it is newly planted—so it is with the unhappy monk who often moves from place to place following his own whim, or who, though he remains in one place, is frequently disturbed by a feeling of hatred for it[1]; he takes no firm root in love, he grows languid in every useful discipline, and no abundant harvest of good works enriches him.[2] Then, when he notices—if indeed he does notice—that he is not making progress, but rather declining into evil ways, he unjustly imagines that the cause of his wretchedness lies not in his own habits but in those of others, and hence miserably works himself up into an even greater hatred of those among whom he lives. Wherefore, if anybody undertakes a monastic profession, it is good that he should concentrate all his attention on becoming rooted with the roots of love in whatever monastery he had made his profession, unless it is so bad that he is unwillingly forced to do evil there. And let him not pass judgement on the habits of others or the customs of the place, however useless they may seem, if they are not contrary to God's commands. Let him put from him every thought of migrating, and rejoice to find himself in a place where he intends to spend his whole life, not unwillingly but by his own free will; and thus quietly let him give himself up entirely to the diligent performance of the exercises of a holy life. And if it seems to him that his spiritual fervour aspires to something higher and more useful than the customs of his present monastery allow, let him think that he is deceived either in preferring something which is no better or possibly worse than these customs, or in presuming to think that he can do something beyond his powers; or at the very least let him think that he is unworthy to have what he desires. If then he is deceived, he should give thanks for God's mercy which has saved him from his error,—the error, namely, either of incurring all in vain the guilt of inconstancy or fickleness in changing the place or manner of his life without profit or with actual loss; or that of attempting things above his strength and being forced to fall back wearied into his former ways or even into something worse. If, on the other hand, he truly desires better things than those which his present life affords and is not yet worthy to receive them, let him patiently endure the judgement of God, which never unjustly denies anything to anyone: otherwise, he may by impatience anger the just Judge, and so be condemned to receive no more than he has, and to lose what he has already obtained, or to continue as he is without profit because

quia non amat inutiliter tenere. Seu vero misericordiam seu judicium erga se in illis quæ non habet et optat persentiat,' lætus ex iis quæ accepit largitati supernæ gratias dignas persolvat. Et quia ad qualemcunque portum de procellosis mundi turbinibus potuit pertingere,' caveat in portus tranquillitatem ventum levitatis, et impatientiæ turbinem inducere. Quatinus mens constantia et mansuetudine tutantibus quieta,' divini timoris sollicitudini et amoris delectationi sit vacua. Nam timor per sollicitudinem custodit, amor vero per delectationem perficit. Scio quia hæc majorem aut scribendi aut colloquendi exigunt amplitudinem, ut plenius intelligatur quibus scilicet dolis antiquus serpens ignarum monachum in hoc genere temptationis illaqueet, et econtra quibus rationibus prudens monachus ejus callidas persuasiones dissolvat et annichilet. Sed quoniam jam brevitatem quam exigit epistola excessi, et totum quod hinc dixi aut dicendum fuit ad custodiendam mentis quietem pertinet,' hujus brevis exortatio epistolam nostram terminet. Nec putes carissime hæc me dicere iccirco quod suspicer te aliqua mentis inquietudine laborare. Sed quoniam domnus Ursio[a][1] cogit me aliquam admonitionem tibi scribere,' nescio quid potius moneam, quam cavere hoc sub specie rectæ voluntatis, quod scio novitiis quibusdam solere surripere. Quapropter amice mi et[b] frater dilectissime consulit, monet, precatur te tuus dilectus dilector totis cordis visceribus, ut totis viribus quieti mentis studeas, sine qua nulli licet callidi hostis insidias circumspicere, vel semitas virtutum angustissimas prospicere. Ad hanc vero monachus qui in monasterio conversatur pertingere nullatenus valet sine constantia et mansuetudine, quæ mansuetudo indissolubilis comes est patientiæ; et nisi monasterii sui instituta quæ divinis non prohibentur mandatis, etiam si rationem eorum non perviderit ut religiosa studuerit observare. Vale, et omnipotens Dominus perficiat gressus tuos in semitis suis, ut non moveantur vestigia tua, ut in justitia appareas conspectui Dei, et satieris cum apparuerit gloria ejus.[2]

[a] Ursus A [b] et *om.* A

[1] Ursio or, as he is called in MS A and in some manuscripts of Anselm's letters, Ursus, was a common friend of Anselm and Lanzo: he may well be the same as the Ursio mentioned in a later letter (*Ep.* 113 [ii, 23]), where he appears as a clerk who had been persuaded to become a monk in another monastery after promising to make his profession at Bec.

[2] cf. Ps. xvi.5, 15 (Vulg.)

without love. Let him be well assured that either mercy or justice withholds from him those things which he desires, and let him rejoice in those things which he has received, giving due thanks for the heavenly bounty. For he has been able to reach some sort of a port in which to shelter from the storms and tossings of the world: let him therefore beware of disturbing the tranquillity of port with the wind of fickleness and the hurricane of impatience, and let his mind, lying at rest under the protection of constancy and forbearance, give itself up to the fear and love of God in carefulness and sweet delight. For fear, by inducing carefulness, guards him, and love, through sweetness, brings him to perfection. I know that these matters require more ample treatment, either in speech or writing, to give a fuller understanding of the wiles by which the old Serpent beguiles the inexperienced monk in temptation of this kind, and likewise of the strategy by which the prudent monk may brush aside and bring to nought his crafty suggestions. But since I have already exceeded the length required in a letter, and since all that I have said or that I have to say concerns the preservation of a quiet mind, I shall conclude with this brief exhortation. Do not, dearest friend, think that these words are prompted by any suspicion that you labour under any restlessness of mind, but since Dom Ursio[1] has forced me to send you some admonishment, I know no better warning that I can give you than to beware of this restlessness, which under the appearance of desiring what is good, often to my knowledge creeps upon novices. Wherefore, my dearest friend and brother, the man whom you love and who loves you counsels you, warns you, beseeches you in all sincerity of heart that you should devote your whole strength to the attaining of a quiet mind without which it is impossible to be on the watch against the devices of the crafty enemy or to survey the strait and narrow paths of righteousness. And this peace of mind is not to be attained by any monk living in a monastery without constancy and forbearance—and forbearance is indissolubly bound up with patience—or without a studious and devout observance of all the customs of the monastery, even if their purpose is not clear, provided they are not contrary to God's commands. Farewell, and the Lord of all power perfect your steps in his paths, that your footsteps slip not, so that you may appear before the face of God in righteousness and be satisfied with His glory when He shall appear.[2]

xxi. *De visionibus quæ illi ostensæ fuerunt cum a languore*
 convaluisset

Inter hæc cum jam ut dictis et scriptis suis mores sui in
nullo discordarent, totam suæ mentis intentionem in
contemptum mundi composuisset, et iis solis quæ Dei
erant totum studium suum infixisset.ʼ contigit ut infir-
mitate correptus graviter affligeretur. Sed ipse in Deo
semper idem existens.ʼ languore paulisper sedato, extra se
per mentis excessum raptus vidit fluvium unum rapidum
atque præcipitem, in quem confluebant omnium fluxuum
purgaturæ, et quarunque rerum terræ lavaturæ. Vide-
batur itaque aqua ipsa nimis turbida et immunda, et
omni spurciciarum sorde horrida. Rapiebat igitur in se
quicquid attingere poterat, et devolvebat tam viros quam
mulieres, divites et inopes simul. Quod cum Anselmus
vidisset, et tam obscenam revolutionem illorum misera-
tus unde viverent, aut unde sitim suam refocillarent qui
sic ferebantur inquireret, accepissetque responsum eos ea
qua trahebantur aqua vivere delectarique.ʼ indignantis
voce 'Fi' inquit 'quomodo? Taline aliquis cæno potus
vel pro ipso hominum pudore se ferret?' Ad hæc ille
qui eum comitabatur, 'Ne mireris' ait. 'Torrens mundi
est quod vides, quo rapiuntur et involvuntur homines
mundi.' Et adjecit, 'Visne videre quid sit verus mona-
chatus?' Respondit, 'Volo.' Duxit ergo illum quasiᵃ in
conseptum cujusdam magni et ampli claustri, et dixit ei,
'Circumspice.' Aspexit, et ecce parietes claustri illius
obducti erant argento purissimo et candidissimo. Herba

ᵃ quasi *om.* TUX

xxi. *Concerning the visions which were shown to him when he was recovering from an illness*

Meanwhile, that his own life might not be at variance with his speech and writings, his whole mind was set on contempt of this world and his whole desire was fixed on those things only which are of God. And in this state he was afflicted with a serious illness, maintaining nevertheless the same spirit towards God. When his weakness had somewhat abated, he was caught up in the spirit in an ecstasy and saw a swift and turbulent river into which flowed all the purgings and filth of the whole earth. The water therefore appeared both raging and impure, disgustingly contaminated with all its filth; it sucked into itself whatever it could reach and carried off both men and women, rich and poor alike. When Anselm saw this, he pitied these people in their so loathsome turmoil, and he enquired what they lived on or how they satisfied their thirst as they were thus borne along. He was told that they were nourished by the water on which they were borne and that they delighted in it. With indignant exclamation, he replied 'How can that be? Would anyone rush to take such filthy drink? If nothing else, a sense of shame would hold him back.' To which his companion said: 'Do not wonder at it. What you see is the torrent of the world by which worldly men are caught and drawn along.' And he added: 'Do you wish to see the true monastic life?' Anselm replied, 'I do'; and his companion led him as it were into the enclosure of a great and spacious cloister and said to him, 'Look about you.' He looked, and behold, the walls of that cloister were covered with the most pure and shining silver. The grass in the

quoque mediæ planitiei virens erat et ipsa argentea, mollis quidem et ultra humanam opinionem delectabilis. Hæc more alterius herbæ sub iis qui in ea pausabant leniter*a* flectebatur, et surgentibus ipsis et ipsa erigebatur.*b* Itaque locus ille totus erat amœnus, et præcipua jocunditate repletus. Hunc ergo ad inhabitandum sibi elegit Anselmus. Tunc ductor ejus dixit ei, 'Eia vis videre quid sit patientia vera?' Ad quod cum ille magno cordis affectu gestiret, et se id quam maxime velle responderet.' ad se subito reversus.' et visionem et visionis demonstratorem dolens ac gemebundus pariter amisit.[1] Duas autem quas viderat visiones intelligens secumque revolvens.' eo magis unius horrorem fugere, quo alterius amœnitate studuit delectari. Totum ergo deinceps sese dedit in hoc ut vere monachus esset, et ut vitam monachicam firma ratione comprehenderet, aliisque proponeret. Nec est privatus desiderio suo. Quod quidem ut estimo aliquantum*c* percipi poterit ex verbis ejus quæ per vices huic opusculo indere rati sumus, juxta quod series gestæ rei quam suscepimus enarrare postulabit. Nec enim videtur mihi pleniter posse pertingi ad notitiam institutionis vitæ illius, si descriptis actibus ejus, quis vel qualis fuerit in sermone taceatur.

a leviter VRP *b* erigebatur: D *begins in the middle of this word.*
c aliquantulum E

[1] This passage from *Sed ipse in Deo semper* (*When his weakness*) is repeated with alterations in *De Similitudinibus,* caps. 186-7, and with the addition: 'Has igitur duas visiones a sancta paternitate, et a paterna sanctitate nobis relatas, libenter audiamus, et audiendo devote teneamus, tenendo mente jugiter revolvamus; ut unius horrorem, dum vacat, fugiamus; alterius vero amoenae jucunditati, et jucundae amoenitati insistamus, nos qui monachatum tenemus.' It is evident from this that the source used here by the compiler of *De Similitudinibus* was not the *Vita Anselmi* itself but a sermon preached by a disciple of Anselm which incorporated material used in the *Vita.* This is one of several indications that the compiler of *De Similitudinibus* had access to a larger collection of Anselmian material than now exists.

middle of the open space was fresh and silvery also, but soft and delightful beyond belief. Like real grass it gently bent under those who rested on it, and unbent again when they got up. So the whole scene was pleasing and delightful in every way, and Anselm rejoiced to have it as a place to live in. Then his guide said to him: 'Now, would you like to see what true patience is?' He assented with eager and heartfelt desire, and replied that he would like to see that above all things; then suddenly he came to himself, the vision and its interpreter vanished leaving Anselm stricken with sorrow and grief.[1] But the more he thought about the two visions which he had seen and understood their meaning, the more he determined to flee the horror of the one, and to make the sweetness of the other his delight. From this time therefore he gave himself up entirely to being a true monk and to understanding the rational basis of the monastic life, and expounding it to others. Nor was his desire left unsatisfied, as in some measure can be seen (I think) from his own words, which I have seen fit to scatter here and there throughout this work, according as the story which I have undertaken to relate requires. For it seems to me impossible to obtain a full understanding of the tenor of his life if only his actions are described and nothing is said about how he appeared in his talk.

xxii. *De discretione quam docuit quendam abbatem exercere
erga pueros in scola nutritos*

Quodam igitur tempore cum quidam abbas qui ad-
modum religiosus habebatur secum de iis quæ monasticæ
religionis erant loqueretur, ac inter alia de pueris in
claustro nutritis verba consereret.' adjecit, 'Quid obsecro
fiet de istis? Perversi sunt, et incorrigibiles. Die et
nocte non cessamus eos verberantes, et semper fiunt sibi
ipsis deteriores.' Ad quæ miratus Anselmus.' 'Non ces-
satis' inquit 'eos verberare? Et cum adulti sunt quales
sunt?' 'Hebetes' inquit 'et bestiales.' At ille, 'Quam
bono omine nutrimentum vestrum expendistis; de homi-
nibus bestias nutrivistis.' 'Et nos' ait 'quid possumus
inde? Modis omnibus constringimus eos ut proficiant,
et nihil proficimus.' 'Constringitis? Dic quæso michi
domine abba, si plantam arboris in horto tuo plantares,
et mox illam omni ex parte ita concluderes ut ramos suos
nullatenus extendere posset.' cum eam post annos ex-
cluderes, qualis arbor inde prodiret?' 'Profecto inutilis,
incurvis ramis et perplexis.' 'Et hoc ex cujus culpa pro-
cederet nisi tua, qui eam immoderate conclusisti? Certe
hoc facitis de pueris vestris. Plantati sunt per oblationem
in horto æcclesiæ, ut crescant et fructificent Deo. Vos
autem in tantum terroribus, minis et verberibus undique
illos coarctatis, ut nulla penitus sibi liceat libertate potiri.
Itaque indiscrete oppressi.' pravas et spinarum more per-
plexas infra se cogitationes congerunt, fovent, nutriunt;

xxii. *Concerning the discretion which he taught a certain abbot to practise towards boys who were being educated in his school*

On one occasion then, a certain abbot, who was considered to be a sufficiently religious man, was talking with him about matters of monastic discipline, and among other things he said something about the boys brought up in the cloister, adding: 'What, I ask you, is to be done with them? They are incorrigible ruffians. We never give over beating them day and night, and they only get worse and worse.' Anselm replied with astonishment: 'You never give over beating them? And what are they like when they grow up?' 'Stupid brutes,' he said. To which Anselm retorted, 'You have spent your energies in rearing them to good purpose: from men you have reared beasts.' 'But what can we do about it?' he said; 'We use every means to force them to get better, but without success.' 'You force them? Now tell me, my lord abbot, if you plant a tree-shoot in your garden, and straightway shut it in on every side so that it has no space to put out its branches, what kind of tree will you have in after years when you let it out of its confinement?' 'A useless one, certainly, with its branches all twisted and knotted.' 'And whose fault would this be, except your own for shutting it in so unnaturally? Without doubt, this is what you do with your boys. At their oblation they are planted in the garden of the Church, to grow and bring forth fruit for God. But you so terrify them and hem them in on all sides with threats and blows that they are utterly deprived of their liberty. And being thus injudiciously oppressed, they harbour and welcome and nurse within themselves evil and crooked thoughts like thorns, and

tantaque eas vi*ᵃ* nutriendo suffulciunt.' ut omnia quæ
illarum correctioni possent adminiculari obstinata mente
subterfugiant. Unde fit, ut quia nichil amoris, nichil
pietatis, nihil benivolentiæ sive dulcedinis circa se in
vobis sentiunt.' nec illi alicujus in vobis boni postea fidem
habeant, sed omnia vestra ex odio et invidia contra se
procedere credant. Contingitque modo miserabili, ut
sicut deinceps corpore crescunt, sic in eis odium, et
suspicio omnis mali crescat, semper proni et incurvi ad
vitia.¹ Cunque ad nullum in vera fuerint caritate nutriti.'
nullum nisi depressis superciliis, oculove obliquo valent
intueri. Sed propter Deum vellem michi diceretis, quid
causæ sit quod eis tantum infesti estis. Nonne homines,
nonne ejusdem sunt naturæ cujus vos estis? Velletisne
vobis fieri quod illis facitis, siquidem quod sunt vos essetis?
Sed esto. Solis eos percussionibus et flagellis ad mores
bonos*ᵇ* vultis informare. Vidistis unquam aurificem ex
lammina auri vel argenti solis percussionibus imaginem
speciosam formasse? Non puto. Quid tunc? Quatinus
aptam formam ex lammina formet.' nunc eam suo instru-
mento leniter premit et percutit, nunc discreto levamine
lenius levat et format. Sic et vos si pueros vestros cupitis
ornatis moribus esse.' necesse est ut cum depressionibus
verberum, impendatis eis paternæ pietatis et mansuetu-
dinis levamen atque subsidium.'² Ad hæc abbas, 'Quod
levamen, quod subsidium? Ad graves et maturos mores
illos constringere laboramus.' Cui ille, 'Bene quidem.
Et panis et quisque solidus cibus utilis et bonus est eo uti

ᵃ Many MSS read in *ᵇ* bonos mores EF

¹ This passage from *Dic, quaeso mihi* (*Now tell me*) is repeated with slight
alterations and additions in *De Similitudinibus*, cap. 178.

² This passage from *Vidistis unquam aurificem* (*Have you ever seen a goldsmith*)
is repeated, with slight alterations and additions, in *De Similitudinibus*, cap.
179.

cherish these thoughts so passionately that they doggedly
reject everything which could minister to their correction.
Hence, feeling no love or pity, good-will or tenderness
in your attitude towards them, they have in future no
faith in your goodness but believe that all your actions
proceed from hatred and malice against them. The
deplorable result is that as they grow in body so their
hatred increases, together with their apprehension of
evil, and they are forward in all crookedness and vice.[1]
They have been brought up in no true charity towards
anyone, so they regard everyone with suspicion and
jealousy. But, in God's name, I would have you tell
me why you are so incensed against them. Are they
not human? Are they not flesh and blood like you?
Would you like to have been treated as you treat them,
and to have become what they now are? Now consider
this. You wish to form them in good habits by blows
and chastisement alone. Have you ever seen a gold-
smith form his leaves of gold or silver into a beautiful
figure with blows alone? I think not. How then does
he work? In order to mould his leaf into a suitable
form he now presses it and strikes it gently with his tool,
and now even more gently raises it with careful pressure
and gives it shape. So, if you want your boys to be
adorned with good habits, you too, besides the pressure
of blows, must apply the encouragement and help of
fatherly sympathy and gentleness.'[2] To which the abbot
replied: 'What encouragement? what help? We do
all we can to force them into sober and manly habits.'
'Good,' said Anselm, 'just as bread and all kinds of
solid food are good and wholesome for those who can

H

valenti. Verum subtracto lacte ciba inde lactentem infantem, et videbis eum ex hoc magis strangulari quam recreari. Cur hoc.ʲ dicere nolo,ᵃ quoniam claret. Attamen hoc tenete, quia sicut fragile et forte corpus pro sua qualitate habet cibum suum.ʲ ita fragilis et fortis anima habet pro sui mensura victum suum. Fortis anima delectatur et pascitur solido cibo, patientia scilicet in tribulationibus, non concupiscere aliena, percutienti unam maxillam præbere alteram, orare pro inimicis, odientes diligere, et multa in hunc modum.¹ Fragilis autem, et adhuc in Dei servitio tenera, lacte indiget, mansuetudine videlicet aliorum, benignitate, misericordia, hilari advocatione, caritativa supportatione, et pluribus hujusmodi. Si taliter vestris et fortibus et infirmis vos coaptatis.ʲ per Dei gratiam omnes quantum vestra refert Deo adquiretis.' His abbas auditis.ʲ ingemuit dicens, 'Vere erravimus a veritate, et lux discretionis non luxit nobis.' Et cadens in terram ante pedes ejus.ʲ se peccasse, se reum esse confessus est; veniamque de præteritis petiit, et emendationem de futuris repromisit. Hæc iccirco dicimus, quatinus per hæc quam piæ discretionis et discretæ pietatis in omnes fuerit, agnoscamus. Talibus studiis intendebat, in istis Deo serviebat, per hæc bonis omnibus valde placebat. Unde bona fama ejus non modo Normannia tota est respersa.ʲ verum etiam Francia tota, Flandria tota, contiguæque his terræ omnes. Quin et mare transiit, Angliamque replevit. Exciti sunt quaque

ᵃ CUR HOC? DICERE NOLO αβ

¹ Matt. v.39; Luke vi.29

digest them; but feed a suckling infant on such food, take away its milk, and you will see him strangled rather than strengthened by his diet. The reason for this is too obvious to need explanation, but this is the lesson to remember: just as weak and strong bodies have each their own food appropriate to their condition, so weak and strong souls need to be fed according to their capacity. The strong soul delights in and is refreshed by solid food, such as patience in tribulation, not coveting one's neighbour's goods, offering the other cheek, praying for one's enemies, loving those who hate us, and many similar things.[1] But the weak soul, which is still inexperienced in the service of God, needs milk,—gentleness from others, kindness, compassion, cheerful encouragement, loving forbearance, and much else of the same kind. If you adapt yourself in this way according to the strength and weakness of those under you, you will by the grace of God win them all for God, so far at least as your efforts can.' When the abbot heard this, he was sorrowful, and said, 'We have indeed wandered from the way of truth, and the light of discretion has not lighted our way.' And he fell on the ground at Anselm's feet confessing himself a miserable sinner, seeking pardon for the past, and promising emendment in the future.

We recount this incident so that from this example may be known how much gentleness and discretion he showed towards all men. In matters like this he was indefatigable; in such ways he served God and made himself beloved by all good men, so that a good report of him spread not only throughout Normandy, but also throughout France, Flanders and all the neighbouring lands. His reputation even crossed the sea and England

gentium multi nobiles, prudentes clerici, strenui milites, atque ad eum confluxere, seque et sua in ipsum monasterium Dei servitio tradidere. Crescit cœnobium illud intus et extra. Intus in sancta religione, extra in multimoda possessione.

xxiii. *Quantum horruerit habere aliquid proprii*

Cum vero abbas Herluinus cujus supra meminimus jam decrepitus monasterii causis intendere et opem ferre non valeret.' quicquid agi oportebat sub Anselmi utpote prioris dispositione fiebat.¹ Exigentibus igitur multiplicibus causis.' eum extra ᵃ monasterium ire sepe necesse fuit. Cui dum nonnunquam equi et alia quæ sunt equitaturis necessaria deessent.' præcepit abbas ei omnia quæ opus erant parari, et illi soli sicut propria ministrari. At ipseᵇ ad nomen proprietatis inhorruit, et reversus de itinere quæ ᶜ sibi specialiter fuerant præparata, in viam ituris communiter exponi jussit; nec propter secuturam quam forsan erat passurus penuriam.' unquam se retraxit quin ex sua copia cæterorum suppleret inopiam. Nec mirandum cum jam mundo illuserat eum se fratribus suis talem exhibuisse, cum sicut ipsemet referre solitus erat.' etiam quando adhuc in seculari vita degebat eo circa alios amore fervebat, ut quemcunque sui ordinis minus se habentem videret.' ejus inopiam de abundantia sua libens pro posse suppleret. Jam tunc enim ratio illum docebat omnes divitias mundi pro communi homi-

ᵃ EXTRA: FORAS αβE ᵇ ille β
ᶜ QUAEQUE αβCЄI

¹ Herlwin died on 26 August 1078 at the age of 84. His strength had been failing for several years before his death, and during the last year of his life he was almost bed-ridden (J. A. Robinson, *Gilbert Crispin*, p. 108: after the consecration of the new church at Bec on 23 October 1077, 'omni membrorum officio destitui penitus coepit'; cf. Porée, 1, pp. 143-6).

was filled with it. From every nation there rose up and came to him many noblemen, learned clerks, and active knights offering themselves and their goods to the service of God in the monastery. So the monastery grew inwardly and outwardly: inwardly in holiness, outwardly in manifold possessions.

xxiii. *His great horror of having anything belonging to him*

Now when Abbot Herlwin, who has been mentioned above, grew very old and was unable to attend to or assist in the affairs of the monastery, it fell to Anselm as prior to do whatever was necessary.[1] So he was often obliged to leave the monastery on all kinds of business. But since he sometimes had no horses or various other things necessary for riding, the abbot gave orders that everything he needed was to be provided and set aside for his use alone, as if it were his own property. But he had a horror of the words private property, and when he returned from his journey, he ordered that everything which had been specially provided for him should be at the common disposal of those going on a journey. He never held back from supplying the necessities of others from his own store, because of the privation which he might thereby incur. Nor is it strange that he should behave in this way towards his brethren after he had said good-bye to the world, for—as he himself used to relate—even when he was still leading a secular life, he felt such a fervent love towards others that when he saw anyone of his own class with less than himself he would do all that he could to supply their needs from his own abundance. For even then reason taught him that all

num utilitate ab uno omnium Patre creatas, et secundum
naturalem legem nichil rerum magis ad hunc quam ad
istum pertinere.[1] Taceo quod sepe illi plura auri et
argenti pondera sunt a nonnullis oblata, quatinus ea in
suos suorumque usus susciperet, servaret, dispenderet:
quæ ipse nulla patiebatur ratione suscipere, nisi forte
communi fratrum utilitati profutura abbati præsenta-
rentur. Sed cum is qui sua offerebat econtra diceret, se
nullam tunc voluntatem habere ut abbati vel monachis
aliquid daret nisi ei soli: referebat ille se talium opus non
habere, nec aliter a quoquam velle quicquam accipere.

xxiiii. *Qualiter aureum anulum in lecto suo repperit*

Illud autem breviter dico, quod inter hujuscemodi
studia: die quadam dum ad lectum suum in dormitorio
diverteret: anulum aureum in eo insperatus invenit, et
admodum miratus est. Reputans ergo apud se ne forte
aliquis eorum qui res monasterii procurabant quovis
eventu eundem anulum ibi reliquerit: levavit eum et
singulis ostendit. Mirantur illi, et se rei conscios omnino
negant. Ostenditur aliis atque aliis, sed hucusque nullus
fuit qui recognoverit unde vel a quo illuc delatus sit. Et
tunc quidem anulus idem in opere æcclesiæ expensus est,
et res ita remansit. Postmodum vero cum ipse Anselmus
ad pontificatum sumptus est: fuerunt qui hoc ipsum per
anulum illum jam tunc quodam præsagio præsignatum
fuisse assererent. Nos autem quæ gesta sunt simplici
tantum stilo digerimus.

[1] For the patristic sources of this doctrine, see R. W. and A. J. Carlyle, *History of Mediaeval Political Theory in the West*, I, 1903, pp. 132-46.

the riches of the world were created by our common Father for the common good of all mankind and that by natural law they belonged no more to one man than to another.[1] I will say nothing here about the large quantities of silver and gold which were frequently offered to him by various people to be kept and spent for the use of himself and his companions. These he would on no account receive unless they were given to the abbot for the common use of the brethren; and if the man who offered them said that he had no wish to give anything to the abbot and monks, but only to Anselm alone, he replied that he had no need of such gifts, and that he would never receive anything from anyone except on these terms.

xxiv. *How he found a gold ring in his bed*

I shall however briefly relate something that happened in the course of these and similar activities. One day when he went to the dormitory to rest on his bed, he unexpectedly and with some surprise found a gold ring on it. He wondered whether perhaps one of the custodians of the things belonging to the monastery had accidentally left the ring there; so he picked it up and showed it to several of them. They were surprised and said they knew nothing at all about it. The ring was shown to many others, but to this day no-one has discovered whence it came or by whom it was brought there. In the end the ring was sold for the needs of the church and there the matter rested. But afterwards, when Anselm was raised to the episcopate, there were those who said that this had been foretold in the prophetic incident of the ring. We however simply set forth the things as they happened without embellishment.

xxv. *Qualiter miles nomine Cadulus audivit demonem Anselmo*
 detrahere

Invitabatur præterea a diversis abbatiis, quatinus ibi et
publice in capitulo fratribus, et secum loqui privatim*ᵃ*
volentibus verba vitæ ministraret. Nanque solenne ex-
titerat omnibus, ut quicquid ab ore illius foret auditum,
sic haberetur quasi plane divinum responsum. Unde
requirendi consilii gratia ex diversis ad eum locis festina-
batur. Quæ res.ʲ invidia gravi diabolum vulnerabat.*ᵇ*
Nonnullos ergo quos ab ea intentione secreta fraude non
poterat.ʲ manifesta increpatione avertere machinabatur.
Exempli causa. Miles quidam erat, Cadulus nomine.
Hic quadam vice vigiliis et orationibus Deo intentus.ʲ
audivit diabolum sub voce scutarii[1] sui extra æcclesiam
in qua erat vociferantem, et turbato murmure equos et
omnia sua fracto hospitio a latronibus jam tunc direpta
esse et abducta conquerentem, nec aliquid eorum ulterius
recuperandum ni citus accurreret. Ad quæ cum ille
nequaquam moveretur, majus videlicet damnum depu-
tans orationi cedere, quam sua perdere.ʲ dolens diabolus
se despectum.ʲ in speciem ursi demutatus est, et æcclesiæ
per tectum illapsus ante illum*ᶜ* præceps corruit, ut hor-
rore saltem et fragore sui casus virum cœpto proturbaret.
Sed miles immobilis permanet, et monstrum securus
irridet. Post quæ statum vitæ suæ proposito sanctiori

ᵃ PRIVATIM LOQUI αβEF *ᵇ* vulneravit VRPMN
ᶜ ipsum β

[1] *Scutarius* is the word from which *squire*, *escuyer* are derived and this is
its sense here; cf. *Bertholdi Annales*, 1065, on the knighting of the young king
of Germany: 'Heinricus rex natalem Domini Goslare, diem autem paschae
Wormatiae celebravit . . . et ibidem accinctus est gladio, anno regni sui ix,
aetatis autem suae xiv, et dux Gotifridus scutarius eius eligebatur' (*M.G.H.
SS.* v, 272).

xxv. *How a knight called Cadulus heard a devil belittling Anselm*

In addition to all this Anselm was invited to various abbeys to speak words of salvation both to the brethren assembled together in the chapter house, and to those who wished to talk to him in private. For everyone took it for granted that whatever he heard from his lips was to be received as it were God's own answer to him. So people crowded to him from diverse parts to seek his counsel. At this the devil was sharply pricked with envy, and he tried to turn them aside from this purpose by secret deceits if possible, or otherwise by open threats. For instance, there was a certain knight called Cadulus, who was one night keeping vigil and saying prayers to God, when he heard the devil shouting and making an uproar outside the church where he was, in a voice like that of his squire,[1] bewailing that the lodging had been broken into by robbers who had seized and carried off the knight's horses and all his goods, which would never be recovered unless he came quickly. But the knight made no movement, thinking it a greater evil indeed to cease praying than to lose his goods. At this the devil was grieved at the contempt with which he was treated and, turning himself into the likeness of a bear, leaped headlong through the roof of the church and landed in front of him, hoping to disturb the knight in what he was doing by the horror and noise of his fall. But the knight remained quite still and braved the monster unmoved. After this, he wished to build his life on a more holy foundation, and he approached Anselm with

fundare desiderans.' Anselmum adiit, consilium ejus
super hoc addiscere cupiens. Verum dum ad ipsum
vadens iter acceleraret.' ecce malignus hostis humanam
vocem ex adverso edens, in hæc verba prorupit, 'Cadule
Cadule quo tendis?' Igitur cum ille ad vocem sub-
sisteret, scire volens quis esset qui talia diceret.' repetivit
demon et ait. 'Quo tendis Cadule? Quid te tantopere
priorem illum hipochritam cogit adire? Opinio siqui-
dem ejus, omnino alia est a conversatione vitæ illius.
Quapropter suadeo, consulo ut celerius redeas, ne se-
ductus ab eo, stultitia qua modo traheris illaqueeris.
Hypochrisis nanque sua jam multos decepit, et spe vana
delibutos, suis vacuos et immunes effecit.' Hæc ille
audiens, et demonem esse qui loquebatur recognoscens.'
signo se crucis munivit, et spreto hoste quo proposuerat
ire perrexit. Quid plura? Audito Anselmo.' abnegato
seipso et seculo religiosæ vitæ se tradidit, et apud Majus
Monasterium monachus factus est. Hunc etenim usum
Anselmus habebat, ut nunquam alicujus commodi causa
suaderet alicui seculo renunciare volenti, quatinus in suo
monasterio potius quam in alieno id faceret. Quod
nimirum eo intuitu, ea consideratione faciebat.' ne ullus
postmodum loco quem ex propria deliberatione non
intraverat aliqua ut fit pulsatus molestia detraheret, et
scandali sui ac impatientiæ murmur persuasioni ipsius
imputaret, itaque se aliis et alios sibi ad multa divisus
graves efficeret.

the intention of obtaining his advice on this matter. While he was hastening on his way, the wicked Enemy broke forth into a human cry at his side, uttering these words: 'Cadulus, Cadulus, where are you going?' At these words the knight stopped, wishing to know who it was who had spoken, and the devil repeated his words, saying, 'Where are you going Cadulus? What is it that so strongly compels you to visit that hypocrite prior? Certainly his reputation is quite at variance with the manner of his life. So my earnest advice is that you should return quickly, in case you are led astray by him and are entrapped in the folly which now leads you on. For his hypocrisy has already deceived many and, having buttered them up with vain hopes, has stripped them and left them destitute.' When he heard these words and recognised that it was the devil who spoke, he fortified himself with the sign of the cross and continued on his way, ignoring the Enemy. And what then? He listened to Anselm, and having denied himself and renounced the world, he gave himself up to a religious life, and became a monk at Marmoutier. For it was Anselm's custom, notwithstanding any hope of advantage, never to persuade anyone who wished to renounce the world, to do so at his own monastery rather than elsewhere. And the consideration which led him to act thus was as follows: if anyone entered the monastery except as a result of his own deliberation, and then—as might happen—found it irksome and began to disparage it, he might attribute his own scandalised and impatient grumbling to Anselm's persuasion, and so make serious divisions between him and the others.

xxvi. *Qualiter in abbatem electus et consecratus sit*

Defuncto sepe superius nominato abbate Herluino.' uno omnium fratrum Beccensium consensu in abbatem eligitur.[1] Quod ipse omni studio subterfugere gestiens.' multas et diversas rationes ne id fieret obtendebat. Sed illis nec auditum quidem rationibus ejus patienter accommodare volentibus.' anxiatus est in eo spiritus ejus,[2] et quid ageret ignorabat. Transierunt in istis dies quidam. Verum ubi Anselmus vidit se monachorum unanimem constantiam non posse verbis mutare.' temptavit si quo modo eam valeret vel precibus inclinare. Eis itaque pro re sub uno constitutis, ac ei ut omissis objectionibus solitis abbas fieri adquiesceret insistentibus.' ille flens et miserandos singultus edens prosternitur in faciem coram omnibus, orans et obtestans eos per nomen Dei omnipotentis, per siqua in eis erant viscera pietatis, quatinus respectu misericordiæ Dei super eum intendant, et ab incepto desistentes se a tanto onere quietum manere permittant. At illi omnes econtra in terram prostrati, orant ut ipse potius loci illius et eorum misereatur, ne postposita utilitate communi se solum præ cæteris singulariter amare convincatur. Acta sunt de his utrinque plurima in hunc modum, sed jam nunc eis istum ponimus dicendi modum. Vicit tandem diligens importunitas et importuna diligentia fratrum jugum Domini sub ejus regimine ferre

[1] The election of Anselm took place a few days after the death of Herlwin on 26 August 1078: 'Obiit dominus abbas Herluinus vii kalendas septembris, lxxxiv aetatis suae anno, monachatus vero xliv, paucisque interpositis diebus electus est abbas Anselmus pro eo, qui tunc erat prior eiusdem loci' ('Courtes annales du Bec', ed. L. Delisle in *Notices et Documents publiés pour la Société de l'histoire de France*, 1884, p. 96; cf. Porée, I, p. 151). He did not receive benediction from the bishop of Evreux until 22 February 1079, so the visit to England described below must have taken place after this date. For details see *Notitia de libertate Beccensis monasterii*, in Bouquet, XIV, pp. 271-2; Porée, I, p. 153.

[2] cf. Ps. cxlii.4 (Vulg.)

xxvi. *How he was elected and consecrated abbot*

When Abbot Herlwin, who has frequently been mentioned already, died, the brethren of Bec all with one consent chose Anselm as abbot.[1] But he used every means to evade this, putting forward many and varied reasons why it should not be. They however would not even listen patiently to his arguments, and he was troubled in spirit,[2] being uncertain what he should do. So the matter stood for several days, and when Anselm saw that his words would not avail to change the unwavering unanimity of the monks, he tried whether his prayers could by any means succeed in shaking it. Therefore when they had all met together for this business and were insisting that he should leave out the usual objections and agree to become abbot, he threw himself down full-length before them all. With tears and pitiable sobs he begged and prayed, in the name of Almighty God, that if they had any bowels of mercy in them, they would act towards him with the mercy of God before their eyes, abandoning their attempt and allowing him to remain free of so great a burden. But they on their side prostrated themselves on the ground and begged him to have mercy on the monastery and on themselves rather than on himself, lest in putting aside the common good he should be convicted of loving himself alone before all others. Many similar things were done on both sides in this affair, but I will now bring it to an end. At last the importunity and diligence of the brethren who wished to bear the Lord's yoke under his rule, prevailed. Also, and much more than

volentium; vicit quoque et multo maxime vicit præcep-
tum quod ut supra retulimus ei fuerat ab archiepiscopo
Maurilio per obœdientiam injunctum, videlicet ut si
major prælatio quam illius prioratus extiterat ipsi ali-
quando injungeretur: nullatenus eam suscipere recu-
saret. Nam sicut ipse testabatur nunquam se abbatem
fieri consensisset, nisi eum hoc quod dicimus imperium
ad hoc constrinxisset. Tali ergo violentia est abbas
effectus, ac Becci debito cum honore sacratus. Qualem
vero se deinceps in cunctis sanctarum virtutum exer-
citiis *a* exhibuerit: inde colligi potest, quod nunquam de
retroacta sanctitatis suæ conversatione causa abbatiæ
quicquam minuit, sed semper de virtute in virtutem ut
Deum deorum in Syon mereretur videre conscendere
studuit.[1]

xxvii. *Quemadmodum in secularibus negotiis placitare*
consueverit

Delegatis itaque monasterii causis curæ ac sollicitudini
fratrum de quorum vita et strenuitate certus erat: ipse
Dei contemplationi, monachorum eruditioni, admoni-
tioni, correctioni jugiter insistebat. Quando autem ali-
quid magni in negotiis æcclesiæ *b* erat agendum, quod in
ejus absentia non estimabatur oportere definiri: tunc
pro tempore et ratione negotium quod imminebat,
mediante justitia disponebat. Abominabile quippe judi-
cabat si quidvis lucri assequeretur, ex eo quod alius
contra moderamina juris quavis astutia perdere posset.
Unde neminem in placitis patiebatur a suis aliqua fraude

a EXERCITIIS VIRTUTUM αβEF
b aecclesiae negotiis VRP
[1] cf. Ps. lxxxiii.8 (Vulg.)

anything, he was constrained by the command which
Archbishop Maurilius—as we have already related—
had enjoined on his obedience: namely, that if a greater
office than that of prior were ever laid upon him, he
should by no means refuse to accept it. For, as he
himself used to testify, he would never have consented to
become abbot unless this command which we mention
had constrained him. Such then was the violence with
which he was made abbot; and he was consecrated at
Bec with due honour. How active he continued to show
himself in the practice of every holy virtue can be
gathered from the fact that he never on account of his
abbacy abated anything of his former exercises in holi-
ness, but strove always to go from strength to strength
in order that he might be found worthy to see the God
of gods in Syon.[1]

xxvii. *How he was accustomed to conduct himself in secular*
pleadings

He delegated the business of the monastery to the care
and attention of brethren in whose uprightness and
energy he had confidence, and he gave himself up con-
tinually to the contemplation of God, and to the instruc-
tion, admonishment and correction of the monks. And
when any important business of the church arose which
it was not thought proper to settle in his absence, he
disposed of it as justice required, according to the cir-
cumstances and nature of the case. For he thought it
would be an abominable thing if anyone were to be the
loser by any sharp practice which he might follow against
the dictates of justice in the hope of gain. Hence he
never allowed anyone to be overreached in law-suits by
any fraud on the part of his advocates, being careful not

circumveniri, observans ne cui faceret quod sibi fieri nollet. Hinc procedebat quod inter placitantes residens, cum adversarii ejus per sua consilia disquirerent quo ingenio, quave calliditate suæ causæ adminiculari, et illius valerent fraudulenter insidiari:' ipse talia nullatenus curans:' eis qui sibi volebant intendere aut de evangelio, aut de alia aliqua divina scriptura, aut certe aliquid de informatione morum bonorum disserebat. Sepe etiam cum hujusce auditores deerant:' suaviter in sui cordis puritate quiescens, corpore dormiebat. Eveniebatque nonnunquam, ut fraudes subtili machinatione compositæ, mox ubi sunt in audientiam illius delatæ:' non quasi a dormiente qui tunc erat, sed sicut a perspicaciter vigilante et intendente sint detectæ atque dissectæ. Caritas enim quæ non emulatur, quæ non agit perperam, quæ non quærit quæ sua sunt:'[1] in eo vigebat, per quam quæ videnda erant veritate monstrante extemplo[a] perspiciebat.

xxviii. *Quam humanus fuerit in cura hospitum, et quam providus in superventuris necessitatibus fratrum*

Quam vigil autem atque sollicitus fuerit circa hospitum susceptionem, eorumque in omni humanitatis officio relevationem:' ex eo probatur, quod illum pio studio in hoc et se et sua novimus expendisse.[2] Se in omni hilaritate, sua in omni largitate. Quod si aliquando ad refectionem corporum victus pro voto suo non omnino

[a] exemplo VRP extinplo Aβ

[1] cf. 1 Cor. xiii.4, 5

[2] The fame of the hospitality of Bec continued into the twelfth century; cf. Ordericus Vitalis, ii, 246: 'De hospitalitate Beccensium sufficienter eloqui nequeo. Interrogati Burgundiones et Hispani, aliique de longe seu de prope adventantes respondeant, et quanta benignitate ab eis suscepti fuerint, sine fraude proferant, eosque in similibus imitari sine fictione satagant. Janua

to do to others what he would not wish to have done to himself. From this it followed that when he was in a crowd of litigants and his opponents were laying their heads together, discussing the crafts and wiles by which they could help their own case and fraudulently injure his, he would have nothing to do with such things; instead, he would discourse to those who would listen about the Gospels or some other part of the Bible, or at least about some subject tending to edification. And often, if there was no-one to listen to such talk, he would compose himself, in the sweet quietness of a pure heart, to sleep. Then sometimes, when the frauds which had been prepared with intricate subtlety were brought to his notice, he would immediately detect and disentangle them, not like a man who had just been sleeping, but like one who had been wide-awake, keeping a sharp watch. For the charity which envieth not, which doeth no evil, which seeketh not her own,[1] was alive in him, and showed him things at a glance as they appeared in the light of truth.

xxviii. *How kind he was in the care of guests, and how thoughtful in providing for the future necessities of the brethren*

How vigilant and solicitous he was in the entertainment of guests and in providing for them in all their needs, is shown by the fact that, as we know, he spared neither himself nor his goods in this pious work; giving himself with all cheerfulness, and his goods with complete liberality.[2] And if at times there was not quite enough food to refresh their bodies as he would have wished, his

Beccensium patet omni viatori, eorumque panis nulli denegatur caritative petenti' (quoted by Porée, I, p. 155).

1

sufficiebat.ʲ hoc quod deerat ejus bona voluntas et vultus alacritas apud hospites gratiose supplebat. Præterea nonnunquam cibus fratrum suo jussu de refectorio sublatus, et hospitibus est allatus atque appositus. Neque enim tunc in promptu aliud erat, quod eis apte posset apponi. Victus autem monachorum ita Deo providente dispensabatur, ut nichil eorum quæ necessitas expetebat illis deesset, licet sepissime in hoc essent.ʲ ut timeretur ne in crastinum eis cuncta deessent. Sicque nonnunquam inter aliquid et quasi nichil ferebantur.ʲ ut aliquid eis non superflueret, et quod erat quasi nichil eos nequaquam per inopiam fatigaret. Quod penitus illis contingebat secundum verba sui patris, qui ea prædicebat dum ministri æcclesiæ apud eum querebantur de formidine imminentis necessitatis. Frequenter nanque a celarariis, a camerariis, a secretariis aditus est, et quid consilii contra penuriam quæ cujusque obœdientiam pessundabat daret.ʲ inquisitus. Quibus cum responderet, 'Sperate in Domino, et spero quia ipse vobis necessaria quæque ministrabit'.ʲ mirabili modo non secus eveniebat in re, quam ipse dicebat se habere in spe. Videres enim post hæc verba statim ipsa die, vel certe sequenti mane, sive quod falli non poterat priusquam penuria aliqua ullum affligeret.ʲ aut naves de Anglia oneratas omni copia in usum illorum juxta appelli,[1] aut quemlibet de divitibus terræ fraternitatem æcclesiæ quærentem cum magna

[1] For English ships coming to Normandy with supplies for Norman monasteries, see *Miracula quae in ecclesia Fiscanensi contigerunt* (ed. A. Långfors, *Annales Academiae scientiarum Fennicae*, xxv, i, 1930, p. 17): 'Eo nanque anno quo Guillelmus obiit rex Anglorum, filius eius Guillelmus, regnum accipiens, inplacabilem contra se maioris fratris invidiam concitavit, qui illico, undecumque collectis auxiliis, ipsum expugnare si posset, si non posset impugnare tentabat, quod hactenus non processit. Adhibuit etiam mari custodes, quos illi piratas vocant, qui naves ab Anglia venientes caperent, captas ei redderent, capturam suis usibus manciparunt. Factum est autem per id tempus ex consuetudine navem huius ecclesiae onustam carnibus

good-will and cheerful countenance among the guests richly supplied what was lacking. Sometimes moreover he ordered food to be brought from the refectory of the brethren, and placed before the guests if there was nothing else at hand which could properly be offered to them. Nevertheless the food of the monks was so organised, by God's providence, that they lacked nothing which their necessity required, although very often they were in such straits that they feared the next day might find them utterly destitute. At times they were so nicely poised between having something and having almost nothing, that their 'something' was never more than just enough and their 'almost nothing' never so little that they suffered want. At such times matters fell out exactly according to the prediction which their abbot used to make when officials of the monastery complained to him about the threat of imminent distress. For he was frequently approached by cellarers, chamberlains, and sacrists, who asked for his advice in overcoming the shortages which weighed heavily on their offices; and he would reply, 'Trust in God, and I am confident that he will supply whatever is needful for you.' In a miraculous way events would turn out to justify the confidence which he said he had. For you would see, soon after he had spoken these words—on that same day, or certainly on the following one, or quite without exception before anyone suffered real want, either ships from England laden with every provision for their use would come to land nearby,[1] or some rich man seeking fraternal association with the monastery would arrive with a large

(the French version says: de char et de bascons salez), ab Anglia venientem cursu propero, Sequanae appulisse, sed eorum insidias penitus non evasisse.'

pecunia adventare, aut aliquem relinquere mundum
volentem se et sua in monasterium offerre, aut denique
aliunde aliquid apportari, unde per plurimos dies neces-
saria quæque poterant ministrari.

xxix. *Quod in Angliam veniens a monachis Cantuariensibus
honorifice sit susceptus, et accepta fraternitate inter eos, unus
ex eis factus*

Habebat præterea ipsum cœnobium plures in Anglia
possessiones, quas pro communi fratrum utilitate necesse
erat per abbatis præsentiam nonnunquam visitari.[1] Ipso
itaque suæ ordinationis anno, Anselmus in Angliam pro-
fectus est.[2] Ad quod licet hæc quam dixi satis firma
causa existeret, alia tamen erat non infirmior ista, vide-
licet ut reverendum Lanfrancum cujus supra meminimus
videret, et cum eo de iis quæ corde gerebat familiari
affatu ageret. Ipse siquidem venerabilis vir jam de
abbate Cadomensi factus fuerat archiepiscopus Cantu-
ariensis, omnibus valde honorabilis, et sullimi probitate
conspicuus. Cum igitur Anselmus transito mari Can-
tuariam veniret, pro sua reverentia et omnibus nota
sanctitate, honorifice a conventu æcclesiæ Christi in ipsa
civitate sitæ susceptus est. Pro quo honore nolens in-
gratus existere, postmodum ipsi monachorum conventui
a gratiarum actione inchoans, procedente in hoc ver-
borum serie de caritate locutus est, rationabiliter osten-

[1] The possessions of the monastery of Bec in England are described in a
confirmation charter of William I of 1081-7, printed by H. E. Salter in
E.H.R. XL, 1925, pp. 74-6. These possessions included tithes and churches
in Essex, Wiltshire, Oxfordshire, Gloucestershire, Berkshire, Buckingham-
shire, Surrey, Hertfordshire and Suffolk; estates in Devon, Oxfordshire and
Surrey; and the manors of Brixton Deverill in Wiltshire and Ruislip in
Middlesex. For the later administration of these possessions see M. Morgan,
The English Lands of the Abbey of Bec, Oxford 1946.

sum of money, or somebody wishing to leave the world
would offer himself and his possessions to the monastery,
or something would somehow turn up by which their
necessities could be supplied for many days to come.

xxix. *Concerning his coming to England, being honourably
received by the monks of Canterbury, and being made a member
of their confraternity*

Moreover the monastery had many possessions in
England, which sometimes needed to be visited by the
abbot personally for the common good of the brethren.[1]
In the very year of his consecration therefore Anselm
set out for England.[2] For this visit the reason which I
have mentioned was quite sufficient, but there was
nevertheless another one which was no less strong,—
namely, the desire to see his revered Lanfranc, whom
we have already mentioned, and to discuss with him
privately some things which he had at heart. This
venerable man, after having been abbot of Caen, had
become archbishop of Canterbury, and was greatly
honoured by all as a man of eminent and outstanding
worth. When Anselm then had crossed the sea and had
come to Canterbury he was honourably received by the
whole congregation of Christchurch, situated in that
city, as befitted his dignity and well-known holiness.
He did not wish to seem ungrateful for this honour, and
he afterwards spoke to the whole body of monks. He
began by expressing his thanks, and continued in the
same address to speak of charity, explaining and proving

[2] This passage is the only evidence we have for Anselm's visit to Eng-
land in 1079, but a visit to supervise the administration of the scattered
possessions in England and to take homage and oaths of fealty would be a
normal action for a new abbot.

dens eum qui caritatem erga alterum habet majus aliquid habere, quam illum ad quem caritas ipsa habetur.[1] 'Ipse enim' inter alia inquit 'qui caritatem habet.' hoc unde Deus ei scit gratias habet; ille vero ad quem tantummodo habetur, minime. Quas etenim gratias michi debet Deus, si tu me vel quilibet alius diligit? Quod si majus est habere hoc unde Deus scit homini grates, quam hoc unde nullas.' cum pro habita caritate gratias sciat, pro suscepta non adeo.' colligitur eum qui caritatem erga alium habet majus quid habere, quam ipsum cui impenditur. Amplius. Is cui dilectio alterius servit.' solius commodi munus perfunctorie suscipit, verbi gratia, beneficium unum, honorem unum, prandium unum, vel quodlibet officii genus in hunc modum. Alius vero, caritatem quæ commodi munus exhibuit, sibi retinuit. Quod in me et in vobis[a] sanctissimi fratres licet[b] in præsenti considerare. Ecce michi unum caritatis officium impendistis. Impendistis inquam michi caritatis officium unum, et a me jam ipsum officium transiit; caritas vero ipsa quæ Deo est grata vobis remansit. Nonne melius judicatis bonum permanens, bono transeunti? Ad hæc, si ex ipso officio circa vos aliquid caritatis in me crevit.' et hoc ipsum vobis ad cumulum retributionis erit, qui fecistis unde michi tantum bonum provenit. Si non.' vobis tamen caritas vestra remansit, a me officium quod exhibuistis penitus transiit. Hæc igitur si recta considera-

[a] IN VOBIS ET IN ME αβE [b] LIBET αβ

[1] This is the first report of Anselm's talk in which Eadmer acts as a first-hand witness. The same thought as Anselm here develops is expressed in a letter to Bishop Gundulf of Rochester in the following year (*Ep.* 91 [ii, 3]): 'Quisquis enim diligit aliquem aut per dilectionem prodest alicui: scitote quia plus sibi prodest quam alii. Multo namque maius est quod tenet ipsam caritatem, quam sit id quod praestat alii per caritatem. Isti enim id solum quod caritas ad tempus potest tribuitur; illi vero et hic ipsa caritas tribuitur et in futuro quantum ipsa est retribuitur.'

that he who loves another possesses something greater than he who is the object of this love.[1] 'For he who has love,' he said among other things, 'has something for which God rewards him; but this is by no means true of the man who is merely the recipient of love. For what thanks does God owe me if you or someone else loves me? If then it is better to have something for which God rewards a man, than to have something for which he does not; and if he rewards a man for the love which he shows, and not for that which he receives; then it is proved that he who shows love to another, has something greater than the man to whom it is shown. Further: he who receives a service from another's love enjoys the gift of a single transitory benefit,—for instance, a single benefit, honour, meal or some service of this kind. But he whose love confers this benefit still keeps his love. And this we may apply in the present instance, most religious brethren, to yourselves and myself. Here then you have bestowed on me a service of love. You have, I say, bestowed on me a charitable service, and now on my side that service is over; on your side, however, the love remains with you and is pleasing to God. Do you not think that the good which remains is better than the good which passes away? Moreover, if from this service I grow in love towards you, this also will be added to the sum of your reward, that you have done something which has produced so much good in me. And if I do not grow in love, your love nevertheless remains with you, while the service you have paid me passes from me utterly. Therefore if we consider these things in their true light, we shall see how much more

tione attendimus.' profecto perspiciemus magis nobis esse gaudendum si alios diligimus, quam si diligimur ab aliis. Quod quia non omnes faciunt.' multi potius ab aliis amari, quam amare alios cupiunt.'[1] Hæc et hujusmodi multa locutus est.' et accepta fraternitate monachorum factus est inter eos unus ex eis, degens per dies aliquot inter eos, et cotidie aut in capitulo, aut in claustro mira quædam et illis adhuc temporibus insolita.' de vita et moribus monachorum coram eis rationabili facundia disserens. Privatim quoque aliis horis agebat cum iis qui profundioris ingenii erant, profundas eis de divinis necne secularibus libris quæstiones proponens, propositasque exponens. Quo tempore et ego ad sanctitatis ejus notitiam pervenire merui, ac pro modulo parvitatis meæ beata illius familiaritate utpote adolescens[2] qui tunc eram non parum potiri.

xxx. *Quid inter illum et Lanfrancum archiepiscopum de beato martire Ælfego dictum actumve sit*

Inter reverendum autem pontificem Lanfrancum et hunc abbatem Anselmum quid in illis diebus actum dictumve sit.' planum est intelligere iis qui vitam et mores noverunt utrorumque. Qui vero non noverunt.' ex eo intelligant, quod in quantum nostra et multorum fert opinio.' non erat eo tempore ullus qui aut Lanfranco in auctoritate vel multiplici rerum scientia, aut Anselmo præstaret in sanctitate vel Dei sapientia. Erat præterea Lanfrancus adhuc quasi rudis Anglus[3]; necdumque sederant animo

[1] This passage from *qui caritatem habet* (*For he who has love*) is reproduced with a considerable alteration and abbreviation in *De Similitudinibus*, cap. 180.

[2] Eadmer was at this time about 19 years of age. See *St Anselm and his Biographer*, p. 231.

[3] *rudis Anglus*: cf. the phrase *novus Anglus* which Lanfranc uses about himself (*Ep.* 4 to Pope Alexander II: ed. Giles, I, p. 23) and below p. 52, *novus Angliae civis*.

we should rejoice if we love others, than if we are loved
by them. It is only because we do not all consider this,
that many desire to be loved by others rather than to
love them.'[1] Such were his words, and many more of a
like kind. Having been received into the fraternity of
the monks, he lived among them as one of themselves
for several days, talking to them daily in the chapter-
house or in the cloister about the life and habits of
monks, setting forth wonderful things which had not
been heard of before this time, with reason and elo-
quence. At other times also he talked privately with
the more intelligent among them, raising deep questions
concerning both sacred and secular books, and giving
his answers to their problems. It was at this time that
I too was found worthy to come to the notice of his
holiness and, considering my insignificance—for I was
only a youth[2]—, I enjoyed no small share of the blessing
of his friendship.

xxx. *The conversation between him and Archbishop Lanfranc*
about the holy martyr Elphege, and its result

The things which were said and done in those days
between the reverend prelate Lanfranc and Abbot
Anselm will require no explanation to those who knew
the lives and habits of both; but those who did not know
them may form some idea from the fact that—in my
opinion and that of many others—there was nobody at
that time who excelled Lanfranc in authority and
breadth of learning, or Anselm in holiness and the
knowledge of God. Moreover Lanfranc, as an English-
man, was still somewhat green,[3] and some of the customs

ejus quædam institutiones quas reppererat in Anglia.
Quapropter cum plures de illis magna fretus ratione,
tum quasdam mutavit sola auctoritatis suæ deliberatione.[1]
Itaque dum illarum mutationi*a* intenderet, et Anselmum
unanimem scilicet amicum et fratrem secum haberet:
quadam die familiarius cum eo loquens, dixit ei, 'Angli
isti inter quos degimus, instituerunt sibi quosdam quos
colerent sanctos. De quibus cum aliquando qui fuerint
secundum quod ipsimet referunt mente revolvo:' de
sanctitatis eorum merito animum a dubietate flectere
nequeo. Et ecce unus illorum est in sancta cui nunc
Deo auctore præsidemus sede quiescens Ælfegus nomine,
vir bonus quidem, et suo tempore gradui archiepiscopatus
præsidens ibidem.[2] Hunc non modo inter sanctos verum
et inter martires numerant, licet eum non pro confessione
nominis Christi, sed quia pecunia se redimere noluit
occisum non negent. Nam cum illum ut verbis utar
Anglorum emuli ejus et inimici Dei pagani cepissent, et
tamen pro reverentia illius ei potestatem se redimendi
concessissent:' immensam pro hoc ab eo pecuniam ex-
petiverunt. Quam quia nullo poterat pacto habere, nisi
homines suos eorum pecunia spoliaret, et nonnullos for-
sitan invisæ mendicitati subjugaret:' elegit vitam perdere,
quam eam tali modo custodire. Quid hinc igitur tua

a mutationi: inquisitioni E

[1] The most interesting account of Lanfranc's liturgical changes at Can-
terbury is in Gasquet and Bishop, *The Bosworth Psalter*, 1908, pp. 27-39 *et
passim*. The validity of the account here given does not seem to be essen-
tially affected by the probability that the *Bosworth Psalter* comes not from
Christ Church, Canterbury, as the authors believed, but from St Augustine's.
The picture of Lanfranc's liturgical activity requires to be completed by a
consideration of his *Monastic Constitutions* (ed. D. Knowles) and of F. Wor-
mald, *English Kalendars before A.D. 1100* (Henry Bradshaw Society, LXXII,
1934).
[2] The murder of Archbishop Elphege took place on 19 April 1012, and
his tomb in London became almost at once the scene of miracles (*A.S.C.*

which he found in England had not yet found acceptance
with him. So he changed many of them, often with
good reason, but sometimes simply by the imposition of
his own authority.[1] While, therefore, he was giving his
attention to these changes, he had Anselm with him, a
friend and brother with whom he was of one mind; and
talking with him informally one day, he said, 'These
Englishmen among whom we are living have set up for
themselves certain saints whom they revere. But some-
times when I turn over in my mind their own accounts
of who they were, I cannot help having doubts about
the quality of their sanctity. Now one of them lies here
in the holy church over which by God's will I now
preside. He was called Elphege, a good man certainly,
and in his day archbishop of this place.[2] This man they
not only number among the saints, but even among the
martyrs, although they do not deny that he was killed,
not for professing the name of Christ, but because he
refused to buy himself off with money. For—to use the
words of the English themselves—when his foes, the
pagan enemies of God, had captured him, out of respect
for his dignity they gave him the possibility of buying
himself off, and demanded in return an immense sum
of money from him. But since he could only have
obtained this by despoiling his own men and possibly
reducing some of them to a wretched state of beggary,
he preferred to lose his life rather than to keep it on such
conditions. Now, my brother, I should like to hear

ann. 1012). His body was translated to Canterbury in 1023 with great
pomp (see *A.S.C.*, especially MS D). The only pre-Conquest account of his
death outside the *Anglo-Saxon Chronicle* is to be found in the *Chronicle of
Thietmar of Merseberg*, viii, 42, which has many inaccuracies but independent
authority (ed. F. Kurze, *M.G.H. in usum scholarum*, p. 218).

fraternitas sentiat, audire desidero.' Et quidem ille sicuti novus Angliæ civis hæc summatim perstringens Anselmo proposuit. At tamen causam necis beati Ælfegi historialiter intuentes.' videmus non illam solam, sed aliam fuisse ista antiquiorem. Denique non ideo tantum quia se pecunia redimere noluit, sed etiam quia paganis persecutoribus suis civitatem Cantuariam et æcclesiam Christi in ea sitam concremantibus, civesque innocuos atroci morte necantibus Christiana libertate obsistere, eosque a sua infidelitate convertere nisus est.' ab eis captus, et crudeli est examinatione occisus. Sed Anselmus ut vir prudens viro prudenti, juxta interrogationem sibi propositam simpliciter ita respondit dicens,[1] 'Palam est quod is qui ne leve quidem contra Deum peccatum admittat mori non dubitat.' multo maxime mori non dubitaret, priusquam aliquo gravi peccato Deum exacerbaret. Et revera gravius peccatum videtur esse Christum negare, quam quemlibet terrenum dominum pro redemptione vitæ suæ homines suos per ablationem pecuniæ illorum ad modicum gravare. Sed hoc quod minus est.' Ælfegus noluit facere. Multo igitur minus Christum negaret, si vesana manus eum ad hoc mortem intentando constringeret. Unde datur intelligi mira vi pectus ejus justitiam possedisse, quando vitam suam maluit dare, quam spreta caritate proximos suos scandalizare. Quamobrem longe fuit ab eo illud Ve, quod Dominus minatur ei per quem scandalum venit.[2] Nec immerito ut reor

[1] Anselm's philosophical explanation of Elphege's claim to be a martyr, which Eadmer here reports, does not appear to have entirely satisfied the monks of Canterbury, for both Osbern and Eadmer added more conventional attributes of the martyr for which their sources seem to have provided no warrant: e.g. exposing himself to death by attempting to convert the heathen. For Osbern's account, see *Anglia Sacra*, II, pp. 134-7.

[2] Matt. xviii.7

what you think about this.' Thus, talking as a recent
citizen of England, he briefly outlined the case and sub-
mitted it to Anselm.

If, however, we look on the matter historically, we
see that this was not the only cause of Saint Elphege's
death, but that there was another and more fundamental
one. It was not only because he refused to buy himself
off with money, but also because like a Christian freeman
he stood out against his pagan persecutors, and tried to
convert them from their infidelity, when they were
burning the city of Canterbury and the church of Christ
which stands there, and when they were putting the
innocent citizens to a horrible death,—it was for this that
they seized him and put him to death with cruel torture.
But Anselm, replying simply to the question put to him,
as one prudent man to another, spoke as follows[1]: 'It is
clear that a man, who has no hesitation in dying rather
than sin against God even in a small matter, would very
much rather die than anger God by committing some
grave sin. And certainly it appears to be a graver sin
to deny Christ than for any lord on earth to injure his
men to some extent by taking away their money. But it
was the lesser of these evils which Elphege refused to
commit. Much less therefore would he have denied
Christ, if furious men had laid hands on him, threatening
him with death unless he did so. From this we can
understand the wonderful hold which justice had in his
breast, since he preferred to give his life rather than to
throw aside charity and become a cause of scandal to
his neighbours. How far from him then is that "woe"
which the Lord threatened "to him by whom scandal
comes".[2] And, in my view, it is not unfitting that one

inter martires computatur, qui pro tanta justitia mortem sponte sustinuisse veraciter prædicatur. Nam et beatus Johannes Baptista qui præcipuus martyr creditur et veneratur a tota Dei æcclesia, non quia Christum negare, sed quia veritatem tacere noluit occisus est. Et quid distat inter mori pro justitia, et mori pro veritate?[1] Amplius. Cum testante sacro eloquio ut vestra paternitas optime novit Christus veritas et justitia sit,' qui pro veritate et justitia moritur,' pro Christo moritur. Qui autem pro Christo moritur,' æcclesia teste martyr habetur. Beatus vero Ælfegus æque pro justitia, ut beatus Johannes passus est pro veritate. Cur ergo magis de unius quam de alterius vero sanctoque martyrio quisquam ambigat, cum par causa in mortis perpessione utrunque detineat? Hæc me quidem reverende pater in quantum perspicere possum rata esse ipsa ratio docet. At tamen vestræ prudentiæ est, et me si aliter sentit ab hoc corrigendo revocare, et quid potissimum in tanta re sentiendum sit, æcclesiæ Dei docendo monstrare.' Ad quod Lanfrancus, 'Fateor' inquit 'subtilem perspicaciam et perspicacem subtilitatem ingenii tui vehementer approbo et veneror, firmaque ratione tua edoctus,' beatum Ælfegum ut vere magnum et gloriosum martyrem Christi deinceps me colere ac[a] venerari ex corde gratia Dei juvante confido.' Quod ipse postmodum devote executus est,' quin et historiam vitæ ac passionis ejus dili-

[a] et β

[1] This might seem no more than a rhetorical question, were it not that it contains the germ of Anselm's philosophical treatise *De Veritate* written *c.* 1086, which defined the scope of *rectitudo* under its twin forms of *veritas* and *iustitia*. The following passage will show how Anselm's argument of 1079 was developed in the later treatise: 'Habes igitur definitionem iustitiae, si iustitia non est aliud quam rectitudo. Et quoniam de rectitudine mente sola perceptibili loquimur, invicem sese definiunt veritas et rectitudo et iustitia. Ut qui unam earum noverit et alias nescierit, per notam ad igno-

who is truthfully pronounced to have suffered death voluntarily for so great a love of justice should be numbered among the martyrs. For John the Baptist also, whom the whole church of God believes to be the chief of martyrs and venerates as such, was killed, not because he refused to deny Christ, but because he refused to dissemble the truth. Indeed, what difference is there between dying for justice and dying for truth?[1] Moreover, there is the witness of Holy Scripture, as you, Father, very well know, that Christ is both truth and justice; so he who dies for truth and justice dies for Christ. But he who dies for Christ is, as the Church holds, a martyr. Now Saint Elphege as truly suffered for justice as Saint John did for truth. So why should anyone have more doubt about the true and holy martyrdom of the one than of the other, since a similar cause led both of them to suffer death? These arguments, reverend father, so far as I can see, are what reason itself teaches me to be sound. But it is for your judgement to correct and restrain me if you feel differently, and to teach and declare to the church of God a better way of looking on this important matter.' To this Lanfranc replied, 'I acknowledge—I approve and deeply respect the subtlety and insight of your mind and now that I have been instructed by your solid argument, I trust that I shall, by God's grace, henceforth worship and venerate Saint Elphege with all my heart, as a truly great and glorious martyr of Christ.' And this he afterwards faithfully carried out, and even ordered a careful

tarum scientiam pertingere possit; immo qui noverit unam, alias nescire non possit' (*De Veritate*, cap. 12). This was precisely the argument by which Anselm had justified the veneration of Elphege as a saint and martyr.

genti studio fieri præcepit. Quam quidem historiam
non solum plano dictamine ad legendum, verum etiam
musico modulamine ad canendum a jocundæ memoriæ
Osberno Cantuariensis æcclesiæ monacho ad præceptum
illius nobiliter editam.' ipse sua prudentia pro amore
martiris celsius insignivit, insignitam auctorizavit, auc-
torizatam in æcclesia Dei legi cantarique instituit, nomen-
que martyris hac in parte non parum glorificavit.[1]

xxxi. *Quod per diversa loca vadens, omnes ad quos veniebat
qualiter in suo ordine vivere deberent instruxerit*

Post hæc Anselmus ad agenda propter quæ venerat terras
æcclesiæ Beccensis per Angliam adiit, utilitati mona-
chorum suorum per omnia studiose secundum Deum
inserviens. Vadens autem et ad diversa monasteria
monachorum, canonicorum, sanctimonialium, necnon
ad curias quorumque nobilium prout eum ratio ducebat
perveniens.' lætissime suscipiebatur, et suscepto quæque
caritatis obsequia gratissime ministrabantur. Quid ille?
Solito more cunctis se jocundum et affabilem exhibebat,
moresque singulorum in quantum sine peccato poterat
in se suscipiebat. Nam juxta apostolum iis qui sine lege
erant tanquam sine lege esset.' cum sine lege Dei non
esset.' sed in lege Christi*ᵃ* esset.' se coaptabat, ut lucri-
faceret eos qui non modo sine lege[2] ut putabatur beati

ᵃ ESSET CHRISTI αβEF

[1] Strictly speaking, only the hymn appears to have been written at
Lanfranc's order: the prose life followed later, as Osbern himself tells us—
'quemadmodum, praecipiente invictissimo totius latinitatis magistro Lan-
franco archiepiscopo, musica virum modulatione dudum extulimus, sic
cogentibus iis quas diximus rationum causis, oratoria eundem narratione
extollamus' (*Anglia Sacra*, II, p. 112). The hymn would no doubt be sung at
matins on St Elphege's day, and it was probably long enough for a brief
summary of the events of the saint's life. It is lost, but its general type may
be inferred from the long hymn for St Dunstan's day by Eadmer (Stubbs,
Memorials of St Dunstan, pp. 424-5). [2] cf. 1 Cor. ix.21

history of his life and passion to be written. This history was nobly written at his command by Osbern, a monk of Canterbury, of happy memory, who wrote it not only in plain prose for reading, but also put it to music for singing; and Lanfranc himself for love of the martyr gave it the seal of his eminent approval, authorised it, ordered it to be read and sung in the Church of God, and in this respect added no small glory to the martyr's name.[1]

xxxi. *How, going to diverse places, he instructed those whom he met how they ought to live, each in his own order*

After this Anselm went through England visiting the lands of the church of Bec, transacting the business for which he had come, and in all things consistent with godliness studying to be useful to his monks. He went moreover to various monastic houses of monks, canons and nuns; and also—as reasonable causes led him—to the courts of a certain number of noblemen: wherever he came he was received with joy and cared for with all the gracious offices of charity. And how did he bear himself? In his usual way he showed himself cheerful and approachable to everyone, conforming himself, so far as he could without sin, to their various habits. For, as the apostle says, 'to those which were without law' he made himself 'as without law (being however not without the law of God, but under the law of Christ) that he might gain them that were without law'[2]—and not only those who were without the law so to say of Saint Benedict, but those also who were given to worldly

K

Benedicti, sed et eos qui seculari vitæ dediti in multis vivebant sine lege Christi. Unde corda omnium miro modo in amorem ejus vertebantur, et ad eum audiendum famelica aviditate rapiebantur. Dicta enim^a sua sic unicuique ordini hominum conformabat, ut auditores sui nichil moribus suis concordius dici posse faterentur. Ille monachis, ille clericis, ille laicis, ad cujusque propositum sua verba dispensabat. Monachos ut ne quidem minima sui ordinis contemnerent admonebat, contestans quia per contemptum minimorum, ruerent in destructionem et despectum omnium bonorum. Quod dictum sub exemplo vivarii proponebat, dicens clausuram illius districtioni ordinis monastici assimilari. 'Quoniam quidem' inquit 'sicut pisces decurrente aqua vivarii moriuntur, si clausuræ ipsius minutatim ac sepe crepant nec reficiuntur,' ita omnis religio monastici ordinis funditus perit, si custodia ejus per modicarum contemptum culparum paulatim a fervore sui tepescit, attestante scriptura quæ dicit,[1] "Qui modica despicit, paulatim decidit".'[2] Clericos quoque qualiter se in sorte Dei custodire deberent instruebat, eisque magnopere esse cavendum, ne si a sorte Dei caderent,' in sortem diaboli per neglectum conversationis et ordinis sui deciderent. Conjugatos etiam qua fide, qua dilectione, qua familiaritate tam

^a ETIAM αβ

[1] Ecclus. xix. 1

[2] This passage from *Quoniam quidem* (*For just as the water*) is reproduced verbatim in *De Similitudinibus*, cap. 123, but in a different context. It appears that the compiler of *De Similitudinibus* had a fuller account of Anselm's words, very probably Eadmer's own report, of which he had given only a brief extract in the *Life*. In *De Similitudinibus* the simile is introduced by the following passage: 'Humana namque natura tam facile per vitia, quam per planum diffunditur aqua. Sic ergo agere debet qui eam restringere appetit, velut qui aquam currentem retinere contendit. Sicut enim ille aquam concludit in stagnum atque coercet, sic iste naturam humanam vagam infra regulam aliquam cohibere debet. Utque ille procurat ne qua parte dirum-

things and lived in many respects without even the law of Christ. Hence the hearts of all, being wonderfully moved to love him, were seized with a ravenous hunger to hear his words. For he adapted his words to every class of men, so that his hearers declared that nothing could have been spoken more appropriate to their station. He spoke to monks, to clerks, and to laymen, ordering his words to the way of life of each. To the monks he gave warning that they should not despise even the minutiae of their order, testifying that through contempt of small things they would fall to destroying and despising every good thing. He elaborated this saying with the simile of a fishpond, comparing its banks to the discipline of the monastic order. 'For,' he said, 'just as the water runs away and the fishes die if the banks slowly but surely break up and are not repaired, so the whole religion of the monastic order entirely perishes if the fervour of its observance grows cold through the neglect of small faults,—as Scripture bears witness, saying[1] "He that despiseth small things shall fall by little and little".'[2] To the clerks he gave instruction how they should keep themselves among the elect of God, taking good heed lest they should fall from the number of God's elect into the inheritance of the devil through negligence in their private life and in the duties of their order. To married persons he taught how great was the fidelity, love, and companionship with

patur stagnum, qua affluat aqua; ita et istum providere condecet, ne suam in quoquam violet regulam, quo ad peccatum proruat. Sic enim restringi carnis appetitus possunt: quod est quandam facere pacem inter ipsam carnem et spiritum; quam quidem pacem nemo melius secum habere poterit, quam qui districtioni ordinis monastici semetipsum subjugare studuerit. Ipsa etenim est quasi quaedam clausura vel stagnum vivarii.'

secundum Deum quam secundum seculum sibi invicem[a]
copulari deberent edocebat; virum quidem ut suam
uxorem sicut seipsum diligeret,[1] nec præter illam aliam
nosset, ejusque sicut sui corporis absque omni sinistra
suspicione curam haberet; mulierem vero quatinus viro
suo cum omni subjectione et amore obtemperaret, eum-
que ad bene agendum sedula incitaret, necne animum
ejus si forte contra æquum in quenquam[b] tumeret.' qua
affabilitate mitigaret. Hæc autem quæ eum vel ad-
monuisse, vel instruxisse, vel edocuisse dicimus.' non eo
ut aliis mos est docendi modo exercebat, sed longe aliter,
singula quæque sub vulgaribus et notis exemplis pro-
ponens, solidæque rationis testimonio fulciens, ac remota
omni ambiguitate in mentibus auditorum deponens.
Lætabatur ergo quisquis illius colloquio uti poterat,
quoniam in eo quodcunque petebatur divinum consilium
in promptu erat. Hinc eum omnis sexus et ætas mira-
batur.' et mirando amplectebatur, quoque potentior aliis-
que præstantior.' eo magis quisque erat ad ministrandum
ei devotior atque proclivior. Non fuit comes in Anglia
seu comitissa, vel ulla persona potens, quæ non judicaret
se sua coram Deo merita perdidisse, si contigeret se An-
selmo abbati Beccensi gratiam cujusvis officii tunc tem-
poris non exhibuisse. Rex ipse Willelmus qui armis
Angliam ceperat, et ea tempestate regnabat.' quamvis
ob magnitudinem sui cunctis fere videretur rigidus ac
formidabilis.' Anselmo tamen ita erat inclinus et affabilis,
ut ipso præsente omnino quam esse solebat stupentibus
aliis fieret alius. Pro sua igitur excellenti fama Anselmus

[a] invicem *om.* β [b] quemque β

[1] cf. Eph. v.33

which they should be bound together both in matters pertaining to God and to the things of this world; that the man on his side should love his wife as himself,[1] knowing none other but her, having regard for the welfare of her body as of his own and entertaining no evil suspicions; that the woman likewise should submit to her husband with all loving obedience, that she should diligently encourage him in well-doing, and calm his spirit with her mildness if he were perchance unjustly stirred up against anyone. And when we say that he admonished, or instructed, or taught these things, he did it not as others are wont to teach, but far differently; he set forth each point with familiar examples in daily life, supporting them with the evidence of solid reason, and leaving them in the minds of his hearers, stripped of all ambiguity.

Everyone therefore who could enjoy his conversation was glad to do so, for on any subject they wished he had heavenly counsel ready for them. Hence men and women of every age admired and loved him, and the more powerful and distinguished they were the more anxious and ready they were to serve him. There was no earl or countess in England, or any other important person, who did not consider that he had lost a chance of gaining merit with God, if he happened not to have shown any kindness to Abbot Anselm of Bec at that time. Even King William who had seized England by force of arms and was reigning at that time—although he seemed stiff and terrifying to almost everyone because of his great power—nevertheless unbent and was amiable with Anselm, so that to everyone's surprise he seemed an altogether different man when Anselm was present. The good report of Anselm thus became known in every

totius Angliæ partibus notus, ac pro reverenda sanctitate carus cunctis effectus." iter repetendi Normanniam ingreditur, ditatus multiplici dono, quod honori ac utilitati æcclesiæ suæ usque hodie servire dinoscitur.[1] Familiaris ergo ei dehinc Anglia facta est." et prout diversitas causarum ferebat ab eo frequentata.

xxxii. *Quod Beccum reversus virum a lepra per lavaturam manuum suarum mundaverit, et quod fratrem de congregatione aqua a se sanctificata aspersum ab infirmitate sanaverit*

Ut autem omnipotens Deus demonstraret se gratiæ ipsius quam invenerat apud homines esse auctorem, et illum apud se quam apud homines gratiam invenisse potiorem." quosdam viros per visum dignatus est visitare, et qualiter per eum ab infirmitate qua nimis graviter vexabantur convalescerent edocere. Horum quæ dico duos qui inter suos non ignobilis famæ erant exempli causa proponam, qui sicut a veridicis ipsius monasterii cujus abbas diu extiterat monachis accepi, in eodem ipso monasterio illis præsentibus per eum curati sunt. Quidam igitur vir nobilis et strenuus, in confinio Pontivi ac Flandriæ præpotens habebatur.[2] Hic in corpore lepra percussus." eo majori merore afflictus est, quo se et a suis contra digni-

[1] Among the things which Anselm took back to Bec was a fragment of the body of St Neot, as appears from a letter written when he was archbishop of Canterbury, and which is known only from an exemplification in the Register of Bishop Oliver Sutton of Lincoln (1280-99): 'Sciatis pro certo quod ego ipse, cum abbas essem Becci, requisivi in Neotesberia, in scrinio quod vocant feretrum, et inveni ossa sancti et preciosi confessoris Neoti; et statim reposui ea in eodem scrinio, excepto uno brachio quod dicitur esse in Cornu galliae, et excepto modico quod mecum, propter memoriam et venerationem eiusdem sancti, retinui; et diligenter serato scrinio, intus clausis eisdem ossibus, retuli mecum clavem ad ecclesiam Becci ubi in hodiernum diem studiose servatur.' (*Ep.* 473; for the source, see R. M. T. Hill, *The Rolls and Register of Bishop Oliver Sutton, 1280-99*, Lincoln Record Society, 48, 1954, iii, p. lxxxiii.) In a list of relics of Bec drawn up in 1134, this relic is mentioned together with a statement, which is disproved by Anselm's letter: 'Maxilla sancti Neoti abbatis, cuius integrum corpus olim asserva-

part of England, and he was beloved by everyone as a man to be revered for his sanctity. Laden with many gifts, which are known to enhance the honour and serve the needs of his church till the present day, he set out to return to Normandy.[1] But from this time England was familiar to him, and was visited by him as business of various kinds required.

xxxii. *How, on his return to Bec, he healed a man of leprosy with the water with which he had washed his hands; and how he cured a sick brother of the community, who was sprinkled with water which had been blessed by him*

Now, in order that almighty God might show that He was the author of the favour which Anselm had found among men, and that he had found even greater favour with Him than he had with men, He deigned to appear to certain men in visions, and to teach them how they might be cured by Anselm of illnesses which grievously afflicted them. I shall give two examples of what I say, relating to men of no mean distinction among their own people. These men, as I have heard from trustworthy monks of the monastery of which Anselm was so long abbot, were cured by him in that very monastery and in their presence.

There was then a certain nobleman, an active and important man, in the country between Ponthieu and Flanders.[2] His body was afflicted with leprosy, and this caused him the more sorrow as he saw himself despised

batur in hoc Beccensi sacrario.' The following items in this list of 1134 must also have come from England: 'Pars casulae et vestis sancti Neoti; De sancto Edmundo rege; Unus dens de sancto Albano martyro; Pars cilicii sancti Edmundi' (Porée, 1, pp. 651-6).

[2] This incident is versified in MS Vat. Reg. 499 (*P.L.* 158, 121-2) but the verses add nothing to the details supplied here.

tatem natalium suorum pro obscenitate tanti mali despici deserique videbat. Conversus itaque ad Deum est, et crebris orationibus cum elemosinarum largitionibus opem ab eo precabatur. Una igitur noctium ei per visum quidam apparuit, monens ut*a* si pristinæ sanitati restitui vellet.᛫ Beccum iret, et apud abbatem Anselmum efficeret, quatinus aquam unde manus inter missam suam lavaret in potum illi conferret. Qui visioni credulus[1]᛫ quo monitus erat*b* impiger tendit, atque Anselmo cur advenerit secrete innotuit. Stupet ille ad verba, et hominem ut talibus desistat multis modis adjurat. At ipse in precibus perstat, et multo magis ut sibi misereatur exorat, nec patiatur ut ea medicina fraudetur, unde sibi celerem salutem affuturam pro divino promisso credebat. Quid plura? Vicit pietas pectus humilitatis, et pro homine Deum postulaturus, matutino tempore missam secretius celebrat. Admittitur eger, et quam petebat aquam de manu viri accepit. Quæ in potum ilico sumpta.᛫ et hominem morbidum integerrimæ sanitati restituit, et in laudem Dei multorum ora dissolvit. Clam itaque virum qui venerat a se Anselmus emisit, denuncians ei in nomine Domini ne unquam hoc factum sibi ascriberet, sed sola divina miseratione perfectum esse certissime sciret, et hoc ita esse tacita funditus mentione suæ personæ sciscitantibus responderet. Quo etiam tempore quidam frater de congregatione valida corporis infirmitate percussus, ad extrema deductus est. Huic in somno quidam astitit, et quod vitam atque salutem re-

a monens eum ut C *b* MONEBATUR αβ

[1] cf. Acts xxvi.19

and deserted even by his own men, despite the dignity of his birth, on account of the foulness of so great an affliction. So he turned to God, and sought His aid in frequent prayers accompanied by much giving of alms. Then one night a man appeared to him in a vision, and advised him, if he wished to regain his former health, to go to Bec and to persuade abbot Anselm to give him water to drink, with which he had washed his hands during Mass. He put his trust in the vision[1] and went as he had been advised, without delay. He told Anselm privately why he had come. Anselm was astonished at his words and emphatically admonished him to desist from such a plan. But he persisted in his entreaties, and begged him all the more to have mercy on him and not to suffer him to be deprived of the medicine whence he believed that God had promised him a speedy cure. And what was the result? Pity prevailed over humility, and in the morning Anselm celebrated a private Mass to offer prayer to God for the sick man, who was allowed to be present and received from Anselm's hands the water which he sought. He drank it on the spot, and it restored him from sickness to the most perfect health; and the mouths of many were opened to praise God. Anselm therefore sent him away secretly as he had come, enjoining him in the name of the Lord never to ascribe this deed to him, but to know most certainly that he was made whole by God's mercy alone: and this was the reply he should give to those who asked him, entirely omitting any mention of Anselm's name.

Moreover, about this time, one of the brethren of the community was smitten with a serious bodily infirmity and came near to death. While he was sleeping someone appeared to him and promised him that he would

cuperaret si aqua ab Anselmo sanctificata aspergeretur ipsi promisit. Eger ergo Anselmum se visitantem silita visione*a* de aqua precatus est, et voluntatis compos effectus.' e vestigio sanitati restitutus est. Hæc pro ostendenda gratia viri paucis interim dicta sint.

xxxiii. *Quod ratione actus a rigore sui propositi propter alios temperaverit*

At tamen de gratia quam meruerat apud homines non multum iis qui mores illius novere mirandum video, propterea quod quædam appetibilis suavitas ubicunque erat ex conversatione ejus emergebat, quæ in amicitiam ipsius ac familiaritatem cunctos agebat. Ipsius etenim studii semper erga omnes extiterat, ut ea potissimum ageret, quæ aliis magis commoda esse posse intelligebat. Unde cum interrogaretur quid emolumenti adquirerent qui servata æquitate aliorum voluntati in quibuscunque possent concordare satagerent, quidve detrimenti incurrerent qui suam potius quam cæterorum voluntatem implere studerent.' hoc modo respondebat. 'Qui aliorum voluntati concordare per omnia in bono nititur.' hoc apud justum judicem Deum meretur, ut quemadmodum ipse aliorum voluntati in hac vita, ita Deus et omnia secum suæ voluntati concordent in alia vita.[1] Qui vero aliorum voluntate contempta suam implere contendit.' id ejusdem judicis sententia damni subibit, ut quoniam ipse in vita præsenti voluntati nullius, nullus quoque in futura

a secundum visionem MN; silita vel tacita visione P; tacita visione VR; solita visione BSWY; solita visitatione TUXO; silita (*corr. to* solita) visione E; solita visione F

[1] cf. *Ep.* 112 [ii, 22] to Hugh the Anchorite (*c.* 1085): 'Concorda cum Deo et cum hominibus, si tantum a Deo ipsi non discordent, et iam incipis cum Deo et cum omnibus sanctis regnare. Nam secundum quod tu concordabis modo cum Deo et hominibus in illorum voluntate, concordabit

recover life and health if he was sprinkled with water which had been sanctified by Anselm. The sick man therefore—saying nothing about the vision—begged some water from Anselm when he was visiting him; and when he had gained what he wanted, he was immediately restored to health. Let these few words suffice for the present to make known God's favour towards Anselm.

xxxiii. *How he tempered the rigour of his own way of life for the sake of others when reason impelled him to do so*

To return however to the favour which he found among men, I do not think that those who knew his way of life will wonder at the charming sweetness which proceeded from his conversation wherever he was, and drew all men to him in friendship and affection. For it was always his aim with all men, to do that which he understood to be most agreeable to others. Hence when he was asked what reward they would receive who—so far as justice would allow—had tried in every way possible to fall in with the will of others, and what punishment they would incur who had striven rather to fulfil their own will than that of others, he replied as follows: 'Whoever tries to fall in with the will of others in all good purposes merits this reward from God, the just Judge: that as he has been in harmony with the will of others in this life, so in that other life God and everything about him will be in harmony with his will.[1] But he who has despised the will of others and striven to fulfil his own, will have this sentence of damnation from that same Judge,—that as in this life he has been in harmony

tunc Deus et omnes sancti tecum in tua voluntate.' See also *De Similitudinibus*, caps. 63-4.

velit aut debeat concors esse voluntati illius. Eadem quippe mensura qua quisque aliis mensus fuerit.' remetietur ei.'¹ Hujus igitur rationis ᵃ Anselmus consideratione subnixus.' nulli gravis, nulli volebat onerosus existere, etiam si a monachicæ institutionis austeritate hac de causa deberet aliquantulum temperare. Et quidem ut eum discretionis ordo docebat.' nonnunquam ab ipsa severitate aliis condescendendo temperabat. In quo quid ii sensuri sint ᵇ qui post nos ista fortassis lecturi vel audituri sunt.' præscire non possumus. Nos tamen qui vitæ illius modum scire meruimus.' magis in eo laudandum estimamus quod a rigore sui propositi aliquando pro ratione descendebat, quam si continue in ipso rigidus indiscrete persisteret.² Ratione siquidem agi virtutis est.' vitii vero contra.

xxxiiii. *Qualiter quidam Boso nomine monachus factus sit,
et a temptatione diabolica liberatus*

Inter hæc quidam clericus ætate juvenis Boso nomine³ Beccum venit, abbatis colloquium expetens. Erat enim idem ingenio acer, et quibusdam perplexis quæstionibus involverat animum, nec reperire quenquam poterat qui eas sibi ad votum evolveret. Loquens igitur cum An-

ᵃ rationis *om.* TUX ᵇ senserint MN

¹ cf. Luke vi.38
² It is very likely that among the critics of Anselm in his own day were some who thought he was insufficiently austere in his treatment of those under his care. In an early letter, written while he was still prior (*c.* 1074), he was required to answer a charge of laxity which had come to Lanfranc's ears: 'Quod autem praecipitis, ut contra quasdam non meas nec alicuius Christiani assertiones simpliciter quam me scitis tenere veritatis sententiam proferam, gratissime accipio et libentissime oboedio. Didici in schola Christiana—quod teneo, tenendo assero, asserendo amo—quia, si quis eorum qui habent substantiam mundi, dederit indigenti vel "calicem aquae frigidae" propter verum amorem dei et proximi, eleemosinam facit et "non perdet mercedem suam". De monachorum vero abstinentia hoc sentio quia, quanto maiore amore Dei aut proximi monachus ab appositis sibi alimentis

with no man's will, so in the life to come no-one else
either may or will wish to be in harmony with his. With
the same measure wherewith anyone shall have measured
to others, it shall be measured to him again.'[1] Fortified
therefore by the consideration of this argument, it was
Anselm's wish to be harsh or burdensome to no-one,
even if he had on this account somewhat to temper the
austerity of the monastic rule. And he did indeed some-
times temper that severity for the sake of others, being
led to do so by a wise discretion. Whatever others may
think about this who may read or hear of it in the future
cannot be foretold. But to us, who had the good fortune
to know his manner of life, it appears more worthy of
praise in him that he sometimes for a reasonable cause
descended from the rigour of his profession, than if he
had held to it stiffly and without discretion.[2] For to be
moved by reason is a sign of strength, but the contrary
is a sign of weakness.

xxxiv. *How a certain Boso became a monk and was set free
from a temptation of the devil*

At this period, a certain clerk—a young man called
Boso[3]—came to Bec seeking an interview with the abbot,
for he had a very acute mind, and he was perplexed by
many intricate problems which no-one whom he had
been able to meet had unravelled to his satisfaction.

abstinuerit, tanto maiorem et facit eleemosinam et acquirit mercedem'
(*Ep.* 49 [i, 41]).

 [3] Boso, fourth abbot of Bec 1124-36. He, with his two brothers Gilbert
and Rainald, took the monastic habit at Bec towards the end of Anselm's
abbacy (his name is 125th out of 163 monks professed while Anselm was
abbot, which suggests a date *c.* 1090). For his place in Anselm's circle of
friends, see *St Anselm and his Biographer*, p. 202. His Life was written by
Milo Crispin and is fully discussed in Porée, I, pp. 280-314.

selmo, ac nodos ei sui cordis depromens.' omnia quæ
desiderabat ab eo sine scrupulo disceptationis accepit.
Miratus igitur hominem est, et nimio illius amore de-
vinctus. Dehinc ergo cum ejus allocutione familiariter
potiretur.' illectus ad contemptum seculi.'· emenso brevi
spatio Becci monachus factus est. Cujus conversioni
simul et conversationi diabolus graviter invidens.' in
tantam illum temptationis procellam demersit, ut suc-
cedentibus sibi variis cogitationum tumultibus, vix mentis
suæ compos existeret. Transierunt in hoc dies quidam,
et seipsa semper immanior fiebat temptatio eadem. Tur-
batus ergo et mente confusus Anselmum adiit, animique
sui fluctus illi exposuit. At ipse cum singula intellexisset.'
hoc solum pio affectu, scilicet 'Consulat tibi Deus' ei
respondit, ilicoque fratrem a se dimisit. E vestigio autem
tanta tranquillitas mentis illum secuta est.' ut sicut ipse-
met michi referebat, ultra quam dictu credibile sit, subito
alius fieret ab eo qui fuit. Itaque omnis illa temptatio
penitus evanuit, nec quicquam hujusmodi in se ulterius
sensit.

xxxv. *Quod multa quæ de eo veraciter scribi possent præter-*
mittantur

Fiebant præterea ab Anselmo plurima in hunc modum,
quæ nos brevitati studentes ex industria præterimus.
Silentio quoque præterire placuit, innumeros homines
tam per lavaturam manuum ejus, quam per reliquias
ciborum ejus de ante illum clam eo subtractas a diversis
languoribus sed maxime febribus curatos, dispensante

He talked therefore to Anselm and laid bare the per-
plexities of his heart; and he received from him all the
answers he required without leaving a shadow of un-
certainty. As a result he was moved to admiration and
captivated by a profound love for Anselm; and as he
came to enjoy the intimacy of his conversation, he was
led on to despise the world, and in a short time became a
monk of Bec. But the devil was filled with hatred at
his conversion and at the manner of his life, and he
swamped him in such a storm of temptation that he
could scarcely remain sane in all the many and varied
tumults of his thoughts. Several days passed in this
state, and the temptation grew ever more severe. So,
disturbed and confounded in mind, he went to Anselm
and told him of his commotion of spirit. When he had
heard everything, he replied simply and with loving sym-
pathy, 'Let God provide for you, and then sent the
brother away. Immediately, as Boso himself has told
me, he was overtaken by such a tranquillity of mind that
(by a change scarcely to be believed) he suddenly became
a different man from what he had been. Thus that
whole temptation utterly disappeared, and he never
afterward experienced anything of the same kind.

xxxv. *How there are many things which could truly be written
about him which are here passed over*

Besides this Anselm did many other things of a similar
kind, which we purposely pass over in the interests of
brevity. We have also decided to pass over in silence
the countless cases of men cured of divers diseases, and
especially fevers, by water in which he had washed his
hands and by morsels of his food surreptitiously removed
from his plate: to each man according to his faith, God

Deo sua dona juxta meritum fidei uniuscujusque. Nam si cuncta quæ inde a veracissimis viris accepimus describere vellemus.' loquacitati potius quam rerum gestarum simplici narrationi nos operam dare ut reor judicari possemus. Quapropter ne nimis longum faciamus hujuscemodi immorando.' istis omissis tendamus ad alia. Verum ne inculta oratio prolixa sui continuatione legentes seu audientes fastidio gravet.' hic primum cœpto operi terminum ponamus, quatinus illis quæ magis delectant recreati.' aliud exordium sequentia nosse volentes expediti reperiant.

EXPLICIT LIBER PRIMUS

distributed His gifts. For if we were to relate all the things which we have been told by most trustworthy men, we might I think be judged to be more interested in our own verbosity than in the telling of a simple tale of things that happened. So we shall omit these things lest we delay too long in telling them, and turn to other matters. But here, lest our unpolished speech weary our readers or listeners by being too long drawn-out, we shall make our first halt in the work we have undertaken, so that those who wish to know what follows may first refresh themselves in some more pleasing way and then set forth again without impediment.

HERE ENDS THE FIRST BOOK

INCIPIT SECUNDUS^a

i. *Qualiter Anselmus in Angliam veniens a juniore Willelmo rege susceptus sit*

DEFUNCTO memorato rege Anglorum Willelmo.[,] Willelmus filius ejus regnum obtinuit. Hic sublato de hac vita venerabili patre Lanfranco.[,] æcclesias ac monasteria totius Angliæ gravi nimium oppressione afflixit.[1] Cujus oppressionis anno quarto.[,] Anselmus invitatus immo districta interpellatione adjuratus ab Hugone Cestrensi comite, multisque aliis Anglorum regni principibus, qui eum animarum suarum medicum et advocatum elegerant, et insuper æcclesiæ suæ prece atque præcepto pro communi utilitate coactus.[,] Angliam ingressus est.[2] Pridie igitur Nativitatis beatæ Dei genitricis et perpetuæ virginis Mariæ Cantuariam venit. Ubi cum quasi ex præsagio futurorum multi et monachi et laici conclamarent illum archiepiscopum fore.[,] summo mane a loco discessit, nec ullo pacto adquiescere petentibus ut ibi festum celebraret voluit. Venienti autem ei ad curiam regis.[,] optimates quique alacres occurrunt, magnoque ipsum cum honore

^a *The MSS have a great variety of forms of this rubric, but none of any significance in illustrating the growth of the text.*

[1] William I died on 9 September 1087; Lanfranc on 24 or 28 May 1089.

[2] For details of the pressure which was put on Anselm to come to England, both by the monks of Bec and by Earl Hugh see *H.N.* pp. 27-9. Anselm arrived at Canterbury on 7 September 1092 and left early in the morning of 8 September. I have discussed Anselm's movements and activities during the succeeding months in *M.A.R.S.* III, 1954, pp. 87-92. Shortly after leaving Canterbury, he met the king, who had recently returned from a Scottish expedition. He then went to Chester to see Earl Hugh, and while he was there the preliminary steps were taken for turning the church of secular canons at Chester into the monastic house of St Werburgh, to be colonised from Bec. By Christmas he seems to have been back at West-

BOOK II

i. *How Anselm came to England and was received by King William the younger*

WHEN THE renowned William king of the English died, his son William inherited his kingdom. Then the venerable father Lanfranc departed this life, and William oppressed the churches and monasteries throughout England most harshly.[1] In the fourth year of this oppression Anselm was invited, nay urgently entreated and required to come to England by Hugh earl of Chester and many other noblemen of the English kingdom, who had chosen him as their spiritual physician and protector; and being moreover constrained by the prayer and command laid upon him by his own church for their common good, he came to England.[2] Thus on the eve of the Nativity of the Blessed and ever Virgin Mother of God he arrived at Canterbury. Here many of the monks and laity, as if foretelling the future, acclaimed him as archbishop; wherefore he left the place early next morning and on no account would consent to celebrate the Feast there, as they besought him to do. Moreover when he came to the royal court all the nobility eagerly met him and received him with great honour.

minster staying with his old friend Gilbert Crispin and preparing for a lengthy stay. He planned to revise his letters, and to complete his *De Incarnatione Verbi*; and probably at this time the first discussions took place which finally led to the composition of the *Cur Deus Homo*. He had with him Baldwin, monk of Bec, who was probably already, and continued to the end of Anselm's life to be, his chief official and adviser (see *St Anselm and his Biographer*, pp. 194-6).

suscipiunt. Rex ipse solio exilit, et ad ostium domus viro gaudens occurrit. Ac in oscula ruens.' per dexteram eum ad sedem suam perducit. Consident, et læta interim quædam inter se verba permiscent. Deinde Anselmus secretius cum rege acturus.' cæteros secedere monet. Omissis igitur monasterii sui causis, pro quibus maxime illuc venisse putabatur.' regem de iis quæ fama de eo ferebat[a] arguere cœpit, nec quicquam eorum quæ illi dicenda esse sciebat, silentio pressit. Pene etenim totius regni homines omnes talia cotidie nunc clam nunc palam de eo dicebant, qualia regiam dignitatem nequaquam decebant.[1] Finito colloquio.' divisi ab invicem sunt, et de æcclesiæ suæ negotiis ea vice ab Anselmo nichil actum. Deinde Cestram ad comitem abiit, ac in partibus illis degere per plures dies ex necessitate compulsus est.

ii. *Quod idem rex infirmatus Anselmum eligat in archiepiscopum, et quod ipse ad consentiendum nec vi compulsus adquiescat*

Interea[2] rex Willelmus gravi languore corripitur, et pene ad extrema perducitur.[3] Suadetur ei inter alia a principibus, ut de matre totius regni æcclesia videlicet Cantuariensi cogitet, et eam a pristina viduitate et calamitate per institutionem pontificis relevet. Adquiescit ille consilio, et Anselmum in hoc opus dignissimum fore pronunciat. Acclamatur ab universis, et dictum regis laudat clerus et populus omnis, nec resonat ibi ulla contradictio

[a] FEREBAT: ANSELMUS *add.* αβ

[1] This passage refers, without doubt, to the homosexual vices of Rufus's court, which were a matter of common repute (see Ordericus Vitalis, iv, 90; William of Malmesbury, *G.R.* II, p. 370; *H.N.* pp. 48-9).

[2] Eadmer here omits the Christmas court of 1092 at which Anselm composed a prayer (now lost) to be used by churches throughout England asking God to move the king's mind to appoint an archbishop of Canterbury (*H.N.* pp. 29-30).

The king himself rose from his throne, and met him at the door of his hall with joy; he fell on his neck and led him by the hand to his seat. They sat down, and for a while exchanged cheerful conversation. Then Anselm asked the others to go apart so that he could talk privately with the king. He put aside the business of the monastery, which was supposed to be his chief reason for coming there, and began to rebuke the king for those things which were reported about him: nor did he pass over in silence anything which he knew ought to be said to him. For almost everyone in the whole kingdom daily talked about him, in private and in public, saying such things as by no means befitted the dignity of a king.[1] When they had finished talking they parted, and Anselm said nothing on that occasion about the business of his church. Then he went off to the earl at Chester and was obliged to remain a considerable time in those parts.

ii. *How the king fell ill and chose Anselm as archbishop; and how Anselm refused to consent despite the use of force*

Meanwhile[2] King William was stricken with a serious illness and came to the point of death.[3] His barons persuaded him, among other things, to take thought for the mother of his whole kingdom, namely the church of Canterbury, and to relieve her long widowhood and misfortune by the appointment of an archbishop. He acquiesced in this advice, and declared that Anselm was the man most fitted for this work. There was universal acclamation, and both clergy and people commended

[3] William became ill at Gloucester at the beginning of March 1093, which was also the beginning of Lent. Anselm was in the neighbourhood, probably waiting to see the king on the business of his monastery.

cujuslibet hominis. Audit hæc ille, et fere usque ad exanimationem sui contradicit, reluctatur et obstat. Prævalet tamen æcclesiæ Dei conventus. Rapitur ergo, et violenter in vicinam æcclesiam cum ymnis et laudibus portatur magis quam ducitur. Acta sunt hæc anno Dominicæ Incarnationis millesimo nonagesimo tertio, pridie Nonas Martii, prima Dominica quadragesimæ.[1]

iii. *Qualiter ad signum sanctæ crucis ignis Wintoniæ extinctus sit*

In subsequenti autem festo Paschæ[2] Wintoniam Anselmus advenit, et in suburbio civitatis hospitatus est. Una igitur nocte in tecta suburbii per incuriam ignis dilabitur. Quo crescente, edificia quæque passim consumebantur. Et jam ignis idem hospitium Anselmi consumpturus, duabus tantum domibus interpositis aderat. Quibusdam igitur ea quæ in domo erant asportantibus, interdixit domina domus, affirmans se nullo modo sibi vel suis aliquid damni timere, quæ tantum hospitem hoc est Anselmum archiepiscopum meruisset secum habere. Pro quibus verbis Balduinus vir strenuus et monachus mulieri compassus, suasit Anselmo ut hospiti suæ subveniret. At ille, 'Ego in qua re?' 'Egredere' inquit 'et signum crucis igni oppone; arcebit illum forte Deus.' Respondit, 'Pro

[1] 6 March 1093: *H.N.* pp. 32-7 has a full account of the incidents of this day. Of these incidents the most important for the future was the manner of Anselm's investiture. Anselm at this time had no objection in principle to lay investiture, but he had a great objection to becoming archbishop. He therefore refused the king's offer of the episcopal staff, which was held against his closed hand by the bishops who were present: 'Clausae manui eius baculus appositus est, et episcoporum manibus cum eadem manu compressus atque retentus' (*H.N.* p. 35). Eadmer's account is confirmed by Osbern of Canterbury writing to Anselm almost immediately after the event: 'Quid . . . ad innocentiam praestantius quam te ante lectum aegrotantis violenter pertractum, dextram aliorum dextris impudenter de sinu extractam, sinistram ne sororem iuvaret fortiter retentam, virgam, caeteris digitulis pertinaciter occlusis, pollici atque indici crudeliter impactam, post

the king's judgement without a single voice being raised in contradiction. When Anselm heard this, he wore himself almost to death in his objections, and in resisting and fighting against it. But the united body of the Church of God prevailed. So he was seized, and forcibly carried rather than led into the neighbouring church with hymns and rejoicings. This took place in the year of our Lord's Incarnation 1093, on 6 March, being the first Sunday in Lent.[1]

iii. *How a fire was put out at Winchester by the sign of the holy Cross*

On the Feast of Easter following,[2] Anselm went to Winchester and lodged in a suburb of the city. One night a fire was carelessly let loose among the houses of the suburb, and as it spread it devoured the buildings in all directions. Soon it was on the point of consuming Anselm's lodging, being no more than two houses away. The men therefore were carrying out the things which were in the house; but the lady of the house forbade them, declaring that she feared no manner of damage to herself or her belongings while she was fortunate enough to have so great a guest as Archbishop Anselm with her. At these words, Baldwin—a capable man and a monk—had compassion on her and urged Anselm to help his hostess. 'But what can I do?' he said. 'Go out,' replied Baldwin, 'and make the sign of the Cross in the face of the fire: perhaps God will ward it off.'

haec toto corpore e terra te elevatum, episcopalibus brachiis ad ecclesiam deportatum, ibique, adhuc te reclamante et importunis nimis obsistente, "Te deum laudamus" esse cantatum?' (*Ep.* 149 [iii, 2]).

[2] Easter was on 17 April in 1093.

me? Nichil est quod dicis.'¹ Egressus tamen domum
est timore incendii ductus, et visis flammantibus globis,
a venerabili Gundulfo episcopo² et ab eodem Balduino
contra ignem signum crucis erecta in altum dextera edere
coactus est. Mirabile dictu. Non prius manum exten-
derat, quam in se incendium retorqueri, flammas deficere
cerneres, et ita ut domum etiam quam vorare cœperant
semiustam relinquerent.

iiii. *Quomodo Cantuariæ sit archiepiscopus consecratus*

Igitur Anselmus propter multas rationes quæ intervene-
rant nondum consenserat electioni quæ de se facta fuerat
ut pontifex fieret:' sed tamen detinente illum rege mora-
batur in Anglia, conversante cum eo ex jussu regis præ-
fato Gundulfo Rofensi episcopo, et ei quæque opus erant
ministrante. Ablatis autem de medio rationibus illis:'
tandem post longum temporis spatium obœdientia simul
ac necessitate constrictus consensit, et pridie Nonas
Decembris debito cum honore ab omnibus episcopis
Angliæ, Cantuariæ consecratus est.³ In qua consecra-
tione, evangelica illa sententia super eum reperta est,
'Vocavit multos. Et misit servum suum hora cænæ

¹ *Nichil est* is a favourite phrase of Anselm's as reported by Eadmer:
see below p. 82, *H.N.* pp. 33, 35, 71. It may be compared with his treat-
ment of the theme 'iniustia sive malum nichil est' in the *De Casu Diaboli*.

² Gundulf, bishop of Rochester 1077-1108, was one of Anselm's oldest
friends from Bec and the recipient of some of his earliest and warmest letters.
He was at this time acting as Anselm's counsellor and guide in providing
for his maintenance on the archbishop's estates (see *H.N.* p. 37).

³ The stages by which Anselm gave his consent to the election are fully
set out in *H.N.* pp. 37-43 and in his correspondence, *Ep.* 148-66 [iii, 1-17].
The main stages are: by August he had obtained the consent of the duke of
Normandy (*Ep.* 153), the archbishop of Rouen (*Ep.* 154), and—though only
in part—of the monks of Bec (*Ep.* 155 [iii, 6]). He then sent his abbot's
staff back to Bec, where it arrived with his announcement of his final de-
cision on 15 August (*Vita Abbatis Willelmi, P.L.* 150, 716). In September

'On my account?' he answered, 'these are idle words.'[1]
Nevertheless he was moved to leave the house from fear
of the fire; and when he saw the mass of flames, the
venerable Bishop Gundulf[2] and Baldwin constrained
him to raise his right hand and to put forth the sign of
the Cross against the fire. Wonderful to relate, no
sooner had he stretched out his hand, than you might
have seen the fire draw back into itself and the flames
die down, so that they left half-burnt even the house
which they had begun to consume.

iv. *How he was consecrated archbishop at Canterbury*

Now Anselm, because of many obstacles which stood in
the way, had not yet consented to the election which
had put him forward into the archbishopric. But he
stayed in England at the instance of the king, who
ordered the aforesaid Gundulf bishop of Rochester to
stay with him and see that he had everything he needed.
At last the reasons which held him back were dissipated,
and after a long delay both obedience and necessity
compelled him to give his consent, and he was consecrated
with due honour at Canterbury by all the bishops of
England on 4 December.[3] At his consecration, this was
the sentence in the Gospels which fell to his lot: ' . . . he
bade many: And sent his servant at supper time to say

he did homage to the king at Winchester and received the temporalities of
the see (*Regesta*, nos. 336-7; *H.N.* p. 41); he then went to Canterbury where
he was enthroned on 25 September (*H.N.* p. 41). He was consecrated at
Canterbury by the archbishop of York on Sunday, 4 December. (For the
incidents of this day, see *H.N.* pp. 42-3; *Historians of the Church of York*, II,
pp. 104-05. The two accounts are distinctly at variance, the York account
being probably the more reliable: see *St Anselm and his Biographer*, p. 303.)

dicere invitatis ut venirent, quia jam parata sunt omnia.
Et cœperunt simul omnes excusare.'[1]

v. *Quod et quamobrem contra eum animus regis conturbatus sit*

Dehinc cum se regali curiæ in Navitate Domini Jesu præ-
sentasset, et honorifice a rege susceptus.'; primos tres dies
festivitatis circa regem lætus transegisset.' post instinctu
diaboli hominumque malorum.'; mutatus est animus regis
contra eum, eo quod ipse spoliatis hominibus suis mille
libras denariorum ei pro agendis munificentiæ suæ gratiis
dare noluit; et ita principe turbato a curia discessit.[2]

vi. *Qualiter in dedicatione æcclesiæ de Herges chrismatorium*
 ejus furto sublatum fuerit et restitutum

Veniens autem in villam suam quæ Herga vocatur.'
dedicavit ibi æcclesiam ad parochiam pertinentem, quam
quidem antecessor ejus Lanfrancus construxerat, sed
obitu præventus dedicare nequiverat.[3] Ad quam dedica-
tionem quidam clericus inter alios de Lundonia veniens,

[1] Luke xiv.16-18
[2] The king held his Christmas court in 1093 at Gloucester (*A.S.C.*;
Regesta no. 338). Eadmer's words here imply that the king demanded a
simoniacal gift in return for his munificence in giving Anselm the arch-
bishopric. But the case was much more complicated than this as the fuller
account in *H.N.* pp. 43-5 shows: the money demanded was an aid for the
king's expedition to Normandy, and Anselm offered £500. The king at first
accepted this; but he was persuaded by his advisers to demand at least
twice this amount. It was into their mouths that Eadmer (*H.N.* p. 43) puts
the words which he here in part repeats: 'Tu eum prae caeteris Angliae
principibus honorasti, ditasti, exaltasti; et nunc cum ille, tua necessitate
considerata, duo millia vel certe, ut levissime dicatur, mille libras *pro agendis
munificentiae tuae gratiis* tibi dare deberet, quingentas, proh pudor, offert?'
Anselm was certainly afraid of the suspicion of simony, which might easily
be implied in a gift made so soon after he became archbishop, and he was
glad to escape suspicion by distributing his rejected £500 to the poor. But
the extremely brief account of the incident given here is misleading in
representing as a purely religious issue a feudal claim over which Anselm's
conduct was not above criticism. See, besides *H.N.*, *St Anselm and his Bio-
grapher*, pp. 155-8.

to them that were bidden, Come; for all things are now ready. And they all with one consent began to make excuse.'[1]

v. *How and why the king's mind was turned against him*

Afterwards he presented himself at the royal court at Christmas time, and was honourably received by the king. He passed the first three days of the Feast pleasantly with the king. But then the king's mind was turned against him, at the instigation of the devil and of evil men, because he refused to despoil his tenants in order to give the king £1,000 as a thank-offering for his munificence. So, having angered his lord, he left the court.[2]

vi. *How his chrismatory was stolen at the dedication of the church at Harrow, and how it was restored*

He went to his village at Harrow and dedicated the church belonging to his diocese. His predecessor Lanfranc had built it but he had died before he was able to dedicate it.[3] Among those who came from London for the dedication there was a certain clerk who, having thrust

[3] Harrow was a manor of the archbishop of Canterbury in the diocese of London. The exercise of episcopal rights over the churches on the estates of bishops, wherever they might be, was a characteristic feature of the regime of proprietary churches (the so-called *Eigenkirchentum*) which had grown up in western Europe since the barbarian invasions. The maintenance of the archbishop's extradiocesan rights, though canonically of doubtful validity, was as strongly insisted on by Anselm as by Lanfranc or Ralph. Of the latter Eadmer makes it a point of special pride that 'ipse ecclesias in omnibus terris totius pontificatus Cantuariensis intus et extra Cantiam, ubi petebatur, inconsultis episcopis dedicabat' (*H.N.* p. 221). For the whole subject see H. Boehmer, 'Das Eigenkirchentum in England' in *Festgabe für Felix Liebermann*, 1921, pp. 301-53; I. J. Churchill, *Canterbury Administration*, I, 1933, pp. 62-81; Lanfranc, *Ep.* 30; Anselm, *Ep.* 170-1 [iii, 19; iii, 164]; *H.N.* pp. 21, 45-7, 221.

seque inter clericos viri quasi ad comministrandum mit-
tens.' crismatorium pontificis clam surripuit, et in turbam
mersus fugam arripuit.¹ Dum igitur iter quod Lun-
doniam ducit ingressus cum furto fuisset.' reflexit gressum,
autumans se ad locum quem fugiebat festinare. Sed
cum rediens adunatæ plebis multitudinem repperisset.'
animadvertit se cupitum iter permutasse, et qua venerat
viam repetit. Aliquantum processerat, et iterum visum
sibi est eo tendere quo fugiebat. Factum est hoc frequen-
tius, et nunc hac nunc illac nesciens quo iret erroneus
ferebatur. Populus autem qui eum sic se habentem in-
tuebatur.' quidnam haberet mirabatur. At ubi ministri
pontificis vas crismatis perditum esse cognoverunt.' con-
fusi et tumultuantes discurrunt, quod perditum erat hinc
inde quærunt, ignorantes a quo vel ubi id certo quærere
debeant. Rumor damni fertur in populum, et opinio
multorum cadit in erroneum clericum. Capitur, et sub
cappa illius vas abreptum invenitur. Refertur antistiti
quod actum erat. At ipse modesto vultu, mente tran-
quilla statim jussit culpam ignosci, et clericum ad sua
liberum dimitti. Tunc ille iter quod furto gravatus
nullatenus tenere sciebat.' liber ilico et nichil hæsitans
ingressus agebat.

vii. *Qualiter pro correctione Christianitatis regem interpellaverit*

Post hæc paucis diebus interpositis mandatur ad curiam
ire Anselmus, regem mare transiturum sua benedictione

¹ The difference between the two accounts of Anselm's visit to Harrow,
here and in *H.N.* pp. 45-7, provides a good example of the division between
public and private events in the two works. Eadmer here concentrates on a
semi-miraculous incident and omits to mention that the canons of St Paul's
came to prohibit the invasion (as they believed) of the episcopal rights of
their bishop. The two sides of the story, however, were more closely con-
nected than he suggests, for the theft of the chrism was no doubt an attempt
to prevent the consecration going forward.

himself in among the archbishop's clerks as if to help them, secretly seized the episcopal chrismatory and made off into the crowd.[1] However, while he was going along the road to London with his stolen property, he turned back, thinking that he had been going in the wrong direction. But when he came back and found the crowd of people who had come together, he realised that he had turned from the right road, and he retraced his steps along the way he had come. He went some distance, and again it seemed to him that he was going back to the place from which he was running away. This happened several times, and he wandered and strayed here and there, not knowing where he was going, so that the people who saw him behaving like this wondered what was the matter with him. Meanwhile, the archbishop's servants had found that the chrismatory was missing, and were rushing about in confusion looking everywhere for the lost vessel, having no idea whom to ask or where to look for it. A rumour of the loss spread among the crowd and the suspicion of many fell on the wandering clerk. He was seized and the stolen vessel was found under his cloak. The whole affair was reported to the archbishop, but he with a mild look and a tranquil spirit at once ordered the fault to be forgiven and the clerk to be set free to go to his own home. As soon as he was free, he went off without hesitation along the road which he had been quite unable to keep to when burdened with his theft.

vii. *How he pressed the king for the correction of abuses in the church*

A few days later, Anselm was sent for to go to the court and speed the king, who was about to cross the sea, with

prosecuturus. Qui transitus dum vento obstante differ-
tur.·' Anselmus opportunum tempus se nactum existimans,
regem pro æcclesiarum quæ de die in diem destruebantur
relevatione, pro Christianæ legis quæ in multis violabatur
renovatione, pro diversorum morum qui in omni ordine
hominum cotidie nimis corrumpebantur correctione
cœpit interpellare. Quæ omnia ipse magna cum in-
dignatione suscipiens, nec se causa illius quicquam de
omnibus acturum fore protestans.·' hominem discedere,
nec se transfretaturum diutius ibi expectare iratus præ-
cepit.[1]

viii. *Quo dolore affligebatur quia priorem suæ mentis tranquilli-*
tatem perdiderat

Considerans Anselmus post hæc quid quietis perdiderit,
quid laboris invenerit.·' anxiatus est spiritu, et vehementi
dolore attritus. Ducebat enim ante oculos mentis suæ
qualem in prioratu et abbatia positus vitam agere sole-
bat, quam scilicet jocunde in Dei et proximi caritate
quiescebat ac delectabatur, quam devote verba vitæ
loquens ab omnibus audiebatur, quam devotius ad suæ
ut sperabat cumulum retributionis quæ dicebat opere
exercebantur, et nunc e converso cum in melius per
episcopatum proficere debuerit.·' ecce die ac nocte in
secularibus laborans videbat se nec Deo nec proximo
secundum Deum juxta pristinum morem intendere posse,

[1] The king was at Hastings from 2 February till mid-Lent (*c.* 19 March)
1094 waiting to go to Normandy, and Anselm was with him during most of
this time. On 11 February, in the presence of the king, he consecrated the
church of Battle Abbey. (*Chron. monasterii de Bello*, p. 41, gives the day, but
gets the year wrong; the year is given correctly in *A.S.C.*) This was a time
of great importance for the future relations of king and archbishop. Anselm
gives an account of the issues in a letter to Hugh archbishop of Lyons written
apparently immediately after the king's departure; they were: 1. the pay-
ment of an aid of £1000 demanded by the king and refused by Anselm;
2. the recognition of Urban II so that Anselm could obtain his pallium;

his blessing. The crossing was delayed by a contrary wind, and Anselm—thinking that he had found a suitable opportunity—began to solicit the King for the relief of the churches which were daily going to ruin, for the revival of the Christian law which was being violated in many ways, and for the reform of morals which every day and in every class of people showed too many corruptions. The king listened to all this with the greatest displeasure, and declared that he would do nothing about any of these things to please him. Then in his anger he ordered him to go, and to wait no longer for the beginning of his voyage.[1]

viii. *His great grief at the loss of his former tranquillity of mind*

When Anselm began now to think of all the peace he had lost and all the labour he had found, his spirit was torn and tormented with bitter anguish. For he saw in his mind's eye the life which he had been accustomed to lead as prior and as abbot,—how joyfully he had reposed and delighted in the love of God and of his neighbour, how devoutly he had been heard by all to whom he ministered the words of life, how still more devoutly his hearers had hastened to put into practice what he taught, and thereby (as he hoped) added to the sum of his reward. And now how different it was! As a bishop he ought to have gone on to better things; but he saw his days and nights taken up with secular business; he saw himself unable to devote his attention either to God or to his neighbour in God's name as he had formerly

3. the holding of an ecclesiastical council; 4. the disposal of some knight's fees in the archbishop's honour which had fallen vacant during the vacancy in the archbishopric (*Ep.* 176 [iii, 24]; cf. *H.N.* pp. 48-52). On all these issues, see *St Anselm and his Biographer*, pp. 154-60.

nec adeo quenquam ex ore suo verbum vitæ quod facto
impleret ad suæ, ut reputabat, detrimentum mercedis
audire velle. Accesserant istis in augmentum mali sui
crudeles suorum hominum oppressiones cotidie auribus
ejus insonantes, et minæ malignantium deteriora in pos-
terum pollicentium circumquaque detonantes. Sciebatur
nempe regiam mentem contra eum in furorem conci-
tatam esse, et ob hoc quisque malus beatum se fore
credebat, si quod illum exasperaret ullo ingenio facere
posset. Multis itaque ac diversis injuriarum procellis
fatigabatur, et nulla terreni honoris vel commodi suavi-
tate unde consolationem haberet fovebatur. Verum salva
in omnibus et ad omnes innocentia conscientiæ suæ.ᐟ ᵃ
modicum respirabat ab his et magnopere consolabatur,
siquando se monachorum claustro inferre, et quæ insti-
tutio vitæ ipsorum expetebat coram eis effari valebat.
Quod ipse quadam vice capitulo eorum præsidens, et ex
more de hujusmodi liberius agens.ᐟ dicendi fine completo,
jocunda hilaritate alludens jocosa comparatione innotuit
dicens, 'Sicut bubo dum in caverna cum pullis suis est
lætatur, et suo sibi modo bene est; dum vero inter corvos
aut corniculas seu alias aves est, incursatur ac dilaniatur,
omninoque sibi male est.ᐟ ita et michi. Quando enim
vobiscum sum.ᐟ bene michi est, et grata ac singularis
vitæ meæ consolatio. Quando vero remotus a vobis inter
seculares conversor.ᐟ hinc inde variarum me causarum
incursus dilacerant, et quæ non amo secularia negotia
vexant. Male igitur michi est quando sic sum, ac tre-

ᵃ innocentia conscientiae suae: innocentiae suae puritate A

done; and he saw no-one willing to listen to the Word of Life from his lips or to carry it out; and thereby he lost (as he thought) his reward. To add to these evils of his own, the cruel oppression of his men daily afflicted his ears; and he was deafened by the threats of worse to follow, made by malicious men on all sides. For it was well-known that the king's mind was worked up into a fury against him, and as a result every wicked man thought himself happy if he could hit on any device to exasperate him further. Thus he was tossed by the storms of injuries of many kinds, without having the consolation of any flattering caresses of worldly honour or prosperity. Nevertheless, he preserved a pure conscience in all things and towards all men; and he even had some relief from these trials, finding his chief consolation in burying himself in the cloister with the monks and talking to them of things pertaining to their rule of life. He referred to this once when he was presiding in their chapter. He had as usual been discoursing freely about matters which concerned their rule, and when he came to the end of his discourse he made a joking comparison, saying with cheerful good-humour: 'Just as an owl is glad when she is in her hole with her chicks and (in her own fashion) all is well with her; and just as she is attacked and torn to pieces when she is among crows and rooks and other birds, and everything then is far from well with her; so it is with me. For when I am with you, all is well with me, and this is the joy and consolation of my life. But when I am separated from you, and my ways lie among men who are in the world, then I am torn this way and that by the onrush of disputes of many kinds and I am harassed by secular business which I hate. Then indeed I am in an ill state,

M

mens pertimesco, ne meum hujuscemodi esse procreet immane dispendium animæ meæ.'[1] Ad quod verbum licet alludens ut dixi cœperit.' amarissime flens subinferens ait, 'Sed quæso miseremini mei miseremini mei saltem vos amici mei, quia manus Domini tetigit me.'[2] Quia igitur[a] in tali conversatione magnopere respirabat.' ea sibi deficiente graviter suspirabat. Deum testor me sepe illum sub veritatis testimonio audisse protestantem, quod libentius vellet in congregatione monachorum loco pueri inter pueros sub virga magistri pavere, quam per pastoralem curam toti Britanniæ[b] prælatus in conventu populorum cathedræ pontificali præsidere. Forte dicet aliquis, 'Si tam bonum, tam jocundum erat illi habitare[3] cum monachis, cur non continue habitabat Cantuariæ cum suis?' Ad quod ego, 'Si hoc solum sibi possibile esset.' magno se consolatum reputaret. Sed et hoc partim remotio villarum suarum, partim usus et institutio antecessorum suorum, partim numerositas hominum sine quibus eum esse pro more terræ[c] pontificalis honor non sinebat.' illi adimebat, eumque per villas suas ire ac inibi degere compellebat. Præterea si Cantuariam assidue incoleret.' homines sui ex advectione victualium oppido gravarentur, et insuper a præpositis ut sepe contingebat multis ex causis oppressi si quem interpellarent nunquam præsentem haberent.' magis ac magis oppressi in destructionem funditus irent.

[a] ERGO αβEF [b] Angliae EF

[c] PRO MORE TERRAE om. αβ

[1] This passage from *Sicut bubo* (*Just as an owl*) is reproduced in *De Similitudinibus*, cap. 188, but in a form which suggests that the compiler had a draft different from that of the final form of the *Life*. The main differences are: 1. After the words 'omnino sibi male est', he inserts 'utpote quem hic rostro male percutit, ille alis in eum irruit, alter vero unguibus discindit'. 2. At the end of the passage there is a brief account of the quarrel with Rufus in 1095, Anselm's journey to Rome in 1097, and his return to England

and I tremble with horror at the great danger to my soul which may ensue.'[1] Although he had begun, as I said, in jest, he broke into most bitter tears as he spoke, adding 'But you at least my friends, do you, at least, take pity on me, for the hand of the Lord is upon me.'[2] Since his chief recreation was in such companionship, when he was deprived of it he was grievously afflicted. God knows I often heard him most vehemently protest that he would rather be one of the boys in the monastic community, trembling under the master's rod, than sit aloft in the pontifical throne among the congregation of the people having the pastoral care of the whole of Britain. Perhaps someone may ask; If he found it so good and joyful a thing to live with the monks,[3] why did he not always live at Canterbury with his retinue? To which I answer: If only this had been possible for him, he would have thought it a great consolation. But he was deprived of this consolation partly by the remoteness of his manors, partly by the traditional usage of his predecessors, and partly by the large retinue which his episcopal dignity and the custom of the country did not allow him to be without: all this obliged him to keep on the move and to live on his manors. Besides, if he had stayed at Canterbury all the time, his men would have had the burden of bringing food to the town, and, if he had never been present on his manors to hear their complaints, his reeves would have oppressed them in many ways (as often happened) until, as the oppression got worse and worse, they were utterly destroyed.

in 1100. This is largely in Eadmer's words as found in the *Life*, but Anselm is incorrectly represented as going to Rome 'absque assensu regis'.

[2] Job xix.21
[3] Ps. cxxxii.1 (Vulg.)

ix. *Qualiter omnibus eum requirentibus et spirituali et corporali subsidio subvenire studuerit*

Nullo tamen loco vel tempore sine suis monachis et clericis erat, iis duntaxat exceptis qui ad eum ex diversis locis confluentes raro deerant. Omnes etenim ad se venientes dulci alacritate suscipiebat, et cuique pro sui negotii qualitate efficaciter respondebat. Videres siquidem istos scripturarum sententiis ac quæstionibus involutos;' mox ratione proposita ab eo evolvi; istos in morum discretione nutantes non segnius informari; illos necessariarum rerum tenuitate laborantes;' datis quibus opus habebant ab inopia relevari. Nec ista largitas solummodo monachorum seu clericorum penuriam sublevabat, sed et in quosque laicos ea indigentes, ea sibi subveniri petentes;' pro posse et nonnunquam ultra posse pii patris redundabat.

x. *Quod cælestibus studiis deditus, epistolam quoque de Incarnatione Verbi domino papæ Urbano scripserit*

Quotiens autem opportunitas sese præbebat;' in remotiorem cameræ suæ locum secedere, solusque cælestibus studiis consueverat inhærere. Unde fidei Christianæ zelo commotus;' egregium et pro illius temporis statu pernecessarium opus *De Incarnatione Verbi* composuit.[1] Quod

[1] The *De Incarnatione Verbi* had been started as an answer to Roscelin's trinitarian heresy before Anselm left Bec. Anselm began revising and adding to it in the winter of 1092-3 during his enforced leisure in England awaiting an interview with the king on the business of the abbey (*Ep.* 147 [ii, 51]); and he completed it as archbishop in 1093-4. Various recensions of the work have been found which illustrate the stages in its development: see Schmitt, I, pp. 281-90; II, pp. 3-35; also Schmitt, 'Cinq recensions de l'epistola de Incarnatione Verbi de S. Anselme de Cantorbéry' in *Revue Bénédictine*, LI, 1939, pp. 275-87, and R. W. Southern, 'St Anselm and his English Pupils', *M.A.R.S.* I, 1941, pp. 29-34. We have no reply from the Pope to Anselm's letter of dedication but, in a letter written shortly after Anselm's departure from England in November 1097, Malchus bishop of

ix. *How he strove to give spiritual and bodily help to all who came to him*

Wherever he went, however, he was never without his monks and clerks—not counting those who flocked to him from various parts, of whom there were generally some. For he received all who came to him with a gracious readiness, and replied helpfully to them all, whatever their business. You might have seen those who were in difficulties over Biblical texts and problems having an explanation given to them and their problems resolved; others, who had been doubtful about some point of morals, being no less readily instructed; and others again who suffered from a lack of the necessities of life having their poverty relieved by gifts according to their needs. Nor was this generosity exercised in relieving the poverty of monks and clerks alone; it extended to the limit and sometimes even beyond the limit of the means of the tender father, to the relief of any needy layman who asked for his help.

x. *How he gave himself up to divine studies, and wrote a letter On the Incarnation of the Word to Pope Urban*

As often as an opportunity occurred, he was in the habit of withdrawing to an inner room in his chamber, and there in solitude he gave himself up to divine studies. It was thus that, being moved by his zeal for the Christian faith, he wrote an excellent—and in the circumstances of his time most necessary—work *On the Incarnation of the Word*.[1] This work was written in the form of a letter

Waterford asks for 'illum librum a vobis compositum de sancta trinitate et commendatum apostolica auctoritate, sicut nuper audivi' (*Ep.* 207). This must certainly refer to the *De Incarnatione Verbi*.

opus epistolari stilo conscriptum, venerabili sanctæ
Romanæ æcclesiæ summo pontifici Urbano dicavit, des-
tinavit. Quod ille gratiose suscipiens, ac invincibili
veritatis ratione subnixum intelligens.' in tanta auctori-
tate habuit, ut postmodum contra Grecos in concilio
Barensi cujus suo loco mentio fiet disputans.'' inde robur
suæ disputationis assumeret, et quam damnabilis fuerit
error eorum in hoc quod Spiritum Sanctum a Filio pro-
cedere negabant, astrueret.¹ Sed nos ista prætermittentes,
et cœptæ narrationi operam dantes.' dicamus quod ipse
Anselmus ad refectionem corporis sedens, modo de sacra
quæ coram eo legebatur lectione materia loquendi
sumpta convescentes ædificabat; modo ex sua parte sacra
verba edisserens, loco sacræ lectionis præsentium mentes
instruebat; modo de aliqua re utili vel necessaria requi-
situs, requirentem pariter et coaudientes mira suavitate
reficiebat.² Hujus rei cognoscendæ gratia quod levius
occurrit exempli causa unum subiciam, non quo ulla
doctrinæ illius efficacia per hoc designetur, sed ut in
quibus lingua ejus inter carnales epulas versari solita
fuerit paulisper intimetur.

¹ For Urban II's use of the *De Incarnatione Verbi* at the Council of Bari,
see *H.N.* p. 105.

² For Anselm's talk during meals, cf. *Ep.* 207, from Malchus bishop of
Waterford to Anselm: 'Rogavi idem vos, ut componeretis dictamine illum
sermonem incarnationis domini nostri Jesu Christi, quem vos narrastis nobis
in festivitate beati Martini ad prandium, quando dimisistis epulas carnales,
ut pasceretis nos spiritualibus escis.' For the date of this incident see below
p. 101. The background to such talk is the Rule of St Benedict, cap. 37,
which gave a somewhat grudging sanction to spiritual discourse at meals:
'Et summum fiat silentium, ut nullius musitatio vel vox, nisi solius legentis, ibi
audiatur... nisi forte prior pro aedificatione voluerit aliquid breviter dicere.'
Anselm evidently made a full and habitual use of this liberty. In the house-
hold of his successor Thomas Becket, who as a secular was of course not
bound by the Rule except in so far as Benedictine habits had become part
of the normal code of religious behaviour, the freedom to talk at meals
extended to the discussion of problems arising from the reading: cf. *Materials
for the History of Thomas Becket*, R.S. III, pp. 226-7, where the biographer

addressed to the venerable Pope Urban, supreme pontiff of the Holy Roman Church, and it was sent to him. He received it with thanks, and having understood the true and invincible reasoning on which it was founded, he held it in such esteem that he afterwards (as will be related in due course) used it as the basis of his argument in the dispute with Greeks at the Council of Bari, showing how damnable was their error in denying that the Holy Spirit proceeded from the Son.[1] But we shall pass this over here and, proceeding with our narrative, we shall describe how Anselm talked at meal-times. While he sat to refresh his body, he sometimes took as his subject-matter the holy lesson which was being read in his presence and spoke to the edification of those at table; sometimes, instead of the lesson, he himself gave a holy discourse for the instruction of those who were present; and sometimes, being asked about some subject of useful or necessary business, he satisfied both the enquirer and all who heard him with the wonderful graciousness of his replies.[2] In this connection an incident comes readily to my mind, and I insert it here as an example—not as an illustration of the power of his teaching, but simply to show in a small way how he was accustomed to employ his tongue at meal-times.

speaks of the archbishop and his household sitting apart from casual guests, 'ne impediretur cum eruditis suis collatio quam super his quae in lectione audiebat mox cum adverteret, et locus faceret quaestionem, frequenter faciebat in mensa'. The spirit of this later period to which Anselm is a bridge from the stricter formality of an earlier time is further expressed in John of Salisbury, *Policraticus*, viii, cap. 9, where the appeal to our Lord's example is instructive for the new currents of thought: 'Ciuile quoque est et sacris litteris consentaneum aut omnino silere in mensa ut audias ad profectum, aut unde proficiant alii aut sine culpa laetentur doctum proferre sermonem; siquidem et inter comedendum Dominus parabolas aut uerba uitae frequenter auditoribus miscet.'

xi. *Quibus modulis linguæ plectrum inter epulas commodaverit*

Venit ad eum quadam vice quidam ex seculari vita monachus factus, consilium de vita sua flagitans. Hic cum alias familiarius ei locutus fuisset;' inter prandendum opportunitate potitus, dixit quia cum se in vita seculari teneret;' intellexit non rectum fuisse iter suum pergendi ad vitam. 'Quamobrem' inquit 'relicto seculo veni ad ordinem monachorum, sperans me ibi posse penitus intendere vitæ perenni et Deo. Ecce autem ex præcepto abbatis mei secularibus negotiis intendo, et dum res æcclesiæ contra seculares defendere tuerique desidero;' placito, litigo, nec michi forsan magnæ curæ est si alii perdunt in meo lucro. Quapropter fere cogor desperare, dum ea quæ reliqui cum tot peccatis videor administrare.' Ad hæc Anselmus tali sub exemplo respondit,[1] 'Tota vita hominum comparari potest molendino super præcipitem fluvium constituto. Sit igitur in hoc molendino ad manum hominis molens mola, qua qui molunt, alii sic suam farinam neglegunt ut tota in fluvium labatur ac defluat; alii parte retenta partem in præceps ire sinant; alii totam colligant atque in sua custodia condant. Horum;' scilicet qui nichil sibi de farina servavit;' quid in vespere comedat non habebit. Qui parum retinuit;' pro portione sua parum inveniet. Qui totam collegit;' large se pascere poterit. Itaque molendino assimiletur ut dixi

[1] The simile may have been suggested by the passage in Cassian, *Collationes*, i, 18: 'exercitium cordis non incongrue molarum similitudini comparatur, quas meatus aquarum praeceps impetu rotante provoluit, quae nullatenus quidem cessare possunt ab opere suo aquarum impulsibus circumactae.' The development of Anselm's simile, however, is different from that in Cassian. The substance of this discourse down to p. 75 (... prout gessit) is found in *De Similitudinibus*, cap. 42; but is not taken from the *Life*, but from the account of Anselm's sayings compiled by the monk Alexander and known as the *Dicta Anselmi* where it forms a separate chapter 11, 'De

xi. *How he employed his tongue as an instrument of spiritual melody during meals*

A certain man who had been converted from a secular to a monastic life once came to him begging for advice about his way of life. After he had had a private talk apart with Anselm, he took the opportunity during the meal to say that, when he had been leading a secular life, he had recognised that he was not on the straight road to everlasting life. 'Wherefore,' he continued, 'I left this world, and entered the monastic order, hoping that therein I could give all my attention to eternal life and to God. But now my abbot orders me to look after secular affairs; and, in my desire to defend and protect the goods of the church against men in the world, I go to law and conduct law-suits, and perhaps I don't care very much if others lose so long as I gain. So I am almost driven to despair when I see myself so sinfully occupied with matters which I had renounced.' To this Anselm replied by way of a simile[1]: 'The whole life of man can be compared to a mill built over a swift-flowing river. In this mill, suppose that there is a millstone with which men grind for their own use. Now of those who grind, some so neglect their flour that it all falls into the river and is carried away; others hold onto part of it, but allow the rest to be swept away; others again collect it all, and put it into safe-keeping. Those then who have kept none of their flour will have nothing to eat when evening comes. Those who have kept a little will have a little as their portion. Those who have garnered it all will be able to feast plenteously. And so it is, as I said,

tripartita consideratione laboris hominum'. For this source see *St Anselm and his Biographer*, pp. 220-1.

vita hominum. Molæ.' actus illorum. Nam sicut mola
dum aliquid molit in circuitu ducitur, et circumducta
simili cursu sepe reducitur.' sic et actus humani quibus-
que temporibus in se revertuntur. Verbi gratia. Arant
homines, seminant, metunt, molunt, panificant, come-
dunt. En circuitum suum mola peregit. Ultrane quiescit?
Nequaquam. Repetitur enim idipsum. Aratur, semi-
natur, metitur, molitur, fit panis et comeditur. Hæc
fiunt omni anno, et more molæ recurrunt in idipsum.
Videas igitur hominem cuncta opera sua pro terreno
commodo facientem, nichil in eis nisi transitorium quid
desiderantem. Iste quidem molit quia operatur, sed
tota farina sua qui fructus est operis, a fluvio id est a
fluxu secularis desiderii rapitur ac præcipitatur. Hic
cum in fine vitæ suæ molendinum egressus, atque in
domum suam reversus.'' operum suorum fructus mandu-
care voluerit.' nichil inveniet, eo quod fluvius torrens
totum absorbuit. Jejunabit ergo væ misero in æternum.
Est alius qui suam non omnimodis farinam perdit,
quoniam nunc aliquam pro Deo elemosinam facit, nunc
ad æcclesiam pro Dei servitio vadit, nunc infirmum
visitat, nunc mortuum sepelit, et aliis in hunc modum
bonis intendit. Verum cum is ipse voluptatibus carnis
inservit, pro illata injuria per odium sevit, humanis
laudibus pascitur, crapula et ebrietate sopitur, horum-
que similibus enervatur.' ne farinæ pars maxima pereat,
nequaquam cautus invigilat. Quid de isto erit in futuro,
nisi quia recipiet prout gessit? Jam tertium genus in
ordine monachorum attende. Est igitur monachus sub
abbatis sui imperio positus, obœdientiam in omnibus

that the mill can be compared to the life of men. The grindstones are their actions. For as the grindstone goes round and round over the same course while it is grinding, so human actions repeat themselves as their time comes round. For example: men plough, they sow, they reap and grind, make bread and eat it. So the grindstone comes round full circle. And does it stop there? By no means. Round it goes again—ploughing, sowing, reaping, grinding, baking, eating. It happens every year; the mill grinds round to where it started. Now you may see one man doing all his work for worldly gain alone, desiring nothing from it but the things which perish. He certainly grinds, for he works hard, but all his flour, which is the fruit of his labour, is caught and carried off by the river, which represents the flux of worldly desires. When he comes to the end of his life he leaves his mill and goes home, hoping to eat the fruits of his toil; but he will find nothing, for the raging stream has engulfed it all. So the wretched man will sorrowfully fast to all eternity. Then there is another man who does not lose the whole of his flour, for he sometimes gives alms in God's name, and sometimes goes to church for the service of God; sometimes he visits the sick, and buries the dead, and performs other good works of this kind. But he also follows the lusts of the flesh, repays an injury with hatred, feeds on men's praise, sleeps in drunkenness and gluttony, and is so weakened by such things that he keeps no careful watch to see that the greater part of his flour is not lost. What will happen to a man like this in the future? He will reap according as he has sown. Now see the third class of men, leading a monastic life. Here is a monk placed under the rule of his abbot, having promised obedience in all matters which are laid upon

quæ sibi secundum Deum injunguntur professus, sua quantum in se est voluntate nunquam claustra monasterii pro quovis seculari negotio egredi volens. Huic forte præcipitur ut extra claustrum ad custodiendam aliquam æcclesiæ villam eat. Excusat se, et ne fiat obsecrat. Perstat abbas in sententia sua, et per obœdientiam jubet peragi imperata. Non audens ille recusare.' paret. Ecce venit ad molam, necessario illum molere oportet. Insurgunt hinc inde querelæ, placita, lites. Custodiat ergo sapiens monachus farinam suam, eamque in vas suum diligenter recipiat, ne in fluvium defluat. Quo inquis pacto? Nichil per inanem jactantiam agat, nichil quod Deus prohibet cujuslibet lucri gratia faciat. Obœdientiæ quæ sibi injuncta est ita studeat, ut et res æcclesiæ contra omnes viriliter justeque tueatur et protegat, et de alieno per injustitiam sub dominium æcclesiæ nil redigere satagat. Si in hujusmodi conversatur et vivit.' quamvis aliquando pro talibus missas perdat, nonnunquam loquatur cum fratres in claustro tacent, et quædam similia horum faciat vel dimittat quæ ipsi nec faciunt nec dimittunt.' obœdientiæ virtus quam exercet hæc cuncta consumit, et vas suum integrum servans.' farinam de sua mola fluentem quæ illum æternaliter pascat, totam ac puram colligit atque recondit. Non enim secundum carnem sed secundum obœdientiam incedit, ac per hoc ut apostolus ait "nichil damnationis illi erit".'[1] 'Et quid de illo sentiendum est' inquit, 'qui se ultro ad dispositionem villarum offert, atque ut id quod cupit ad effectum perveniat.' clam sibi adjutores advocat, munera pollicetur,

[1] Rom. viii.1

him according to God's will, altogether unwilling (so far as his own will is concerned) to leave the monastery for any secular business whatsoever. It happens, however, that he is ordered to leave the cloister and go to defend some manor belonging to the church. He asks, he begs to be excused. The abbot persists in his decision, and orders him on his obedience to do as he has been ordered. Not daring to refuse, he obeys. Now see; he comes to the grindstone; he must perforce set about grinding. On all sides he is beset with complaints, with pleas, with lawsuits. But, let him like a wise monk, hold on to his flour, and store it carefully in his bin lest it be carried off by the river. And how, you ask, will he do this? By doing nothing for vainglory; by doing nothing that God forbids because of any hope of gain; by so carrying out the task enjoined on his obedience that he both protects and preserves the goods of the church manfully and justly against all men, and yet tries to bring nothing belonging to another into his church's possession by injustice. If he so acts and lives, although he may lose some masses on this account, and sometimes talk when his brethren in the cloister are silent, and either do or leave undone such things as they either never do or never omit to do, yet all this is swallowed up in the worth of the obedience which he practices. He preserves his vessel intact, collecting and keeping the flour which comes from his grindstone pure and without loss so that it may feed him in eternity. For he walked not according to the flesh, but in a spirit of obedience, and in this, as the apostle says "there is no damnation".'[1] 'And what,' said the other, 'must be thought of one who voluntarily offers himself for the management of manors, and who, in order to bring to effect what he desires,

gratiam spondet?' Refert, 'Nichil hoc ad propositum monachi pertinet.' Ait, 'Quare? Nonne hic talis licet hoc quod dixi cupiat, tamen sine licentia prælati sui nil facere temptat?' Respondit, 'Licentia multos decipit. Obœdientia enim et inobœdientia, contraria sunt. Harum media, licentia est. Is igitur quem obœdientia non constringit claustra monasterii egredi, vult tamen exire, regulæque districtionem licenter declinare;' quamvis nolit sine licentia id præsumere, et iccirco actum suum licentia qua nititur possit defendere;' peccatum tamen habet ex illicita voluntate. Nec enim postquam mortuus mundo claustrum subiit;' ad mundi negotia vel voluntate ullatenus redire debuit. Quia tamen ipsum velle suum nonnisi permissus facto implere voluit;' obœdientia quam in hoc amplexus est ipsum factum excusabit; sed velle quod contra obœdientiam habuit, periculosum nisi pœnituerit illi erit. Quod nonnulli minus attendentes;' licentia quam pro implenda voluntate sua expetunt, sepe falluntur.'[1]

[1] This passage from *Licentia multos decipit* (*Permission is something*) is found almost verbatim in *De Similitudinibus*, cap. 89, but it there appears as part of a much longer 'Similitudo inter matronem et divinam voluntatem' (*ibid.* caps. 85-9). In this *Similitudo* a matron is described having three daughters, each with a maid, all of whom were committed to a governess with instructions that they were not to go out of doors. The daughters kept the command; but the maids began to murmur and to ask permission to go out. This was sometimes allowed; and while they were out they stopped work. But among them there was one of evil disposition (*ancilla latro*) who, not content with going out when permission was given, sought every opportunity to go out without permission, and railed at the governess. The story concludes: 'Ut ergo hac similitudine potest colligi, tria sunt genera voluntatis in subditis. Horum autem primum obedientia, secundum licentia, tertium inobedientia dici potest. Haec vero genera omnia inveniri possunt in monachis, quos matrona quaedam magistrae cuidam commendavit, id est, voluntas divina voluntati abbatis eorum supposuit. Licentia quippe multos decipit ... [here follows the passage in the *Life*] ... Ut igitur breviter loquar et succincte, sub ipsa obedientia viventes sunt matronae regalis filiae. Ancillarum vero nomine, licentiae adhaerentes accipe. Inobedientia vero, quae dicitur & ipsa latro, rebelles designantur in ordine monastico.' It will be seen that the context of the discussion is in both cases related to the monastic life, but whereas in the *Life* it is given a practical setting, in *De Similitudinibus*

secretly enlists helpers, promises gifts, and pledges his favours?' To this he replied: 'The monastic profession has no place for such as this.' 'Why not?' he said. 'For though he may have the desires I have described, nevertheless he attempts to do nothing without the permission of his superior.' Anselm replied: 'Permission is something which deceives many. Obedience and disobedience are contraries: permission lies between these extremes. He who is not obliged by obedience to leave the walls of the monastery, but wishes nevertheless to do so, and would gladly have freedom from the strictness of the rule—such a man sins in having an unbridled will, even if he is unwilling to presume to act without permission, and thereby is able to defend his actions by the permission on which he relies. For no-one, after he has become dead to the world and has entered the cloister, ought on any account, even in intention, to return to worldly affairs. Since however he was unwilling to follow his own will without permission, the deed alone will be excused by the obedience which in this respect he has observed; but the will itself, since it was contrary to his obedience, will be perilous to him unless he repents. It is because this is not always recognised, that permission often deceives those who seek it as a way of carrying out their own wishes.'[1]

it is part of an elaborate allegory which introduces a favourite distinction of Anselm between the free, because obedient, will, and the servile, because disobedient, will. Anselm no doubt used the same simile on various occasions, and Eadmer may well have made more than one report in almost identical words. For a similar case, see above p. 55. A further practical application of Anselm's views on this subject may be seen in *Ep.* 137 [ii, 42] to Lanfranc, nephew of the archbishop, who, from being a monk of Bec had become abbot of St Wandrille without the permission of Anselm, his own abbot: 'Non te excuses dicens michi "Non intravi per inobedientiam quia non prohibuisti." Sufficit ad removendam rectitudinem quia non per obedientiam introisti.'

Hæc ut dixi non pro ostendenda doctrinæ suæ qualitate proposui, sed quibus inter epulas occupari solitus erat levi exemplo monstravi. Nam si de humilitate, de patientia, de mansuetudine, et de hac quam nunc paululum tetigi obœdientia, necne de aliis innumeris ac profundis sententiis eum ut singulis fere diebus audiebamus disserentem introducerem;' aliud opus cudendum, et quod in manu habemus esset intermittendum. 'Quando ergo' ait aliquis 'manducabat?' Manducabat plane inter loquendum, parce quidem, et ut aliquando*a* mirareris unde viveret. Veruntamen fatebatur et verum esse cognovimus, quia dum alicui longæ disputationi occupatus erat;' magis solito nescienter edebat, nobis qui propinquiores sedebamus clanculo panem ei nonnunquam sumministrantibus. Cum vero absentibus hospitibus privatim cum suis ederet, et nulla quæstio spiritualis cujusvis ex parte prodiret;' prælibato potius quam sumpto cibo;' mox cessabat, lectionique intendens manducantes expectabat.[1] Quod si aliquem cerneret aut pro sui expectatione celerius comedentem, aut forte cibum relinquentem, utrunque redarguebat, et quo suo commodo nichil hæsitantes operam darent, affectuose admonebat. Ubi autem aliquos libenter edentes advertebat;' affabili vultus jocunditate super eos respiciebat*b*; et aggaudens levata modicum dextra benedicebat eis dicens, 'Bene vobis faciat.'

a ALIQUANDO *om.* αβ *b* ASPICIEBAT EF

[1] cf. Athanasius, *Vita sancti Antonii*, cap. 22: 'Nam frequenter cum fratribus sedere, a cibo qui fuerat appositus, memoria escae spiritualis abstrahebatur. Edebat tamen, utpote homo, saepe solus, saepe cum fratribus' (*P.L.* 73, 146).

I have related these words, as I said, not as a way of showing the quality of his teaching, but to make clear by a small example the way in which he was accustomed to occupy himself during meals. For if I were to describe him as he discoursed about humility, patience, gentleness, or about this obedience which I have just shortly touched on, or about any other of the innumerable and profound subjects on which we heard him talk almost every day, I should have to compose another work and put aside the one which I have undertaken. But when, someone will say, did he eat? He ate indeed while he talked, but sparingly, so that you would sometimes wonder how he supported life. He himself confessed, and we know that it was true, that when he was engaged in any lengthy argument, he was more than usually careless about his food, and we who sat nearest to him sometimes kept secretly plying him with bread. Then, when there were no guests and he took his meals privately with his own household, and when no spiritual subject was brought up by anyone, he would toy with rather than take his food and soon stop eating to listen to the reading, waiting while others ate.[1] But if he saw anybody eating hastily because he was waiting, or perhaps leaving his food, he used to reprove them and affectionately urge them to look after themselves without any hesitation. On the other hand, if he saw any of them enjoying their food, he would give them a friendly and cheerful look, and, full of pleasure, would raise his right hand a little, blessing them and saying 'May it do you good.'

N

xii. *Quod pro indiscreta ut quidam putabant virtutum custodia a nonnullis repræhensus sit*

Exposito igitur quibus modulis Anselmus inter suas epulas delectari consueverit.' ut paucis quoque exponatur quibus etiam aliis horis intenderit.' repetam quod de eo me superius dixisse recordor, videlicet ejus ori nunquam Christus defuit, sive justitia, vel quicquid ad veram vitam pertinet.[1] Omneque tempus perditum iri asserebat, quod bonis studiis, aut necessariæ utilitati non serviebat. Opinari autem illum secus vixisse quam docebat.' profiteor nefas esse. Nam cum illum ex quo religionis habitum sumpsit usque ad susceptam pontificatus dignitatem omnium virtutum ornamentis ratum sit studuisse, ipsasque virtutes in quorumcunque mentibus poterat verbo et exemplo inseruisse.' ita nichilominus ratum esse confirmamus.'· eum totius Britanniæ[a] primatem factum omnimodis hac in parte claruisse. Unde etiam pro ipsarum indiscreta ceu nonnullis et mihi quoque aliquando visum est virtutum custodia sepe reprehensus, et quod monachus claustralis quam primas tantæ gentis esse deberet præjudicatus est. Hoc pro excellenti humilitate ejus, hoc pro immensa patientia ejus, hoc pro nimia abstinentia ejus dicebatur, dictum accusabatur, accusatum damnabatur. Præcipue tamen in servando mansuetudinem indiscretionis arguebatur, quoniam sicut a pluribus putatum est, multi quos æcclesiastica disciplina corripere debuerat, intellecta lenitate ejus in suis pravitatibus quasi licite quiescebant. Verum audita super his

[a] Angliae EF

[1] See above p. 14.

xii. *How he was reproved by some for what seemed to them an
exaggerated cultivation of certain virtues*

I have said something about the spiritual melody in
which Anselm used to find pleasure at meal-times. Now
—in order to express in a few words his occupations at
other times—I shall repeat something which I remember
I said about him higher up, namely that the name of
Christ, or of justice, or of something appertaining to
eternal life was never absent from his lips.[1] He would
maintain that all time was wasted which was not devoted
either to profitable studies or to necessary business. And
I confess that it would be unthinkable to suppose that
his life differed from his teaching. It is certain that from
the moment he assumed a religious habit to the time of
his elevation to the episcopacy he devoted himself to the
cultivation of every virtue, and by word and example
sowed those virtues in the minds of others whenever
possible; and it is not a whit less certain, as we can
testify, that after he became primate of all Britain he
was equally distinguished in all these activities. He was
often even blamed, and suffered in his reputation on
account of his exaggerated—as it seemed to some people,
and myself among them—cultivation of those virtues
which were more fitting for a monk of the cloister than
for the primate of so great a nation. His high humility,
his boundless patience, his too great abstinence, were
all in this respect noted, censured and condemned. And
above all he was blamed for his lack of judgement in the
mildness of his proceedings, for—as most people saw it—
there were many on whom he ought to have inflicted
ecclesiastical discipline, who took advantage of his mild-
ness to remain in their wickedness as if by his consent.

excusatione sua, nam neminem spernebat, nemini ratio-
nem ad inquisita reddere contemnebat.' mox liquido
cognoscebatur, ipsum aliter quam faciebat minime in
talibus facere debere vel posse, dum se in regula veræ
discretionis vellet absque errore tenere.

xiii. *Quod secularia negotia nullo poterat pacto cum sui corporis*
sospitate sustinere

Secularia vero negotia æquanimiter ferre nequibat, sed
pro posse suo modis omnibus suam eis præsentiam sub-
trahebat. Si quando autem talis causa emergebat, ut ei
necessario interesse oporteret.' soli veritati studere, nulli
fraudem, nulli quodlibet præjudicium quantum sua inter-
erat patiebatur inferri. Si vani clamores, si contentiones,
si jurgia ut fit oriebantur.' aut ea sedare, aut citius sese
absentare curabat. Nisi enim ita faceret.' tedio affectus
statim animo deficiebat, et insuper gravem corporis egri-
tudinem incurrebat. Quam consuetudinem ejus edocti.'
sepe illum re ipsa cogente de medio multitudinis eduxi-
mus, proponentesque ei aliquam ex divina pagina quæsti-
onem.' ilico corpus et animum ejus quasi salubri antidoto
medicatum in consuetum statum reduximus. Requisitus
autem quam ob rem sic imbecillis ad seculares causas ac
pusillanimis existeret.' respondebat, 'Qui omnem secu-
larium rerum amorem et concupiscentiam ab animo meo
jamdudum pepuli.' qualiter in causis earum fortis et
diligens existam? Immo veritatem dico non mentior,
quia quando ipsæ michi sese importune et ex necessitate
ingerunt.' ita mens mea illarum horrore concutitur, sicut

But when his own explanation of his actions was heard —for he neither despised anyone nor scorned to give a reason when anybody asked for one—it was immediately apparent that he neither ought nor could have acted differently so long as he sought to keep himself free from error in the exercise of a true discretion.

xiii. *How he found secular business insupportable and even dangerous to his physical health*

Secular business however was something which he could not patiently abide, and he used every pretext to withdraw himself from it so far as he could. But if some case came up at which it was necessary for him to be present, his only concern was for the truth, and he would not allow anyone to be deceived or injured in anything connected with his affairs. When useless uproars, controversies and altercations arose, as sometimes happens, he tried either to stem them or to get out as quickly as possible. For unless he did this, he was immediately overcome with weariness; his spirits drooped, and he even ran the risk of serious illness. When long experience had taught us this tendency of his, we drew him out of the crowd when such an occasion arose and put to him some question of Holy Scripture; and so we brought his body and mind back to their accustomed state, restored to health by this sort of wholesome antidote. When he was asked why he was so weak and faint-hearted in secular business, he replied: 'Long ago I drove all love and craving for secular things from my mind. How then shall I now be strong and diligent in attending to them? I tell you the truth without a lie in saying that, when these affairs press importunately and inescapably upon me, my mind is seized with a horror

infans cum aliqua terribilis imago vultui ejus ingeritur.
Nec in earum dispositione magis delector, quam puer in
uberibus matris delectatur, dum illis acerba amaritudine
superlitis ablactatur.' His necessitudinibus *a* actus.' totam
domus suæ curam et dispositionem Balduino *b* monacho
cujus supra meminimus imposuit, quatinus ad nutum
illius cuncta penderent, et statuta contra ordinationem
ejus irrita fierent. Ita igitur securitate potitus.' spiritu-
alibus disciplinis et contemplationi operam dabat.

xiiii. *Quod inter alia diversarum causarum incommoda, sui*
quoque homines ei facti sint infideles

Veruntamen diversæ tribulationes et anxietates quas cum
propter terras æcclesiæ quas quidam maligni injuria rege
non prohibente invadebant, tum pro pecuniarum exac-
tionibus quæ totum regnum sed maxime suos homines
in immensum devastabant, tum pro monasteriorum
oppressionibus quas sedare non poterat et cotidie ad eum
referebantur, tum pro multis aliis *c* in hunc modum sepe
patiebatur.' hanc ejus quietem interrumpebant, et aliena
quædam meditari compellebant. Præterea ii qui ante
episcopatum viro summissi eum diligebant, diligendo
favebant, favendo *d* quæque electa de suis alacres con-
ferebant.' nunc terras æcclesiæ petere, nunc equos rogare,
nunc pecuniam, nunc hoc vel illud ad quod scilicet sua
quemque voluntas trahebat ab eo precari. Adverteres *e*
itaque petita obtinentes in præsentia ejus ficta pace
aggaudere, retributiones et obsequia polliceri, alios in

a necessitatibus TUXY
b DOMNO BALDUINO αβC
c aliis: quae *add.* A
d fovebant, fovendo A
e animadverteres A

of them, such as an infant might feel when face to face
with some terrible apparition. And I feel no more
pleasure in the ordering of these things than a child
feels in his mother's breasts when they are smeared with
something sharp and bitter at his weaning.' This
aversion constrained him to commit the whole care and
disposition of his household to the monk Baldwin, whom
we have mentioned above, so that everything hung on
his word, and whatever was decided against his will was
null and void. In this way he was able to hold himself
aloof and give his mind to spiritual exercises and to
contemplation.

xiv. *How, among various other troubles, even his own men
were unfaithful to him*

Nevertheless various troubles and anxieties interrupted
his quiet and forced him to think of other things. There
was trouble about the lands of the church which wicked
men unjustly occupied with the king's complaisance;
also about the monetary exactions which very greatly
impoverished the whole kingdom, and especially his
tenants; also about the oppressions of the monasteries
which he was powerless to check and which were daily
brought to his notice; and about many similar things
which frequently added to his sufferings. Moreover the
men who had loved him most devotedly before he be-
came a bishop, who had made much of him and had
cheerfully given to him the best they had, now began to
ask for church lands, and to beg for horses, money or
whatever happened to take their fancy. Then you
should have seen those who had got what they wanted
putting on an expression of false satisfaction and pleasure
in his presence, and promising repayment and service;

contraria lapsos honori ejus detrahere, homines ejus pro
posse impugnare, in immensum minari. Ille autem in
patientia sua sciens possidere animam suam.' cum iis^a
qui oderunt pacem erat pacificus, verba mansuetudinis
et pacis semper reddens impugnatoribus suis, cupiens
malum illorum in bono vincere.¹ At tamen ea quæ in
sequenti tempore poterant æcclesiæ suæ damno esse.'
nequaquam æquo animo tolerare, aut sub negligentiam
cadere patiebatur. Sed quid dicam? Tanta cupiditas
ea tempestate dominabatur in mentibus quorundam, ut
nec patientia ipsius deliniti monitis ejus^b adquiescerent,
nec terroribus pulsati cecitatem sui cordis exirent.^c
Verum de extraneis non multum forte mirandum. Ipsi
sui proprii ac domestici homines mentiti sunt ei, et in-
fideles facti. Animadvertentes quippe mansuetum, lene,
simplexque cor ejus.' in pluribus causis fraudulenta calli-
ditate compositisque sermonibus eum multotiens circum-
venere, et quæ illius juris esse debebant diminuentes, ac
exinde sua non jure augentes.' qua ei fuerant alligati
fidem perdidere. Qua de re cum a Balduino aliisque
fidelibus suis nimiæ simplicitatis minorisque prudentiæ
familiariter reprehenderetur.' simplici admiratione re-
spondebat dicens, 'Quid est hoc? Nonne Christiani
sunt? Et si Christiani, num alicujus commodi causa
vellent contra fidem suam scienter mentiri? Nichil est.²
Tanto nempe studio michi loquentes verba sua com-
ponunt, et ea fide sua interposita vera esse jurant.' ut

^a *Most MSS (following the Vulgate) here read* his. ^b eius *om.* β
^c exuerent EFK; dimitterent M

¹ Luke xxi.19; Ps. cxix.7 (Vulg.); Rom. xii.21
² See above p. 66 *n.* 1

and the others who had not got what they wanted be-
smirching his good name, abusing his men with all their
might, and breathing out wild threats. Meanwhile he
knew how to possess his soul in patience; he was a peace-
maker among those who hated peace; to those who
attacked him he spoke words of gentleness and peace,
desiring to overcome their evil with good.[1] Nevertheless
he would by no means suffer with equanimity, or allow
anything to happen through negligence, which could in
the future be a source of loss to his church. But the
truth of the matter is that there was so much greed
uppermost in the minds of some of the men of that time,
that they were neither softened by his patience to follow
his advice, nor stirred up by fear to shake off the blind-
ness of their hearts. This indeed is perhaps not much to be
wondered at in strangers, but his own men and those even
of his household lied and were disloyal to him. When
they saw that he was mild, gentle, and simple in heart,
they cheated him many times and in many ways with
their fraud and deceit and false words: and they broke
the oath of fealty with which they were bound to him,
in diminishing the rights which ought to have been his,
and unjustly feathering their own nests with what he
had lost. When Baldwin and others of his followers
spoke to him about this and blamed him, as friends, for
his too great simplicity and lack of prudence, he replied
in simple amazement: 'What is all this? Are they not
Christians? And if they are Christians would they
knowingly lie, contrary to their fealty, for some temporal
advantage? It is out of the question.[2] They speak to
me so earnestly, swearing on their oath that what they
say is true, that it might well be ascribed to a lack of
trustfulness in me if I were unwilling to believe that

incredulitati putetur posse ascribi, nolle credere eos ipsa
veritatis firmitudine niti.' Dicebat hæc ille, estimans
ipsos sibi nolle, quod sciebat se nemini facere velle.
Cunque responderetur sui moris illos non esse:' aiebat,
'Fateor malo decipi bona de illis credendo, etiam si me
nesciente mali sunt:' quam decipere meipsum credendo
mala de ipsis quos nondum vere probavi quod boni non
sint.' Hæc tamen in principio pontificatus sui dicta
meminerim. Postmodum enim rei veritas viro innotuit,
et quæ sibi a vere suis dicta fuerant, nimis vera fuisse
cognovit. Quamvis igitur solitam fidem non ex toto
verbis eorum deinceps *a* præbuerit:' tamen suis rebus in
posterum non parum offuit, quod ipsis in principio tam
credulus fuit. Siquidem illi certo scientes eum pro malis
sibi illatis ad mala reddenda cor non habere:' a timore
suspensi, sibique ipsis deteriores effecti, in pejus pro-
fecere. Quod pater tractans apud se:' magis illorum
quam subsequi prævidebat perditioni, quam suæ indoluit
transitoriæ deceptioni. Pro qua tamen deceptione, et
fidei non servatæ corruptione:' sepe Anselmus dicere
solitus erat eos quandoque aut in se aut in liberis suis de
rebus æcclesiæ quibus tunc in sullime raptabantur ex-
hæredandos, et antiquæ paupertati in qua nati fuerant et
nutriti subjugandos, aut certe aliqua gravi et contu-
meliosa vindicta ante mortem vel in morte quod deterius
esset puniendos. Quod dictum ejus jam in quibusdam

a deinceps *om.* E

their words were grounded on the very rock of truth.'
This he said, thinking that they would be unwilling to
do to him what he believed he would never willingly do to
them; and when it was argued that their ways were not
his, he replied: 'I confess I would rather be deceived in
believing good of them, even if they are rogues without
my knowing it, than deceive myself in believing evil of
those to whom I have no certain proof that they are not
good.' It was, however, at the beginning of his pontifi-
cate that I remember him saying these words. For later
the truth of the matter became clear to him, and he
recognised that what had been said to him by his real
friends was only too true. For although he did not
afterwards, as he had been accustomed to do, put com-
plete faith in all that these deceivers said, it was never-
theless no small disservice to his later affairs that he had
been so ready to believe them at first. They, on their
side, knowing for certain that he had no inclination to
repay with evil the evil they had done to him, cast off
all fear and went from bad to worse, excelling themselves
in wrong-doing. When the Father reflected on this, he
was more grieved on account of the damnation which he
saw must follow for them, than for the passing deceit
which had been practised on him. Anselm would often
say that, for their deceit and for the taint of broken faith,
they would sometime, either in their own person or in
that of their children, be disinherited of the church
possessions, on which they were then riding so high, and
be plunged back into the original poverty in which they
were born and brought up; or else they would certainly
receive some heavy and ignominious punishment either
before they died or, what would be worse, in the manner
of their deaths. This judgement of his we see already

completum videmus, et ex hoc quid aliis etiam timendum sit conjectamus. Ideo autem eos corrigere nequibat.' quoniam ipsi more densarum spinarum perplexi, argutis verborum assertionibus se tales non esse qui hujusmodi correctione opus haberent, affirmabant. At ille contentioni servire devitans.' dimittebat eos sibi, timens ne mensuram discretionis excederet, si in rimandis actibus illorum nimis studiosus existeret.

xv. *Quanto studio peccati horrorem devitaverit*

Nil enim in mundo quantum peccare timebat. Conscientia mea teste non mentior, quia sepe illum sub veritatis testimonio profitentem audivimus, quoniam si hinc peccati horrorem, hinc inferni dolorem corporaliter cerneret, et necessario uni eorum immergi deberet.' prius infernum quam peccatum appeteret. Aliud quoque non minus forsan aliquibus mirum dicere solebat, videlicet malle se purum a peccato et innocentem gehennam habere, quam peccati sorde pollutum cælorum regna tenere. Quod dictum cum aliquibus extraneum videretur.' reddita ratione temperabat dicens, 'Cum constet solos malos in inferno torqueri, et solos bonos in cælesti regno foveri.' patet nec bonos in inferno si illuc intrarent.' posse teneri debita pœna malorum, nec malos in cælo si forte accederent.' frui valere felicitate bonorum.'[1] Hæc propter magno semper studio nitebatur peccatorum contagia devitare, et quicquid eis aliquam nascendi occasionem poterat ministrare.' ab intentione sua omni sollicitudine propulsare. Nec in his momentaneus erat. In

[1] This passage from *si hinc peccati* (*if he should see before his very eyes*) appears in *De Similitudinibus*, cap. 191, but in the first person and with some verbal alterations.

fulfilled in some cases, and from this we may guess what
the others have to fear. He was, however, unable to
correct them, because they were as twisted as thorns in
a thicket, and with much verbal cunning they declared
that they were not the sort of men who needed that kind
of correction. So he avoided controversy and left them
to themselves, being afraid that if he too officiously
enquired into their actions, he would overstep the bounds
of discretion.

xv. *With what care he avoided the horror of sin*

For he was more afraid of sinning than of anything else in
the world. We have often—and, upon my conscience,
this is no lie—heard him solemnly protest that if he
should see before his very eyes the horror of sin on the
one hand and the pains of hell on the other, and was
obliged to plunge into one or the other, he would choose
hell rather than sin. And he was in the habit of saying
something else, which perhaps appeared to some people
not less remarkable,—that he would prefer to be free
from sin and go to hell innocently, than to go to the
kingdom of heaven polluted with the stain of sin. Since
this saying seemed strange to some people, he explained
and softened it, saying: 'It is certain that only the
wicked are tormented in hell, and only the good are
happy in the kingdom of heaven.[1] Therefore it is clear
that the good, if they could enter hell, could not be
visited with the punishment due to the wicked; nor
could the evil, even if they could get to heaven, enjoy
there the blessedness of the good.' Hence he always
strove with all his might to avoid being infected by sin,
and he was most solicitous in driving from his mind
anything that could occasion even the first beginnings of

his denique versabatur cotidiana institutio morum ejus, in his stabat assidua conversatio vitæ ejus, in his vigebat indeficiens executio propositi ejus. In istis Deo serviebat, pro his quibusque bonis acceptus erat, per hæc vitam æternam adipisci satagebat.

xvi. De divulgato placito apud Rochingeham

Regem autem de transmare regressum Anselmus adiit, et ut sibi Romam ad papam Urbanum pro stola sui archiepiscopatus eundi licentiam daret, humiliter petiit.[1] At ille ad nomen Urbani turbatus.' dixit se illum pro papa non tenere, nec suæ consuetudinis esse ut absque sua electione alicui liceret in regno suo papam nominare. Hinc igitur orta quædam gravis dissentio est,[2] sed in aliud tempus discutienda est dilata.[3] Jubetur ergo ut totius Angliæ episcopi, abbates et principes ad discussionem discidii hujus apud castrum quod Rochingeham[4]

[1] The king returned to England and landed at Dover on 29 December 1094 (*A.S.C.*). Anselm's meeting with him took place at the royal manor at Gillingham near Shaftesbury, probably in January 1095. According to Eadmer's account, Anselm did not argue against the principle that in cases of disputed papal elections it was the king's duty to decide which pope to recognise; he simply argued that the matter had been settled so far as he was concerned, 'quod ipse abbas Beccensis existens Urbanum pro papa susceperit, nec ab illius oboedientia et subjectione quoquomodo discedere voluerit' (*H.N.* p. 53).

[2] The passage *Regem autem* (*Now when the king*) . . . *dissentio est* (*difference of opinion*) is largely reproduced in *De Similitudinibus*, cap. 188 (see above p. 71, *n.* 1).

[3] According to *H.N.* p. 53 it was Anselm who proposed that the question should be referred to a general meeting of bishops, abbots and barons; and it was at this time that he first suggested the possibility of his leaving the country if the decision went against Urban.

[4] Rockingham was a royal castle on the borders of Northamptonshire and Leicestershire. The description of this meeting briefly summarised here is one of the most vivid passages in the whole *H.N.*, where it occupies thirteen pages (53-67) and forms the most extensive of all the pieces of detailed reporting in Eadmer's writings. It remains nevertheless in many ways mysterious. Anselm made his demand for the recognition of Urban II in January and the most natural course would have been to postpone a decision to the Great Council at Easter which met in Winchester on 25 March.

sin. Nor were these merely passing moods: rather, they were the foundation of his daily habits; they informed the whole tenor of his life; and they provided an unfailing source of strength in the performance of his duties. In these paths he served God; through them he was acceptable to all good men; along them he pressed forward to attain everlasting life.

xvi. *Concerning the public dispute at Rockingham*

Now when the king returned from across the sea, Anselm went to him, and humbly sought permission to go to Pope Urban at Rome for his archiepiscopal pallium.[1] But the king flared up at the name of Urban, and said that he did not recognise him as pope, and that it was contrary to established usage to allow anyone in his kingdom to nominate a pope not of his choosing. Hence there arose a serious difference of opinion,[2] but the discussion of it was put off till another time.[3] The order went out therefore to the bishops, abbots, and barons of all England that they should come together at the castle of Rockingham[4] to discuss this difference. They did as

The meeting at Rockingham took place a month before Easter, and brought together, according to Eadmer (*H.N.* p. 53), the nobility of almost all the kingdom. The Anglo-Saxon Chronicle in its otherwise full account of the year says nothing about it; and it is only from Eadmer that we know of its existence. The Council met on the third Sunday in Lent, 25 February 1095, and lasted for three days. In *H.N.* p. 53, Eadmer gives the date of the meeting as 11 March, but Rule showed that this is a fortnight in advance of the real date (p. lxii). The probable explanation of this is that, in his notes, Eadmer dated events by the ecclesiastical calendar, but, in translating them into days and months, for some reason he put Easter a fortnight too late. The meeting appears to have ended by Anselm taking an oath, which is not mentioned in Eadmer's accounts of the council, either here or in *H.N.*; but the terms of it are given later in *H.N.* p. 84. Anselm swore, according to the king, to observe and defend the customs of the kingdom; or (in Anselm's version) all those customs of the kingdom 'quas per rectitudinem et secundum Deum in regno tuo possides'.

dicitur una veniant. Factum est, et tertia septimana quadragesimæ[a] juxta edictum convenerunt. Causa in medium ducitur, et Anselmus diversis querelis hinc inde concutitur. Siquidem multi sed maxime episcopi regiæ voluntati favere volentes,' spreto æquitatis judicio id probare nitebantur, quod Anselmus salva fide quam regi debebat, nullatenus posset in regno ipsius Urbanum sedis apostolicæ præsulem pro papa tenere. Quibus cum plura quæ ratio tulerat objecta fuissent, et Anselmus eos ex verbis Domini, 'Reddite quæ sunt Cæsaris Cæsari, et quæ sunt Dei Deo,'[1] aliisque nonnullis quæ ratio nulla refellere poterat penitus infrenasset,' illi econtra quid dicerent non habentes, eum in regem blasphemare uno strepitu clamavere, quandoquidem ausus erat in regno ejus nisi eo concedente quicquam vel Deo ascribere. Igitur ad unam regiæ indignationis vocem quidam ex episcopis archiepiscopo suo atque primati omnem sub-jectionem, professamque[b] obœdientiam uno impetu ab-negant, eique unitatem fraternæ societatis pari voto miserandi abjurant[c]; quidam vero in eis tantum quæ ex parte Urbani papæ preciperet illi se negant obœdituros.[d] Episcopi itaque omnes qui affuerant, Rofensi solo ex-cepto aut uno aut alio modo debitam illi subjectionem et obœdientiam abnegant. Rex etiam ipse cunctam ei confidentiam et securitatem in suis omnibus adimit, nec se illum pro archiepiscopo vel patre amplius habiturum jurat, nisi ipse[e] vicario Beati Petri se ulterius obœditurum statim deneget. Tres dies in isto negotio clamoribus in

[a] tertia septimana quadragesimae *om.* B MN VRP
[b] -QUE *om.* αβ
[c] obiurant β
[d] OBOEDITUROS NEGANT αβEF
[e] ipso MNVRP
[1] Matt. xxii.21

they were bidden, and assembled in the third week of
Lent. The case was brought forward, and Anselm was
attacked from all sides on various pretexts. Many—but
above all the bishops—wishing to be on the king's side
and having no regard for justice and equity, tried to
prove that Anselm could not recognise Urban, the
bishop of the apostolic see, as pope within the king's
realms without breaking the faith which he owed to the
king. Many arguments, supported by reason, were
brought forward against these men, and Anselm alto-
gether confounded them with the words of the Lord
'Render unto Caesar the things which are Caesar's, and
to God the things which are God's,'[1] and with some
other passages which no argument could refute. Then
they, having nothing that they could answer, raised a
loud clamour that he was blaspheming against the king,
simply because in his kingdom and without his consent
he had dared to ascribe anything even to God. There-
fore, at one word of royal indignation, some of the
bishops made haste to throw off all submission and the
obedience which they had promised to their archbishop
and primate, and in the same breath the wretches
renounced all brotherly intercourse with him. Others
of them simply refused to obey him in any orders which
he gave them on behalf of Pope Urban. So by one
means or another all the bishops who were present, with
the single exception of the bishop of Rochester, re-
nounced the submission and obedience due to him.
The king moreover for his part withdrew from him all
assurance of security in his affairs, and swore that he
would no longer treat him as archbishop or Father
unless he immediately renounced his obedience to the
vicar of Saint Peter. Three days, heavily charged with

o

Anselmum et contumeliis gravidi expensi sunt, et tandem in hoc quem dixi fine conclusi sunt. Tunc Anselmus in suo proposito constans per internuncios conductum a rege postulat, quo tutus regno[a] decedat. Quod principes multis damnosum fore dinoscentes,[c] pro restituenda pace inducias utrinque usque ad Pentecosten dari precantur et obtinent, ac sic eum ne regno decedat impediunt. Spondet igitur rex se rebus ejus usque ad præfixum tempus induciarum plenam pacem et tranquillitatem indulturum, et tunc voluntati illius pro sua religione multum in negotio quod emerserat condescensurum. Verum omnino in contraria lapsus est, et Anselmus domno Balduino extra regnum depulso, hominibusque suis captis et spoliatis,[b] terrisque vastatis, in immensum afflictus.[1] At tamen post hæc et Urbanum per Walterum Albanensem episcopum qui pallium Anselmo a Roma Cantuariam detulit,[2] pro papa suscepit, et principum regni[c] consilio actus,[c] in amicitiam suam virum vel specie tenus[d] recepit.[3]

[a] a regno VRP [b] expoliatis β
[c] REGNI: SUORUM αβ [d] VEL SPECIE TENUS om. αβ

[1] *H.N.* p. 67 mentions the expulsion of Baldwin, 'in quo pars major consiliorum Anselmi pendebat', and his two clerks; also the arrest of Anselm's chamberlain 'in sua camera ante suos oculos captum, alios homines ejus injusto judicio condemnatos, depraedatos, innumeris malis afflictos'.

[2] According to the Anglo-Saxon Chronicle the legate arrived in England towards Easter (togeanes Eastron). This is translated by *Fl. Wigorn.* p. 37 as 'ante Pascha', but since Easter was on 25 March and the Rockingham meeting lasted till 27 February this is impossible. Eadmer, however (*H.N.* p. 69), says he arrived 'nonnullis diebus ante Pentecosten' and this is much more likely. According to Eadmer, the king sent his clerks Gerard and William to Urban to negotiate for the sending of the archbishop's pallium immediately after the meeting at Rockingham. If they left on 28 February they could (given the need for speed) have been in Piacenza, where Urban then was, by the end of March. This would just give them time to negotiate with Urban II and to return with the legate shortly before Whitsunday, which fell on 13 May. The mission was accomplished with remarkable speed and this allowed the king to present Anselm at the Whit-

outcries and insults against Anselm, were spent on this business, and in the end the conclusion of them was as I have described. Then Anselm, unshaken in his resolve, sent intermediaries to the king asking for a safe conduct to leave the kingdom. The barons saw that this would be injurious to many people, and they begged for and obtained a truce on both sides until Pentecost in the hope of restoring peace: and so they stopped him leaving the kingdom. The king therefore promised that he would leave all his goods in full peace and tranquillity until the date fixed for the end of the truce; and that he would then out of respect for him make some consider-able concession to his wishes in the business which had arisen. But everything in fact turned out quite differ-ently, and Anselm was grievously molested,—Dom Baldwin being driven from the kingdom, his men seized and plundered, and his lands devastated.[1] And yet, after all this, the king recognised Urban as pope through the agency of Walter, bishop of Albano, who brought the pallium for Anselm from Rome to Canterbury[2]; and, acting on the advice of his barons, he extended his friendship at least in appearance[3] to Anselm.

sun Council, to which the question of the recognition of Urban II had been referred, with a *fait accompli*. This decision was certainly in the sense which Anselm desired, but it was made in such a way as to cause the archbishop the maximum humiliation: he had no part in the decision and the legate had instructions to go through Canterbury on the way to the royal court without meeting him (*H.N.* p. 68). Anselm received the pallium from the legate at Canterbury on 27 May 1095 (another date in this year which Eadmer, *H.N.* p. 72, gives a fortnight too late, probably for the same reason as that mentioned above, p. 85, *n.* 4), a fortnight after the Whitsun Council at Windsor when the recognition of Urban II by the king was made public.

[3] The words *vel specie tenus* which Eadmer inserted in the later recen-sions of the *Life* no doubt reflect the real state of affairs, but it is important not to overlook the amount of co-operation between Anselm and William II, which at this time was possible. See *St Anselm and his Biographer*, p. 131.

xvii. *Quomodo renovato discidio inter se et regem licentiam*
petiverit eundi Romam[1]

Verum post aliquantum tempus idem rex a Gualis victor
regressus,· renovata ira propter milites quos sicut falso a
malignis dicebatur male instructos in expeditionem An-
selmus direxerat, contra ipsum conturbatus *a* est.[2] Tunc
Anselmus considerans apud se omni tempore talia pro
nichilo posse oriri, et se eis occupatum semper ab officio
pontificali posse impediri,· tractavit secum sibi Romam
eundum, et consilium a sede beati Petri super his peten-
dum. Cum igitur in solennitate Pentecostes ad curiam
apud Windleshoram venisset,· per familiares suos regi
mandavit sibi pernecessarium esse Romam ire, et hoc si
ei placeret se per licentiam ejus facere velle.[3] At ille
'Nequaquam' inquit. 'Nec enim eum aut in iis*b* quæ
agenda sunt cujusvis consilii inscium, aut alicui gravi

a turbatus EF *b* HIS αβEF

[1] Eadmer has omitted the events of two whole years, Whitsun 1095–
Whitsun 1097. Even in *H.N.* he has little to say about them. They were
a time of quiet ecclesiastical administration on Anselm's side: we hear only
of consecrations of bishops, the building of Christ Church, Canterbury, the
finishing of the *De Incarnatione Verbi* and the beginning of the *Cur Deus Homo*.
Of the disputes which had disturbed Anselm's first two years as archbishop,
the only outstanding one which lay dormant during this period was the
continued royal prohibition of an ecclesiastical council. When the dispute
once more broke out, the breach came initially from a new quarter on the
question of military service. Meanwhile there were negotiations between
Rufus and Urban II which led to a truce on matters in dispute between
them till Christmas 1096. It was characteristic of Urban II to subordinate
other matters to the prosecution of the Crusade, just as it was characteristic
of Anselm to temporise nowhere. But of all this Eadmer says, and saw,
nothing.

[2] This complaint followed the king's expedition into Wales between
Easter and Whitsun 1097 (*H.N.* p. 78). F. M. Stenton, *The First Century of
English Feudalism*, pp. 145-8, connects this complaint with the belief held at
Canterbury a century later that some at least of Lanfranc's knights were
Anglo-Saxon drengs who had been converted into knights by Lanfranc
(*Epistolae Cantuarienses*, ed. Stubbs, R.S. p. 225). This theory however is
not supported by the predominantly French names of the Canterbury
knights of *c.* 1090 (*Domesday Monachorum*, ed. D. C. Douglas, pp. 16 *n.*, 105)

xvii. *How the dispute between him and the king was renewed,
and how he sought the king's permission to go to Rome*[1]

But after a certain time this same king returned vic-
toriously from Wales with his anger once more kindled
against Anselm, because of the knights whom Anselm
had sent on the expedition, who were falsely reported
by malicious tongues to have been badly equipped.[2] At
this Anselm reflected that this sort of thing could crop
up all the time about nothing, so that he would always
be thus occupied and unable to carry out his episcopal
duties. So he decided that he must go to Rome and
seek advice about these things from the See of St Peter.
Therefore at the Feast of Pentecost, when he went to the
court at Windsor,[3] he sent some members of his household
to the king to say that it was very necessary for him to
go to Rome, and, if he agreed, he would be glad to have
his permission to go. But the king refused, 'For,' he
said, 'we have not found him so lacking in counsel in

or by any other evidence. It is more likely that the king's complaints
(which may well have had a solid foundation) took up an earlier point of
controversy with Anselm, namely the archbishop's refusal to confirm in the
hereditary possession of their fiefs the knights to whom the king had given
Canterbury lands during the vacancy of the see (*H.N.* p. 40). In itself, the
complaint does not seem to have been very serious since Anselm made no
reply to it and the king apparently did not pursue the matter further
(*H.N.* pp. 78-9). The incident, however, was important because it per-
suaded Anselm that his hope of peace with the king was vain, and that even
when the affairs of the kingdom (which had so far served as an excuse for
not allowing a Council to be held) were settled he would still not be allowed
to carry out the measures of reform in the enforcement of ecclesiastical
discipline which he thought necessary. For this phase of his conflict with
the king, see *St Anselm and his Biographer*, pp. 159-60.

[3] Whitsunday 1097 was on 13 May. The king had returned from
Normandy on 24 March (*A.S.C.*) and he must have set out for Wales
immediately.

peccato obnoxium esse scimus, unde vel papam con-
sulere, vel illius absolutionem illi necesse sit implorare.'[1]
Et res igitur ita tunc quidem remansit.

xviii. *De liberatione leporis*

Discedente autem Anselmo a curia, et ad villam suam
nomine Heisam[2] properante.' pueri quos nutriebat lepo-
rem sibi occursantem in via canibus insecuti sunt, et
fugitantem[a] infra pedes equi quem pater ipse sedebat
subsidentem consecuti sunt. Ille sciens miseram bestiam
sibi sub se refugio consuluisse.' retentis habenis equum
loco fixit, nec cupitum bestiæ voluit præsidium denegare.
Quam canes circumdantes, et[b] haud grato obsequio hinc
inde lingentes.' nec de sub equo poterant eicere, nec in
aliquo ledere. Quod videntes, admirati sumus. At An-
selmus ubi quosdam ex equitibus aspexit ridere, et quasi
pro capta bestia lætitiæ frena laxare.' solutus in lacrimas
ait, 'Ridetis? Et utique infelici huic nullus risus, lætitia
nulla est. Hostes ejus circa eam sunt, et ipsa de vita
sollicita confugit ad nos, præsidium flagitans. Hoc plane
est et animæ hominis. Nam cum de corpore exit.' mox
inimici sui maligni scilicet spiritus qui eam in corpore
degentem per anfractus vitiorum multis modis persecuti
sunt crudeliter assunt, parati eam rapere, et in mortem
æternam præcipitare. At ipsa nimis anxia huc illucque
circumspicit, et qua tueatur defensionis et auxilii manum
sibi porrigi ineffabili desiderio concupiscit. Demones
autem e contrario rident, et magno gaudio gaudent, si

^a fugientem EF ^b et: linguis suis *add.* A

[1] A longer but similar account of the incident is given in *H.N.* pp. 79–80.
[2] Hayes was the manor of the archbishop nearest to Windsor, about
ten miles away.

what needs to be done, that he must needs consult the
pope, nor subject to any grave sin, for which he must
implore his absolution.'[1] And so the matter rested for
the time being.

xviii. *How a hare was set free*

Anselm left the court and, while he was hastening to his
manor at Hayes,[2] the boys of his household with their
dogs chased a hare which they came upon in the road.
As they were pursuing it, it fled between the feet of the
horse on which Anselm sat. The horse stood still; and
Anselm—knowing that the wretched animal looked to
find a place of refuge beneath him, and not wishing to
deny it the help it needed—drew his horse by the reins
and kept it still. The dogs came round, snuffling about
on all sides and restrained against their will, but they
could neither make it move from under the horse, nor
harm it in any way. We were astonished at the sight.
But Anselm, when he saw some of the horsemen laugh
and make merry at the expense of the cornered animal,
burst into tears and said: 'You laugh, do you? But
there is no laughing, no merry-making, for this unhappy
beast. His enemies stand round about him, and in fear
of his life he flees to us asking for help. So it is with the
soul of man: when it leaves the body, its enemies—the
evil spirits which have haunted it along all the crooked
ways of vice while it was in the body—stand round
without mercy, ready to seize it and hurry it off to ever-
lasting death. Then indeed it looks round everywhere
in great alarm, and with inexpressible desire longs for
some helping and protecting hand to be held out to it,
which might defend it. But the demons on the other
hand laugh and rejoice exceedingly if they find that the

illam nullo fultam adminiculo inveniunt.' Quibus dictis.ʲ
laxato freno in iter rediit, bestiam ultra persequi clara
voce canibus interdicens. Tunc illa ab omni lesione im-
munis.ʲ exultansᵃ præpeti cursu campos silvasque revisit.[1]
Nos vero depositis jocis, sed non modice alacres effecti
de tam pia liberatione pavidi animalis.ʲ cœpto itinere
patrem secuti sumus.ᵇ

xix. *De relaxatione avis*

Alia vice conspexit puerum cum avicula in via ludentem.
Quæ avis pedem filo innexum habens.ʲ interdumᶜ cum
laxius ire permittebatur, fuga sibi consulere cupiens avo-
lare nitebatur. At puer filum manu tenens.ʲ retractamᵈ
ad se usque deiciebat, et hoc ingens illi gaudiumᵉ erat.
Factumqueᶠ est id frequentius. Quod pater aspiciens.ʲ
miseræ avi condoluit,ᵍ ac ut rupto filo libertati redderetur
optavit. Et ecce filum rumpitur, avis avolat, puer plorat,
pater exultat. Et vocatis nobis.ʲ 'Considerastis' inquit
'jocum pueri?' Et confessis considerasse.ʲ ait, 'Simili
consideratione jocatur diabolus cum multis hominibus,
quos suis laqueis irretitos pro sua voluntate in diversa vitia
pertrahit. Sunt enim quidam ut verbi gratia dicam
avaritiæ seu luxuriæ et similium flammis succensi, et ex
mala consuetudine illis addicti. Hiʰ contingit aliquando
ut sua facta considerent, defleant, seque amodo a talibus
cessaturos sibi promittant. En more avis liberos volare

ᵃ exultans et hylaris A ᵇ PATREM SECUTI SUMUS: VIAM DETRIVIMUS αβ
ᶜ INTERDUM: SEPE αβ ᵈ retractam; retentam VRP ᵉ GAUDIUM ILLI αβ
ᶠ -QUE om. αβ ᵍ CONDOLUIT AVI αβ
ʰ Hi: *This is what Eadmer wrote but many MSS* (AEFHKXY) *have cor-
rected it to* His, *and some* (MO) *to* Hic.

[1] This passage from *Discedente autem Anselmo* (*Anselm left the court*) is
reproduced in *De Similitudinibus*, cap. 189.

soul is bereft of every support.' When he had said this, he slackened his rein and set off again along the road, raising his voice and forbidding the dogs to chase the animal any more. Then the hare leapt up unhurt, and swiftly returned to its fields and woods[1]; while we, no longer laughing and not a little uplifted by so affecting a deliverance for the frightened animal, followed the Father along our appointed way.

xix. *How a bird was released*

On another occasion he saw a boy playing with a little bird by the roadside. The bird had its foot tied to a string, and now and then, when it was allowed a little freedom, it tried to fly away, hoping to succour itself by flight. But the boy holding the string pulled it back and brought it down beside him. This gave him enormous pleasure, and he did it again and again. When the Father watched this, he was sorry for the wretched bird, and hoped that it would break the string and regain its freedom. And suddenly the string did break; the bird flew off: the boy wept; and the Father rejoiced. Then he called to us and said 'Did you notice the game the boy was playing?' When we admitted that we had done so, he said 'Consider likewise how the devil plays with many men, whom he catches in his toils and drags into various vices at his pleasure. For instance some men are consumed by the flames of avarice or lust or such-like things, and are chained to them by evil habit. Sometimes it happens to them that, when they consider what they are doing, they weep over it and promise themselves that they will leave off such things in future. So, like the bird, they think they can fly away free. But,

se autumant. Sed quia pravo usu irretiti ab hoste tenen-
tur;' volantes in eadem vitia deiciuntur. Fitque hoc
sepius. Nec omnimodis liberantur;' nisi magno conatu
per respectum gratiæ Dei funis pravæ consuetudinis di-
rumpatur.'[1]

xx. *Quemadmodum tertio denegatam sibi licentiam eundi*
Romam, ipsemet super se acceperit[2]

Hinc iterum Anselmus curiam veniens;' jam petitam
licentiam Romam eundi a rege petivit, sed eam non
obtinuit.[3] Post quæ in mense Octobri invitatus a rege
Wintoniam vadit, et quod jam bis rogaverat, attentius
per internuncios tertio rogat.[4] Turbatur ille,[a] et nimium
se vexari ab eo anxie queritur.[5] Ad quod Anselmus,

[a] *At this point* A *inserts chapter 53 in its early form (as found in* αβ) *followed
by the first three words of chapter 54:* Rex autem Henricus. *The scribe evidently
then realised his mistake: he crossed out the three words he had just written and sum-
marised the beginning of chapter 20 as follows:* verum alia vice curiam veniens
hoc ipsum petit sed impetrando nichil proficit. De hinc in mense Octobri
invitatus a rege Wintoniam vadit, et nimium *etc.*

[1] This chapter 19 is reproduced in *De Similitudinibus,* cap. 190. Peter
Damian used a similar image, but with a different application in *Ep.* vi, 4
to Hugh of Cluny: 'Is etiam qui aucupio delectatur, dum iniecto funiculo
pedibus tenet volucrem securus avolandi datam simulat facultatem; et illa
quidem fugam tentat, alarum librat ex more remigium; sed dum exilire
conatur, aucupe funiculum stringente, retrahitur. Vos etiam me tuto ad
propia remisistis, quem videlicet glutino vestrae caritatis astrictum insolu-
biliter retinetis. Nam recedere quidem corpore potui, sed mente de vestris
manibus non exiui' (*P.L.* 144, 374). For a very different application, see
Henry Fielding, *The History of Tom Jones,* Book iv, chapters 3-4.

[2] The title of this chapter (a later addition: see above, p. xxii) gives the
false impression that Anselm left England without the king's permission.
This distortion also appears in *De Similitudinibus,* cap. 188.

[3] The royal court at which Anselm made this second request for per-
mission to go to Rome must have been held after the king's return, at the
beginning of August, from the second Welsh expedition of 1097. See *A.S.C.*
where it is stated that the king remained in Wales from midsummer almost
until August, and suffered great losses of men and horses. Eadmer does not
mention this expedition, but only the earlier one between Easter and Whit-
sun which culminated in the king's complaint against Anselm and for which
he is the only authority. Likewise Eadmer, here and in *H.N.* p. 80, is the
only authority for the meeting of the royal court after the summer expedition.

being enmeshed by evil habits, they are held by the enemy, who pulls them back into the same vices, as they fly away. This happens time and again, and they are never entirely set free unless, by a great effort and by the operation of God's grace, the cord of evil custom is broken.'[1]

xx. *How, when permission to go to Rome had thrice been refused, he took it upon himself to go*[2]

After this Anselm came once more to the court, and he again sought permission from the king to go to Rome, but in vain.[3] Afterwards, in the month of October he went to Winchester at the king's invitation, and a third time and more insistently he asked through intermediaries for what he had twice already sought.[4] The king was vexed and querulously complained that he was being troubled by him too much.[5] At this Anselm broke

[4] See *H.N.* pp. 80-7 for a long account of this meeting of the king's court. The date given in *H.N.* is 14-15 October 1097, and this is indirectly confirmed by *A.S.C.*, which says that Anselm got the king's permission to go to Rome after the appearance of a comet which lasted for almost a week after 4 October. *Fl. Wigorn.* II, 41 says that the comet appeared on 29 September and lasted a fortnight, but this may simply be an unlucky attempt to correct an apparent contradiction in *A.S.C.*'s method of dating. (For a similar unfortunate expansion of *A.S.C.* by *Fl. Wigorn.*, see above p. 87, n. 2.) In any case, they both agree that it was immediately after this that Anselm had permission to go to Rome though they have very little information about the cause of the dispute: *Fl. Wigorn.* mentions Anselm's frustrated desire to hold a synod and *A.S.C.* briefly says 'he left the country because, in his opinion, little was done lawfully in this land or as he directed'.

[5] The discussion about Anselm's request is much more fully reported in *H.N.* pp. 80-7: Walchelin, bishop of Winchester, who was shortly to become one of the king's justiciars during his absence in Normandy, and Robert, count of Meulan, appear for the first time as the main speakers on the king's side. Walchelin died early in the next year, but Robert of Meulan remained the leading advocate of the king and his successor throughout his remaining disputes with Anselm.

'Et quidem quod Romam ire dispono.' causa sanctæ
Christianitatis quam in hac terra regere suscepi, causa-
que salutis animæ meæ, causa etiam sui honoris et utili-
tatis si credere velit id ago. Si ergo michi bono animo
licentiam dederit eundi.' gratiosus accipiam. Si non.'
ego utique quod Deus præcipit postponere non debeo,
quia scriptum est, "Obœdire oportet Deo magis quam
hominibus".'¹ Quod ille audiens.' turbato animo jubet
ut aut cœpto desistat, et insuper se nunquam beatum
Petrum vel sedem ejus pro quolibet negotio appellaturum
jurejurando promittat, aut sine mora omni spe remeandi
sublata.' suo regno decedat.² Et subdens ait, 'Si vero
territus istis cœpto desistere, et remanere quam ire de-
legerit.' tunc volo ᵃ michi prout judicabit curia mea emen-
det, quoniam illud sibi concedi a me tertio petiit, in quo
se perseveraturum certus non fuit.' Respondit, 'Dominus
est; quod vult dicit. Ego tamen sciens ad quid assumptus
sim, et quid in Anglia gerendum susceperim.' non michi
honestum esse pronuncio cujusvis transitorii commodi
causa illud omittere, quod in ope misericordiæ Dei spero
futuris temporibus æcclesiæ ejus utile fore.' Acta sunt
hinc his multo plura, quæ quoniam alias scripsimus, hic
paucis perstringimus. Rege igitur et curialibus contra
virum in iram permotis.' ipse ad eum placido ᵇ vultu in-
greditur, et dextram ᶜ ejus ex more assidens.' ait, 'Ego
domine ut disposui vado, sed vobis primo meam bene-
dictionem si eam non abicitis dabo.' Quam cum ille

ᵃ VOLO: QUATINUS *add.* αβ (ℯı erased); ut *add.* E ᵇ hilari VRP
ᶜ ad dexteram ES; dexteram BFOW; dextera M

¹ Acts v.29
² These alternatives are reported in *H.N.* p. 84 without the explicit
threat of permanent exile—if he chose to go, Anselm was to go at once and
to take nothing with him without the royal permission; the question of his
return was left in abeyance.

out: 'Now truly it is for the sake of the holy estate of the Christian religion which I have undertaken to rule in this land, and for the health of my own soul, and also— if he would believe it—for his own honour and advantage, that I have decided to go to Rome. If then he will give me permission to go with a good will, I shall gladly accept it. But if not, I least of all should put aside the commands of God, for it is written, "We ought to obey God rather than man".'[1] When the king heard this, he angrily ordered him either to desist from this enterprise and promise on his oath that he would never again on any account appeal to St Peter or his See; or leave the kingdom without delay and give up all hope of returning.[2] And he added: 'If this frightens him, and he chooses to drop his plan and remain rather than go, then I require him to pay such a fine as my court shall decide; for he has asked me three times to grant him something in which he had no assurance that he should persevere.' Anselm answered: 'He is lord; his word is law. But I know to what end I have been chosen, and what I undertook in assuming authority in England; and I declare that it would not be honourable for me in the desire for temporal gain to omit anything which I hope, with the aid of God's mercy, will be useful to his Church in time to come.' Many more things than these took place over this affair, but since we have written about them elsewhere, we shall here shortly dispose of them. The king, then, and all the members of the court were moved to anger against Anselm, but Anselm came to him with unruffled countenance and sat down at his customary place at his right hand, saying: 'My lord, I go as I have determined; but first, if you do not refuse it, I shall give you my blessing.' The king replied that

se nolle abicere responderet.ᶜ conquiniscentemᵃ ad hoc
regem levata dextera benedixit, sicque relicta curia Can-
tuariam venit.¹

xxi. *Qualiter Romam profecturus monachos Cantuarienses allo-
cutus sit, et quomodo accepta pera et baculo peregrinantium more
Dofras ierit*

Postera die adunatos monachos in ipsa sede Domino
Christo famulantes his verbis allocutus est. 'Fratres et
filii mei dilectissimi, sicut audistis et scitis, ego regno huic
proxime sum decessurus. Causa quippe quæ inter domi-
num nostrum regem et me jam diu de Christianæ religi-
onis correctione versata est ad hoc est tandem perducta,
ut aut ea quæ contra Deum et honestatem meam sunt me
oporteat agere, aut huic regno sine mora decedere. Et
ego quidem libens vado, sperans in respectum miseri-
cordiæᵇ Dei.ᶜ iter meum libertati æcclesiæ futuris tem-
poribus nonnichili profuturum. Super vos tamen quos
ad præsens relinquo non modica pietate moveor, utpote
quos tribulationes et angustias, oppressiones et contu-
melias acerbius solito me absente passuros intueor. Licet
enim constet illas nec me præsente ex toto fuisse remotas.ᶜ
tamen quando emergebant, contra eas vobis quoddam
quasi umbraculum extiti, et ne in immensum vos feri-
rent.ᶜ scuto me vestræ protectionis medium objeci. Et
quidem majori pace ac securitate vos usos existimo post-
quam inter vos veni, quam a decessu venerandæ memo-
riæ Lanfranci patris nostriᶜ usi fueritis usque ad introitum

ᵃ conquiescentem A ᵇ MISERICORDIS αβ ᶜ VESTRI αβ

¹ Anselm left the royal court at Winchester on 15 October, having
eleven days in which to leave the country (*H.N.* p. 87). He did not arrive
at Canterbury until Saturday 24 October, the last possible date for spending
a day with the community. The intervening days were probably spent on
the archiepiscopal manors.

he had no wish to refuse it, and as he bent forward for it, Anselm raised his right hand and blessed him; and so, leaving the court, he came to Canterbury.[1]

xxi. *How he spoke to the monks of Canterbury on setting out for Rome; and how, after receiving a pilgrim's purse and staff, he went to Dover*

The next day, he called together the monks who served the Lord Christ in that church, and spoke these words to them: 'My dearest brethren and children, as you have heard and already know, I am shortly to leave this kingdom. The long drawn-out dispute between our lord king and myself about the reform of Christian discipline has at last come to this, that either I shall have to do things which are against God and my honour, or leave the kingdom without delay. For my own part I go willingly, trusting that by the workings of God's mercy my journey will be of some use to the liberty of the church in time to come. But for you, whom I am leaving for the time being, I am filled with compassion, seeing what tribulations and sufferings, what oppressions and insults—even worse than usual—you will suffer when I am away. For though these have never wholly been absent even when I was present, still, when they arose, I was able to be some sort of a shelter for you against them, and I placed myself as a shield for your protection so that they did not hurt you beyond measure. And I truly think that you enjoyed greater peace and security after I came among you, than you had done between the death of our Father Lanfranc of blessed

mei. Unde etiam videor michi videre eo magis ipsos qui vos infestare solebant adversum vos me abeunte sevituros, quo a dominatu quo vos opprimebant vident se in præsentia mei dejectos. Sed vos non estis rudes aut hebetes in scola Domini, ut qualiter in hujusmodi si ingruerint debeatis vos habere.' opus habeatis doceri. Paucis tamen suggero, ut quia Deo militaturi[1] in conseptum monasterii hujus convenistis.' præ oculis semper habeatis quemadmodum militetis. Non enim omnes uno modo militant. Quod etiam in terrenorum curiis principum videre planum est. Est etenim princeps, diversi ordinis in sua curia milites habens. Habet nempe qui pro terris quas de se tenent servitio suo invigilant. Habet qui pro stipendiis in militaribus armis sibi desudant. Habet etiam qui pro recuperanda hæreditate quam in culpa parentum suorum se perdidisse deplorant, invicta mentis virtute voluntati suæ parere laborant. Ii ergo qui pro terris quas possident serviunt.' jam radicati sunt et fundati, nec evelli formidant.' dum se in domini sui voluntate conservant. At ii qui pro stipendiis in militiam sese dederunt.' nonnunquam fatigati laboribus a militia quam aggressi sunt segniter cadunt, dum forte magnitudini exercitii atque laboris, magnitudo sicut ipsi estimant non æquatur impendii ac retributionis. Qui vero recuperandæ causa hæreditatis serviendi conditionem arripuere.' quamvis nunc istis vel illis laborum generibus opprimantur, nunc his vel illis contumeliis afficiantur.' æquanimiter omnia sustinent, si firmum recuperandæ

[1] *Deo militaturi*: cf. 2 Tim. ii.4; *Reg. S. Benedicti*, Prol.: 'Domino Christo vero regi militaturus.' From these beginnings, the phrase and its numerous derivations became commonplace in the Middle Ages.

memory and my arrival. But from this fact also I seem to perceive that those who used to injure you will be the more violent against you in my absence, because so long as I have been present they have seen themselves cast down from that lordship with which they used to oppress you. You, however, are not so raw or dull in the Lord's service, that you need to be told how to conduct yourselves in circumstances like this if they arise. Nevertheless, since you have come together to serve God[1] within the precincts of this monastery, I shall add a few words to keep you in mind of the nature of your service. For not all men serve in the same fashion, as we see clearly in the courts of secular princes. For a prince has different kinds of soldiers at his court: he has some who are active in his service in return for the lands which they hold from him; he has others who bear arms and toil on his behalf for pay; and he has yet others who labour with unbroken fortitude to obey his will for the sake of receiving back again an inheritance of which they bewail the loss through their parents' fault. Those then who serve him for the lands which they hold, are already rooted and grounded, and have no fear of being torn up so long as they conform themselves to their lord's will. Those on the other hand who have entered military service for pay, sometimes are wearied by their exertions and idly fall away from the service they have undertaken, thinking maybe that the wages and rewards are not equal to the amount of toil and exertion. But those who have submitted to the conditions of service for the sake of recovering their inheritance—although they are ground down by toil of one kind or another, and suffer insults of every description—yet bear everything with steadfast minds so long as they have a firm desire to

P

hæreditatis suæ amorem certæ spei gratia tenent. Hæc inter homines fieri[a] liquet, et hinc quid in curia principis omnium fiat, re ipsa monstrante advertere libet. Deus enim cujus sunt omnia quæ sunt,' in his tribus generibus distinctam,' ad sui obsequium curiam habet. Habet quippe angelos qui æterna beatitudine stabiliti, sibi ministrant. Habet etiam homines, sibi pro terrenis commodis quasi milites stipendiarii servientes. Habet quoque nonnullos qui die noctuque suæ voluntati inhærentes,' ad regnum cælorum quod in patris sui Adæ culpa perdiderunt, hæreditario jure pervenire contendunt.[1] Sed nobis ad beatorum spirituum societatem magis est suspirandum, quam de eorum procinctu quo Deo perenniter astant in præsenti disputandum. Ad solidarios Dei milites verba vertamus. Videatis quamplurimos in seculari vita degentes, Deum in iis quæ possident specie tenus diligentes, et ejus per quædam bona opera quæ faciunt famulatui insistentes. Supervenit his Dei judicio temptatio aliqua, perdunt sua. Quid dicam? Mutata protinus mente volant ab amore Dei, deserunt bona quæ faciebant, murmurant, injustitiæ Deum accusant. Quid de istis dicendum? Solidarii sunt, et impletur in illis quod dicit psalmus, "Confitebitur tibi cum bene feceris ei."[2] Hoc de secularibus dictum. Sed nos monachi utinam tales essemus, ut horum similes non essemus. Nam qui in propositi sui norma quam professi sunt stare

[a] FIERI INTER HOMINES αβEF

[1] The allegory of the knights, i.e. this passage from *Est etenim princeps* (*For a prince*) is found in *De Similitudinibus*, cap. 80, and is also very briefly alluded to in cap. 39. The text in *De Similitudinibus* is not dependent on the *Life* at this point but reproduces an independent version of the same idea. Both these versions are equally independent of a third version in the *Dicta Anselmi*, cap. 10, entitled *Quot causis homines Deo serviunt*. We must conclude that this simile was frequently used by Anselm and that it was preserved both by Eadmer and Alexander in various forms. See above pp. 74, 77. [2] Ps. xlviii.19 (Vulg.)

recover their inheritance and are supported by a sure
hope. This is clearly the case among men, and one may
gather from this what happens in the court of the Ruler
of all men. For God, to whom all things belong, has his
court divided into these three classes of those who do
his will. He has angels who minister to him: they are
firmly grounded in eternal blessedness. But also he has
men who serve him like mercenary soldiers for worldly
gain. Then in addition he has some men who keep to
their purpose day and night, and strive to reach the
heavenly kingdom which, being theirs by inheritance,
they lost through the fault of their father Adam.[1] Our
task however is rather to press forward to the company
of the spirits of the blessed, than to discourse at present
about the order in which they stand unchangeably before
God. So let us turn to God's mercenary soldiers. You
may see very many men leading a secular life, who have
the appearance of loving God in the midst of their
possessions, and who in certain good works which they
do are active in his service. Then by the judgement of
God some trial befalls them; they lose their goods. What
follows? They straightway face about, rush away from
the love of God, abandon the good works which they
were doing, grumble and accuse God of injustice. What
are we to say about these men? They are mercenaries
and the words of the Psalmist are fulfilled in them: "A
man will praise thee when thou doest well to him."[2] So
much for men living in the world. But we who are
monks—let us not be such as they are! For if men
refuse to stand in the straight path of that profession
which they have undertaken unless all things which

recusant, nisi cuncta quæ sibi ad votum sunt copiosius
habeant, nec hinc propter Deum cujuslibet rei penuriam,
et hinc regulæ disciplinam pati volunt.' quibus obsecro
rationibus juvabuntur, ne horum similes habeantur? In
omni quippe opere suo prius mercedem exigunt, quam
cui merces debetur ministerii munus exolvant. Et hi
tales, regni cælestis hæredes erunt? Fidenter dico ne-
quaquam, si non pœnituerint se tales fuisse. Qui vero
ad recuperandum vitæ regnum obsequii sui dirigit inten-
tionem.' Deo per omnia inhærere, et totam fiduciam suam
inflexibili statu mentis in eum defigere nititur. Nulla
hunc adversitas Dei servitio detrahit, nulla transeuntis
vitæ voluptas ab ejus amore compescit. Per dura et
aspera viam mandatorum illius incedit, et ex spe retri-
butionis futuræ cor suum indeficienti caritatis ardore
succendit, ac sic in cunctis vera patientia fretus.' cum
psalmista lætus canit, "Magna est gloria Domini."[1]
Quam gloriam sic in hac peregrinatione positus gustat,
gustando ruminat, ruminando desiderat, desiderando a
longe salutat.' ut ad illam spe perveniendi subnixus, ea se
inter mundana pericula consoletur et alacriter cantet,
"Magna est gloria Domini." Et sciatis quod hic ipsa
gloria Domini nullo modo defrudabitur,[a] quoniam totum
quod in eo viget voluntati Domini famulatur, atque ad
hanc obtinendam dirigitur. Sed o jam ab istis inter vos
michi cessandum video. Fratres mei, obsecro, obsecro
vos, si hic dolentes nunc ab invicem separamur.' tendite
ut in futuro ante Deum læti ad invicem conjungamur.

[a] defraudabitur HK

[1] Ps. cxxxvii.5 (Vulg.)

minister to their wants are present in abundance, and if they are unwilling to suffer any kind of privation or strictness of rule on God's behalf, what arguments, pray, can save them from being such as those others? They simply seek the reward for all they do before carrying out the service for which the reward is due. Shall such men as these inherit the Kingdom of Heaven? I say certainly not, unless they repent of being like this. For he whose aim in serving is directed towards the recovering of the kingdom of eternal life, strives to stick to God through thick and thin, and with unshakeable perseverance to place his whole trust in him. No adversity tears him away from God's service, and no earthly pleasure holds him back from his love. Through difficulties and adversities he follows the way of his commandments; he warms his heart with an undying fire of love in the hope of the reward in store for him; and thus, strong in patience, he rejoices in all things, and says with the Psalmist: "Great is the glory of the Lord."[1] This glory, even in this earthly pilgrimage, he has a taste of; he savours it; and, as he savours, he desires it; and with great desire he salutes it while yet far off. Thus he is supported by the hope of attaining it, and consoled by it in the midst of all earthly dangers, and he sings with joy "Great is the glory of the Lord." And you may be sure that he will by no means be cheated of this glory of the Lord; for his whole being is subject to the Lord's will and is directed to obtaining this glory. But now, oh now, I see I must make an end of talking of these things with you. My brethren, I beseech you, I beseech you, if here and now we part in grief, press on, so that in the future we may be joined together before God in gladness. Act like men who truly desire to be-

Estote illi, qui veraciter velitis effici hæredes Dei.'[a1] His
dictis.' erumpentes ab ejus oculis lacrimæ, eum plura
loqui prohibuere. Gemitum fratrum qui subsecutus est,
quis enarrabit? Ita fletus implevit omnia, ut vox nulli
superesset ad verba. Tandem pater medios rumpens sin-
gultus.' ait, 'Karissimi mei, scitis quid vos esse, et quo vos
tendere cupiam. Sed hora hæc plura loqui vetat. Deo
omnipotenti et beatissimo apostolorum principi Petro
vos commendo, ut et ipse Deus inter suas oves vos
agnoscat, et beatus Petrus in sui tuitionem sicut oves
Dei sibi commendatas vos suscipiat. Ego vestra licentia
et benedictione vado, ac ut Deus pacis et dilectionis
vobiscum maneat oro.' Post hæc surrexit, et dato pacis
osculo cunctis.' in oratorium ivit, populo sanctum ejus
alloquium præstolanti pro instantis qualitate negotii ver-
bum consolationis et exortationis ministraturus. Quod ubi
excellenter peregit.' astante monachorum, clericorum, ac
numerosa populorum multitudine.' peram et baculum
peregrinantium more coram altari suscepit, commenda-
tisque omnibus Christo, ingenti fletu et ejulatu prosecutus
egressus est.[2] Ipso die ad portum Dofras ivimus, ibique
clericum quendam Willelmum nomine[3] a rege ad An-
selmum directum invenimus.[b] Detenti autem ibi sumus
quindecim diebus, vento nobis transitum prohibente. In
qua mora idem Willelmus cum patre intrans et exiens,

[a] Dei: Christi β [b] REPPERIMUS αβ

[1] Rom. viii.17
[2] Anselm left Canterbury the day after his arrival. The date of his
departure is given in the short annals of Christ Church, Canterbury
(Liebermann, *Ungedruckte Anglo-Norman. Geschichtsquellen*, p. 4) as 25 Oct-
ober 1097, the day before the eleven days' grace granted him at the Council
of Winchester expired.
[3] The clerk was William of Warelwast, a chaplain of William II and
later of Henry I, who became bishop of Exeter in 1107. Ralph de Diceto,
Historical Works, R.S. 1, p. 226 gives his full name, but whether from a

come heirs of God.'[1] At these words, tears which prevented him from saying more broke from his eyes; and who can describe the anguish of the brethren which followed? They were so overcome with weeping that they had no voice for words. At last the Father, breaking through his sobs, said; 'You know, my dearest friends, what I wish you to do, and whither I wish you to direct your course. But the hour forbids more talk. I commend you to Almighty God, and to the most blessed Prince of the Apostles, Peter, that God may number you among his sheep, and Saint Peter may receive you into his keeping as God's sheep committed to his care. With your permission and blessing I go, and I pray that the God of Peace and love may remain with you.' Having said this, he rose and, after giving the kiss of peace to all, he went into the church to speak such words of consolation and encouragement to the people who awaited his holy exhortation as the urgency of the situation allowed. This he excellently performed; and in the presence of the monks, clerks and a large concourse of people, he took his scrip and staff like a pilgrim from the altar; then he commended them all to Christ, and, setting forth with much weeping and lamentation, he left them.[2] On the same day, we came to Dover and there we found a certain clerk called William,[3] sent to Anselm from the king. We were detained there for a fortnight by a wind which made our crossing impossible. While we were delayed, this William was constantly with us and ate daily at the Father's table, but he

source we no longer possess or by intelligent guesswork we cannot tell. William had been one of the king's messengers to Urban II in 1095 (*H.N.* p. 68), and under Henry I he was the chief agent of the king in his negotiations with the Pope (see esp. *H.N.* p. 181).

et in mensa illius cotidie comedens.' nulli propter quam missus fuerat rem denudare volebat.

xxii. *Quomodo Willelmus nuncius regis sua omnia in litore maris perscrutatus sit*

Die vero quinto decimo cum nos nautæ urgerent naves petere, et nos transire avidi ad hoc fatigaremur.' ecce videres rem miserandam. Patrem patriæ, primatem totius Britanniæ.'·ª Willelmus ille quasi fugitivum et alicujus criminis reum in litore detinet, ac ne mare transeat ex parte sui domini jubet, donec omnia quæ secum ferebat singulatim sibi revelet. Allatæ igitur ante illum bulgiæ et manticæ reseratæ sunt, et tota supellex illius spe pecuniæ reperiendæ subversa et exquisita est.' ingenti plebis multitudine circumastante, ac nefarium opus pro sui novitate admirando spectante, et spectando exsecrante. Rebus ergo eversis, sed nichil eorum quorum causa eversæ sunt in eis reperto.' delusa sollicitudo perscrutantis est, et Anselmus cum suis abire permissus.[1]

xxiii. *Quomodo ad vocem ejus in mari ventus mutatus sit*

Itaque navem ingreditur, ventis vela panduntur,[2] et aliquanto maris spatio promovemur. Cum subito nautæ primo inter se summurmurantes, ac deinde manifesta voce murmur ipsum depromentes.' affirmant nullo penitus conatu, nullo numerosorum remorum impulsu, eo

ª Angliae UX

[1] The date was 8 November 1097.

[2] This passage from cap. 21: *astante monachorum clericorum* to cap. 23: *ventis vela panduntur* is repeated almost verbally in *H.N.* pp. 87-8. The only detail which Eadmer here omits is the fact that at Winchester Rufus had warned Anselm that a clerk would meet him and tell him what he could take with him: the presence of the royal clerk was not therefore the surprise which Eadmer, by way of heightening the effect of the indignity

revealed to no-one the purpose for which he had been sent.

xxii. *How William the king's messenger searched all his belongings on the sea-shore*

Then on the fifteenth day you might have seen a pitiful spectacle. When the sailors urged us to go aboard, and we in our eagerness to get away were straining ourselves to do so, the Father of his country, the Primate of all Britain, was detained on the sea-shore like a fugitive and a common criminal. This same William, on behalf of his lord, forbade him to cross the sea until he had shown him piece by piece everything that he was taking with him. So the bags and baggages were brought and opened before him, and all his belongings were turned out and searched in the hope of finding money, while a huge crowd of people, astonished at the novelty of the proceedings, stood round watching and abominating the nefarious deed. When everything had been turned out and none of the things for which the search was instituted had been found—the officiousness of the searcher being thus derided—Anselm and his party were allowed to depart.[1]

xxiii. *How the wind changed on the voyage at his word*

The ship therefore was boarded, the sails spread out to the winds[2] and we were carried some distance out to sea. Suddenly there was a murmuring among the sailors, at first in a low voice; then raising their voices they declared that no amount of effort and no number of oars could

offered to the archbishop, suggests. The most likely object of the search was compromising correspondence from bishops or others to the Pope.

quo ferebamur vento Witsandis pertingendum, immo si
marinis fluctibus pariter involvi nollemus sine mora
remeandum. Ingemuit Anselmus ad ista, et ait, 'Si
omnipotentis Dei judicio placet me magis in pristinas
redire miserias, quam liberatum ab illis tendere ad id
quod ipse novit me animo proposuisse.' ipse videat, ipse
dispenset; ego voluntati ejus obsequi paratus sum. Nec
enim meus, sed ipsius sum.' Dixit. Et suffusis in lacri-
mas oculis ejus, concussisque in gemitum cordibus nostris
qui hæc audiebamus ac videbamus.' ilico ventus ex alio
latere surgens in velum percussit, et nautas jam velo
reflexo terram petentes, ad priorem cursum reverti co-
egit. Nos igitur non modicum exhilarati, et in brevi
prosperrime marinos fluctus evecti.' Witsandis pro voto
appulimus.

xxiiii. *Quod in navi qua per undas evectus est magnum foramen
sit inventum, nec tamen aqua per illud transierit*

Egredientibus autem nobis de navi.' ii quorum navis
erat retinentes domnum Balduinum quem provisorem et
ordinatorem rerum Anselmi supradiximus.' ostenderunt
ei mirabile quiddam quod acciderat. In fundo etenim
navis quæ virum per undas transvexerat.' fractura unius
tabulæ foramen unum ferme duorum spatio pedum mag-
nitudinis habens effecerat, quod fluitanti elemento latum
demonstrabat, sed nullum omnino quandiu Anselmus in
ea fuerat reserabat introitum. Quæ res si admirationem
sese intuentibus intulit.' non puto mirandum. Tunc
Balduinus summo studio cunctis rem celare præcepit, et
ea re*a* per id temporis non multis innotuit. Ego tamen

a res βAM

possibly take us to Wissant, with the wind blowing in its present direction. Unless we wanted to go down all together into the sea, we must return without delay. At this Anselm groaned and said: 'If it be the judgement of Almighty God that I should return to my former miseries, rather than get free of them and pursue that purpose on which he knows I have set my mind, let him see to it and so dispose. I am ready to obey his will. For I am not mine, but his.' He finished speaking and the tears stood in his eyes, while our hearts were smitten with sorrow at what we heard and saw. At that moment the wind began to blow from another quarter and filled the sail, forcing the sailors who had changed direction and were making for land to turn back on their former course. We, therefore, were greatly cheered, and in a short time, after a prosperous voyage, we landed at Wissant as he desired.

xxiv. *How a large hole was found in the ship which brought him across the sea; and how the water nevertheless did not enter*

But when we left the boat, those to whom it belonged detained Dom Baldwin who (as we have said above) was the steward and manager of Anselm's affairs. They showed him something wonderful which had happened. In the bottom of the boat, which had carried the archbishop over the waves, a plank had been broken, making a hole almost two feet across and exposing the hold to the watery element. But no water had entered while Anselm was on board. I think it is not to be wondered at that this sight should have amazed the beholders. Baldwin immediately and emphatically ordered all of them to conceal what had happened, and it was thus not known to many at the time; but a rumour of these

cum inde quædam persensissem, ac post longum tempus dum istis quæ in manu habemus scribendis animum applicuissem, nichilque unde michi vel levis dubitatio inesse poterat describere voluissem.' interrogavi eundem virum de negotio, et veritatem magnopere sciscitatus sum. Qui interposita veritatis assertione qua servus Dei ac verus monachus inniti debet.' confessus est rem ex toto sicut eam retuli factam, nec quicquam in ea confictum.[1] Anselmus itaque extra Angliam positus.' in eo magnifice lætatus est, et multiplices Deo gratias egit, quod se quasi immanem Babilonis fornacem evasisse,[2] et culmen quodam modo placidæ quietis contigisse videbat. Willelmus autem rex audito Anselmum transfretasse.' confestim præcepit cuncta quæ illius juris fuerant in suum transcribi dominium, et irrita fieri omnia quæ per ipsum statuta fuisse probari poterant ex quo venerat in archiepiscopatum.[3] Quas itaque tribulationes ecclesia Christi passa sit intus et extra.' cogitatu nedum dictu percipere difficile esse pronuncio.

xxv. *Qualiter apud Sanctum Bertinum susceptus, et consecrato altari apud Sanctum Audomarum, quo dolore afflictus sit quia puellæ confirmationis donum petenti ut negaret adquievit*

Igitur Anselmus a Witsandis mane discedens, et post dies ad Sanctum Bertinum veniens.' magna plebis, clericorum ac monachorum alacritate susceptus est, et per quinque

[1] This miracle which is so different from any that Eadmer himself witnessed may not unreasonably be connected with the more credulous and active disposition of Baldwin. See *St Anselm and his Biographer*, pp. 195-6.

[2] cf. Daniel iii.

[3] This passage from *Willelmus autem rex* (*King William, however,*) repeats almost verbatim *H.N.* pp. 88-9.

things reached me, and, a long time afterwards, when I
was giving my mind to writing what I am now engaged
on, I asked Baldwin about the business, and most
earnestly begged him to tell me the truth, for I was
unwilling to describe anything about which I could have
the slightest doubt. He—swearing by the truth which
should be the support of a servant of God and a true
monk—declared that the incident happened altogether
as I have described it, and that nothing in it was in-
vented.[1] Anselm therefore, being now out of England,
rejoiced exceedingly and gave thanks repeatedly to God
because he saw that he had escaped as from the great
furnace of Babylon,[2] and had attained a sort of peak of
calmness and rest. King William, however, when he
heard that Anselm had crossed over, immediately
ordered that everything belonging to him should be
transferred to the royal demesne, and that all the trans-
actions, which could be proved to have been concluded
by him since he succeeded to the archbishopric, should
be null and void.[3] It would, I declare, be difficult to
conceive in thought, much less put into words, the
tribulations which Christ Church suffered both in itself
and in its possessions.

xxv. *How he was received at Saint Bertin's and consecrated an
altar at Saint Omer; and the great grief he felt at agreeing to
refuse the gift of confirmation to a girl who sought it*

The next morning Anselm left Wissant and after a few
days came to Saint Bertin, where he was received with
great rejoicing by the monks, clergy and people, who

dies ibi detentus.¹ Interea rogatu canonicorum altare unum apud Sanctum Audomarum consecravit.² Quo facto,ʲ venerunt ad eum honorati quidam de indigenis viri ᵃ flexis genibus obsecrantes, quatinus filios eorum per impositionem manus suæ sacri crismatis unctione signaret. Ad quod mox ita respondit, 'Et hos pro quibus petitis libens in hac causa suscipiam, et alios hoc sacramento egentes, si presto fuerint, non abiciam.' Qua illi facilitate responsi benignitatem viri admirantes,ʲ magnifice lætati sunt et gratias egerunt; confirmatisque pueris suis, ilico totam urbem iis quæ ab ejus ore acceperant impleverunt. Videres ergo viros ac mulieres, magnos ac parvos e domibus ruere, certatimque currendo ad nostrum hospitium prædicti gratia sacramenti properare. Plures siquidem anni iam ᵇ apud eos transierant, in quibus nullus episcoporum illic fuerat tali officio passus occupari.³ Sexto demum die, cum jam innumeram multitudinem confirmasset, et nos a loco discessuros longum

ᵃ viri de indigenis VRP ᵇ iam *om.* EF

¹ Anselm arrived at Wissant on 8 November and left the next morning. From here to St Omer is about 30 miles and since, according to Eadmer, he took more than one day over the journey, he probably arrived in the evening of 10 November. The following day was the Feast of St Martin, and it was on this day that Malchus, bishop of Waterford, heard him speak at supper about the Incarnation. (See above, p. 73, *n.* 2.) He left St Omer on the sixth day, i.e. 16 November. His discussions with the abbot, Lambert, during this time are described in the *Tractatus de moribus Lamberti abbatis S. Bertini* (*M.G.H. SS.* xv, pp. 946-53): 'Positi in invicem sancti viri pariter et totius orbis iudicio eruditi loquebantur de caelestibus, spiritualia spiritualibus colloquiis disserentes. Conferebant de religione, de instantia orationis, in his propositum monachorum diffinientes. Disputabant de tribus generibus quae in mundo habentur, id est bonis, et malis, et mediis; tria quippe in hoc mundo dicuntur, quae sunt bonum, malum et medium.' The author of the treatise goes on to elaborate this theme, attributing all the ideas to Abbot Lambert. The distinction between the *bonum*, *malum* and *medium*, however, is found in several of Anselm's Similitudes and the general tone of the discussion which he reports is strongly reminiscent of Anselm.

kept him there for five days.[1] During this time, at the request of the canons, he consecrated an altar at Saint Omer.[2] When he had done this, some of the notabilities among the inhabitants came to him, beseeching him on bended knees, to confirm their children by the laying-on of his hands, and by anointing them with holy oil. To this he replied: 'I shall gladly receive for this purpose those for whom you make your request; and if there are any others in need of this sacrament, I shall not turn them away if they come.' They admired the goodness shown in his ready reply, and thanked him with exuberant rejoicing. Their children were confirmed, and thereupon they filled the whole city with the words they had heard from his lips. Then might you have seen men and women, great and small, rushing from their houses and running eagerly to our lodgings to receive this sacrament. For at that time many years had passed among these people during which no bishop had been allowed to perform this office among them.[3] At last, on the sixth day, when he had already confirmed a vast multitude, and the long journey which lay ahead of us

[2] There were two great churches at St Omer: the church of the secular canons of St Omer within the town and the Benedictine abbey of St Bertin outside the walls. There were close links between the monks of Canterbury and the monks of St Bertin, and it was natural that Anselm should stay with them. *H.N.* p. 89 gives the additional information that the altar at St Omer dedicated by Anselm was dedicated to St Lawrence, and that Anselm supped with the canons but refused to stay the night. *H.N.* however omits the incidents which fill the remainder of this chapter.

[3] The bishopric of Thérouanne, in which St Omer was situated, had had a troubled history of successive intrusions and depositions during the previous twenty years. In 1097 the see was in the throes of a disputed election between two claimants, John archdeacon of Arras who was supported by the abbots of the diocese, and Aubert de Heuchin who was supported by the secular clergy. They both appealed to Rome, and John with the support of Anselm and Hugh archbishop of Lyons obtained a favourable judgement in 1099. See *Gesta abbatum S. Bertini, M.G.H. SS.* XIII, pp. 646-7.

iter ipsius diei quod instabat festinare compelleret.' ecce
puella quædam domum de qua equos ascensuri egredie-
bamur introiit, flebili pietatis affectu se confirmari de-
poscens. Quod quidam ex sociis nostris audientes.' nimis
moleste tulerunt, et verba illius utpote qui jam talium
erant tedio affecti contradicendo depresserunt. Quid
plura? Virum precibus puellæ assensum præbere volen-
tem.' ipsi objecta longitudine diurnæ viæ, objectis peri-
culis quæ nocturnos viatores in peregrina quammaxime
patria comprehendere solent, objecto quoque quam-
plures ob id ipsum pro foribus attentos stare paratosque
irrumpere si ei soli adquiesceret, detinuerunt, et ne voci
ipsius auditum præberet obtinuerunt. Sed ubi aliquan-
tum processimus.' venit patri in mentem quibus ad-
quieverit, quid egerit. Ilico nimiæ impietatis seipsum
arguens.' tantum exinde concepit in corde dolorem, ut
quamdiu vitæ præsenti superfuit, pœnitudo ipsius facti
ut sepe fatebatur ab animo ejus non recesserit.

xxvi. *Qualiter ab omnibus excipiebatur*[1]

Nobis dehinc cœptum iter de die in diem accelerantibus.'
fama viri multo celerius præcurrebat, et multiplici popu-
los voce replebat. Unde turbarum concursus, clericorum
cœtus, monachorum exercitus.': ei quocunque veniebat
occurrunt, isti gaudio et exultatione concrepantes, illi
vexillis et sonoris concentibus Deo pro illius adventu
conjubilantes.

[1] Chapter 26 is found almost verbatim in *H.N.* p. 89, but Eadmer
here omits the incident of the meeting with the duke of Burgundy (*H.N.*
pp. 89-90), and the arrival at Cluny on 22 December. Anselm was travel-
ling slowly. From Cluny, he sent to Hugh, archbishop of Lyons, with whom
he had long corresponded, to announce his arrival, and Hugh sent the
bishop of Mâcon to escort him to Lyons (*H.N.* p. 91).

that day compelled us to hasten our departure from this place, suddenly a girl entered the house which we were just leaving, when we were about to mount our horses. With tearful and pious devotion she begged to be confirmed. When some of our companions heard this, they were highly annoyed and silenced her with their objections, being men who were by now tired of such scenes. What then? The archbishop wished to accede to the girl's prayers; but they put forward as objections, the length of the day's journey, and the dangers which were apt to beset travellers at night, especially in a foreign country; they objected moreover that if he gave way to this one girl, there were many others waiting by their doors ready to jump out with the same request. Thus they held him back and persuaded him not to lend his ear to the girl's words. But when we had gone a certain distance, it came into the Father's mind what he had done, and in what arguments he had acquiesced. There and then he accused himself of great heartlessness, and conceived thereby such sorrow of heart, that—as he often used to say—his penitence for that action would never leave his mind so long as he lived.

xxvi. *How he was received by everyone*[1]

Thence we hastened day by day on the journey we had undertaken, but the report of his coming flew ahead much faster and spread varying rumours among the people. So wherever he came he was met by crowds of people, gatherings of clergy and armies of monks, who acclaimed him with joy and enthusiasm, and showed forth their praise to God for his arrival with banners and melodious song.

Q

xxvii. *Quod Lugduni consistens nuncios suos Romam direxerit*

Cum autem Lugdunum venisset, et ab archiepiscopo
civitatis ipsius gloriose susceptus fuisset,' post dies paucos
missis litteris consilium a domino papa de negotio suo
quaesivit, et quia partim imbecillitate sui corporis, partim
aliis pluribus causis praepeditus ultra Lugdunum progredi
nequaquam posset ei suggessit.[1] Ita ergo Lugduni re-
sedit, reditum nunciorum suorum ibi expectans. Post
tempus Roma nuncii redeunt, et quoniam omni excusa-
tione sublata eum ad se papa properare praeceperit,'
referunt. Ille nescius morae pontificalibus jussis obaudit,
viae se periculis mortem pro Deo non veritus tradit.

xxviii. *Qualiter Secusiam venientes ab abbate loci ipsius simus*
suscepti, et de ipso Anselmo inquisiti

Hinc Secusiam venimus, et nos abbati loci illius praesen-
tavimus.[2] Eramus quippe monachi tres, dominus vide-
licet et pater Anselmus, domnus Balduinus, et ego qui
haec scribo frater Edmerus. Qui ita ibamus quasi pares
essemus, nullo indicio quis cui praestaret coram aliis
ostendentes. Ab abbate igitur qui vel unde essemus
interrogati,' paucis respondimus. Et audito quosdam
ex nobis Beccensis coenobii monachos esse,' sciscitatus est,
'Fratres obsecro vos vivit adhuc ille ille Dei et omnium
bonorum amicus, Anselmus scilicet ipsius coenobii abbas,

[1] The text of this letter is in *H.N.* pp. 91-3 (*Ep.* 206 [iii 166]). For
its significance, see *St Anselm and his Biographer*, pp. 161-2. Besides ill-health,
the other reasons for delay were the situation in Italy and the occupation
of the route by the enemies of Urban II (*H.N.* p. 94).

[2] From Lyons to Susa Anselm did not follow the Mont Cenis route as
might have been expected, but took a more southerly road via Mont
Genèvre. He left Lyons on 16 March, the Tuesday before Palm Sunday
(*H.N.* p. 94) and arrived at Aspres-sur-Buech on Saturday 20 March
(*H.N.* p. 95). From here he would go via Gap and Embrun to Susa.

xxvii. *How he stayed at Lyons and sent messengers to Rome*

But a few days after he had come to Lyons and had been
splendidly received by the archbishop of that city, he
sent letters to the lord pope asking his advice about his
business, and indicating to him that he was unable to go
further than Lyons, partly because of his bodily weakness
and partly because of many other hindrances.[1] He
therefore settled down at Lyons and awaited the return
of his messengers. After a time the messengers returned
from Rome and reported that the pope had ordered him
to put aside every objection and to make haste to come
to him. He obeyed the pontifical commands without
any thought of delay, and, being unafraid of death in
God's service, he exposed himself to the perils of the road.

xxviii. *How we came to Susa and were received by the abbot of
that place; and how we were questioned about Anselm*

From here we came to Susa and presented ourselves to
the abbot of the place.[2] We were just three monks: our
lord and father Anselm, Dom Baldwin, and myself,
brother Eadmer, who writes this. We journeyed as if
we were equals, showing by no external sign to others
who was the superior or who the inferior. Therefore
when we were asked by the abbot who we were and
whence we came, we replied in a few words. When he
heard that some of us were monks of Bec, he enquired:
'Tell me, brethren, I beg you, does that friend of God
and of all good men, Anselm, the abbot of that monastery
and a man approved and acceptable in every religious

vir in omni religione probatus et acceptus?' Balduinus[1]
ad hæc, 'Ille' ait 'ad archiepiscopatum in aliud regnum
raptus est.' At ille, 'Audivi. Sed nunc quæso qualiter
est? Valet?' 'Equidem' ait 'ex eo tempore quo func-
tus est pontificatu.' non vidi eum Becci. Dicitur tamen
bene valere ubi est.' Tunc abbas, 'Et valeat oro.' Hæc
de se Anselmus dici audiens.' confestim tecto cucullæ suæ
capitio capite.' demisso vultu sedebat. Nolebamus enim
agnosci, ne forte præcurrente fama de adventu tanti viri,
cuivis periculo nostra incuria fieremus obnoxii.[2]

xxix. *Quo honore vulgique favore prosecutus Romam pervenerit,
et qualiter a pontifice urbis Urbano susceptus sit, ac profectus
inde in Apuliam*

Celebratis dehinc in cœnobio Sancti Michaelis Arch-
angeli quod in monte situm Clusa vocatur, Passionis ac
Resurrectionis Dominicæ solenniis.'[3] in iter reversi Romam
festinavimus. Mirum dictu. Pauci atque ignoti per loca
peregrina ibamus, neminem agnoscentes, nemini qui vel
unde essemus innotescentes.' et ecce solus Anselmi as-
pectus in admirationem sui populos excitabat, eumque
esse virum vitæ designabat. Unde cum jam hospitati

[1] Baldwin was here the spokesman for the party, as he had been a few
days earlier in a similar conversation at Aspres. The conversation at
Aspres is reported in *H.N.* presumably because it concerned public affairs,
whereas the present conversation, which was of a more personal kind, found
a place in the *Life*. At Aspres they heard the rumour that the archbishop
of Canterbury had turned back at Piacenza and was once more at Lyons
(*H.N.* p. 95).

[2] This caution was necessary for the presence of the archbishop in
this area must have been known to many people. Indeed the rumours
which they heard at Aspres (see previous note) indicate the kind of talk
which was current in the district. Anselm later wrote to Count Humbert of
Savoy of his experiences at this time: 'Nec sum oblitus quia, cum Romam
tenderem, benigna vestra largitas Lugduni prompta fuit me conducere
atque necessaria quaelibet impendere' (*Ep.* 262 [iii, 65]). The power of
Count Humbert did not extend beyond Chiusa, at the north of the Val di
Susa: from this point Anselm was in hostile territory. (See C. W. Previté
Orton, *The House of Savoy*, pp. 274-6.)

work, still live?' To this Baldwin replied[1]: 'He has
been carried off to an archbishopric in another kingdom.'
'So I have heard,' he said. 'But now, tell me, how is
he? Is he well?' 'To tell the truth,' he replied, 'I
haven't seen him at Bec since he became archbishop;
but they say that he is very well where he is.' Then the
abbot said, 'And I pray that he may continue so.'
Anselm heard these things being said about himself, and
covering his head hastily in the hood of his cowl, he sat
with downcast face. For we were unwilling to be recog-
nised, in case the report of the coming of so great a man
should go before us and cause us to run into danger by
our carelessness.[2]

xxix. *How he came to Rome accompanied by marks of popular
honour and esteem; and how he was received by Pope Urban,
and then set out for Apulia*

After this we celebrated the festivals of our Lord's Passion
and Resurrection in the monastery of St Michael the
Archangel, which is called Chiusa and lies in the
mountains.[3] Then we returned to our road and hurried
on to Rome. It is worthy of remark, that though we
were few and unknown, journeying in a foreign land,
knowing no-one, and telling no-one who we were or
whence we came, nevertheless the mere appearance of
Anselm stirred people's admiration for him and they
pointed him out as a man of God. Hence, though we

[3] The reason for Anselm's choice of the monastery at Chiusa as the
place at which to spend Easter (28 March), was no doubt the presence of
his nephew, the younger Anselm, among the monks. There was also an
undefined family connection with the monastery (see *Ep.* 328 [iv, 114]).
The younger Anselm returned to Canterbury with his uncle and stayed
until the archbishop's death in 1109 (see *St Anselm and his Biographer*, p. 10).

etiam inter eos quorum insidias metuebamus fuissemus.' nonnunquam viri cum mulieribus hospitium intrare, et ut hominem videre, ejusque mererentur benedictione potiri obnixe precari. Tali ergo vulgi favore Romam usque prosecutus.' Lateranis ubi tunc temporis summus pontifex morabatur advenit.[1] Nunciatur pontifici patris adventus, et ovans jubet illum in parte ipsius sui palatii hospitari, et die illo indulgere quieti. Mane confluit ad papam Romana nobilitas, et de novi hospitis adventu sermo conseritur. Adducitur cum reverentia vir in medium, et in qua coram papa decenter sedeat sella profertur. Ingressus humiliat se pro more ad pedes summi pontificis, sed statim ab ipso erigitur ad osculum ejus. Sedet, ac pro adventu illius lætari se apostolicus cum Romana curia dicit. Acclamat curia dicto. Postea silentio facto.' multa in laudem hominis papa locutus est, virum virtutis ac totius religionis illum esse contestans. 'Et quidem' inquit 'ita est. Cunque illum utpote hominem cunctis liberalium artium disciplinis innutritum pro magistro teneamus, et quasi comparem velut alterius orbis[2] apostolicum et patriarcham jure venerandum censeamus.' ita tamen excellens menti ejus humilitatis constantia præsidet, ut nec marinis periculis, nec longissimis peregrinæ terræ spatiis terreri[a] potuerit, quin vestigiis beati Petri pro nostræ parvitatis ministerio se præsentare,

^a terrere TXS

[1] Anselm must have reached Rome in the latter half of April. According to *H.N.* p. 96, he spent ten days at the Lateran before going to Liberi.

[2] According to William of Malmesbury, *G.P.* p. 100, Urban II used a similar phrase with reference to Anselm at the Council of Bari later in this year: 'Includamus hunc in orbe nostro, quasi alterius orbis papam.' But I suspect he is simply transferring this striking phrase from this passage to another occasion. The idea of an *alter orbis* comes from the ancient doctrine that the habitable world, comprising Europe, Africa and Asia, was surrounded by an Ocean belt in which were Islands, and chief among them Britain 'insula interfuso mari toto orbe divisa' (Isidore, *Etymologiae*, xiv, 6, 2)

were now travelling among those whose molestations we feared, it sometimes happened that men and women entered our lodgings, earnestly begging to see this man and to receive his blessing. With such marks of popular esteem, then, he progressed as far as Rome, and went to the Lateran, where the supreme pontiff was at that time staying.[1] When the arrival of the Father was announced to the pope, he joyfully ordered him to be lodged in a part of his palace and to spend the day quietly. The next morning the Roman nobility flocked to the pope and the talk turned on the arrival of the new guest. He was conducted into the assembly with marks of respect, and a chair was placed for him in which he could conveniently sit facing the pope. On entering he humbled himself in the customary way at the feet of the supreme pontiff, who immediately raised him up and kissed him. He sat down, and the successor of the Apostles said that he and the whole Roman curia rejoiced at his arrival. At this the court applauded. Then, when silence was restored, the pope said many things in his praise, affirming that he was a man of high religion and virtue. 'And indeed,' he said 'so he is. For though we consider him as a master steeped in all branches of the liberal arts, and though we justly regard him as one to be venerated almost as our equal—for he is the apostolic patriarch of that other world[2]—, nevertheless so excellent a humility and constancy rules his mind, that he could not be frightened away by the perils of the sea or by the vast expanses of foreign soil from presenting himself at the feet of St Peter for the service of our humble selves, or from coming to us—who rather

nosque magis illius quam illum nostro egentem consilio
super causis suis consulendos adire studuerit. Qua-
propter considerate, quo amore, quo honore suscipi-
endus sit, et amplectendus.' Hæc cum Anselmus de se et
multo his plura pro sui laude dici audiret.' sicut ipsemet
sepe fateri solebat non parum erubuit, quoniam se talem
apud se, qualis a tanto viro prædicabatur minime cog-
novit. Veruntamen erat inter verba tacens, decentius
fore perpendens ad hujusmodi silere quam loqui. Post
hæc de sui adventus causa percunctatus a papa.' eo sibi
modo eam enarravit, quo veritatis ac discretionis ratio
poposcit. Ille ad audita miratur, et subventionem ple-
nam pollicetur. Præcepit itaque, ut ipsius subventionis
effectum, circa se Anselmus præstolaretur. Verum quia
calor æstatis in partibus illis cuncta urebat, et habitatio
urbis nimium insalubris sed præcipue peregrinis homi-
nibus erat.' Johannes quidam nomine, olim monachus
Becci, tunc autem abbas cœnobii Sancti Salvatoris Tele-
sini.'[1] annuente papa suscepit eum ut proprium patrem
in sua, et duxit in villam suam Sclaviam[2] nomine, quæ
in montis vertice sita.' sano jugiter aere atque tepenti
conversantibus illic habilis extat.

[1] John abbot of Telese (S. Salvatore Telesino, about fifteen miles N.E.
of Caserta and two and a half miles from the former town of Telese). In
H.N. p. 96, Eadmer describes him as a Roman who came to France to
study and was attracted by the fame of Anselm to become a monk of Bec.
His place in the list of monks indicates that this happened in the early part
of Anselm's abbacy. Some years later Urban II rebuked Anselm for
having made John, who was a clerk of the Roman Church, a monk and
priest, thus assuming a privilege proper to the Roman Church (Ep. 125
[ii, 32]). For some time after this John was an assistant to the bishop of
Beauvais, and it was he who brought to Anselm's notice the teaching of
Roscelin, which led Anselm to write his De Incarnatione Verbi (Ep. 128, 129
[ii, 35]). He must have returned to Rome shortly afterwards. He became
cardinal-bishop of Tusculum in 1100, or shortly before; he came to England
as papal legate in 1101 (Ep. 213 [iii, 42] and was present at the royal court

need his counsel than he ours—to consult us about his affairs. Consider therefore with what love and honour we ought to receive and embrace him.' Anselm himself often used to confess that when he heard these and many other things said about himself in his own praise, he was greatly embarrassed, for in his heart he recognised that he was not such as he was made out to be by so great a man. However he remained silent during the talk, deeming it more fitting to say nothing about such a subject than to speak. After this the pope asked him about the cause of his coming, and he explained it to him in a manner which met the demands of both truth and discretion. The pope was astonished at what he heard and promised his full support. He ordered therefore that Anselm should stay near him till he gave effect to this support. But since the heat of summer in those parts scorches everything, and living in the city is very unhealthy especially for foreigners, a former monk of Bec, John by name, who was then abbot of the monastery of Holy Saviour at Telese,[1] entertained him, with the pope's permission, as if he were his own father. He took him to his village called Liberi,[2] which, being on the top of a mountain, has always a healthy and cool air agreeable to those living there.

at Windsor on 3 September, on which day he witnessed a series of royal charters (*Regesta* nos. 544, 547, 548). He died in 1119. (See H. W. Klewitz, *Reformpapsttum und Kardinalkolleg*, p. 121.)

[2] Sclavia: The name of this hill-village (about ten miles N. of Telese) was changed to Liberi in an enthusiasm for liberty in 1860.

xxx. *Quod instar solitudinis in monte constitutus, librum Cur Deus Homo perfecerit*

Igitur habitatio nostra in montis erat summitate locata, a turbarum tumultu instar solitudinis vacua. Quod Anselmus advertens,' ex spe futuræ quietis exhilaratus, ait, 'Hæc requies mea, hic habitabo.'[1] Ad primum igitur conversationis ordinem quem antequam abbas esset habebat, quemque se in pontificatu positum maxime perdidisse deflebat,' vitam instituit, sanctis operibus, divinæ contemplationi, misticarum rerum enodationi die noctuque mentem intendens. Unde Christianæ fidei amore permotus,' insigne volumen edidit, quod, *Cur Deus Homo* intitulavit.[a][2] Quod opus sicut in prologo ejus ipse testatur, in Anglia cœpit, sed hic in Capuana videlicet provincia constitutus absolvit.

xxxi. *Qualiter puteus aquæ in montis vertice per eum factus sit*

Inter hæc omnibus omnia sese fecit,[3] cunctis pro posse subveniens, cunctos qui se audire volebant non considerata alicujus persona ad suum colloquium admittens, et singulis pro qualitate motæ quæstionis benigna affabilitate atque affabili benignitate satisfaciens. Quapropter fama illius in brevi circumcirca percrebruit, et in dilectionem ac venerationem ejus cunctorum corda convertit. Quicunque igitur eum videre, ejusque potuit

[a] TITULAVIT α (*except* M) βCϵιEF

[1] Cf. Ps. cxxxi.14 (Vulg.)

[2] The composition of the *Cur Deus Homo* had evidently occupied a considerable time during the years between 1094 and 1098, and I have elsewhere suggested that it owed its initial inspiration to Anselm's conversations with Gilbert Crispin in the winter of 1092-3 (see *M.A.R.S.* iii, 1954, pp. 78-115). In his Preface Anselm speaks of the circulation of incomplete copies which had been surreptitiously obtained before the work was finished, but none of these have come to light; so the growth of the work cannot in this case be illustrated from the manuscripts (Schmitt ii, pp. 42-96).

[3] 1 Cor. ix.22

xxx. *How he finished his Cur Deus Homo, living on a mountain as if in a desert*

Thus we took up our abode on the mountain top, as far removed from the thronging crowd as it were in a desert. When Anselm saw this, his spirits rose with the hope of future quiet, and he said: 'This is my resting-place: here I shall live.'[1] He ordered his life therefore on the lines of his early routine before he became abbot, which he deplored more than ever having had to give up since he became archbishop: day and night his mind was occupied with acts of holiness, with divine contemplation, and with the unravelling of sacred mysteries. Being then moved by his love of the Christian faith, he put out a remarkable book which he entitled *Cur Deus Homo*.[2] He had begun this work, as he explains in the prologue to it, in England; but he finished it while living in this place, in the province, that is, of Capua.

xxi. *How a well of water was made by him on top of the mountain*

At the same time, he made himself all things to all men,[3] helping everyone to the extent of his power, admitting to his conversation all who wished to hear him without regard to who they were, and satisfying each one with his kindness and affability whatever the nature of the subject they raised might be. So in a short time his fame spread abroad in that district, and it turned all men's hearts to love and venerate him. Whoever, therefore, could see him and obtain his blessing looked on

benedictionem habere.' beatum se proprii censura judicii
estimavit. Monachus etiam qui villæ ipsius pro abbatis
imperio custos erat, quique nobis more boni hospitis in
nonnullis ministrabat.' considerans vitam et actus patris,
concepit apud se spem magni boni et gratiam Dei in eo
vigere, crediditque quod Deus multa libens faceret ob
merita ejus. Homines autem villæ multas incommodi-
tates cotidie patiebantur pro penuria aquæ. In devexo
tamen latere montis puteus unus nimiæ profunditatis
habebatur, sed ita singulis diebus exhauriebatur.' ut ab
hora diei nona nulla quæ extrahi posset in illo aqua
usque mane reperiretur. Quo incommodo frater ille
subventum iri desiderans.' rem Anselmo conquerentis
more innotuit, et suæ voluntati inesse subjunxit, puteum
ipso quo habitabamus loco facere, si forte Deus sua pietate
dignaretur hoc incommodum propulsare. Laudat An-
selmus piam fratris voluntatem, et rem temptare suadet.
Lætatur ille ad hæc, et rogat quatinus ipse locum in-
spiciat, ac præmissa prece cum benedictione sua primus
terram aperiat. Adquiescit ille precanti, nolens offen-
dere voluntatem hospitis sui. Quid dicam? Cernebatur
miræ celsitudinis rupes, et quasi dementia videbatur, in
tali loco velle fontem aquæ investigare. Vadit tamen
Anselmus nobis comitatus ad locum, et supplici prece
præmissa, hoc est ut abundantiam jugis atque salubris
aquæ Deus inibi largiretur.' tertio terram feriens aperuit,
et reliquo operi dare operam jussit. Perpauci dies cœpti

himself as a happy man. Moreover the monk, who was
bailiff of that village wielding the authority of the abbot,
and who like a good host attended to our various needs,
observed the life and behaviour of the Father. Then,
judging that the grace of God was strong in him, he
conceived the hope of a great benefit therefrom, believing
that God would be willing to do many things on account
of his merits. For the men of that village suffered daily
many inconveniences from the scarcity of water. They
had indeed in the steep side of the mountain a single
well of great depth, but it became exhausted each day
so that from the ninth hour of the day there was no
water in it which could be drawn up until the next day.
It was for this inconvenience that the brother desired
some relief, and he mentioned the matter to Anselm in
a tone of lamentation. He added that he would like to
make a well in the place where we were living, if by any
chance God would be mercifully pleased to take away
this inconvenience. Anselm approved the pious desire
of the brother and encouraged him to attempt to carry
it out. The brother was glad at this, and asked him to
inspect the place, and to be the first to open up the
ground after offering a prayer with his blessing. Anselm
agreed to do as he wished, being unwilling to go against
his host's wishes. And now what shall I say? There
was a rock of a wondrous height within sight, and it
seemed almost like madness to want to look for a well of
water in such a place. But Anselm set off to this place,
accompanied by us. He first offered a humble prayer
that God would grant a perpetual abundance of whole-
some water at that spot; then, striking the ground thrice,
he opened it up and ordered the rest of the work to be
proceeded with. The work in hand had continued for

operis transierant, et ecce fons vivus e duritia rupis erum-
pens.' ingenti cunctos stupore percussit. Nec mirum.
Aqua enim quam se magister operis nec in plurimis
diebus reperturum putabat.' non mirum si stuporem in-
cussit brevi reperta. Perfectus itaque puteus est, modicæ
quidem profunditatis exstans, sed limpidissimæ atque
salubris aquæ jugi fonte redundans. Quæ res ilico di-
vulgata non parvæ admirationi fuit, et eam viri meritis
omnis qui audivit ascripsit. Itaque puteus ille, puteus
archiepiscopi Cantuariensis usque hodie ab incolis ipsius
terræ vocatur.¹ Ferunt autem ii qui ad nos inde sepe
venerunt, quia multi diversis languoribus ac febribus
tenti.' sumpta in potum eadem aqua pristinæ sanitati
mox restituuntur.

xxxii. *Quod in profundam cisternam corruens nil mali pertulerit*

His diebus,² Rogerus dux Apuliæ civitatem Capuam ob-
sidebat.³ Qui fama viri permotus.' mittens rogavit eum
venire ad se. Ascendimus, ivimus, et plures in obsidione
dies exegimus, remoti in tentoriis a frequentia et tu-
multu perstrepentis exercitus. Erat autem ubi eramus
quædam æcclesiola penitus deserta, et juxta ostium cis-

¹ There is at Liberi a well known as St Anselm's well, but its position
does not agree with the description given by Eadmer. I was told, however,
that there are springs among the rocks above the village, though these
easily dry up in dry weather. It seems probable that the spring described
by Eadmer was one of them. The existence of such springs makes Anselm's
choice of a site for a well less surprising than Eadmer suggests. A similar
miracle of St Dunstan must have been in his mind when he described the
scene, for his language is clearly similar to a passage in his *Vita S. Dunstani*,
describing a miraculous supply of water produced by the saint at the
dedication of a church: 'Ubi ad ministerium aqua deficiente et ob hoc
hominem nonnulla moestitudine corripiente, famulus Dei praemissa prece
terram baculo percussit, ilicoque fons limpidissimus erumpens omnes qui
praesentes erant non modicum laetificavit. Qui fons usque hodie manans
Dunstani nomen et meritum celebre facit.' (*Memorials of St Dunstan*, R.S.
p. 204). There is a similar miracle of St Benedict in the *Dialogi* of Gregory
the Great, ii, 5.

a very few days, when lo! a living fountain broke from the stony rock, and everyone was struck with great amazement. And no wonder! For it is not to be wondered at if astonishment followed the rapid finding of water, which the master workman did not expect to find even after many days. The well therefore was finished, and, though it was only of moderate depth, it nevertheless contained a perpetual stream of the most clear and wholesome water. When this became known throughout the neighbourhood, it was a matter of no small wonder, and everyone who heard it put it down to the merits of the archbishop. Hence the well is known by the inhabitants of that district as the well of the archbishop of Canterbury to this day.[1] Moreover those who have often come to us from those parts declare that many sufferers from various sicknesses and fevers have been immediately restored to perfect health by drinking some of its water.

xxxii. *How he fell into a deep cistern and came to no harm*

During these days[2] Roger, duke of Apulia, was besieging the city of Capua,[3] and he was moved by the archbishop's fame to send asking him to come to him. We rose up and went, and spent several days at the siege, living in tents well away from the turmoil and commotion of the noisy army. Where we were there was a little deserted

[2] The first three sentences of this chapter, but not the incident which follows, are found almost identically in *H.N.* p. 97.

[3] Roger, duke of Apulia 1085-1111, the son and successor of Robert Guiscard, had undertaken the siege to restore his relative Richard II, prince of Capua, who had been driven out of his capital by the inhabitants. The siege lasted for forty days and was over by the end of June 1098. The main source for the siege is Geoffrey Malaterra, *De rebus gestis Rogerii Comitis* (Muratori, new edit., v, pp. 104-06; cf. F. Chalandon, *Histoire de la Domination Normande en Italie et en Sicile*, 1907, I, pp. 303-07).

terna desuper diruta, magnæ profunditatis hiatum sua
diruptione prætendens.¹ In qua æcclesia velut in camera
pro velle conversabamur, tam quieti quam operi in ea
indulgentes, et ducem ipsum cum suis nobiscum singulis
diebus ad quæ volebamus in promptu habentes. Qua-
dam vero nocte cum in ea dormiremus.ʲ contigit Ansel-
mum sui corporis necessitate silentio surgere, et ne in-
quietaremur suo more lento pede ad ostium tendere.
Quod cum exisset, et immemor foveæ per tenebras in
partem divertisset.ʲ in profundum cecidit, clamosa voce
cadendo dicens, 'Sancta Maria'. Ad quem sonitum nos
ac socii nostri qui in tentoriis quiescebant expergefacti.ʲ
lectis prosiluimus, accurrentes hominem in profundo
vidimus, et præ timore simul et angustia cordis exanimati
fere sumus. Quod ipse percipiens.ʲ mox levato capite,
comi vultu, jocundo intuitu nobis innuit, nil læsionis sese
perpessum. Descendentes igitur quidam ex nostris ex
altera parte ipsius præcipitii qua via erat descendendi.ʲ
eduxerunt eum a loco, sanum omnino atque incolumem.

xxxiii. *Quantæ reverentiæ etiam a paganis habitus fuerit*

Cum post hæc² sedis apostolicæ pontifex Urbanus illo
adventaret, et ei ab Anselmo et principibus totius exer-
citus obviam itum esset.ʲ ingenti secularis *a* gloriæ pompa
prosecutus, ductus est in tentorium quod juxta nos sibi

a secularis: MUNDALIS (*or, in many MSS*, MUNDIALIS) αβCEF Harv.HDI
Є1-3. *This was the last alteration made to the text, and it is found only in* Є *in its
final state, and in* KG.

¹ I was unable, during a brief visit, to identify this church. A. Cantoni,
Di cinque Antichissime Chiese dell'Archidiocesi de Capua, Capua 1906, p. 145,
identifies it with S. Maria di S. Vincenzo dell'Agneno at Vitulaccio, but
this is too far from the scene of the siege. It is moreover in the wrong
direction, for it is clear from what both Eadmer and Geoffrey Malaterra
say that Anselm was lodged to the south of the besieged town.

church, which had beside its door a cistern with a broken top exposing through the gap a drop of great depth.[1] We used this church at our pleasure as a chamber in which we both rested and worked; and here each day we had the duke and his retinue with us, ready to do whatever we wished. One night, when we were sleeping in this church, Anselm happened to get up silently to relieve himself. He went to the door with a gentle step, as his manner was, lest he should disturb us. But when he had got outside, he forgot the hole, and, making his way towards it in the darkness, he fell in, crying with a loud voice as he fell, 'Holy Mary.' At this noise, we and our companions who were sleeping in the tents, leaped up from our beds in a panic and ran to him. When we saw him at the bottom, we were almost beside ourselves with fear and anguish of spirit. Seeing this, he at once raised his head and with a courteous air and cheerful look told us that he had come to no harm. Some of us therefore climbed down on the side opposite to the sheer drop where there was a way of descent, and brought him out of the place altogether safe and sound.

xxxiii. *How even the pagans treated him with great reverence*

After this,[2] Urban, the bishop of the apostolic See arrived. He was met by Anselm and by the leaders of the whole army and conducted with an immense display of worldly glory to a tent where we were, which was more

[2] The first three sentences but not the remainder of this chapter are found almost identically in *H.N.* pp. 97-8.

R

erat cæteris excellentius constitutum.[1] Sicque donec civitas in deditionem transiit.' obsidio illius dominum papam et Anselmum vicinos habuit, ita ut familia utrorumque magis videretur una quam duæ, nec facile quivis declinaret ad papam, qui non diverteret ad Anselmum. Papa nanque colebatur a cunctis quemadmodum pater et pastor communis; Anselmus vero diligebatur ab omnibus sicut homo mansuetus et mitis, et cui suo judicio nichil debebatur a quovis. In papa denique supereminens vigebat cum dignitatis auctoritate potestas, in Anselmo mira et quæ cunctos demulcebat pura cum simplicitate humilitas. Multi ergo quos timor prohibebat ad papam accedere, festinabant ad Anselmum venire, amore ducti qui nescit timere. Majestas etenim papæ solos admittebat divites, humanitas Anselmi sine personarum acceptione suscipiebat omnes. Et quos omnes? Paganos etiam, ut de Christianis taceam. Siquidem nonnulli talium; nam eorum multa milia in ipsam expeditionem secum adduxerat homo ducis Rogerus comes de Sicilia[2]; nonnulli inquam talium fama bonitatis ejus inter

[1] Urban II was in Rome on 11 May and he was probably at the siege of Capua early in June 1098. The purpose of his visit to southern Italy, which lasted until November, was two-fold; to come to an agreement with Roger count of Sicily about the organisation of the church in his lands, and to settle the discipline of these former provinces of the Greek church. Geoffrey Malaterra says that Count Roger made six tents available for his use at the siege of Capua (Muratori, new edit., v, p. 106); he also states, in slight contradiction to Eadmer, that the pope left the siege before it ended and went to Benevento; but he returned to find the siege over and hastened after Count Roger to catch him before he embarked for Sicily. He caught him at Salerno, and here on 5 July he granted the famous privilege which gave Roger and his successors a legatine or quasi-legatine position in the Sicilian kingdom. Anselm stayed at the siege until its end, and he accompanied the pope towards Salerno as far as Averso (*H.N.* p. 98), where he left him to return to Liberi until the time of the Council. Anselm may thus not have known about the legatine privilege granted to the count of Sicily, but it is noteworthy that he attempted to gain something very similar for Canterbury in the following years (see *St Anselm and his Biographer*, p. 131; and, for the text and interpretation of the

splendidly made than the others.[1] Thus the lord pope
and Anselm were neighbours at the siege until the city
surrendered, so that their households seemed rather to
be one than two, nor did anyone willingly come to visit
the pope without turning aside to Anselm. For the pope
was reverenced by all as their general father and pastor;
but Anselm was loved by all as a mild and gentle man to
whom—in his own eyes—nobody owed anything. In
the pope moreover there shone forth supreme power and
the authority of high position; but in Anselm a wonderful
and pure humility and simplicity which won all hearts.
Many therefore who were afraid to approach the pope,
hurried to come to Anselm, being led by the love which
knows no fear. The majesty of the pope gave access only
to the rich: the humanity of Anselm received all without
any acceptance of persons. And whom do I mean by
all? Even pagans—not to speak of Christians. There
were indeed some pagans, for the count of Sicily,[2] a
vassal of duke Roger, had brought many thousands of
them with him on the expedition. Some of them, I say,
were stirred by the report of his goodness which circu-

Sicilian privilege, E. Caspar, *Die Legatengewalt der Normannisch-Sicilischen
Herrscher im 12 Jahrhundert*, Quellen u. Forschungen aus Italienischen
Archiven und Bibliotheken, VII, 1904, pp. 189-219).

[2] Roger, count of Sicily, the brother of Robert Guiscard and uncle
of Roger duke of Apulia. He was the vassal of Duke Roger, who was
nominally in command of the siege, but he was in every way a more
important man than his lord and the true founder of the Sicilian state.
There is a long account of his activity at this siege in Geoffrey Malaterra,
De rebus gestis Rogerii Comitis (Muratori, new edit., v, pp. 104-06). His army
with its large Arab contingent, now appearing for the first time in southern
Italy in the service of the Norman count, had crossed over from Sicily in
the first week of April 1098 and it arrived before Capua after Whitsuntide
(16 May). Count Roger's army invested Capua from the south, while the
duke of Apulia and prince of Capua were on the north. The fact that both
the pope and Anselm tolerated the count's prohibition against the con-
version of his Arab troops is a striking illustration of the cessation of mis-
sionary activity at this time.

suos exciti.' mansionem nostram frequentabant, et sump-
tis ab Anselmo corporalibus cibis gratiosi revertebantur,
admirandam viri benignitatem suis prædicantes quam ex-
periebantur. Unde in tanta deinceps veneratione etiam
apud eos habitus est.' ut cum per castra illorum quæ in
unum locata erant transiremus.' ingens multitudo eorum
elevatis ad cælum manibus ei prospera imprecarentur,
et osculatis pro ritu suo manibus propriis, necne coram
eo genibus flexis, pro sua eum benigna largitate grates
agendo venerarentur. Quorum etiam plurimi velut com-
perimus se libenter ejus doctrinæ instruendos summisis-
sent, ac Christianæ fidei jugo sua per eum colla injecissent.'
si crudelitatem comitis sui pro hoc in se sevituram, non
formidassent. Nam revera nullum eorum pati volebat
Christianum impune fieri. Quod qua industria ut ita
dicam faciebat.' nichil mea interest; viderit Deus et ipse.

xxxiiii. *Quod in concilio apud Barum collecto Grecos in pro-
 cessione Spiritus Sancti errantes confutaverit*

Dehinc soluta obsidione.' Anselmus multa prece papam
ad hoc flectere conatus est, quatinus ab onere pontificali
eum absolveret, et quieti liberum vacare concederet.[1]
Verum cum in quantum quidem ad effectum spectabat
in nichilum laborasset.' fretus benedictione ejus Sclaviam
reversus est, opperiens ibi tempus concilii quod idem
papa apud Barum Kal. Octobris erat celebraturus.[2] Cui

[1] Eadmer omits to mention here that after the end of the siege of
Capua Anselm accompanied the pope to Aversa, and that his attempt to
get the pope to release him from the archbishopric took place while they
were there. (*H.N.* pp. 98-104 has a full account of this incident.)

[2] According to Eadmer, the Council of Bari was summoned for Friday,
1 October 1098 (see also *H.N.* p. 104), but the *Anonymi Barensis Chronicon*
(Muratori, v, p. 155) says that Urban II only entered the city on 3 October.
The Council lasted a week (Muratori, *loc. cit.*), and Urban was certainly
still in Bari on 10 October when he issued a Bull organising the diocese of
Agrigento (Mansi, xx, cols. 951-2). Eadmer (*H.N.* pp. 104-110) gives a
lively account of the Council and he is the chief authority for its preceedings,

lated among them to frequent our lodging. They grate-
fully accepted offerings of food from Anselm and returned
to their own people making known the wonderful kindness
which they had experienced at his hands. As a result he
was from this time held in such veneration among them,
that when we passed through their camp—for they were
all encamped together—a huge crowd of them, raising
their hands to heaven, would call down blessings on his
head; then kissing their hands as they are wont, they
would do him reverence on their bended knees giving
thanks for his kindness and liberality. Many of them
even, as we discovered, would willingly have submitted
themselves to his instruction and would have allowed the
yoke of the Christian faith to be placed by him upon
their shoulders, if they had not feared that the cruelty of
their count would have been let loose against them on
this account. For in truth he was unwilling to allow
any of them to become Christian with impunity. With
what policy—if one can use that word—he did this, is
no concern of mine: that is between God and himself.

xxxiv. *How in the Council at Bari he refuted the errors of the
Greeks on the Procession of the Holy Spirit*

Afterwards, when the siege was ended, Anselm tried to
persuade the pope with many prayers to relieve him
from his episcopal burden and to allow him to live in
peace and freedom.[1] But, so far as any practical result
went, he laboured in vain, and with the pope's blessing
he returned to Liberi to wait there until the time of the
council, which the pope was going to hold at Bari on
1 October.[2] When Anselm had presented himself at the

though more than half his account is occupied with his disquisition on the
cope worn by the archbishop of Benevento. The accounts in William of

concilio dum Anselmus se præsentasset, et persuasus a papa Grecos in processione Spiritus Sancti utpote quem a Patre non a Filio procedere astruebant errantes, rationabili atque catholica disputatione confutasset.' magni apud omnes habitus est, et veneratione dignissimus comprobatus.[1] Finito concilio.' Romam cum apostolico profecti sumus.

xxxv. *Qualiter Willelmus nuncius regis Anglorum ad hoc Romanum pontificem perduxerit ut de causa ejus inducias regi daret, et quemadmodum ipse Anselmus Romæ habitus sit*

Transactis autem aliquantis diebus.' venit Romam Willelmus ille cujus in exitu Angliæ mentionem fecimus.[2] Is inter alia hoc effecit apud apostolicum, ut inducias regi Angliæ daret de causa Anselmi, usque ad festum Sancti Michaelis Archangeli. Quod Anselmus agnoscens.' ilico Lugdunum redire volebat, sed prohibitus a papa est, propter concilium quod se tertia hebdomada Paschæ Romæ habiturum statuerat. Morati itaque Romæ sumus ferme per dimidium annum, continue circa papam degentes, et quasi in commune viventes. Unde et ipse

Malmesbury *G.P.* pp. 99-101 and *Fl. Wigorn.* ii, p. 43 are both derived from Eadmer and have no independent value; Paschal II's letter to Anselm, *Ep.* 282 [iii, 167], supplies a fact omitted by Eadmer that the Council condemned lay investiture, but no Acts have survived which give the text of this or other decrees.

[1] Eadmer gives a fuller account of Anselm's discourse in *H.N.* pp. 105-06 and says that he omits to say more 'eo quod ipsemet Anselmus postmodum inde diligentius atque subtilius tractans egregium opus scripsit, idque per multa terrarum loca ubi eiusdem erroris fama pervenit ab amicis suis rogatus direxit.' The treatise *De Processione Spiritus Sancti* (Schmitt, ii, pp. 177-219), while no doubt preserving the essential argument of the speech, does not necessarily follow it in detail: it was finished by the summer of 1102 when Anselm sent it to Hildebert bishop of Le Mans (*Ep.* 239 [iii, 160]; 240 [iii, 53]).

Council, he was induced by the pope to confute the Greeks, who erred on the procession of the Holy Spirit, in asserting that He proceeded from the Father but not the Son. Having accomplished this in a reasoned and catholic disquisition, he was held in great honour by all and established as a man worthy of the highest veneration.[1] Then, the Council being finished, we returned to Rome with the pope.

xxxv. *How William, the messenger of the king of England, persuaded the pope to grant a delay to the king; and how Anselm was entertained at Rome*

After some days, the same William whom we mentioned in connection with our departure from England came to Rome.[2] Among other things he induced the pope to grant a delay to the king of England in the matter of Anselm till the Feast of St Michael the Archangel. When Anselm learnt this, he wanted to return to Lyons at once, but the pope forbade him because of a Council which he had decided to hold at Rome in the third week after Easter. So we stayed at Rome for almost half a year, being constantly with the pope and living almost as one household. The pope on his side sometimes called on

[2] William of Warelwast (see above p. 97, *n*. 3) arrived in Rome about Christmas 1098, bringing the king's reply to the letter which the pope had written shortly after Anselm's arrival in April 1098 demanding the archbishop's restoration. Since the reply was unsatisfactory Urban's first reaction was to require the king's compliance by the end of April 1099, when the pope intended to hold the Council mentioned below. William of Warelwast, however, succeeded in gaining a respite until Michaelmas 1099 (see *H.N.* pp. 110-112). Eadmer here tones down the expression of disgust at this concession (obtained as he asserts by judicious bribery) which he allowed himself in *H.N.* p. 111: 'Quod videntes, vane nos ibi consilium vel auxilium opperiri inteleximus, petitaque licentia Lugdunum remeare decrevimus.' With this exception, the remainder of the chapter repeats with slight alterations the words of *H.N.*

papa nonnunquam ad Anselmum veniebat, læte cum eo
sese agendo, et curiam ei faciendo. Dedit quoque illi
hospitium in quo conversabamur eo jure, ut si aliquando
Romam rediret, contra omnes homines illud sibi vindi-
caret. Ipse in conventu nobilium, in processionibus, in
stationibus,[1] semper et ubique a papa secundus erat, præ
cunctis honoratus, cunctis acceptus, et ipse omnibus sim-
plici humilitate summissus.

xxxvi. *Quod Angli Romam venientes ad jussum papæ sua
oblatione pedes ejus sicut pedes papæ honoraverint*

Præterea Angli illis temporibus Romam venientes.' pedes
ejus instar pedum Romani pontificis sua oblatione hono-
rare desiderabant. Quibus ille nequaquam adquiescens.'
in secretiorem domus partem fugiebat, et eos pro tali re
nullo patiebatur ad se pacto accedere. Quod ubi papæ
relatum est.' admiratus in homine humilitatem mundi-
que contemptum, jussit sese tenere in se,[a] et nullum bene
facere ultro volentem prohibere, sed omnes pro tali causa
adventantes patienter admittere. At ille modesta qua-
dam verecundia ictus.' jussa profecto postponeret, si non
inobœdientiæ nevo corrumpi timeret.

xxxvii. *Qualiter multi Romanorum eum capere volentes, subito
mutata voluntate projectis armis ab eo se benedici petiverint*

Quid referam nonnullos cives urbis quorum ingens multi-
tudo propter fidelitatem imperatoris ipsi papæ erat in-

[a] IN SE TENERE αβEF

[1] *stationes*: the solemn processions on the days when the pope celebrated
Mass at the 'station-churches' of Rome.

Anselm, making himself agreeable to him and paying
his court to him. Moreover he gave him the lodging
where we stayed with the privilege that if ever he re-
turned to Rome he could claim it as his own against all
men. In gatherings of the nobility, in processions and
in *stationes*,[1] he always and everywhere had second place
after the pope, being held in honour before all men,
acceptable to all, and subject to all in simplicity and
humility.

xxxvi. *How Englishmen coming to Rome honoured him by
prostrating themselves at his feet as if at the pope's—and this at
the pope's command*

Moreover the Englishmen who came to Rome at that
time wished to honour him by prostrating themselves at
his feet, as at the feet of a Roman pontiff. But this he
would by no means allow, and he retired to a private
part of the house, where he would not allow them to
come to him for such a purpose on any account. When
this was told to the pope, he marvelled at the humility of
the man and his contempt for worldly things, and he
asked him to restrain this impulse and to forbid no-one
who in future wished to do him honour, but patiently to
admit all who came with such a purpose. But he was
overcome with a certain bashful modesty, and would
certainly have disregarded these orders, had he not
feared to be tainted with the fault of disobedience.

xxxvii. *How, although many of the Romans wished to capture
him, they suddenly changed their minds, threw down their arms
and sought his blessing*

And what shall I say about some of the citizens of Rome?
A great number of these were hostile to the pope because

festa;· nonnunquam in unum conglobatos Anselmum a
Lateranis ad Sanctum Petrum cum suis euntem, propter
odium papæ capere volentes,¹ sed mox viso vultu ejus
territos projectis armis terræ procumbere, et se illius
benedictione deposcere insigniri? Hi honores, et horum
similes vulgi favores illum ubique comitabantur, quia
mores sui in cunctis Deo famulabantur. Hinc etiam erat
quod non facile a quoquam Romæ simpliciter 'homo'
vel 'archiepiscopus', sed quasi proprio nomine 'sanctus
homo' vocabatur. Quicunque igitur ei serviebamus;·
amori et honori cunctis eramus.

xxxviii. *Quod papa in concilio Romæ habito laicos investituras
 æcclesiarum dantes et ab eis accipientes excommunicaverit*

Cum vero ad præfatum concilium ventum esset, et jam
quæ recidenda recisa, et quæ statuenda videbantur
statuta fuissent;· excommunicationis sententiam tam in
laicos qui investituras ecclesiarum dant, quam in eos
qui de manibus eorum illas suscipiunt, cum toto concilio
papa intorsit. Eadem quoque sententia damnavit et eos,
qui in officium sic adepti honoris aliquem sacrant.²

¹ The uncertain hold of Urban II on the city of Rome and its surround-
ings is illustrated by the fact that the anti-pope, Clement III, was able
to maintain himself at Albano until October 1099, when he moved to Tivoli
and then to Sutri. The circumstances of Urban II's death also show the
disturbed state of the city. Urban II died on 29 July 1099 in the fortress
of his supporter Petrus Leonis 'apud sanctum Nicolaum in Carcere', where
he may have retreated for safety, and his body had to be moved to Saint
Peter's 'per Transtyberim propter insidias inimicorum'. (See G. Meyer
von Knonau, *Jahrbücher des Deutschen Reiches unter Heinrich IV und Heinrich V*,
v, pp. 71-80, for these and other signs of disturbance, and the authorities
there quoted.)

² The proceedings of the Vatican Council of 1099 are more fully
described in *H.N.* pp. 112-14. Eadmer here omits to mention the decree
against clerical homage, which was one of the main issues in the years
1100-06, perhaps because it was reversed in the agreement of 1106. The
words with which he describes this decree in *H.N.* p. 114 are essential for
understanding Anselm's actions during these years. After describing the
investiture decree in words similar to those in the *Life*, *H.N.* continues:

of their loyalty to the emperor. More than once, when Anselm was going with his companions from the Lateran to Saint Peter's, they banded themselves together and wanted to capture him because of their hostility to the pope.[1] But as soon as they saw his face, they were filled with fear and, throwing down their arms, they prostrated themselves on the ground and asked him to favour them with his blessing. Everywhere he was followed by similar marks of popular honour and good-will, for in all his actions his life was spent in the service of God. Hence scarcely anyone in Rome referred to him simply as that 'man' or 'archbishop', but—as if it were his own name—as 'the Saint'. And all we who served him were likewise held in universal love and honour.

xxviii. *How the pope held a Council at Rome and excommunicated both laymen who give investiture of churches and those who receive them at their hands*

When the Council I have mentioned came on, and had dealt with whatever seemed to need correction or decision, the pope and the whole Council launched a sentence of excommunication both against laymen who give investiture of churches and against those who receive them from their hands. He also pronounced the same sentence against those who consecrate anyone to an office obtained in this way.[2]

'Eos nihilominus sub ipsius anathematis vinculo colligavit, qui pro ecclesiasticis honoribus laicorum hominum homines fiunt, dicens nimis execrabile videri, manus quae in tantam eminentiam excreverunt, ut, quod nulli angelorum concessum est, Deum cuncta creantem suo ministerio creent et eundem ipsum pro redemptione et salute totius mundi summi Dei Patris obtutibus offerant, in hanc ignominiam detrudi ut ancillae fiant earum manuum quae die ac nocte obscenis contagiis inquinantur, rapinis ac injustae sanguinum effusioni addictae commaculantur. His praesentes fuimus, haec conspeximus, his ab universis, "Fiat, fiat", acclamari audivimus, et in his consummatum concilium scimus.' Eadmer is the only

xxxix. *Quod a Roma Lugdunum reversus præcipuo honore habitus sit*[1]

Soluto conventu.' accepta licentia Roma digredimur. Via vero redeundi multis erat periculis obnoxia, sed protegente nos Domino pericula cuncta evasimus, ac Lugdunum illesi pervenimus. Ubi summo cum honore gaudioque suscepti, et a pontifice civitatis venerabili scilicet Hugone detenti.' mansionem nostram illic firmavimus, amissa omni fiducia vivente rege Willelmo Angliam remeandi. Habitus est ergo ibi Anselmus non sicut hospes aut peregrinus, sed vere sicut indigena et loci dominus. Unde nusquam ipse ipsius urbis antistes eo præsente suo volebat loco præsidere, sed præsidente ubique Anselmo.' ille mira humilitate et honestate præditus, inferioris et quasi suffraganei loco simul et officio fungebatur. Super hæc ut episcopale officium per totam parochiam suam pro velle exerceret.' in voluntate ejus ac deliberatione constituit. Quod ubi per loca vicina innotuit.' ilico frequens populorum concursus factus est, unctionem sacri chrismatis per impositionem manus ejus[a] poscentium sibi conferri. At ille omnes ad gratiam ipsius sacramenti[2] admittebat, ita ut sepissime in hoc totus dies

source for the decree on homage, which was by his account a last-minute addition made by the pope himself. Other sources emphasise a variety of different subjects—the Crusade and Friday feasting (*Chronicon S. Maxentii Pictavensis*, ed. Marchegay and Mabille, *Chroniques des églises d'Anjou*, 1869, p. 418), the Greek schism (*Gesta Lamberti Atrebatensis episcopi, P.L.* 162, 644), clerical concubines and the Crusade (*Bernoldi chronicon, M.G.H. SS.* v, p. 466) without mentioning either homage or investitures. The date of the Council is also reported with slight variations in different sources but all are agreed that it was in the third week after Easter, probably 24-5 April 1099. (For sources, see G. Meyer von Knonau, *Jahrbücher des Deutschen Reiches unter Heinrich IV u. Heinrich V*, v, p. 71 *n.*, and Mansi xx, cols. 961-4, where the Acts of the Council so far as they have survived are printed.)

 [a] EIUS: ILLIUS αβEF

xxxix. *How he returned to Lyons from Rome and was held in great honour*[1]

When the Council was over, we obtained permission and left Rome. Our return journey was beset with many dangers but, by God's protection, we escaped them all and came to Lyons without harm. Here we were received with great honour and joy, and invited to stay by the venerable archbishop of the city, Hugh; so we fixed our abode here, having lost all hope of returning to England while king William was alive. In this place, Anselm was treated not like a guest or a foreigner, but like a native and lord of the place. Hence the prelate of the city himself never willingly presided in his own see while Anselm was present, but with amazing humility and goodness he assumed the position and performed the offices of an inferior, and almost of a suffragan. Besides this he ordained that Anselm should perform episcopal functions throughout his diocese whenever he wished and saw fit. When this became known in the surrounding countryside the people frequently flocked to him, asking to be anointed with the holy oil in the laying on of his hands. For his part he admitted them all to the benefit of this sacrament,[2] so that the whole day was very often spent in its administration, and we who assisted him

[1] This chapter repeats in slightly shorter form *H.N.* pp. 114-15. Eadmer once more omits the expression of dissatisfaction with the pope which occurs in *H.N.* p. 114: 'Roma digredimur, nil judicii vel subventionis praeterquam quod diximus per Romanum pontificem nacti.' (See above p. 113.) Anselm left Rome the day after the Council ended (*H.N.* p. 114: *postera die*); at his slow rate of travel he would reach Lyons towards the end of May 1099.

[2] *scil.* of Confirmation.

expenderetur, et nos qui ei ministrabamus gravi tedio afficeremur, ipso semper jocundo et hilari vultu existente. Crevit autem ex hoc in eum mira quædam et incredibilis dilectio omnium, et bonitas ejus divulgabatur per circuitum.

xl. *Qualiter duo milites a quartanis febribus per reliquias mensæ illius Viennæ sint liberati*

Igitur qui illis diebus saltem reliquias de mensa illius poterat habere, contra omnia pericula et infirmitates se salutifera credebat medicina ditatum. Nec ista fides eos fallebat. Nam re vera nonnullos febribus tentos, et quibusdam aliis infirmitatibus pressos, mox sumptis ciborum ejus reliquiis novimus integræ sanitati restitutos. Exempli gratia, Festivitas Beati Mauricii celebris habetur Viennæ.[1] Rogatus itaque Anselmus a Guidone ipsius urbis archiepiscopo,[2] in ipsa festivitate venit eo.[a] Et celebrato solenni missæ et prædicationis officio cum ad refectionem corporis sedisset, venerunt ante illum milites duo, voce et vultu egrotationis molestiam qua premebantur præferentes, rogantes quatinus de micis sui panis eis dare dignaretur. At ille 'Nequaquam' inquit. 'Nec enim pane integro, nedum micis vos indigere conspicio. Sed si comedere vobis placet, locus amplus est; sedete, et cum benedictione Dei quæ vobis apponentur comedite.' Responderunt se pro hoc non venisse. 'Nec ego' ait 'vobis aliud faciam.' Intellexerat enim quo intenderent. Unus ergo ex iis qui in ejus dextra sedebant, intelligens

[a] eo venit VRP

[1] 22 September. Since Anselm was in Lyons from May 1099 to August 1100 the year must be 1099.

[2] Guido, archbishop of Vienne, 1088-1119; pope, as Calixtus II, 1119-24. For his abortive legatine mission to England in 1101, see *H.N.* p. 126.

were overcome with weariness, while he remained bright and cheerful to the end. Out of this there grew up a wonderful and unbelievable love for him among all the people, and his goodness was the talk of the whole neighbourhood.

xl. *How two knights were cured of quartan fevers by scraps from his table at Vienne*

Hence, whoever in those days was able to obtain even the leavings from his table believed that he was endowed with a cure and remedy against all dangers and diseases. And their faith did not deceive them. For we knew some without doubt who were afflicted with fevers or suffering from other infirmities, and who were restored to perfect health as soon as they had eaten some of the remains of his food. For instance: the Feast of St Maurice is solemnly observed at Vienne,[1] and Anselm went there for the Feast at the invitation of Guy, the archbishop of the city.[2] After he had celebrated High Mass and preached, and was sitting down to take some refreshment, two knights came to him. Both their voice and appearance bore witness to the ravages of the sickness from which they were suffering. They asked that he would deign to give them some crumbs of his bread. But he said: 'Certainly not; for I see that you are not in need of even a whole loaf, much less some crumbs. But if you will please eat, there is plenty of room: sit down and eat what is placed before you, with God's blessing.' They replied that they had not come for this. 'And I,' said Anselm, 'will do nothing else for you but this'—for he had understood their intention. One of those, there-

illos salutis propriæ curam habere, et virum in hoc nichil quod miraculo posset ascribi velle facere.' quasi eorum importunitate pertesus, arrepta desuper mensa fragmenta præbuit eis, et ne hominem fatigarent secedere monuit. Qui statim ut exinde modicum gustaverunt.' cum benedictione viri egressi sunt. Post mensam in secretiorem locum me tulerunt, magnopere postulantes, quatinus adjuti mea ope.' ad missam patris mererentur de manu ejus dominicum corpus et sanguinem sumere. Quos cum libenter audissem, et quando quove^a id fieret edocuissem.' gratiosa voce responderunt, 'Et nos quidem sicut dicis omni excusatione semota veniemus, si hac medicina quam nunc de ipsius mensa suscepimus, a quartanis et mortiferis febribus ac intestinorum tortionibus quibus intolerabili cruciatu concutimur.' liberati non fuerimus. Et hoc erit signi inter nos et te, quoniam si convaluimus non veniemus, veniemus si non convaluimus.' Adquievi dicto, et divisi ab invicem sumus. Non venerunt, quia sicut accepi ab eis qui utrunque noverunt.' eo quod de mensa susceperant ad plenum Dei gratia cooperante^b convaluerunt. Quod quidem si ita non fuisset.' quemadmodum illos infirmitate gravatos sanitati voluisse restitui credibile est.' ita eos ab requisitione istius posterioris medicinæ supersedere noluisse dubium non est. Certo nempe tenebant ista se quin convalescerent falli non posse, scientes quendam non ignoti nominis virum eo solo quod spe sanitatis recuperandæ missæ illius interfuit, a pari tunc noviter^c invaletudine convaluisse.

^a QUOVE: IN LOCO *add.* αβE
^b COOPERANTE *om.* αβ
^c noviter *om.* β

fore, who sat with him at his right hand—knowing that it was their health they were concerned about, and that Anselm would do nothing in this matter which could be ascribed to a miracle—as if wearied by their importunity, seized some scraps from the table and offered them to the men, admonishing them to go away and not pester the archbishop. They immediately ate a portion of what was offered, and went off with Anselm's blessing. After the meal they took me aside and earnestly begged that by my assistance they might be allowed to receive the Body and Blood of our Lord from the hands of the Father at his Mass. I gladly listened to their request, and told them when and where it would take place. They expressed their gratitude, and replied: 'And we, for our part, will come where you have told us without fail, if this medicine which we have just received from his table does not free us from the deadly quartan fevers and belly-aches which cause us intolerable sufferings. And this will be a sign between us and you: if we have recovered we shall not come; if we have not recovered, we shall come.' I agreed to this and we parted. They did not come, because—as I have been told by those who knew them both—by God's grace, they were entirely cured by what they had received from his table. Indeed, if this had not been the case, they would undoubtedly not have neglected to seek this further medicine, when they were clearly so anxious to be restored to health from the sickness with which they were afflicted. For they certainly believed that they could not fail to be cured by this, knowing that a man of no small importance had lately been cured of a similar illness by the mere fact that he attended a Mass of Anselm's in the hope of recovering his health.

s

xli. *Quomodo unus e principibus terræ illius eo quod missæ*
ipsius interfuit ab intestinorum et febrium cruciatibus sit sanatus

Siquidem unus e principibus terræ illius, diu eadem qua
ipsi languoris molestia vexatus fuerat. Hic agnito An-
selmum in æcclesia beati Stephani[1] missam ex more
celebraturum,' festinavit illo, arbitrans sibi ad recuperan-
dam sanitatem utile fore, si missa tanti viri ac benedic-
tione meruisset potiri. Fateor vidimus hominem suorum
manibus innixum æcclesiam introeuntem, mortuo quam
viventi similiorem. Sedit, et finita missa egressus est.
Nobis vero nec quis vel unde, aut cur advenerit scientibus
aut curantibus.' idem vir evolutis paucis diebus ad patrem
venit, flexis genibus ei pro adepta sanitate gratias agens.
Ad quod cum ille obstupesceret,'ᵃ indicavit ei ordinem
gestæ rei, asserensᵇ quod ab ea hora qua se missæ illius
præsentavit, omni doloris vexatione depulsa sanitati re-
stitutus sit. At ille nichil hoc ad se pertinere, sed ipsius
fidei ac meritis beati martiris ad quem divertit ascriben-
dum asserens.' iis quæ saluti animæ illius competerent
eum instruxit, et familiarem sibi effectum, correctiori
vitæ ut post multorum testimonio comperimus reddidit.

ᵃ obstupuisset VRP
ᵇ CONFIRMANS αβℭɪ; affirmans A

[1] The ancient church of St Stephen was the cathedral church of Lyons
until the thirteenth century, when the neighbouring church of St John
acquired this position (*Dictionnaire d'archéologie chrétienne et de liturgie*, x, 250).

xli. *How one of the barons of that district was cured of fevers
and belly-aches by being present at a Mass of Anselm's*

Furthermore, one of the barons of that same district
had long been troubled by attacks of the same sickness
as these men. When he heard that Anselm was going to
celebrate Mass in the church of St Stephen according to
his custom,[1] he made haste to go there, thinking it would
be a help to him in recovering his health, if he could
enjoy the Mass and blessing of so great a man. I can
testify that we saw the man enter the church, supported
by his attendants and looking more dead than alive.
He sat down, and when Mass was finished he went out.
We neither knew nor cared who he was, nor whence he
had come, nor why. Then a few days later, he came to
the Father, giving him thanks on his bended knees for
his new-found health. Anselm was astonished at this,
but the man recounted what had happened and declared
that, from the time when he had been present at the
Mass, all pain and distress had vanished, and he had
been restored to health. Anselm however affirmed that
no credit for this belonged to him, but that it must be
ascribed to the man's own faith and to the merits of the
blessed martyr to whom he had resorted. He then
instructed him in those things which concerned his soul's
health and in making a friend of him, brought him, as
we have since learnt from many witnesses, to a stricter
way of life.

xlii. *Qualiter mulierem mente captam signo sanctæ crucis super eam edito integræ sanitati restituerit*

His fere temporibus[1] Cluniacum euntibus nobis,' occurrit quidam sacri ordinis homo, lacrimosis precibus virum deprecans, quatinus et se oculo misericordiæ, et sororem suam nuper amentem effectam dextera suæ benedictionis dignaretur respicere. Et subdens.' 'Ecce' ait 'in via qua transituri estis inter multos tenetur, sperantes quia si tu domine manum ei[a] imposueris.' continuo favente gratia Dei suæ menti restituetur.' Ad hæc ille muta voce, et quasi surda pertransiit aure. Presbyterum autem eo magis instantem, ac preces multiplicantem, reppulit a se, omnimodis affirmans[b] tam extraneum factum nulla sibi ratione temptandum. Hæc inter procedimus, et illam in medio adunatæ multitudinis comminus teneri conspicimus, furibundos motus, et inhumanos nutus.' vultu, ore, oculis, et totius[c] corporis gestu edentem. Populus itaque virum advenientem circundat, retentis habenis preces ingeminat, ut miseræ mulieri manum imponat, orat, obsecrat. Obsistit ille, dicens quod postulant nequaquam sapientiæ esse. Obiciunt illi vulgi more quæ occurrebant, saltem improbitate vincere gestientes. Tunc vir aliter se non posse evadere sentiens.' hoc solo eis

[a] ei domine manum β [b] ASSERENS αβEF
[c] TOTIUS *om.* α (*except* A) β

[1] To judge from its position in the narrative, and from the fact that prayers for rain were being offered on the return journey, this visit would appear to have taken place in the spring or summer of 1100. Probably at this time Anselm preached the sermon *De beatitudine caelestis patriae*, which was reported by Eadmer (*P.L.* 159, 587-606). The case is complicated by another version of the same sermon among the reports of Anselm's *Dicta* by the monk Alexander. Since Alexander was not one of Anselm's companions during his first exile he must have heard the sermon on some other occasion. A comparison of the *Vita Anselmi* and the other records of Anselm's talk, however, provides plenty of evidence that Anselm often

xlii. *How he restored a mad woman to complete health by the sign of the holy Cross which he made over her*

At about the same time,[1] when we were on our way to Cluny, we were met by a man in holy orders who begged Anselm with tears to deign to look upon him with the eye of mercy and to stretch out the right hand of his blessing over his sister who had lately gone mad. And he added: 'Look—there is a crowd holding her in the way you are to pass by in the hope that if you, my lord, lay your hand upon her, she will at once, by the grace of God, be restored to her right mind.' At this Anselm said nothing and passed by as if he were deaf. The priest became all the more urgent and redoubled his prayers, but Anselm repulsed him, firmly protesting that on no account would he attempt anything so extraordinary. Meanwhile we continued on our way, and we saw her close at hand, held in the middle of a large crowd, gesticulating wildly and making inhuman grimaces with her face, mouth, and eyes, and in the movements of her whole body. The people therefore surrounded Anselm as he approached, taking hold of his reins, reiterating their prayers and beseeching him to lay his hand on the wretched woman. He resisted, saying that what they asked was most unwise. They made whatever answer came into their minds, as the manner of crowds is, trying to convince him by insults if nothing else. Then Anselm, feeling that he would not escape on any other terms, gave way to them to this extent—and it

repeated the same thoughts, sometimes in the same words, and there would be nothing unusual in the same sermon being preached on various occasions. For the whole subject, see *St Anselm and his Biographer*, pp. 362-4.

morem gessit, videlicet quod nulli negare solebat signo
eam sanctæ crucis levata dextra signavit. Quo facto.'
laxatis habenis otior abit. Impositoque cucullo capiti
suo*.' remotis sociis singularis vadit, infelicis feminæ
erumnas, pietatis affectu* tenerrime deflens. Hac nos
contritione afflicti Cluniacum, illa vulgi manibus acta
domum tetendit. Necdum pes ejus limen suæ domus
attrivit, et integerrimæ sanitati donata.' in laudem viri
linguas omnium solvit. Quam rem sic factam dum certa
relatione Cluniaci accepissemus.' gavisi sumus, et pro sua
misericordia gratiam Deo* et gloriam dedimus.

xliii.　*Qualiter ad preces ejus pluvia copiosa descenderit*

Actis deinde propter quæ Cluniacum advenimus.' rever-
suri Lugdunum iter per civitatem Matisconensem ar-
ripuimus. Ubi Anselmus rogatu episcopi et canonicorum
missam publice apud Sanctum Vincentium celebravit,
et inter sermonem quem ad populum habuit.' ut omnes
Dominum pro siccitate qua in immensum terra aruerat
communiter precarentur admonuit. Dicunt se id jam
sepius fecisse sed nil effecisse, et ea re ut ipse prece sua
preces eorum* coram Deo* efficaces efficiat.' magnopere
orant et obsecrant. Quid dicam? Nondum* pransi
eramus, et ecce subito stupentibus cunctis serenitas cæli
in nubilum vertitur, ipsaque die priusquam civitatem
egrederemur.' pluvia dulcis et copiosa terris illabitur.
Plebs igitur viso hoc facto.' benedicit* Dominum, et ejus
post Deum auctorem magnis laudibus prædicant An-
selmum. Itaque in habitaculum nostrum Lugdunum

a CUCULLO CAPITI SUO: CUCULLAE SUAE CAPITIO CAPITI αβℰ1
b AFFECTU: PERFUSUS LACRIMIS *add.* αβ　　*c* DEO GRATIAM αβ
d PRECES EORUM IPSE PRECE SUA αβ　　*e* nil effecisse . . . Deo *om.* A
f NECDUM αβ　　　　*g* benedixit β

was his custom to refuse this to no-one: he raised his right
hand and made the sign of the Cross over her. When
he had done this, they let go his reins and he rode quickly
away. He pulled his cowl over his head, drew away from
his companions, and rode on alone, being moved by pity
and bewailing most tenderly the sad plight of the un-
happy woman. While we went on to Cluny afflicted by
this grief, the woman was taken home by the crowd.
But before her feet crossed the threshold of her home, she
was restored to perfect health, and the tongues of all
were loosed in praise of Anselm. At Cluny we received
a reliable report that this had happened, and we rejoiced
and gave thanks and glory to God for his mercy.

xliii. *How a copious rain fell at his prayer*

Then, when we had finished the business which brought
us to Cluny, we set out on our return journey to Lyons,
through the city of Mâcon. Here Anselm celebrated
Mass publicly at St Vincent's at the request of the bishop
and canons. During the sermon which he delivered to
the people, he advised them all to pray together to the
Lord against the drought which had dried the land
exceedingly. They said that they had often done so
already, but had achieved nothing; and they earnestly
begged and prayed him to make their prayers about this
effective with God by the addition of his own. What
then? We had not yet dined when suddenly to every-
body's amazement the clear sky became over-clouded,
and on that same day before we left the city a soft and
abundant rain watered the earth. The people therefore,
seeing this, blessed the Lord, and loudly sang the praises
of Anselm as, next to God, the source of this gift. And
so we returned to our quarters at Lyons, and led a quiet

reversi.' quietam vitam ab omni tumultu negotii secularis agebamus. Anselmus vero vitam veri servi Dei, in sanctis meditationibus, in omnis sexus, ætatis et ordinis hominum ad se venientium edificationibus, ac in cæterarum virtutum exhibitionibus exercebat.

xliiii. *Quod libellum De Conceptu Virginali et alia quædam tunc temporis scripserit*

Per id etiam temporis scripsit librum unum *De Conceptu Virginali et de Peccato Originali*, et aliud quoddam opusculum multis gratum et delectabile, cui titulum indidit, *Meditatio Redemptionis Humanæ.*[1]

xlv. *De obitu papæ Urbani, et de signis mortem regis Anglorum præsignantibus*

Inter hæc Urbanus sedis apostolicæ pontifex huic vitæ decedit,[2] et ad inducias quas de causa Anselmi regi dederat non pervenit. Quo tempore multa etiam de regis interitu a multis prædicebantur, et tam ex signis quæ nova et inusitata per Angliam monstrabantur, quam et ex visionibus quæ pluribus[a] religiosis personis revelabantur,[3] quia ultio Divina in proximo eum pro persecutione Anselmi oppressura esset ferebatur. Sed Anselmus in nichil eorum animum ponens.' cotidie pro conversione et salute ejus Deum deprecabatur.

[a] pluribus *om.* CЄ1

[1] For the *De Conceptu Virginali et de Originali Peccato*, see Schmitt, II, pp. 137-73; and for the *Meditatio Redemptionis humanae*, the last and longest of Anselm's Meditations, Schmitt, III, pp. 84-91. Eadmer is our sole authority for their date 1099-1100, but this is from every point of view entirely acceptable.

[2] Urban II died 29 July 1099.

[3] Signs and visions are reported by *Fl. Wigorn.* (II, p. 45) in the annal for this year: 'Eiusdem regis tempore, ut ex parte praetitulatum est, in sole, luna, et stellis multa fiebant signa; mare quoque littus persaepe egrediebatur, et homines et animalia summersit, villas et domos quamplures

life remote from the tumult of secular affairs. Anselm indeed lived like a true servant of God in holy meditation, in the edifying of all who came to him of every sex, age and condition of life, and in the exercise of every other virtue.

xliv. *How at this time among other things he wrote a book On the Virgin Birth*

During this time he also wrote a book *On the Virgin Birth and Original Sin*, and another small work which found favour and gave joy to many, which he entitled *A Meditation on Human Redemption*.[1]

xlv. *Concerning the death of Pope Urban and the signs fore-telling the death of the king of the English*

Meanwhile Urban, the bishop of the Apostolic See, de-parted this life[2] before the period of grace which he had granted the king in the Anselm affair had ended. At this time also many things were prophesied by many people about the king's death, and it was said—both because of the strange and unusual signs which were seen throughout England and because of the revelations which were made to many religious persons in visions[3]—that the Divine vengeance was soon going to fall on him for his persecution of Anselm. But Anselm gave no heed to these things and daily prayed God for the king's conversion and safety.

subvertit; in pago qui Barrucscire nominatur, ante occisionem illius, sanguis de fonte tribus septimanis emanavit (this detail is also in *A.S.C.*, where it may be a doublet of the entry for 1098; see Plummer, II, p. 286); multis etiam Normannis diabolus in horribili specie se frequenter in silvis ostendens, plura cum eis de rege et Rannulfo (*scil.* Flambard) et quibusdam aliis locutus est.'

Ordericus Vitalis (iv, 83, 6) also independently reports that, in the month of July, . . . 'horrendae visiones de rege in coenobiis et episcopiis ab

xlvi. *Quod sententia damnationis in regem fuerit ante Deum promulgata*

Hinc exilii nostri anno tertio, qui eo quo a Roma Lugdunum venimus erat secundus,' ivit Anselmus Marciniacum loqui domno abbati Cluniacensi Hugoni et sanctimonialibus.[1] Ubi cum ante ipsum abbatem consedissemus, et de iis quæ inter Anselmum et regem eo usque versabantur verba ut fit nonnulla hinc inde proferrentur,' intulit idem venerabilis abbas sub testimonio veritatis proxime præterita nocte eundem regem ante thronum Dei accusatum, judicatum, sententiamque damnationis in eum promulgatam.[2] Ex quibus verbis admirati non modice sumus, sed perpendentes eminentiam sanctitatis ac reverentiæ ejus,' fidem iis quæ*a* dicebat nullatenus

utrisque ordinibus visae sunt; unde populis publicae collocutiones in foris et cimiteriis passim divulgatae sunt.' He goes on to recount a dream of vengeance of a monk of St Peter of Gloucester, which was reported to the king by Abbot Serlo of Gloucester, and a prophetic utterance of Fulcheredus, abbot of Shrewsbury, in a sermon delivered at Gloucester on 1 August.

William of Malmesbury (*G.R.* II, pp. 377-8) likewise says: 'Multa de ipsius nece et praevisa et praedicta homines ferunt, quorum tria probabilium relatorum testimonio lecturis communicabo.' His three examples were: Eadmer's story in cap. xlvi, a dream of the king the night before he died, and a dream of a foreign monk which Robert fitz Haimo told to the king. Robert fitz Haimo had very close links with Gloucester Abbey, and it may well be that the stories of William of Malmesbury and Ordericus Vitalis, in so far as they are independent of Eadmer, all came from the same source, the abbey of St Peter, Gloucester.

a dicebat . . . Itaque cum (*cap. 51 inc.*) om. B, *which here lacks one leaf*

[1] The date is July 1100, which Eadmer correctly describes as the third year of the exile beginning in November 1097, and the second year of the stay in Lyons beginning in May 1099. Marcigny was a Cluniac foundation for nuns in which Abbot Hugh had a special interest; cf. Gilo, *Vita S. Hugonis*, ed. A. L'Huillier, *Vie de S. Hugues, abbé de Cluny*, 1888, pp. 586-7. Some years later Anselm tried to get his sister Richeza accepted as a nun at Marcigny but he was frustrated by the opposition of the abbot of Chiusa. (*Ep.* 328 [iv, 114].)

xlvi. *How sentence of damnation was passed upon the king of the English in the presence of God*

Thereafter, in the third year of our exile, and in the second year after our coming from Rome to Lyons, Anselm went to Marcigny to speak with Hugh, the lord abbot of Cluny, and with the nuns.[1] When we were there and were sitting together in the presence of the abbot, certain things passed to and fro in conversation, as usually happens, about the proceedings between Anselm and the king up to that date. Then the venerable abbot interjected, as a matter of assured truth, that during the previous night the king had been accused before the throne of God, judged, and had sentence of damnation passed upon him.[2] At these words we were not a little startled, but—considering the speaker's eminent sanctity and the respect due to him—we were

[2] This conversation took place on 30 July 1100, three days before the king's death. The prophecy is reported independently in Gilo's Life of St Hugh of Cluny: 'Mortem regis momentaneam pater Hugo prenuntiavit sic priusquam accidisset. Erat apud Marciniacum, adjuncto sibi collega consimili, preclaro videlicet Anselmo Cantuariensi archiepiscopo, qui propter justiciam ab archiepiscopatu semotus patris nostri jocundabatur solatio. Ibi dum mundi luminaria se vicarie animarent sermonibus melle dulcioribus, beatissimus Hugo divina revelatione commotus inquit: Quoniam dompnum Archiepiscopum de secretis Dei docere superfluum credimus, vos fratres que dico advertite. Aderant fratres boni testimonii Balduinus de Torniaco, et Emerus sacerdos, & Beccensis Eustachius. Preterita, inquit, nocte, rex Anglorum Willelmus districti judicis sententia mortis proscriptioni est addictus, nec diu fallaci fruetur gloria. Quod predixit amator veritatis, probavit eventus infelicitatis. Eodem quippe anno rex, inimicos conculcans, manu amici vulnus excepit, et domesticus parans obsequium, incurrit nescienter homicidium.' (A. L'Huillier, *Vie de S. Hugues, abbé de Cluny,* 1888, pp. 588-9.) Gilo's work was probably written in 1122. The Lives of St Hugh by Hildebert and the monk Hugh tell the same story without adding any new details. Further records of the conversation between Anselm and the Abbot of Cluny are preserved in the *Dicta Anselmi* (see *M.A.R.S.* IV, 1958, pp. 188-90, 205-13; an edition of this material is being prepared by Dom F. S. Schmitt and myself.

habere nequivimus, et ideo sola verborum ipsius fide contenti, qualiter hoc sciret percunctari omisimus.*

xlvii. *Qualiter clerico ejus revelatum fuerit discidium quod inter illum et regem erat sopitum fuisse, et alii eundem regem obisse*

Postera die cum inde digressi Lugdunum venissemus, et in instanti festo beati Petri quod colitur Kal. Augusti dictis matutinis nos qui circa Anselmum assidue eramus quieti indulgere cuperemus' ecce quidam juvenis ornatu ac vultu non vilis, clerico socio*b* nostro qui prope ostium cameræ jacebat, et necdum dormiens oculos tamen ad somnum clausos tenebat' astitit, vocans eum nomine suo.[1] 'Adam' inquit 'dormis?' Cui dum ille responderet, 'Non.' dixit illi, 'Vis audire nova?' 'Et libens' inquit. At ille, 'Pro certo' ait 'noveris, quia totum discidium quod est inter archiepiscopum Anselmum*c* et regem Willelmum' determinatum est atque sedatum.' Ad quod ille alacrior factus' ilico caput levavit, et apertis oculis circumspectans, neminem vidit. Sequenti autem nocte inter matutinas unus nostrum clausis oculis stabat et psallebat. Et ecce quidam illi cartulam admodum parvam legendam exhibuit. Aspexit, et in ea 'Obiit rex Willelmus' scriptum invenit. Confestim aperuit oculos, et nullum vidit præter socios.[2]

a ET IDEO . . . OMISIMUS *om.* αβ
b SOCIO *om.* αβ
c Anselmum *om.* EF

[1] Adam is the only member of Anselm's household, besides the three monks Baldwin, Eadmer and Alexander, named in the *Life*. His vision took place on the morning of 1 August 1100 before dawn.
[2] This vision took place early on the morning of 2 August 1100. William Rufus died later on this day.

obliged to have faith in what he said; and so we were content to trust his words alone, and omitted to ask him how he knew this.

xlvii. *How it was revealed to one of his clerks that the dispute between him and the king was settled, and to another that the king had died*

The next day, we departed and came to Lyons. On the following day, being the Feast of St Peter which is observed on 1 August, we had said matins, and those of us who were in constant attendance on Anselm wanted to settle down to rest. Then suddenly a young man, comely in dress and appearance, stood beside our fellow clerk, who was lying near the chamber door, not yet asleep but with his eyes shut ready for sleep. He called him by his name.[1] 'Adam,' he said, 'are you asleep?' 'No,' he replied. Then he said, 'Do you want to hear some news?' 'Gladly,' he replied. 'Then know for certain,' he said 'that the whole dispute between Archbishop Anselm and King William is at an end and settled.' At this he became more wide-awake, raised his head and looked round with wide open eyes. But he saw no-one. Then on the next night during matins, one of us was standing singing the psalms with closed eyes. Suddenly someone put a rather small piece of parchment before him for him to read. He looked at it, and on it he found written, 'King William has died.' Immediately he opened his eyes, but he saw no-one except his companions.[2]

xlviii. *Qualiter ignem cælitus lapsum a domibus quas vorabat*
extinxerit

Post triduum abhinc.' ad abbatiam quæ vocatur Casa
Dei multis precibus invitatus Anselmus perrexit.¹ Ubi
cum honorifice susceptus et hospitatus fuisset.' una dierum
fratribus loci ipsius post mensam in lectis suis pausantibus,
subito fragore cælum intonuit, et vibrantibus coruscis
crebra per montem fulgura volitant. Crescit tempestas
illa, et multiplicata non modicum fulminis super domum
qua fænum monasterii servabatur præcipitat. Unde pro-
tinus horridus ignis accensus.' teterrimum atque fœten-
tem ex se fumum per aera sparsit. Quicunque igitur cum
Anselmo in hospitio erant.' timore concussi dissiliunt.
Remansi itaque solus cum solo. At ille lecto decum-
bere volens.' interrogavit me utrumnam ignis qui eru-
perat sopitus esset. Cui cum responderem, auctum esse
potius quam sopitum.' erexit se, et vultu placido atque
modesto dixit, 'Melius est ut nobis provideamus, quia
juxta poetam ª "tunc tua res agitur paries cum proximus
ardet".'² Quo dicto.' ad ignem concitus venit, eoque
viso.' illi mox sanctæ crucis signum levata dextra objecit.
Videres e vestigio flammam ita se demittentem.' acsi pro
suscipienda benedictione illius conquinisceret. Ignis ergo
statim in semet rediens totus elanguit, nec aliquid ab-
sumpturus usquam processit. Quodque fortassis non mi-
nus stupeas.' voratis quibusdam edibus quæ circa erant,

ª IUXTA POETAM *om.* αβℓ1
¹ La Chaise-Dieu, in Auvergne about seventy miles from Lyons, was a
monastery where Anselm's works had long been known (*Ep.* 70-1 [i, 61-2]).
Post triduum implies that he set out from Lyons on 5 August, three days after
the vision which has just been reported. The journey to La Chaise-Dieu
may have occupied several days.
² Horace, *Ep.* I, 18, 84

xlviii. *How he put out a fire which fell from heaven and was consuming some houses*

After three days Anselm went to the abbey called La Chaise-Dieu, to which he had been very pressingly invited.[1] He was honourably received and entertained there, and one day, when the brethren of that place were resting on their beds after their meal, a sudden burst of thunder rent the heavens, and frequent flashes of lightning darted among the hills. The tempest grew, and at its height a great flash of lightning struck the building in which the hay of the monastery was kept. At once a hideous fire broke out there, filling the air with most foul and stinking fumes. Everyone therefore who was with Anselm in the guest-house leaped up and rushed off in alarm. I was left with him alone. He wanted to lie on his bed, and he asked me whether the fire which had broken out had been extinguished. When I replied that it had rather increased than died down, he got up and said with a peaceful and gentle air: 'We had better look after ourselves, for (as the poet says) "You too are threatened when your neighbour's dwelling burns".'[2] Having said this, he roused himself and came to the fire. When he saw it, he at once raised his right hand and made the sign of the Cross towards it. Instantly you might have seen the flames sinking down as if they were stooping to receive his blessing. Thus the whole fire immediately turned in on itself and died down, nor did it spread further to consume anything else. And what is perhaps not less surprising, is that while some of the surrounding houses were destroyed, no damage was done

nil læsionis intulit fæno monachorum qui Anselmum hos-
pitem habebant, quo scilicet fæno domus ferme plena
erat super quam fulmen *ᵃ* ipsum primo corruerat.

xlix. *Quod gemens fleverit audito regis interitu, et quod a novo
rege Anglorum Angliam remeare diligenter rogatus sit*[1]

Exin duo sui monachi ad Anselmum venerunt, nunci-
antes ei decessum præfati regis.[2] Siquidem secunda die
mensis Augusti qui post primam visionem quam Lugduni
factam noviter retuli secundus, et post secundam primus
illuxit.' idem rex mane in silvam venatum ivit, ibique
illum sagitta in corde percussit, et nulla interveniente
mora extinxit.[3] Quo Anselmus vehementi stupore per-
cussus.' mox est in acerbissimum fletum concussus. Quod
videntes.' admirati admodum sumus. At ille singultu
verba ejus interrumpente.' asseruit quia si hoc efficere
posset, multo magis eligeret seipsum corpore, quam illum
sicut erat mortuum esse. Nobis post hæc Lugdunum
reversis.' ecce nuncii unus post unum Anselmo occurrunt,
litteras ei cum precibus ex parte matris æcclesiæ Anglo-
rum, ex parte novi regis Henrici qui fratri successerat,
necne ex parte principum regni deferunt, summopere
postulantes eum festinato gressu redire, et asserentes

ᵃ FULMEN: FULGUR αβ

[1] This chapter compresses a somewhat longer account in *H.N.* pp.
118-19.

[2] According to *H.N.* p. 118 the news of the king's death reached Anselm
on the third day of his visit to La Chaise-Dieu, probably soon after the
middle of August 1100. Of the two monks who brought the message, one
came from Canterbury and one from Bec (*ibid.*). The speed with which
the news was brought, suggests that a monk of Canterbury was at the king's
court and crossed directly to Normandy taking in Bec *en route*. This would
make possible the chronology of events given by Eadmer.

[3] John of Salisbury, *Vita S. Anselmi*, *P.L.* 199, 1031, adds a detail which
is worth preserving: 'Sic, sic patiente Basilio, letali telo ad consolationem
ecclesiae perimitur Julianus; et altero Juliano perempto in Anglia, ad
consolationem ecclesiae revocatur Anselmus. Quis alterutrum miserit telum

to the hay of the monks whose guest Anselm was, although the building which the lightning first struck was almost full of hay.

xlix. *How he lamented and wept when he heard of the king's death; and how he was earnestly invited by the new king of the English to return to England*[1]

After this, two of his own monks came to Anselm announcing the death of the aforesaid king.[2] In fact, on 2 August—the second day to dawn after the first vision at Lyons which I have just described, and the day following the second vision—the king went hunting in a wood in the morning, and there an arrow pierced his heart and killed him instantly.[3] At this Anselm was utterly stupefied and soon burst into bitter tears. We onlookers were somewhat surprised. But he declared, in words broken with sobs, that if it had been possible he would much rather that his own body had died than that the king had died in his present state.

We then returned to Lyons, and messengers came to Anselm one after the other bringing letters with requests from the mother church of the English, from the new king, Henry, who had succeeded his brother, and also from the barons of the kingdom, begging him with all earnestness to return quickly, asserting that the whole

adhuc incertum est quidem. Nam Walterus Tyrrellus ille, qui regiae necis reus a plurimis dictus est, eo quod illi familiaris erat et tunc in indagine ferarum vicinus, et fere singulariter adhaerebat, etiam cum ageret in extremis, se a caede illius immunem esse, invocato in animam suam Dei iudicio, protestatus est. Fuerunt plurimi, qui ipsum regem iaculum quo interemptum est misisse asserunt, et hoc Walterus ille, etsi non crederetur ei, constanter asserebat.' The considerable body of evidence and legend about the king's death has been assembled and fully discussed by E. A. Freeman, *The Reign of William Rufus*, II, pp. 657-76.

T

totam terram in adventum illius attonitam, omniaque
negotia regni ad nutum ejus pendere dilata.[a][1]

1. *Quod rex Henricus Romana decreta postponens Anselmum in
multis afflixerit, et tandem pro mutandis ipsis decretis ut ipse
Romam rediret poposcerit*

Verum ubi Serberiam ad regem venit,[2] et ei quid de
æcclesiarum investituris in Romano concilio acceperit
plano sermone innotuit,[v] turbatus est rex ac vehementer
indoluit, nec nutum ejus in aliquo sicut nuncii dixerant
expectare voluit.[3] Quæ igitur inter eos per duos semis
annos pro isto negotio acta sint, et quot quantasve minas
ac tribulationes Anselmus passus sit, vel quomodo nuncii
semel et iterum Romam pro mutatione ipsorum decre-
torum missi sint, quidque effecerint, qui nosse voluerit,[v]
opus illud cujus in prologo hujus opusculi mentionem
fecimus legat, et ibi singula plane[b] ut puto digesta re-
periet.[4] Post quæ omnia,[v] rogavit Anselmum rex qua-
tinus ipsemet Romam[5] iret, et cum nuncio quem eo

[a] His acceptis Anselmus velox Angliam petit. *add.* VRP
[b] plane: plene VRP
[1] On Anselm's return to Lyons, and only then, a letter urging his
return to England arrived from the community at Canterbury; this has
not been preserved. He then set out for England and, before he got to
Cluny, Henry I's letter, written after the coronation at Westminster on
5 August (*Ep.* 212 [iii, 41]), reached him. Anselm arrived at Dover on
23 September (*H.N.* p. 119).
[2] The king was at Salisbury 'in concilio' on 29 September 1100
(*Regesta*, II, nos. 494-5), and it was here that Anselm met him.
[3] From this point the *Life* becomes very brief: for the reason and
probable change in the method of composition, see above p. x. Eadmer
omits to mention that the immediate cause of the dispute was the king's
requirement that Anselm should renew the homage which he had done to
William II. Anselm on his side, following the decrees of 1099, refused to
perform or sanction any such acts of homage, and also stated that, if the
king made any investitures of bishoprics or abbeys, he could have no
communion either with him or with those whom he had invested. For the
sequence of events after this, see *St Anselm and his Biographer*, pp. 168-80.

land was on tip-toe for his arrival, and that all the
business of the kingdom was at a stand-still, hanging on
his wishes.[1]

1. *How King Henry disregarded the Roman decrees and perse-*
cuted Anselm in many ways; and how in the end he proposed that
Anselm himself should return to Rome to get the decrees altered

But when he came to the king at Salisbury[2] and told him
plainly what he had heard in the Council at Rome about
investitures of churches, the king was disturbed and
troubled beyond measure, and he showed no desire to
defer to Anselm's wishes in anything, as the messengers
had said.[3] Whoever wants to know about the negotia-
tions which took place between them on this subject
during the next two and a half years, and the many great
injuries and tribulations which Anselm suffered, not to
mention the two occasions on which messengers were
sent to Rome to obtain a change in these decrees and
what they achieved, should read the work which is
mentioned in the prologue of this little book; and there
he will find, I think, everything plainly set forth.[4] After
all this the king asked Anselm to go himself to Rome[5]
with the messenger whom he would send to lend his

[4] These events are copiously described in *H.N.* pp. 120-47 and are
illustrated by a mass of letters of unprecedented bulk.
 [5] It was after the Easter court of 1103, held at Winchester on 29 March
and on the following days, that Anselm agreed to go to Rome. On the way,
he spent four days at Canterbury and reached Wissant on 27 April. Ead-
mer, *H.N.* pp. 148-9, gives a characteristic explanation for his decision.
The main thing which troubled him was the possibility that he might
communicate with those whom the Council of 1099 had condemned:
'Festinato igitur ratus est Anglia exeundum, ne illic excommunicatis com-
municando aliqua excommunicationis culpa involveretur.' The immediate
reason for his haste was that he had an unopened Papal letter (*Ep.* 281 [iii,
74]) which would (he rightly feared) have led to a chain of excommunica-
tions, if it were opened while he was still in England.

directurus erat, causæ quæ emerserat pro suo honore
opem ferret. In quo cum omnes totius Angliæ episcopi,
abbates et principes adquiescerent, et eum pro tanta re
quin iret nullatenus supersedere debere conclamarent.'
se quidem iturum respondit, sed nil quod vel æcclesiarum
libertati, vel suæ deberet*a* obviare honestati, suo vel
rogatu vel consilio unquam papam acturum viva voce
spopondit.

li. *Qualiter a Roma Florentiam venit, et qualiter a lecto in quo*
quieverat hospes ejus eo discedente cohibitus sit

Itaque cum Romam venisset.' a domino papa Paschale*b*
qui Urbano successerat, totaque urbis nobilitate honori-
fice susceptus est.[1] Die dehinc constituto.' Willelmus ille
cujus supra meminimus[2] a rege directus causam regis in
medium tulit, ac inter alia quod rex ipse nec pro regni
amissione investituras æcclesiarum pateretur amittere
minacibus verbis asseruit. Ad quæ papa, 'Si quemad-
modum dicis rex tuus nec pro regni amissione patietur
æcclesiarum donationes amittere.' scias ecce coram Deo
dico, quia nec pro sui capitis redemptione eas illi ali-
quando Paschalis papa impune permittet habere.' In
his negotium regis finem ita*c* tunc temporis sumpsit,*d* et
Anselmus aliis atque aliis cum papa de æcclesiasticarum
rerum institutionibus actis.'[3] in iter reversus civitatem

a deberet: POSSET αβ
b PASCHALI αβ
c ita finem β
d sumpsit: assumpsit DI

[1] Anselm probably reached Rome in October 1103 after a slow
journey, of which the stages are Wissant on 27 April, Chartres on 18 May
(Whitsunday); then a return to Bec to await cooler weather, and a fresh
start about the middle of August (*H.N.* p. 151).

[2] For William of Warelwast, see above p. 113, *n.* 2. The course of the
negotiations between him and the pope is described at greater length in
H.N. pp. 152-4.

assistance in safeguarding the royal honour in the dispute which had arisen. The bishops, abbots and barons of the whole of England agreed to this, crying out that he should let nothing stand in the way of his going in a matter of so much importance. He replied that he would certainly go, but he openly declared that he would never ask or advise the pope to do anything which could injure either the liberty of the churches or his own honour.

li. *How he came from Rome to Florence, and how after his departure his host was warned off the bed in which he had slept*

When, therefore, he arrived in Rome, he was received with honour by Pope Paschal, who had succeeded Urban, and by all the nobility of the city.[1] A day was then fixed, on which the king's envoy William, whom we have mentioned above,[2] expounded the king's case. Among other things he asserted with threatening words that the king would not submit to the loss of ecclesiastical investiture, even to keep his throne. To this the pope replied: 'If, as you say, your king will not consent to give up the conferring of churches even to keep his kingdom, before God I say, neither will Pope Paschal ever permit him to have them with impunity, even to buy his own liberty.' With these words the king's business was brought to a close for the time being, and Anselm—after various dealings with the pope over the ordering of ecclesiastical affairs[3]—set out on the return journey and

[3] The 'other business' referred to was no doubt the negotiation for the primatial privilege (*Ep.* 303 [iii, 169]) which Anselm took back with him. This is dated 16 November 1103 and he must have left Rome almost immediately afterwards. For this phase in Anselm's negotiations with Paschal II, see *St Anselm and his Biographer*, pp. 136-9.

Florentiam usque pervenit, et nocte una in ea quievit. Lecto igitur in quo sopori antistes indulserat.ʲ dominus domus eo discedente pro more decubuit. Cui obdormienti.ʲ astitit quidam ignoti vultus homo, monens ut lecto otior decederet. 'Nec enim' inquit 'decet te tua præsentia loco præripere, quod ex præsentia tanti viri meruit obtinere.' Qui mane consurgens, et visum mente revolvens.ʲ phantasmati deputat, ac nocte sequenti in eodem se lecto nil hæsitans collocat. Dormit, et ecce qui venerat, secundo jam vultu paulum*ᵃ* minaci assistit, repetens dicta quæ primo protulerat. At ille expergefactus, ac visione ut primo posthabita.ʲ nocte tertia in loco solito*ᵇ* somno se tradit. Et sopore depresso.ʲ*ᶜ* idem qui secundo apparuerat tertio apparuit, irati mentem vultu ac voce prætendens. 'Quare' ait 'facis, quod jam tibi semel*ᵈ* et iterum dixi ne faceres?*ᵉ* Nunc igitur vel tertio admonitus surge, et te a lecto pontificis amodo cohibe. Nam dico tibi quia si ultra in eo repertus fueris.ʲ experieris nichil phantasmatis esse in istis quæ audis.' Tunc ille vehementer exterritus.ʲ lecto desilit, episcopum civitatis super negotio consulturus matutinus*ᶠ* adit, eique ordinem rei in præsentia multorum exponit. Episcopus autem jamdudum viri sanctitatem fama discurrente edoctus, ac nuperrime ex collocutione ipsius eam nonnichil expertus.ʲ hominis audaciam durius increpavit, et quia stulte ac

ᵃ *Many MSS* (MNVTXOYEF) *read* paululum.
ᵇ ѕᴏʟɪᴛᴏ ʟᴏᴄᴏ αβE
ᶜ et sopore depresso: ᴄᴜɪ ᴏʙᴅᴏʀᴍɪᴇɴᴛɪ αβEF
ᵈ semel tibi β
ᵉ ɴᴇ ꜰᴀᴄᴇʀᴇѕ ᴅɪxɪ αβЄɪEF
ᶠ ᴍᴀᴛᴜᴛɪɴᴜѕ: ᴄᴇʟᴇʀɪᴜѕ αβ

came to Florence, where he rested for one night. When he left, the owner of the house lay down as usual on the bed in which the archbishop had taken his rest, and while he slept a man whose features were unfamiliar appeared to him and warned him to get out of the bed quickly. 'For' he said 'it is not fitting that by your presence you should take away from the bed a quality which it has been found worthy to receive from contact with so great a man.' When he got up in the morning and went over in his mind what he had seen, he thought it was mere imagination, and the next night he got into the same bed without hesitation. He slept, and, behold, the man who had come before stood by him a second time with a face somewhat menacing, repeating the words which he had spoken at first. When he awoke, he ignored the vision as on the first occasion, and on the third night went to sleep in his usual place. While he was asleep, the same man who had appeared the second time, appeared yet a third time, bearing the marks of anger in his face and voice. 'Why,' he said, 'do you do what I have already forbidden you to do, not once but twice? Now, therefore, at least at this third warning get up, and from now on keep yourself from the bishop's bed. For I tell you that if you are found in it again you will discover that the things you are hearing are not imaginary.' Then in a violent fright he leaped out of bed, and next morning went hastily to consult the bishop of the city about the affair. In the presence of many witnesses he told him what had happened. The bishop had long been familiar with Anselm's sanctity by report, and he had just had some experience of it in talking to him. He therefore roundly inveighed against the man's audacity, declaring that he had acted stupidly and like

insipientium more egerit, quod lecto ubi vir tantus quie-
verat cubare præsumpsit asseveravit. Eundem itaque
lectum reverenter deinceps servatum iri præcepit, et ne
aliquis in eo ulterius jacere præsumeret, jussit. Quod
usque hodie uti ab eodem viro qui ad nos in Angliam
postmodo venit^a accepimus, servatum est.

lii. *Qualiter reditus in Angliam ei interdictus sit*

Anselmus autem cum emenso itinere Lugduno appro-
pinquasset, præfatus Willelmus comitatum illius deserere
volens, interdixit ei ex parte domini sui regis redire in
Angliam, nisi ipse omnes patris ac fratris ipsius consuetu-
dines postposita sedis apostolicæ subjectione et obœdien-
tia, se ei servaturum certo promitteret. Quod ille audiens,
admiratus est, sciens se alia conditione Angliam exisse.
Perveniens vero Lugdunum, resedit ibi, ex more antiquo
in pace et quiete propriam præfati reverendi Hugonis
ejusdem urbis archiepiscopi domum inhabitans, et ne ad
horam quidem ab iis quæ Dei sunt verbo se vel actu
elongans.[1]

^a AB EODEM VIRO QUI AD NOS IN ANGLIAM POSTMODO VENIT *om.* αβ

[1] The meeting between Anselm and William of Warelwast at Lyons
is described at greater length in *H.N.* pp. 157-8, where the text of the letter
which Anselm wrote to the king (*Ep.* 308 [iii, 88]) is also given. The
general tone of this letter is one of inactive resignation: 'Unde precor ut
mihi vestram, si placet, mandetis voluntatem, utrum sic, quemadmodum
dixi, possim in pace vestra et officii mei potestate redire in Angliam.
Paratus enim sum et vobis et populo divina mihi dispositione commisso
officii mei servitium pro viribus et scientia mea, servata regulari oboedientia,
fideliter exhibere. Quod si vobis non placuerit, puto quia, si quod animarum
detrimentum inde contigerit, mea culpa non erit.'
 There was no period in Anselm's career when his course of action
aroused a greater variety or volume of protest. To the majority even of his
friends, especially in the community at Canterbury, he appeared to be
condemning himself to inactivity over a trifle, as the following extracts
from his correspondence will show:
 'Pro uno verbo cuiusdam Willelmi fugere decrevisti, et relicto hoste
dilacerandas impiis oves tuas dimisisti' (*Ep.* 310 [iii, 170], probably from
Prior Ernulf of Canterbury); 'Nequissime itaque improperant mihi quia

a fool in presuming to lie on a bed where so great a man had rested. So he ordered that the bed should be reverently preserved from then onwards and that no-one should henceforth presume to lie on it. And this order —as we have learned from the same man who afterwards came to us in England—has been observed to this day.

lii. *How he was forbidden to return to England*

When Anselm then had continued his journey and was approaching Lyons, the aforesaid William desired to leave his company, and forbade him on behalf of his lord the king to return to England unless he would definitely promise to ignore his submission and obedience to the Apostolic See, and to observe towards the king all the customs of his father and brother. When he heard this he was astonished, for he knew that he had left England on quite different terms. But when he reached Lyons he settled down there, living as of old in peace and quietness in the house of the already mentioned and revered archbishop of the city, Hugh; and not an hour passed in which he was not engaged either in word or deed in the things which belong to God.[1]

aliena curo, mea negligo' (*Ep.* 327 [iii, 100] to Ordwy a monk of Canterbury); 'Queritur caritas vestra quia propter contemptibilia verba unius clerici non redii in Angliam; sed non ita est' (*Ep.* 330 [iv, 44] to Gundulf bishop of Rochester); 'Ad hoc autem quod dicis te audisse quia non magnopere curo ad vos redire: respondeo quia, postquam de Anglia exivi, numquam intellexi quomodo rationabiliter redire possem' (*Ep.* 336 [iv, 45] to Ordwy); 'De hoc quod tu, frater et fili Ordwie, obtendis mihi quia non redeo in Angliam: scito quia non fugio mortem, non abscisiones membrorum, non quaelibet tormenta, sed peccatum et ignominiam ecclesiae dei, et maxime Cantuariensis' (*Ep.* 355 [iii, 108] to Farman, Ordwy and Benjamin of Canterbury); 'Quae modulando / clara solebat / dicere laudes / fistula vestras / murmure rauco / nunc canit, atque / lugubris extat; / dicit et "unde / vos ab ovili, / pastor, abestis?"' (*Ep.* 366 from Gilbert Crispin, Abbot of Westminster).

These extracts reflect the general attitude in England among Anselm's

liii. *De cæco illuminato* [a]

Accidit autem una dierum, dum ipse pater celebrato solenni missæ officio, solus uti sepe solebat[b] in oratorio per fletum Deo sese mactaret,[.] ut quidam homo pedes suos baculo regente adveniret, oratorium ipsum irrumpere gestiens. Quem frater et socius noster Alexander,[1] monachus scilicet æcclesiæ Cantuariensis, qui pro foribus egressum patris[c] præstolabatur,[.] intuens æcclesiam subire volentem,[.] detinuit, sciscitans quidnam vellet. At ille clamosa voce se oculorum lumen amisisse respondit, ac velle ut servus Dei manum sibi imponeret, sciens quod sancta merita ejus sibi subvenirent. Pater igitur clamorem audiens, sed verba minime discernens,[.] innuit nominato[d] fratri venire ad se, et causam ipsius clamoris intimare. Tunc ille, 'Domine pater' ait, 'pauper unus[e] venit,[f] conquerens se in oculis gravi dolore vexari,[g] precaturque per vos eis signum sanctæ crucis imponi.' At ipse pio vultu, 'Veniat' dixit. Itaque tertio super oculos ejus quod petebat signum crucis cum pollice pingens,[.] oravit sic, 'Virtus crucis Christi illuminet oculos istos, et ab eis omnem infirmitatem depellat, integræque sanitati restituat.' Et aspergens eos aqua sanctificata,[.] hominem

closest friends. By contrast, it is probable that in Lyons Anselm was under pressure to pursue a more determined policy of hostility to Henry I.

[a] NM *omit this chapter entirely; in* A *it is misplaced (see above p.* 91); *in* B *it occurs in the right place but it is distinguished from the rest of the text by a large capital letter and the first sentence reads:* Accidit autem una dierum dum ipse pater Anselmus Lugduni moraretur celebrato solenni missae officio . . . (*the text which follows is of the early recension*); *in* VRP *the chapter is paraphrased and reads:* Quadam die dum ibi moraretur celebrato solemni missae officio, dum in oratorio per fletum Deo se mactaret, venit quidam homo baculo regente oculorum lumen se emisisse dicens ac velle ut servus Dei manum sibi imponeret. Quem mox vir sanctus accersiri iussit tertioque super oculos eius quod petebat signum crucis cum pollice pingens oravit sic, 'Virtus crucis Christi illuminet oculos istos'. Et aspergens eos aqua sanctificata omni caecitate fugata hominem praecepit abire. *For an explanation of these peculiarities see p.* xiii.

liii. *Concerning the healing of a blind man*

It happened one day that, after the solemn celebration
of Mass, the Father, as he was wont, was alone in a
chapel, offering himself to God with many tears, when
a man guiding his footsteps with a stick approached the
chapel and tried to burst in. Our companion, brother
Alexander,[1] a monk of the church of Canterbury, hap-
pened to be waiting beside the door for the Father to
come out. Seeing that the man wanted to enter the
chapel, he detained him and asked him what he wanted.
At this he made a loud outcry and replied that he had
lost the sight of his eyes and wanted the servant of God
to lay his hand on him; for he knew that his holy merits
would come to his aid. The Father then, hearing the
noise but not at all distinguishing the words, signalled to
the aforesaid brother to come to him and tell him the
cause of the outcry. He therefore said: 'My lord and
father, a poor man has come here complaining that he is
grievously troubled with his eyes and he begs you to
make the sign of the Cross over them.' 'Let him come,'
he said with a look of compassion. Then with his thumb
he thrice made the sign of the Cross on his eyes as he had
asked, and prayed thus: 'May the virtue of the Cross of
Christ illuminate these eyes, and cast out all their
infirmity, and restore them to perfect health.' Then he

^b uti sepe solebat: PROUT EI CONSUETUDINIS ERAT ABβ
^c patris: FORTE *add.* ABβ
^d nominato: PRAEFATO ABβ
^e unus: QUIDAM ABβ
^f venit: HUC *add.* ABβ
^g gravi dolore vexari: GRAVITER AFFLIGI ABβ
[1] This is the first mention of Alexander in the *Life*, though he had been
a member of Anselm's household since 1101.

præcepit abire. Alexander vero mox illum reducens.ʲ
monuit ut si factum viriᵃ non usquequaque illi hac prima
viceᵇ profuissetᶜ mane rediret, pollicens seᵈ hoc ipsum
illi repetita vice fieri impetraturum.ᵉ Ad quæʲ ille, 'Ego
equidem, bone domine hac de causa non redibo, quia
gratia Dei et fidelis famuli ejus omni cæcitate fugata
clarissime video.' Hæc ita scripsi, sicut ab ore ipsius
Alexandri qui præsentem se fuisse testatur accepi. Ego
enim aliis ut fit occupatus intendebam.ᵍ

liiii. *Quod rex Angliæ Anselmum suis omnibus spoliaverit*

Rex autem Heinricus ut comperit papam in sua sententia
stare.ʲ mox archiepiscopatum in dominium suumʰ rede-
git, et Anselmum suis omnibus spoliavit. Acta sunt hinc
inter eos multa, et anno uno ac semis indignatio regis
non est sopita.

lv. *De reliquiis sanctæ Priscæ martiris*

Inter hæc venit ad nos Walo episcopus Parisiacensis,[1]
vir bene religiosus, et ecclesiasticarum consuetudinum
institutionibus ab ineunte ætate imbutus. Hic Romæ
notus, et apostolicæ legationis ministerio functus.ʲ[2] fami-

ᵃ viri: DEI *add.* ABβ
ᵇ VICE PRIMA β
ᶜ PROFUIT ABβ
ᵈ se: QUOD ABβЄI
ᵉ IMPETRARET ABβЄI; impetrare A
ʲ quae: quem A
ᵍ EGO ENIM ALIIS UT FIT OCCUPATUS INTENDEBAM *om.* ABβ
ʰ SUUM DOMINIUM αβ

[1] Walo had been a pupil and successor of Ivo of Chartres as a regular
canon and abbot of St Quentin, Beauvais. He was elected bishop of
Beauvais in 1100 but never succeeded in getting possession of his see, despite
letters in his favour from Anselm (*Ep.* 272 [iii, 69]) and Ivo of Chartres
(*Ep.* 87, 89, 92, 93, 97, 104, 105). In 1104 he became bishop of Paris and
went to Rome for consecration, returning with papal letters dated 6 April
1105 (J-L nos. 6019, 6020). It must have been on his return journey in
April or May 1105 that the incident here described took place.

sprinkled them with holy water and told the man to go. Alexander then led him away, advising him to come back the next day if the action of the man of God had not benefited him at the first attempt, and promising that he would bring about a repetition of the same act on his behalf. To this he replied: 'I shall certainly not return on this account, my good sir, for by the grace of God and of His faithful servant, all my blindness has gone away and I see with perfect clearness.' I have written this as I heard it from the mouth of Alexander, who testifies that he was present; for I happened to be busy and was attending to other things.

liv. *How the king of England despoiled Anselm of all his possessions*

Now King Henry, when he heard that the pope was firm in his decision, at once took the archbishopric into his own hands and deprived Anselm of all his possessions. There were many negotiations between them over this, and the king's anger was not appeased for a year and a half.

lv. *Concerning the relics of the martyr St Prisca*

During these proceedings Walo bishop of Paris came to us.[1] He was a man of sound religion, and steeped in ecclesiastical customs and discipline from an early age. He was well-known at Rome, had filled the office of papal legate,[2] and enjoyed the friendship of father

[2] Walo had been sent to Poland as a papal legate during the time when he was vainly trying to get possession of the see of Beauvais. See *Annales capituli Cracoviensis, M.G.H. SS.* xix, p.588: 'Gualo episcopus Belvacensis sedis apostolicae legatus intrat Poloniam anno 1104.' (1103 would probably be more correct: see P. Fabre, 'La Pologne et le Saint-Siège du X^e au XIII^e Siècle,' in *Études d'histoire du Moyen Age dédiées à Gabriel Monod*, 1896, p. 169n.)

liaritate patris Anselmi potiebatur. Iste igitur a Roma
ad nos veniens.' quorundam sanctorum reliquias secum
ferebat, quas ut certo comperimus sibi Romæ datas
habebat. Itaque cum Anselmo me præsente loquens.'
innotuit ei quid reliquiarum a Roma secum detulerit.
Ad quod cum ille Deo gratias ageret.' episcopus os unum
quod de capite beatæ martiris Dei Priscæ esse asserebat
protulit,ᵃ et id qualiter adeptus fuerit ilico subinferens ait,
'Romæ eram, et oratorium nominatæ martyris in quo
beatissimus apostolorum princeps Petrus altare sacravit
vetustate consumptum dirutum est, et corpus martyris in
nova recondendum æcclesia me astante levatum.¹ Igitur
cum loci ipsius cardinalis reliquias sanctæ in suo jure
haberet, et ipse idem mihi familiaris existeret.' os istud
quod videtis de sacro corpore sumptum, michi pro signo
mutui amoris dedit.' Finierat præsul in istis. Ast ego
earundem reliquiarum habendi amore illectus.' ut ex ipso
osse michi partem daret deprecari episcopum cœpi. Et
ille, 'Accipe' inquit, 'et quantum inde primo conatu
frangere poteris, tuum sit.' Accepi, et en extra quam
sperabam in principio mei conatus una michi particula
in dextera manu remansit. Cumque de parvitate ipsius
merorem animi dissimulare nequirem, et ut semel adhuc
inde frangere michi liceret magnopere gestirem.' rupit
desiderium meum pater Anselmus et ait, 'Noli noli; quod
habes sufficiat tibi. In veritate quippe dico tibi, quia
pro toto auro quod Constantinopolim et ultra citrave
habetur, non omitteret domina ipsa cujus est quin illud

ᵃ protulit: E PIXIDE PROTULIT αβEF
¹ Rome was the scene of considerable activity in church restoration
in the early twelfth century, but nothing is known about the restoration
of the church of St Prisca at this time. The tradition of St Peter's connec-
tion with the church has been kept alive by the existence of a font in the

Anselm. He came to us then from Rome, and brought with him relics of certain saints, which—as we found out for certain—had been given to him at Rome. For when he was talking to Anselm in my presence, he told him what relics he had brought with him from Rome. At this Anselm gave thanks to God, and the bishop produced from a box a single bone which, he said, came from the head of the blessed martyr of God, Prisca. Explaining how he got it, he added: 'The church of this martyr, in which the altar was consecrated by Peter the most blessed Prince of the Apostles, was decayed and broken down with age. When I was in Rome, the body of the martyr was taken up so that a new church could be built.[1] I was present at this, and since the cardinal of that church, who had charge of the saint's relics, was a friend of mine, he took this bone, which you see, from the holy body, and gave it to me as a token of our mutual affection.' The bishop stopped speaking; then, drawn on by a love of having some of these relics, I began to entreat the bishop to give me a piece of this bone. 'Take it,' he said, 'and as much as you can break off at your first attempt shall be yours.' I took it, and, behold, it turned out otherwise than I hoped: just as I began to pull, a piece came away in my right hand. When I was unable to hide my chagrin at its smallness and earnestly pressed him to allow me to break off another piece, Anselm broke off my petition. 'No, no,' he said, 'let what you have be sufficient for you. Truly I tell you that the lady whose it is will not fail to claim it for herself in the day of general Resurrection, not for all the gold which is in Constantinople, or on this side

crypt at which he was believed to have administered baptism. See C. Huelson, *Le chiese di Roma nel medio evo*, 1927, p. 424.

sibi vindicaret in die resurrectionis cunctorum. Quam
ob rem si debitam illi reverentiam exhibueris.' æque
suscipiet, ac si toti corpori ejus exhiberes.' Quod ego
audiens.' adquievi, et quam decentius potui ipsum os *a*
hucusque servavi. De quo osse post plures dies Petrus
quidam monachus Cluniacensis, vir suo tempore magnæ
auctoritatis, qui camerarius erat domini papæ Urbani
atque Paschalis[1] ad nos veniens, a me percunctatus est
quid sentiret. At ille ubi me referente accepit qualiter
id adeptus fuerim.' vera omnino esse confessus est quæ
episcopus inde dixerat, seque præsentem fuisse asseruit,
quando idem os a corpore martyris sublatum a cardinali
susceperat.

lvi. *Qualiter rex et Anselmus sint reconciliati*

Post hæc cum pro exercendo æcclesiasticæ disciplinæ
rigore, tum pro æcclesiarum in Anglia constitutarum
relevatione.' relicta Burgundia Anselmus Franciam ivit.[2]
Quod ubi regi Anglorum Heinrico innotuit.' rogatus ad
eum in Normanniam venit; ibique rex timore simul et
amore Dei correptus.' revestivit illum de suis, et in ami-
citiam ejus receptus est.

lvii. *Quomodo Anselmus ab infirmitate convaluerit*[3]

Conversante dehinc Anselmo in Normannia, reversisque
Balduino et Willelmo, qui ex jussu regis atque pontificis

a os: EX HOC αβ

[1] Peter, the earliest known papal chamberlain, was one of the most
important papal officials of the early twelfth century (see K. Jordan, 'Zur
päpstliche Finanzgeschichte in 11 u. 12 Jahrhundert', *Quellen u. Forschungen
aus Italienischen Archiven und Bibliotheken*, xxv, 1933-4, pp. 94-6). He was in
Rouen towards the end of 1106 (Guibert of Nogent *De vita sua*, iii, 4) and
apparently in England in 1108 (*Ep.* 451 [iii, 152], August 1108, Anselm to
Paschal II, where there is a reference to the presence of Bernard, *servientem
domni Petri camerarii vestri*). Eadmer might have met him and talked to him
about his relic on either of these occasions.

of it, or beyond. Wherefore, if you have treated it with proper reverence, that will be as acceptable to her as if you had done so to her whole body.' When I heard this, I was satisfied, and to this day I have preserved that bone as decently as I could. A long time afterwards Peter, a monk of Cluny and a man of great authority in his day, being chamberlain of popes Urban and Paschal,[1] came to us, and I asked him what he thought about this bone. When he heard my account of how I obtained it, he testified that everything the bishop had said about it was true, and he declared that he himself had been present when the bishop received the bone taken from the martyr's body by the cardinal.

lvi. *How the king and Anselm were reconciled*

Afterwards Anselm left Burgundy and went to France, in order to bring into force the rigour of ecclesiastical discipline, and to relieve the condition of the churches in England.[2] When this was made known to Henry, king of the English, he invited him to come to Normandy; and then the king—moved both by the fear and the love of God—reinvested him with his possessions and received him into his friendship.

lvii. *How Anselm recovered from his illness*[3]

Henceforth Anselm lived in Normandy, until the return of Baldwin and William, who had been sent to Rome

[2] *H.N.* pp. 163-6 contains a fuller account of these events. I have discussed the reasons for Anselm's decision to take active measures against Henry I in *St Anselm and his Biographer*, pp. 174-6.

[3] The chronology of the two years 1105-07 which occupy the next four chapters may here be briefly summarised, with references to the *Historia Novorum* where it supplements the information given below:

May 1105: Anselm left Lyons and proceeded northwards via Cluny and La Charité-sur-Loire, where he learned that Adela countess of Blois

Romam pro expletione negotii^c quod de investituris æc-
clesiarum inter eos eo usque versabatur.^c directi fuerant.^d
Willelmus Angliam ad regem vadit, ac in brevi Beccum
ad Anselmum regressus.^d rogat eum ex parte ipsius regis,
ut jam sopitis retroactis querelis.^d otior Angliam visitet.[1]
Cui cum ille promptus adquiesceret, et iter aggressus
Gemmeticum venisset^a.^d infirmitate ne iter expleret inibi
detentus est. Qua sopita.^d Beccum revertitur, regem
Angliæ transfretaturum illic præstolaturus. Ubi cum pro
reditu ejus omnes exultatio mira teneret.^d ecce infirmitas
Anselmi renovata, et ipsum lecto, et subversa exulta-
tione, gravi cunctos merore prostravit. Igitur ipse nec
manducare, nec aliquid unde salutem ejus sperare pos-
semus facere poterat, et de morte tantum illius formido
nos immensa tenebat. Hæc inter ut in cibum aliquid
sumeret diligenti cura petebatur, sed ille nichil sibi animo
esse quomodo poterat anhelo spiritu fatebatur. Nobis
tamen preces multiplicantibus.^d tandem adquiescens,^b ne

was ill at Blois. He went to Blois and thence, in the company of the
 countess, to Chartres (*H.N.* pp. 163-4).

22 July 1105: The meeting between Anselm and the king at Laigle: An-
 selm's lands restored; it is agreed to send messengers to Rome (*H.N.*
 pp. 165-6).

July 1105 - May 1106: Anselm at Bec with visits to Rheims (*H.N.* pp.
 168-9) and Rouen (*H.N.* pp. 177-81).

May 1106: Anselm set out for England at the king's invitation, after
 receiving the papal letter of 23 March (see below p. 135, *n.* 1), but was
 overtaken by illness at Jumièges and returned to Bec. He became ill
 again and his death was expected but he recovered (*H.N.* p. 182).

15 August 1106: Final reconciliation between Anselm and the king at Bec
 (*H.N.* pp. 182-3).

September 1106: Anselm returned to England (*H.N.* p. 183).

28 September 1106: Battle of Tinchebrai (*H.N.* p. 184).

14 April 1107: The king having returned from Normandy, Anselm attended
 the Easter court at London (*see below*) or (according to *A.S.C.*) Windsor.

Whitsuntide, 3-10 June 1107: Anselm at Bury St Edmund's, where he again
 fell ill (*H.N.* p. 185).

1 August 1107: Anselm and the king make their agreement public at
 Westminster (*H.N.* p. 186).

by the king and archbishop to complete the business which still remained unsettled between them over church investitures. William went on to the king in England and soon returned to Anselm at Bec, requesting him on behalf of the king—now that the former quarrels were settled—to come with all speed to England.[1] Anselm promptly agreed to do this and set out on his way as far as Jumièges, but here he was detained by sickness and unable to continue his journey. When he was better, he returned to Bec to wait there till the king of England crossed over to him. But here, when the expectation of his return filled all men with an extraordinary joy, suddenly Anselm's illness came on again and confined him to his bed, putting an end to the rejoicing and filling everyone with sorrow and heaviness. As a result he could neither eat or do anything which would give us hope for his recovery, and we looked forward only to his death with an immense dread. Meanwhile with anxious care we besought him to take some food, but he, drawing his breath with difficulty, said that he had no stomach for anything. Nevertheless we urged him repeatedly, and at last he agreed rather than burden us further by

^a VENIRET αβ
^b ADQUIESCENS *om.* αβЄ1
[1] Eadmer's words gloss over the long delay in sending messengers to Rome. In July 1105 Henry had promised that messengers would be sent at once so that Anselm could be back in England by Christmas 1105. But he continued to delay and to make specious excuses for doing so, and the messengers did not actually leave until early in 1106. The letter which Baldwin brought back to Anselm from the pope was dated at Benevento on 23 March 1106, and cannot therefore have reached him at Bec until the end of April 1106 (see *Ep.* 367-71 [iii, 173-5; iv, 63-4]; 377-8 [iv, 67; iii, 114]; 397 [iii, 140]).

penitus negando nos magis magisque gravaret.' 'Forte' ait 'de perdice comederem si haberem.' Quid plura? Per campos et silvas dispersi sunt quique suorum, et dies unus in requirenda perdice casso labore consumptus. Contigit autem ut unus ex monasterii servientibus ipsa die per vicinam silvam iter forte carperet, negotio quo alii occupabantur nichil intendens, et ecce in via qua gradiebatur bestiola quam martiram vocant perdicem in ore ferebat. Quæ bestiola viso homine, suam ei prædam reliquit, sibique fuga consuluit. At ille perdicem assumens.' ad nos detulit. Ex qua eger noster refectus.' statim meliorari ab egritudine cœpit, ac demum in dies melius meliusque habendo.' pristinam est sanitatem adeptus.

lviii. *Quod qui ei detrahebat equo dejectus cum dedecore sit*

Post hæc episcopis et abbatibus qui exequiarum illius causa convenerant in sua remeantibus.' remeavit etiam Radulfus abbas cœnobii Sagiensis, qui unus erat ex eis.[1] Unus igitur ex hominibus[a] ejus per viam cœpit Anselmo detrahere, et quod merito nullus infirmitati ejus compati deberet, 'præsertim' inquiens 'cum ipse cibo et potu saluti suæ si remota jactantia vellet facile succurrere posset.'' maledica voce astruere. Quod abbas audiens.' hominem monuit ut sileret, nec de tanto viro quid sinistri ultra proferret. Quæ[b] cum ille subsannando despiceret, et in iis quæ cœperat furore quodam exagitatus persisteret.' intulit abbas se de justitia Dei ita certum existere,

[a] ex omnibus hominibus β

[b] quae cum ille . . . libertatus est.: QUAE ILLE SUBSANNANDO DESPICIENS, ET IN IIS QUAE COEPERAT FURORE QUODAM EXAGITATUS PERSISTENS'. EQUO CALCARIBUS INSTITIT, UT AB ABBATE ELONGATUS LIBERIUS EDERET, QUOD SUAE MENTIS AMARITUDO SIBI PROPONERET. VERUM CUM IPSE PRAEPETI CURSU FERRI GESTIRET, AC REMISSIS HABENIS OTIOR IRE INCIPERET'. QUEM SEDEBAT QUADRUPES CORRUIT, EUMQUE MAGNO CUM DEDECORE TERGO SUO EXCUSSIT, AC PER DEVEXUM MONTEM LONGO ROTATU PRAECIPITATUM A VIRI BLASPHEMIA LINGUAM COMPESCERE DOCUIT. αβЄ1

an absolute refusal. 'Perhaps' he said 'I might eat some partridge, if I had some.' There was no need to say more. All his people dispersed through the fields and woods, and a whole day was spent in the lost labour of seeking a partridge. But it happened that one of the servants of the monastery was going that same day through a neighbouring wood, with no thought of the business which was occupying the others; and suddenly a little animal which they call a marten appeared on the road along which he was walking with a partridge in its mouth. When the animal saw the man, it dropped its prey and saved itself by flight. He picked up the partridge and brought it to us. Our invalid took some nourishment from it, and at once he began to recover from his sickness; and he got better from day to day until at length he was restored to perfect health.

lviii. *How a detractor was ignominiously thrown from his horse*

Afterwards the bishops and abbots who had come together for his burial went home again, including Ralph abbot of the monastery of Séez who was one of them.[1] On the way one of his men began to belittle Anselm, saying that he deserved no sympathy in his illness, 'especially,' as he scurrilously put it, 'since he could easily have recovered his health with food and drink, if he had wanted to and if he had swallowed his pride.' When the abbot heard this he told the man to be quiet and not to talk any more evil about such a great man. He scoffed at these words and pooh-poohed them, and working himself up into a rage he persisted in the remarks he had begun to make. Thereupon the abbot declared that

[1] This is Ralph, later bishop of Rochester, 1108-14, and archbishop of Canterbury, 1114-22; see above p. xx, and *St Anselm and his Biographer*, pp. 305-07.

ut injuriam servi sui non pateretur impunitam transire. Ille ridet ad^a hæc, cœpto itinere pergens. Offendit interim properans frondosam quercum, ex qua sicut erat equo sedens ramusculum tollere nisus est, sive muscas fugaturus, seu inde umbraculum sibi facturus. Verum dum frangendo ramo hæreret:' subito equus exiliens hominem tergo dejecit, eumque uno pede per strivile pendentem rapido cursu per terram longius traxit. Sociis^b autem beatam Mariam ut quasi spiritum jam exhalaturo succurreret elata voce inclamitantibus^c:' tandem a viri blasphemia linguam ulterius compescere edoctus, a periculo liberatus est.

lix. *Quod eum suæ compotem voluntatis rex in omnibus fecerit*

Dehinc in Assumptione Beatæ Dei Genitricis et perpetuæ Virginis Mariæ rex Henricus Beccum adveniens:' omnia quæ inter se et Anselmum de sepefato^d negotio resederant, moderante sedis apostolicæ sanctione delevit, atque de singulis ad quæ tendebat suæ illum voluntatis compotem fecit.

lx. *Qualiter freneticum sano sensui restituerit*

Dum^e igitur Angliam repetendi iter Anselmi certis ex causis aliquantisper demoraretur:' rogatus ab abbate Beccensi dedicavit capellam unam infra curtem^f ipsius cœnobii sitam. In qua dedicatione quidam clericus frenesis valitudine tunc noviter captus:' a suis est ante

^a ad: et CΘDHIK (*It is clear that Eadmer mistakenly wrote* et: ad *is a correction supplied by* EF.)

^b sociis autem . . . libertatus est.: ET QUO BEATA MARIA IAM QUASI SPIRITUM EXHALATURO SUCCURRERET, ELATO CLAMORE VOCES OMNIUM SOLVIT, ITAQUE LIBERATUM A VIRI BLASPHEMIA LINGUA ULTERIUS COMPESCERE DOCUIT. C

^c inclamitantibus: inclamantibus DEFHI

^d sepefacto MNTXWYS; sepefacto *corr. to* sepefato A

^e dum: CUM αβCDEFHI

^f curtem: CURIAM αβ

as he trusted in God's justice, he was certain that he
would not allow this injury to his servant to pass un-
punished. The man laughed at this and went on his
way. Then as he rode along he came to a leafy oak,
from which he tried to pull a branch, as he sat on his
horse, either to drive away the flies or to make a shelter
for himself from the sun. But while he was clinging to
the branch trying to break it off, his horse suddenly gave
a bound and threw the man from his back. His foot
caught in the stirrup and he hung there while the horse
bore him rapidly along the ground for some distance.
His companions, with a loud voice called on Saint Mary
to help him, now (as it seemed) about to give up the
ghost, until at last he was freed from danger, with this
lesson to keep his tongue in future from speaking evil of
Anselm.

lix. *How the king satisfied his wishes on all points*

Thereafter on the Assumption of the Blessed Mother of
God and ever Virgin Mary, King Henry came to Bec,
and within the bounds prescribed by the Apostolic See,
settled all the outstanding points in the oft-mentioned
controversy between him and Anselm, and satisfied
Anselm's wishes on the various issues for which he had
striven.

lx. *How he restored a madman to his right mind*

Various causes, however, delayed Anselm's return to
England, and he was therefore asked by the abbot of
Bec to dedicate a chapel standing within the courtyard
of the monastery. During the dedication a clerk who
had lately been seized with violent fits of frenzy was

pontificem ductus, ilicoque ad benedictionem ejus a suæ
mentis alienatione sanatus.

lxi. *Quod in Anglia pane a se benedicto virum quendam ab*
infirmitate qua gravabatur curaverit

Cum post hæc prospero cursu Angliam venisset.' magno
sanctæ æcclesiæ gaudio et honore susceptus est. Inde
evolutis nonnullis diebus.' Anglus quidam vir nobilis qui-
dem et dives valida corporis infirmitate gravatus, ab
Anselmo sibi panem a se benedictum transmitti per nun-
cium petiit et accepit. Unde paululum gustans.' juxta
fidem suam statim convalescere cœpit, integræque post
modicum*a* sanitati donatus.' Deo et Dei viro ex corde
gratias egit.

lxii. *Quod rex Normanniam sibi subactam illi gratiosus man-*
daverit

Hæc inter rex in Normannia positus.' valde lætabatur
sicut ferebant ii qui ad nos inde veniebant, quod fuerat
Anselmi pace potitus. Unde etiam firma sibi spe applau-
debat, suo se dominio totam Normanniam subjugaturum.
Quod et factum est. Nam conserto gravi prœlio.' fratrem
suum Robertum Normanniæ comitem, et alios principes
qui contra illum in bellum venerunt cepit.*b* Tali ergo
victoria usus.' totam terram gratulabundus obtinuit,*c* id-
que per epistolam*d*[1] Anselmo gaudenter et gratiosus mox

a POST MODICUM *om.* αβ
b coepit Є
c tali . . . obtinuit: INNUMERISQUE PEREMTIS TOTAM TERRAM VICTOR
OBTINUIT αβCЄιEF
d epistolam: LITTERAS αβ
[1] The battle of Tinchebrai took place on 28 September 1106 at about
nine o'clock in the morning and lasted for scarcely an hour. The text of
the letter which Henry sent to Anselm announcing his victory is in *H.N.*
p. 184 (see *Regesta* no. 788). The phrase 'innumerisque peremtis' in

brought before the archbishop by his servants, and by his blessing his mental aberration was cured on the spot.

lxi. *How in England he cured a man, who was oppressed by illness, with some bread which he had blessed*

After this he came to England after a prosperous voyage and was received with great joy and honour by holy church. Some time after this, a certain Englishman— a nobleman and rich—was troubled with a grievous bodily ailment, and he asked Anselm by messenger to send him some bread which had been blessed by him. He received it and ate a little of it. According to his faith he immediately began to recover, and after a time he was completely restored to health, and gave thanks to God and to the man of God with all his heart.

lxii. *How the king joyfully announced to him the subjection of Normandy*

Meanwhile the king was in Normandy, and those who came to us from there reported that he was heartily glad that he had made his peace with Anselm. He even fortified himself with the firm hope that he would thereby subdue the whole of Normandy to his rule. And this came to pass. For after fighting a severe battle, he captured his brother Robert, duke of Normandy and other barons who had taken up arms against him. Availing himself of this victory, he took over the whole country with much rejoicing, and at once sent letters[1] to Anselm telling him of this with joy and thanksgiving.

Eadmer's first recension of the *Life* is derived from the king's letter, and may have been omitted later as inconsistent with the true facts, which are best given in a contemporary letter of a priest of Fécamp, printed in *E.H.R.* 1909, xxiv, p. 728, and more correctly *E.H.R.* 1910, xxv, p. 295.

intimavit. Omnes vero qui hæc gesta tunc temporis audiere:' ea meritis concordiæ quam rex cum Anselmo fecerat ascripsere.

lxiii. *Quod ad abbatiam Sancti Edmundi iverit, et ibi quædam officia pontificalia celebraverit*

Ipso anno[1] Anselmus celebrata paschali solennitate in curia regis apud Lundoniam:'[2] abiit ad abbatiam Sancti Eadmundi,[a] electum inibi abbatem sua auctoritate roboraturus, et alia quædam officia pontificalia pro suo jure celebraturus.[3] Quæ ubi solenniter cuncta peregit:' gravissima febre correptus, per plures dies pæne usque ad emissionem ultimi flatus vexatus est. Pro quo illic octavas Pentecostes usque detentus est:' et consilium quod se viduatis æcclesiis rex proposuerat collaturum, propter ejus absentiam in Kal. Augusti dilatum est. Eo igitur tempore adunatis in palatio regis Lundoniæ cunctis primoribus Angliæ:' victoriam de libertate æcclesiæ pro qua

[a] EDMUNDI αβEF

[1] *Ipso anno* is clearly a mistake: Eadmer has passed from September 1106 to Easter 1107. He may have forgotten the date of the Battle of Tinchebrai, but, whatever the reason, the error is a further indication that this part of the *Life* was written some time after the events it describes.

[2] According to *A.S.C.* the royal court at Easter (14 April) 1107 was at Windsor, not as Eadmer here states at Westminster. If, as I have suggested above p. x, Eadmer wrote this part of the *Life* after Anselm's death and not from contemporary notes, *A.S.C.* is probably to be preferred.

[3] The abbey of St Edmund's had been in a disturbed state since the deposition of Robert in 1102. A new abbot, also called Robert, formerly prior of Westminster, was elected in 1103 and ruled the abbey without benediction for over four years (*Memorials of S. Edmund's Abbey*, I, p. 356). But there was evidently an appeal to Rome over the election (see *Ep.* 408 [iv, 78], and it was not until after Anselm's visit that the abbot received benediction at Canterbury on 15 August 1107 (*H.N.* p. 188). Since the monastery was exempt from diocesan authority, episcopal functions such as the dedication of altars were performed by a bishop or—as here—an archbishop chosen by the community for the occasion. The performance of these functions provided the occasion for Anselm's visit, as Eadmer says (*H.N.* p. 185), 'crucem magnam ibi consecraturus et alia quaedam episcopalia officia administraturus'. Eadmer's words are confirmed by a notice in British Museum MS. Harl. 1005, which contains a record of various

Indeed everyone who heard of these events at that time ascribed them to the merits of the understanding which the king had come to with Anselm.

lxiii. *How he went to the abbey of St Edmund and performed there certain episcopal offices*

In the same year[1] Anselm celebrated the Feast of Easter in the royal court at London,[2] and then went to the Abbey of St Edmund's to confirm with his authority the abbot who had been elected there and to perform certain other episcopal offices, as he was entitled to do.[3] When everything had then been solemnly enacted, he was seized by a very serious fever and for several days he was troubled with it and brought almost to his last gasp. This kept him there till the octave of Whitsuntide, and because of his absence the Council which the king had proposed to hold for the filling of the vacant churches was postponed till August 1st. At this date, therefore, all the nobility of England were assembled in the king's

domestic details of altars, consecrations and buildings, including the following: 'Altarem sancte crucis retro chorum dedicavit Albericus Hostiensis episcopus quando functus est legationem totius Anglie tempore Stephani regis, et hec dedicatio in vigilia sancti Eadmundi facta est (19 Nov. 1138). Anselmus vero abbas tunc Romam iverat. Ipsam vero magnam crucem a Gaufrido sacrista per Wohancum pictorem preparatam et multis infra dorsum et magnis ab ipso reliquiis reconditis, longe ante dedicavit Anselmus Cantuariorum archiepiscopus tempore Roberti abbatis. Miraculaque ante ipsam contigisse audivimus. Dignum quippe est ut Dei filius formas sue sacre crucis virtutibus honoret, in qua humanum genus redimere dignatus voluit. Referunt etiam de hac cruce quod dum robur eius difficile unde delatum fuit ad findendum esset et appositis cuneis titubatio fieret inter artifices lignorum ne si male scinderetur inutile ad opus propositum foret, post mirantibus cunctis per se sissatum repertum est. Ita posse contingere Deo volente non dubito; affirmationem tamen veritatis relatoribus commendo.'

diu laboraverat Anselmus quodam modo *a*1 adeptus est.
Rex enim antecessorum suorum usu relicto,*'* nec personas
quæ in regimen æcclesiarum sumebantur per se elegit,
nec eas per dationem virgæ pastoralis æcclesiis quibus
preficiebantur investivit.[2]

lxiiii. *Quod crebrius solito infirmabatur, et propterea ad diversa
loca tendens lectica vehebatur*

Scripsit inter hæc Anselmus libellum unum de concordia
præscientiæ et prædestinationis et gratiæ Dei cum libero
arbitrio.[3] In quo opere contra morem moram in scri-
bendo passus est, quoniam ex quo apud Sanctum Ead-
mundum*b* fuerat infirmatus,*'* donec presenti vitæ super-
fuit, solito imbecillior *c* corpore fuit. Quapropter de loco
ad locum migrans,*'* lectica decubans non equo sedens

a QUODAM MODO *om.* αβ
b EDMUNDUM αβEF
c imbecillior VP; imbecilior R

[1] Eadmer's later addition of the words *quodam modo* no doubt reflects
his growing and well-justified doubt about the completeness of Anselm's
victory. For a fuller account of the Council of August 1107, see *H.N.* pp.
186-7.

[2] Eadmer accurately reports the king's concessions, but he does not
mention that the prohibition of homage by abbots and bishops, after
election but before consecration, was withdrawn. That this was the con-
dition of the king's concessions is clearly stated in *H.N.* p. 186: 'papa ...
concesserat hominia quae Urbanus papa aeque ut investituras interdixerat,
ac per hoc regem sibi de investituris consentaneum fecerat.' William of
Malmesbury, *G.R.* II, p. 493, makes the same distinction more cryptically:
'rex ... investituram annuli et baculi indulsit in perpetuum; retento tamen
electionis et regalium privilegio' Rule, p. xlii argued that Eadmer had
no accurate information about the terms of the final settlement and that a
distinction was made between lay vassals who were held to do homage and
ecclesiastical tenants in chief who were only obliged to swear fealty. But
there is nothing in the documents to support this argument, and everything
points to the conclusion that homage went on being taken from abbots and
bishops. At the end of Henry II's reign, the rule was: bishops did homage
after election but before consecration; if they were already consecrated (for
example, on translation from one see to another) they swore fealty but did
not do homage (see Glanvill, *De Legibus et Consuetudinibus Regni Angliae*, ix, 1:
'Episcopi vero consecrati homagium facere non solent domino regi etiam

palace in London, and Anselm to some extent[1] achieved
the victory for the liberty of the church for which he had
laboured so long. For the king abandoned the custom
of his ancestors and he himself neither elected the persons
who undertook the government of churches nor did he
invest them with the churches over which they were set
by giving them the pastoral staff.[2]

lxiv. *How he was ill more often than usual, and therefore was
carried from place to place in a litter*

During this time Anselm wrote a treatise on the recon-
ciliation of the foreknowledge, predestination and grace
of God with free-will.[3] Contrary to his usual practice
he suffered some interruption in the writing of this work
for, from the time he was ill at St Edmund's until the
end of his life, he was weaker in body than he had been.
Hence from this time, when he went from place to place,
he was carried about lying on a litter, not sitting on a

de baroniis suis, sed fidelitatem cum iuramentis interpositis ipsi praestare
solent. Electi vero in episcopos ante consecrationem suam homagia sua
facere solent.'

[3] Eadmer's reference to Anselm's illness fixes the time of the com-
position of the *De concordia praescientiae et praedestinationis et gratiae Dei cum
libero arbitrio* to the years 1107-08, but the composition of such a work had
been forecast at least twenty years earlier in the first recension of the *De
Libertate Arbitrii*, which ends abruptly with these words:

Discipulus: Sed quoniam libero arbitrio praescientia et praedestinatio et
gratia dei videntur repugnare, gratissimum mihi erit, si eas illi non
tam auctoritate sacra, quod a multis satis factum est, quam ratione,
quod sufficienter factum nondum me memini legisse, concordare facias.
Auctoritate vero ad hoc non indigeo, quia illam quantum ad hoc quod
quaero pertinet, sufficienter novi et suspicio.

Magister: De praescientia et praedestinatione similis et pariter difficilior
quam de gratia quaestio est. (Schmitt, I, p. 226).

For the finished work and its earlier recension, see Schmitt, II, pp. 245-88.
It is difficult to see why Eadmer should contrast the delays in the com-
position of this work with Anselm's method of writing his earlier works,
since long delays were experienced at least in the *De Incarnatione Verbi* and
the *Cur Deus Homo* and possibly in other works.

deinceps vehebatur.*ª* Vexabatur præterea frequentibus
et acerbis infirmitatibus, ita ut vix illi vitam promittere
auderemus. Ipse tamen nunquam pristinæ conversationis
obliviscebatur, sed semper aut meditationibus bonis, aut
exortationibus sanctis, aut aliis piis operibus occupabatur.

lxv. *Quanto studio consecrationi Dominici Corporis etiam cor-*
pore deficiens interesse voluerit

Tertio igitur anno postquam a secundo exilio per regem
Heinricum revocatus est,⸴ omnes cibi quibus humana
natura vegetatur et alitur in fastidium ei versi sunt.
Manducabat tamen naturæ suæ vim faciendo, sciens se
vivere non posse sine cibo. Qua vi per dimidium circiter
annum vitam quoquomodo transigens,⸴ sensim corpore
deficiebat, animi virtute semper idem qui esse solebat
existens. Spiritu itaque fortis, sed carne nimium fragilis,⸴
pedes oratorium adire nequibat. Attamen consecrationi
Dominici Corporis quod speciali quodam devotionis
affectu venerabatur interesse desiderans,⸴ singulis diebus
illuc se in sella faciebat deferri. A quo dum nos qui ei
serviebamus eum quia multum exinde fatigabatur de-
clinare niteremur,⸴ vix quinto ante sui exitus diem evin-
cere potuimus. Exin ergo assidue lecto decumbens,⸴*b*
anhela voce omnes qui ad eum accedere merebantur, in
suo quenque ordine Deo vivere ortabatur.

lxvi. *Quomodo et qua hora de hac vita migraverit*

Illuxerat Dominica dies Palmarum, et nos pro more
circa illum*c* sedebamus. Dixit itaque ei unus nostrum,

ª lectica . . . vehebatur.: LECTICA DEINCEPS NON EQUO SEDENS VEHE-
BATUR. αβ
b lecto decumbens: LECTULO DECUBANS αβF (lecto decubans OSUWXY;
lectulo decumbens E)
c illum: eum β

horse. Besides he was troubled with frequent and grievous sicknesses, so that we scarcely dared give him hope of living. But he never forgot his former way of life, and he was always occupied with profitable meditations, or holy exhortations or other acts of piety.

lxv. *How despite his weakness he greatly desired to be present at the consecration of the Lord's Body*

Then in the third year after he was recalled from his second exile by King Henry, all forms of food with which human beings are strengthened and nourished, became distasteful to him. Still, he ate in order to keep his strength up, knowing that he could not live without food. On the strength of this he lived after a fashion for about half a year, slowly losing strength, but mentally as alert as he had ever been. Thus strong in spirit but weak in flesh he was unable to go on foot to the church. But since he wished to be present at the consecration of the Lord's Body, which he venerated with a special devotion and love, he had himself carried there each day in a chair. We who attended on him tried to dissuade him from this, for he was greatly tired by it, but it was not until the fifth day before his death that we were able with difficulty to gain our point. From this time therefore he lay continuously on his bed, and, though speaking with difficulty, he exhorted all those who had the good fortune to come to him, to live each in his own station for God.

lxvi. *How and at what time he departed this life*

Palm Sunday dawned and we were sitting beside him as usual. One of us therefore said to him: 'My lord and

'Domine pater ut nobis intelligi datur, ad paschalem
Domini tui curiam relicto seculo vadis.' Respondit, 'Et
quidem si voluntas ejus in hoc est.' voluntati ejus libens
parebo. Verum si mallet me adhuc inter vos saltem tam
diu manere, donec quæstionem quam de origine animæ*
mente revolvo absolvere possem.' gratanter* acciperem,
eo quod nescio utrum aliquis eam me defuncto sit solu-
turus.*¹ Ego quippe si comedere possem.' spero convale-
scerem. Nam nichil doloris in aliqua corporis parte
sentio, nisi quod lassescente stomacho ob cibum quem
capere nequit totus deficio.' Vesperascente dehinc tertia
feria cum ipse verba quæ intelligi possent edere jam nulla
valeret.' rogatus a Radulfo Rofensi episcopo ut nobis qui
aderamus et aliis filiis suis, regi quoque ac* reginæ cum
liberis eorum, ac populo terræ qui in ejus obœdientia se
sub Deo tenuerat suam absolutionem et benedictionem
largiretur.' dexteram quasi nil mali pateretur erexit, et
signo sanctæ crucis edito.' demisso capite sedit. Jam
fratrum conventus in majori æcclesia matutinas laudes
decantabat, et unus nostrum qui aderamus* sumpto
textu evangeliorum legit Passionem coram eo quæ ipsa
die ad missam legi debebat. Ubi autem venit ad verba
Domini,* 'Vos estis qui permansistis mecum in tempta-
tionibus meis, et ego dispono vobis sicut disposuit mihi

* DE ANIMAE ORIGINE αβ
* gratanter: GRATIOSUS αβ
* ABSOLUTURUS αβ
* ac: ATQUE αβEF
* unus . . . aderamus: UNUS EORUM (nostrum UX) QUI CIRCA PATREM
(eum UX) EXCUBABANT (sedebant UX) αβ
* verba Domini: recipiens sacrum corpus Domini nostri Iesu Christi
cum sacra unctione in haec verba legentis passionem Domini *add.* I
¹ The problem which exercised Anselm was no doubt the conflict
between the creationist and traducianist view of the origin of the soul.
His pupil Gilbert Crispin attempted to resolve the problem but whether
his views here as elsewhere represent those of Anselm we cannot tell.
Gilbert favoured the traducianist view as the only way of explaining the

father, we cannot help knowing that you are going to leave the world to be at the Easter court of your Lord.' He replied: 'And indeed if his will is set on this, I shall gladly obey his will. However, if he would prefer me to remain among you, at least until I can settle a question about the origin of the soul, which I am turning over in my mind, I should welcome this with gratitude, for I do not know whether anyone will solve it when I am dead.[1] Truly I think I might recover if I could eat something, for I feel no pain in any part of my body, except that I am altogether enfeebled by the weakness of my stomach which refuses food.' Then, on the Tuesday evening, when he could no longer speak words which could be understood, he was asked by Ralph, bishop of Rochester, to give his absolution and blessing to those of us who were present and to his other sons, and to the king and queen and their children, and to the people of the land who lived under his authority subject to God. He raised his right hand as if nothing was wrong with him, and, after making the sign of the holy Cross, he sat with his head bent down. Now, when the community of the brethren was singing lauds in the morning in the main church, one of us who were with him took the copy of the Gospels and read to him the account of the Passion which was appointed to be read at Mass on that day. And when he came to the words of the Lord 'Ye are they which have continued with me in my temptations; and I appoint you a kingdom, as my Father hath appointed unto me, that ye may eat and

transmission of Original Sin. See J. A. Robinson, *Gilbert Crispin*, pp. 72-3; the Treatise, which is unprinted, is in British Museum MS. Add. 8166, ff. 37-9. For the general state of the question at this time, see T. Gregory, *Platonismo medievale: studi e ricerche* (Istituto storico Italiano per il medio evo, studi storici, fasc. 26-7, 1958), pp. 7-8.

x

pater meus regnum, ut edatis et bibatis super mensam
meam in regno meo.''[1] lentius solito spiritum trahere
cœpit. Sensimus igitur eum jamjam obiturum, et de
lecto super cilicium et cinerem positus est. Adunatoque
circa illum universo filiorum suorum agmine.' ultimum
spiritum in manus Creatoris emittens, dormivit in pace.
Transiit autem illucescente aurora quartæ feriæ præ-
cedentis Cœnam Domini quæ erat xi. Kal. Maii, anno
videlicet Dominicæ Incarnationis millesimo centesimo
nono, qui fuit annus pontificatus illius[a] sextus decimus,
vitæ vero septuagesimo sextus.[2]

<div align="center">

lxvii. *De abundantia balsami*

</div>

Loto igitur ex more corpore ejus.' petiit supra sepe memo-
ratus rerum Anselmi provisor ac dispensator Balduinus,
quatinus facies patris defuncti[b] balsamo quod admodum
parum in parvulo vase sibi majori ejus parte amissa[c]
remanserat.' inungueretur, sperans atque præoptans eo
modo illam vel modice amplius servatum iri ne corrum-
peretur. Adquievimus, viri industriam amplectentes.
Vas ergo ipsius liquoris in manum episcopus sumpsit, et
uncturus vultum defuncti.' digitum fundo vasis immersit.
Quem ilico extrahens, sed vix summitatem ejus[d] made-
factam reperiens.' ratus est balsamum ipsum unguendæ

[a] ILLIUS: EIUS αβF (*om.* E)
[b] DEFUNCTI *om.* αβ
[c] amissa: PERDITA αβ
[d] eius: SUI αβC

[1] These words from Luke xxii.28-30, occur in the Gospel for Wednesday
before Easter, the day of Anselm's death.

[2] The coincidence that the two most famous monks of the day died
within a short period of each other, Anselm on 21 April 1109 and Hugh
abbot of Cluny on 29 April 1109, was frequently remarked on by con-
temporaries. It was the subject of a vision by Fulgentius, abbot of Afflig-
hem in Brabant, which found its way into several Belgian chronicles
(*M.G.H. SS.* xiii, p. 652). In England, Baldwin the head of Anselm's
household at Canterbury had an experience which he reported to Raynald,

drink at my table in my kingdom,'[1] he began to draw
his breath more slowly than usual. We felt therefore
that he was now on the point of death, and he was lifted
from his bed onto sackcloth and ashes. The whole
congregation of his sons gathered round him and, send-
ing forth his soul into the hands of the Creator, he slept
in peace. And so he passed away as dawn was breaking
on the Wednesday before the institution of the Lord's
Supper, on 21 April in the year of our Lord's Incarnation
1109, which was the sixteenth year of his pontificate, and
the seventy-sixth of his life.[2]

lxvii. *Concerning the abundance of balsam*

His body therefore was washed according to custom.
Then Baldwin, the organiser and manager of Anselm's
affairs who has often been mentioned above, suggested
that the face of the dead Father should be anointed with
some balsam, of which only a small quantity remained
in a little jar—the greater part of it having been lost—
in the hope and desire that thereby the face or a little
more should be saved from corruption. We agreed and
seconded his efforts. The bishop therefore took the jar
of the liquid in his hand, and dipped his finger to the
bottom so that he could anoint the face of the departed.
When he drew it out, however, he found that only the
tip of his finger was wet, and he thought that the balsam

archbishop of Lyons, the biographer of Hugh of Cluny: 'Cuius (i.e.
Hugonis) exequias, ipsa nocte qua migravit ad Dominum, frater quidam
religiosus, Balduinus nomine, olim domini Anselmi Cantuariensis dispen-
sator, in spiritu, sicut ipse michi narravit, ab Anglia per ordinem vidit. . . .
Tunc vocato Rofensi episcopo domino Rodulfo, qui tunc Cantuariensem
ecclesiam de recenti obitu domini archiepiscopi Anselmi consolabatur,
visionem exposuit et sanctum senem de seculo migrasse praedixit. Igitur
notata die atque hora, post non multos dies sanctum virum obiisse didicit, et
notatum tempus iuxta visionem quam viderat invenit' (*Acta Sanctorum*,
Aprilis, iii, 653).

faciei haudquaquam posse sufficere. Quapropter rogat
balsamum quod conficiendo crismati in majori æcclesia*
servabatur afferri, cupiens* una cum capite dexteram
ejus per quæ multa bona atque divina dixerat et scrip-
serat tali unctura honorari. In his cum episcopo eram,
et eum in ministerio ipso juvabam. Impressi post eum
in vas balsami digitum meum, et æque aut certe minus
digito ejus madentem extraxi. Itaque rogatus episcopus
michi vas in palmam versare, si forte inde aliqua gutta
deflueret.' adquievit, et ilico stupentibus cunctis liquor
desiliens, copia sui manum meam complevit et super-
effluxit. Hoc ipsum secundo et tertio, ac sepius factum
est. Et quid dicam? Tantam abundantiam balsami vas
ferme vacuum ministravit.' ut intacto vase æcclesiæ non
solum caput et manus, sed brachia et pectus, pedes quo-
que et totum corpus ejus non una sed sepius repetita
vice omni ex parte inungueremus.¹ Dehinc more summi
pontificis vestibus est sacris indutus, et in oratorium
debita cum veneratione delatus.

lxviii. *De augmento sarcophagi*

In crastino autem cum sepulturæ traderetur.' sarcofagum
quod illi fuerat pluribus retroactis diebus præparatum,
longitudine quidem et latitudine aptum, sed profunditate
magna ex parte minus habens inventum est. Quod con-
siderantes.' animo deficiebamus, nulla scilicet ratione pati

ª ecclesia Salvatoris I
ᵇ cupiens: VIDELICET *add.* αβ
¹ Eadmer's circumstantial account of the miraculous increase in the
supply of balsam may be compared with the following scene after the death
of St Hugh of Cluny a week later: 'Defertur ergo in capitulum; prius aqua,
consequenter vino a fratribus dealbatis abluitur; ad ultimum etiam modico
balsamo, quod supererat in brevi vasculo, perunctum est caput, pars quoque
aliorum membrorum sanctissimi corporis, quod vix ad solum lepidum capu

would by no means suffice for anointing the face. So he asked that the balsam which was kept in the main church for making up the holy oil should be brought, since he wished that the right hand as well as the head—the instruments by which he had spoken and written many good and heavenly things—should have the honour of this anointing. I was with the bishop while he was doing this, helping him in his ministrations. I put my finger into the jar of balsam after him, and when I pulled it out it was about as wet or even less so than his had been. So I asked the bishop to tip up the jar into the palm of my hand to see whether any drops would come out. He agreed, and to everybody's amazement the liquid poured out in such quantity that it filled my hand to overflowing. And this happened a second and third time and even oftener. In short, the almost empty jar supplied such an abundance of balsam that, without touching the jar from the church, we anointed not only the head and hands, but also the arms and breast, and even his feet and whole body in every part not just once but several times over.[1] He was then clothed in his sacred vestments in the habit of an archbishop and carried into a chapel with the veneration due to him.

lxviii. *Concerning the enlargement of the stone coffin*

The next day however, when he was committed for burial, the stone coffin which had been prepared for him many days earlier was found to be sufficient as to length and breadth, but too shallow for the most part. When we saw this we were at a loss, being determined not to allow him to be damaged in any way by the pressure of

sufficeret, nisi benedictione celesti inter obsequentium manus superabundaret.' (*Vita S. Hugonis* by Gilo, ed. A. L'Huillier, pp. 613-14.)

valentes, ut superiori lapide pressus, sua integritate ali-
quatenus læsus privaretur. Cum itaque in hoc plurimi
fluctuarent, et alii sic, alii vero sic rem posse componi
dictitarent.ʲ quidam ex conferta multitudine fratrum ac-
ceptum baculum episcopi Rofensis qui funeris officium
præsens agebat, per transversum sarcofagi super corpus
patris ducere cœpit, et jam illud omni ex parte corpori
jacentis præminere magna nobis exinde admiratione per-
motis invenit. Ita ergo venerabile corpus patris Anselmi
Dorobernensis archiepiscopi ac primatis totius Britanniæ
sepulchro inclusum.ʲ ᵃ quid conditio sortis humanæ habeat
in se, omnes qui pertranseunt sui exemplo monet atten-
dere.¹ Sane in obitu et post obitum ejus multa a multis
visa narrantur, quæ gloriæ ejus quam pro meritis suis
eum a Deo recepisseᵇ non dubitamus attestantur. Quibus
tamen scribendis laborem subireᶜ noluimus, magis vide-
licet eligentes silentio nostro omnes qui dormiendo ea
viderunt pares facere, quam ista scribendo illa non scri-
bendo, unum alii quasi potiora viderit anteferre. Ut enim
cuncta scribantur.ʲ infiniti negotii est. Aperta denique
facta quæ Deus per eum facere dignatus est, et nos talium
nudi pro posse digessimus.ʲ puto sufficere ad notitiam re-
tributionis vitæ et conversationis ejus.ᵈ Quædam autem
quæ non per somnium accidisse elapso post obitum ejus

ᵃ et in ecclesia Salvatoris Cantuariae sepultum cum magno honore
(*in marg.* in navi aecclesiae in medio prope Lanfranco) *add.* I

ᵇ RECEPISSE A DEO αβEF

ᶜ subire: INTRARE αβ

ᵈ αβC here end, with this addition: SIT ITAQUE DEO OMNIPOTENTI PATRI
ET FILIO ET SANCTO SPIRITUI LAUS ET GRATIARUM ACTIO, NUNC ET PER OMNIA
SECULORUM SECULA. AMEN.

¹ The sentiment here expressed is of course a commonplace among
writers of epitaphs, and there is no need to seek for any special source. It
may be noted, however, that Anselm's death called forth a number of
epitaphs and poems, of which six have survived. They are printed in *P.L.*
158, 137-42; *Downside Review*, L, 1932, pp. 498-501; J. Werner, *Beiträge
zur Kunde der lat. Literatur des Mittelalters*, 1905, p. 36. Some of these com-

the stone lid. So there was much difference of opin on, some saying it could be arranged one way, and some another. Then one of the assembled multitude of brethren took the staff of the bishop of Rochester, who was then performing the burial service, and started to draw it along the top of the sarcophagus over the body of the Father. To our great astonishment he now found that the sarcophagus was higher than the recumbent body at every point, and so the venerable body of Father Anselm, archbishop of Canterbury and primate of all Britain was shut in its sepulchre, a warning to all passers-by to learn from its example the condition to which mankind is subject.[1] Many visions indeed are related which were seen by many both at the time of his death and afterwards; and these, we have no doubt, bear witness to the glory which he has received from God for his merits. But we have decided not to undertake the labour of describing them, choosing by our silence to put on an equality all who in their sleep have seen these things, rather than by describing some and not others to give one the preference over another, as if he had seen things of more importance. For it would be an endless task to describe all. In short, I think the public deeds which God deigned to perform through him and which we (who are destitute of such things) have arranged to the best of our ability, will suffice to make clear the reward of his life and conversation.

I am however compelled by the strong love towards him, which still animates some of my companions, to

positions were no doubt written for the mortuary roll, which would carry the announcement of the archbishop's death to the religious houses of England and France.

A marginal note in MS I says that Anselm was buried 'in navi aecclesiae in medio prope Lanfrancum.' This note may have been copied

non longo temporis spatio.¹ sed in gravi discrimine consti-
tutis per memoriam pii nominis ejus provenisse feruntur.ᵃ
vis amoris quo erga eum quidam meorum adhuc ardent
paucis me notare compellit.

lxix. *Qualiter Arnulfus comes cum suis propter merita ejus*
 liberatus sit a periculo maris

Arnulfus quidam nomine, filius comitis Rogerii de Monte
Gummeri et ipse comes.ᵃ¹ de Normannia Angliam rediens
marini itineris medium prospero cursu peregerat. Et
ecce contra spem omnium in navi consistentium.ᵃ subito
nebula nimiæ densitatis exurgit, supercrescit, quin et
ventus omnis quo vehebantur cadit, evanescit, deperit.
Navis in medio pelagi nullum quo in ulteriora raperetur
ventum habens.ᵃ nec quæ in ea consistebat hominum
multitudo præ densitate nebulæ quam teneret viam di-
noscere valens.ᵃ huc et illuc inter undarum cumulos navis
nullum iter explicans fluctuabat, et consistens in ea tedio
vehementi afflicta virorum turba animo deficiebat. Mare
siquidem eos per dies duos tali modo sibi haud grato
obsequio vindicabat, et in diversa vota mentes illorum
quo a suo retinaculo solverentur et ora concitabat. Tan-
dem memoratus comes memorandæ memoriæ patris An-
selmi recordatus.ᵃ vota omnium rupit, et ut sibi paucis
intenderent brevi alloquio cunctos admonuit. 'Omissis'

from I's exemplar D, and if so would have almost contemporary authority.
It agrees with Ordericus Vitalis, iv, 298: 'in basilica sanctae et individuae
Trinitatis ante Crucifixum sepultus est.' At the translation of ?1168
Anselm was moved to the chapel which thereafter took his name (see *St
Anselm and his Biographer*, pp. 264-5, 340).

¹ Arnulf of Montgomery was a younger son of Roger earl of Shrews-
bury who died in 1094. He was lord of Pembroke and Holderness and his
title of *comes* is confirmed by Ordericus Vitalis (ii, 422-3, 425-6; iv, 177)
though the territorial basis of this title is uncertain. He married the
daughter of Murchertach, king of Ireland. He joined the rebellion of his

indicate briefly some of the things which are reported to
have happened not long after his death—not in dreams,
but in assistance given to those in great danger by the
remembrance of his holy name.

lxix. *How, through his merits, Earl Arnulf and his men were
delivered from the perils of the sea*

A son of Earl Roger of Montgomery, Arnulf by name,
who was himself an earl,[1] was returning from Normandy
to England. The journey was prosperous and he had
accomplished one half of the sea voyage, when suddenly
contrary to the hopes of all on board, an ominously
black cloud arose, and continued to grow while the wind
by which they were borne along fell, faded away and
vanished altogether. The ship was in the middle of the
sea, having no wind to carry it further, and the crowd
of men in the ship were unable to see their way ahead
because of the thick cloud which covered them. So the
ship drifted here and there among the rolling waves, set
on no course, and the hearts of all of the men in her failed
them, for they were smitten with great fears. For two
days the sea held them thus in its power against their
will, and it stirred up their minds and loosened their
tongues to a variety of vows in the hope that they might
be freed from its grasp. At last the earl, whom I have
mentioned, recalled to mind the ever memorable name
of Father Anselm; he interrupted them all in their
devotions and asked everyone to pay attention to him
while he spoke a few words. 'Let us,' he said, 'in our

brother Robert of Bellême in 1102 and was banished from England. It has
generally been assumed that he never returned, but a letter from Murcher-
tach to Anselm of about 1106-07 makes it clear that Anselm had effected a
reconciliation between him and Henry I (*Ep.* 426 [iv, 85]). Arnulf's
devotion to Anselm's memory thus had a practical foundation. The
incident recorded here must have taken place shortly after Anselm's death.

ait 'omnibus aliis in causa præsenti.' convertamus cor et
linguam nostram ad patrem et pontificem nostrum sanc-
tum Anselmum quem sepe vidimus, cui adhesimus, cujus
sacra doctrina imbuti, et beata sumus benedictione sepius
perfuncti, implorantes notam nobis pietatem pectoris
ejus, quatinus sanctis meritis suis impetret a Creatore
nostro et omnium Domino Jesu Christo nobis et pecca-
torum remissionem, et hujus gravissimæ incommoditatis
quam pro eis juste patimur celerem absolutionem.'
Assenserunt omnes admonitioni ejus. Magna Dei pietas,
magna potentia. Necdum eam quam statim ad verbum
comitis cœperant Dominicam orationem perdixerant.'
cum subito evanescente nebula cæli serenitas tota redit,
et litus ad quod primo festinarant non longe abesse læti
conspiciunt. Gratias igitur Deo et fideli famulo ejus
agentes.' animæquiores effecti.' oppanso velo prosperrime
in portum sunt desideratum evecti. Inde petentes curiam
Heinrici regis Anglorum.' cuncta quæ illis acciderant
ordine supra digesto ipsi regi præsentibus episcopis regni-
que primoribus exposuerunt. Quod auditum.' multis
multum placuit, non dubitantibus vitam ejus in mundo
talem extitisse, quæ et hoc et multo majora debuerit a
Deo mundo sublatus merito obtinuisse.

lxx. *Quomodo Robertus monachus res suas de Tamisia illesas
receperit*

Item monachus erat Robertus nomine assiduus in ser-
vitio Radulfi Rofensis episcopi[1] cujus in superioribus

[1] Ralph, bishop of Rochester, became archbishop of Canterbury on
26 April 1114: the work therefore, as far as chapter lxxi, was completed
before this date. If the note in MS I (p. 150 *n*; and see above p. xx) is to
be trusted, chapter 72 was a later addition made at Ralph's command
and therefore probably after he became archbishop.

present need, put aside everything else, and turn our hearts and tongues to our saintly father and bishop, Anselm, whom we have often seen, to whom we have clung, with whose sacred teaching we are imbued, and whose holy blessing we have so often enjoyed. Knowing his compassion for us, let us implore him by his holy merits to obtain for us from our Creator, and from Jesus Christ, the Lord of all, remission of our sins and a speedy delivery from this most heavy trouble which we justly suffer because of those sins.' They all agreed to follow his advice. O the greatness of God's mercy and power! They had not yet finished saying the Lord's Prayer which they had begun immediately at the earl's behest, when the cloud suddenly vanished, the whole sky became clear again, and they saw with joy that the coast to which they had been rapidly journeying in the first place was not far away. Therefore giving thanks to God and to his faithful servant, and in a calmer frame of mind, they spread their sail and were borne prosperously to their desired haven. From here they sought the court of Henry, king of the English and related to the king and to the bishops and magnates of the realm who were there, all that had happened as set forth above. The story gave much pleasure to many who heard it, for they had no doubt that Anselm's life on earth had been such that, now he was removed from the earth, his merits would be able to obtain from God not only this but much greater things.

lxx. *How the monk Robert recovered his belongings from the Thames without damage*

Further, there was a monk called Robert, a man active in the service of Ralph, bishop of Rochester,[1] whose name

habita memoria est. Hic per pontem Lundoniæ eo fere
tempore pergens.' infortunio quodam subito percussus
est ex casu equi qui manticam suam ferebat. Idem
etenim equus minus caute per pontem hinc inde dirup-
tum a famulo tractus.' in fluvium cecidit, ubi major vis
undarum et aquæ profunditas extitit.[1] Licet igitur nomi-
natus frater cujus hæc omnia erant damno animalis et
rerum quæ in mantica servabantur contristatam aliqua-
tenus mentem haberet.' tamen quasi eorum omnium im-
memor, pro uno de libris beatæ memoriæ patris Anselmi
qui inter alia inibi habebatur inclusus, valde erat solli-
citus. Pergebat igitur per pontem quomodo poterat pro
libri custodia et restitutione ob merita illius qui eum
fecerat Dominum orans, et equus in profunditate tumidi
fluctus tendebat ad ripam forti conamine natans. Quid
dicam? Utrique emenso itinere, iste pontis ille fluminis.'
altrinsecus sese consecuti sunt. Mox deposita mantica
et reserata, ut qua plena timebatur aqua excuteretur.'
reperiuntur omnia quæ intus erant preter unam solam
lineam vestem ita ab humore vacua, quasi eadem man-
tica nunquam tincta fuisset in aqua. Reversus ad epis-
copum.' rem gestam me præsente retulit, et in laudem
Dei audientium ora resolvit.

lxxi. *Quibus auctoribus hæc scripta sint*

Hinc fini præsens opusculum subdam,[2] dum omnes id
legere vel audire dignantes prius brevi commoneam, qua-

[1] It might seem incredible that there should be holes in London Bridge
big enough for a horse to fall through, but cf. *A.S.C.* 1097, which reports
the exactions on many shires to assist (among other things) 'in repairing
the bridge (of London) nearly all of which had been carried away'.

[2] *Hinc . . . subdam*: for this expression cf. Eadmer's *Vita S. Dunstani*
(*Memorials of St Dunstan*, p. 248): 'Hinc iam, expleto promisso, debitum
finem ratio postulat et nos quidem illum, ecce, hic ponimus.'

has been recorded on previous occasions. At about
this same time he was going over London Bridge when
he was visited by a sudden misfortune through an
accident to the horse which carried his baggage. The
bridge was broken in places and, as the horse was being
led without proper care by a servant, it fell into the river,
at a point where the force of the current and the depth
of water were at their greatest.[1] This brother I have
mentioned, to whom they belonged, had some regrets
for the loss of the animal and the things which were in
his baggage; yet he was almost unmindful of everything
else in his great anxiety for one of the books of Father
Anselm of blessed memory, which was packed in his bag
among his other things. He went therefore across the
bridge as best he could, praying the Lord for the safe-
keeping and recovery of the book, by the merits of him
who had written it. Meanwhile the horse swam in the
midst of the swollen stream, and by a mighty effort
reached the bank. What more can I say? Each of them
accomplished the journey—the one across the bridge,
the other across the river—and met on the other side.
The bag was taken off and opened, in order to empty out
the water with which it was feared it would be full, but
everything inside, with the exception of one solitary linen
shirt was found to be as free from moisture, as if the bag
had never been dropped in the water. When he returned
to the bishop, he told him in my presence what had
happened, and the mouths of all the listeners were
opened in praise of God.

lxxi. *The authorities for this work*

Here then I shall bring this small work to an end,[2] first
however giving all who deign to read or listen to it a

tinus nulla incredulitate ex iis quæ descripta sunt mentem vulnerent. Talibus enim in eis scribendis auctoribus usus sum.' in quorum relatione omnem falsitatis suspicionem procul abesse dubius non sum. Siquidem plurima quæ primi libri series continet.' ex verbis ejusdem patris _a_ collegi. Solebat enim nonnunquam ut homo jocunditate prestantissimus inter alia dicta sua quasi ludens quid puer, quid juvenis, quid ante susceptum monachi habitum, quid in ipso habitu positus, quid prior, quid abbas egerit.' simplici sermone referre, autumans audientes eadem qua ferebantur intentione et perfunctorie illa suscipere. Ea vero quæ inter miracula in ipso libello computantur.' quædam a Balduino, quædam a Bosone, quædam a Riculfo monachis Beccensibus quorum me _b_ inibi meminisse recordor accepi,[1] quibus sicut ipsi narrabant aut interfuere, aut in seipsis ea experti fuere, aut ab illis qui testati sunt se dum fierent præsentes fuisse, accepere. Quæ autem libro secundo notantur.' pene omnia aut propriis oculis intuitus sum, aut auditu aurium sensi, aut aliquo alio modo utpote qui ejus præsentia jugiter ex quo pontificatu functus est potitus sum.' per memetipsum _c_ addiscere merui. Falsa vero scienter aliquem in sacris historiis scribere.' nefas esse pronuncio. Nam quotiens ea vel leguntur vel audiuntur.' anima scriptoris occiditur, eo quod omnibus per ea quæ falso scripsit infando ore mentitur.

a patris: Anselmi _add._ I
b me Edmerum monachum ecclesiae Salvatoris Cantuariae I
c memetipsum Edmerum I
[1] For Boso see above p. 60; and for Riculfus p. 24.

brief warning not to allow their minds to be injured by
any lack of belief in the things which have been des-
cribed. For in writing about them, I have made use of
such authorities as I was quite certain were far removed
from any suspicion of falsehood. Indeed I put together
much of the first book from the words of the Father
himself. For sometimes—since he was a man of a most
pleasant disposition—he used as if in jest to relate in
homely language in the midst of his other conversation
what he did as a boy, as a young man, or before he
adopted the monastic habit, or while he was a monk, or
while he was prior or abbot, thinking that his hearers
would take these stories in the same casual spirit in
which they were told. As for the miracles which are
recorded in that same book, I got some of them from
Baldwin, some from Boso and others from Riculfus, all
monks of Bec whom (as I remember) I have mentioned
in passing.[1] They themselves told me that they were
either present at these miracles, or experienced them in
their own persons, or heard them from those who testi-
fied that they were present when they took place. Those
miracles which are recorded in the second book were
almost all either seen by me with my own eyes, or heard
with my own ears, or learnt in some other way by
personal experience, for it was my good fortune to enjoy
his company constantly from the time when he began
his pontificate. And I affirm that it is a shocking thing
for anyone knowingly to write what is false in sacred
histories. For the soul of the writer is slain every time
they are read or listened to, since in the things which he
has falsely written he tells abominable lies to all his
readers.

lxxii. *Qualiter servata sint aliter quam præceperit ipse pater*
Anselmus de quo scripta sunt

Præterea*[a]* cum operi manum primo imposuissem, et quæ
in cera dictaveram pergamenæ magna ex parte tradi-
dissem.' quadam die ipse pater Anselmus secretius me
convenit, sciscitans quid dictitarem, quid scriptitarem.[1]
Cui cum rem magis silentio tegere quam detegere malu-
issem.' præcepit quatinus aut cœpto desistens aliis inten-
derem, aut quæ scribebam sibi ostenderem. Ego autem
qui jam in nonnullis quæ scripseram ejus ope fretus et
emendatione fueram roboratus.' libens parui, sperans eum
insita sibi benivolentia quæ corrigenda correcturum,
quæ aliter se habebant singula loco sibi competenti ordi-
naturum. Nec hac spe, opinio mea fefellit me. Siquidem
in ipso opusculo nonnulla correxit, nonnulla subvertit,
quædam mutavit, probavit quædam. Unde cum non-
nichil corde lætarer, et quod edideram tanta ac tali auc-
toritate suffultum forte plus æquo pænes memetipsum*[b]*
gloriarer.' post paucos correcti operis dies vocato michi
ad se pontifex ipse præcepit, quatinus quaterniones in
quibus ipsum opus congesseram penitus destruerem, in-
dignum profecto sese judicans, cujus laudem secutura pos-
teritas ex litterarum monimentis pretii cujusvis haberet.
Quod nimirum egre tuli. Non audens tamen ipsi pre-
cepto funditus inobediens esse, nec opus quod multo
labore compegeram volens omnino perditum ire.' notatis

[a] *Here* I *has the following marginal note:* Edmerus qui hunc librum secun-
dum composuit hic finem ponit, qui vidit testimonium perhibuit: ex pre-
cepto Radulphi pontificis perfecit.
[b] memetipsum Edmerum I
[1] For this incident and its probable effect on the composition of the
Life, see above p. x.

lxxii. *How this work was preserved otherwise than Father Anselm himself had ordered*

Moreover, when I had first taken the work in hand, and had already transcribed onto parchment a great part of what I had drafted in wax, Father Anselm himself one day called me to him privately and asked what it was I was drafting and copying.[1] And, when I had shown my desire to conceal the subject by silence rather than disclose it, he ordered me either to desist from what I had begun and turn my mind to other things, or to show him what I was writing. Now as I had been supported by his help and strengthened by his corrections in some other things which I had written, I willingly obeyed, hoping that out of his natural kindness of heart he would correct whatever needed to be corrected and rearrange in its proper order anything which had taken place otherwise than I had described. Nor were my hopes deceived in this belief, for he did in fact, correct some things, and suppress others, change the order of some, and approve other things in this small work. At this my heart was not a little rejoiced, and I prided myself perhaps more than I ought to have done that what I had written was fortified by so great and rare an authority. But a few days after the work had been corrected, the archbishop called me to him, and ordered me to destroy entirely the quires in which I had put together the work, for he considered himself far too unworthy for future ages to place the least value on a literary monument to his honour. This was certainly a severe blow to me. Nevertheless, I dared not entirely disobey his command, and yet I was not willing to lose altogether a work which I had put together with much labour. So I observed the

Y

verbis ejus quaterniones ipsos destruxi, iis quibus scripti
erant aliis quaternionibus primo inscriptis. Quod factum
meum inobœdientiæ peccato forte non caret.[a] Aliter
enim implevi præceptum ejus, ac illum intellexisse sci-
ebam. Quapropter ab omnibus in quorum manus forte
ista ceciderint, si quidem istic quicquam quod non om-
nino quantum ad fatuitatem narrationis displiceat rep-
pererint petitum iri summopere postulo, quatinus pro
hoc et pro aliis peccatis meis dignentur intercedere, ne
moles eorum me tantum deprimat, ut ad illum cujus
vitam et actus qualicunque stilo digessi pertingere posse
non sinat. Nec enim animo elabi potest qualiter michi
responderit cum quadam vice illum rogarem ut sicut in
imis me consortem laboris habuerat, ita et in superis
participem suæ retributionis efficeret. Ait nempe id se
quidem libenter ac læte facturum, providerem solum-
modo ne in hoc me nimii ponderis facerem. In quo si
peccatorum meorum pondus justi Judicis æquitas pietate
remota[b] appenderit, profecto anima mea non sursum sed
in profundum abissi præceps ibit. Unde quemadmodum[c]
cœpi adhuc quibus possum precibus insto, quatinus quam
sibi impendi desiderant, michi secum a Deo levamen et
veniam delictorum obtineant, ne nimiis me peccatis one-
ratum quo pollicitus est pius pater sullevare non valeat.
Quod sua clementia procul avertat, qui super omnia
Deus vivit, dominatur et regnat. Amen.[d]

EXPLICIT VITA ANSELMI CANTUARIENSIS ARCHIEPISCOPI[e]

[a] *The words* inoboedientiae *and* forte non caret *are written on erasures in* Є*;
the whole sentence is a marginal addition in* D. [b] D *here ends incomplete.*
 [c] quemadmodum: ego Edmerus *add.* I
 [d] *All MSS except* Є *in its final state,* HIK *and* D *before its mutilation, end
at this point.*

letter of his command, and destroyed those quires, having first copied their contents onto other quires. Perhaps my action was not free from the sin of disobedience, for I carried out his order otherwise than I knew that he intended. Wherefore I earnestly beg all those into whose hands these pages may fall; that—if there is anything in them that they find not altogether displeasing despite the weakness of the narrative—they will deign to intercede for this and for my other sins, lest the weight of them so holds me down that I am unable to come to him whose life and deeds I have however crudely described. For I can never forget how he replied to me once when I asked him to bring it to pass that, as he had had me for a companion in his labours here below, so I might share in his reward in Heaven. He said certainly he would willingly and gladly do this, only let me take care not to make myself too heavy for him. As to this, however, if the just Judge should put away his pity in assessing the weight of my sins, my soul would certainly not rise but go headlong into the bottomless pit. Wherefore, as I began to say, now with all the prayers at my command I urge my readers to seek from God for me as for themselves that relief and remission of sins which they also desire to obtain. Otherwise the compassionate Father may be unable to raise me whither he has promised, burdened as I am with many sins; which may God who liveth, ruleth and reigneth over all, of his mercy keep far from me. Amen.

HERE ENDS THE LIFE OF ANSELM
ARCHBISHOP OF CANTERBURY

 e ARCHIEPISCOPI: edita ab Edmero eius discipulo et huius sanctae Cantuariensis ecclesiae monacho, et postea priore ecclesiae Christi Cantuariae tempore Radulphi archiepiscopi. *add.* I

INCIPIT PROLOGUS IN DESCRIPTIONEM QUORUNDAM MIRACULORUM GLORIOSI PATRIS ANSELMI ARCHIEPISCOPI

CUM VITAM venerandi patris Anselmi scribendi officio jam terminarem, et me in ea quæ circa obitum ejus quibusdam visa sunt inibi scripturum negarem, eo quod omnia quæ admiratione digna de eo revelata fuerunt scribere infiniti negotii judicaverim, nec hæc scribere et illa non scribere quasi huic quam illi magis crederem, tanquam digniori revelatione glorificato adquiescere voluerim.' æquus Arbiter hanc in me ut verum eloquar stultitiam mentis examinans, quædam non per somnium visa sed re ipsa pro eodem patre in obitu et post obitum ejus operari dignatus est, quæ et evidentem scribendi materiam sumministrarent, et quæ dormientibus quasi per somnium visa sunt, non phantasiis somniorum, sed indiciis certæ rei potius esse ascribanda præmonstrarent. Unde quæ tunc prætermisi pauca ex multis scribere coactus sum, quæ non solum michi sed et pluribus in tantum innotuerunt.' ut ea in populis prædicent, et me quod ea non scripserim nimiæ simplicitatis accusent. Quædam igitur quæ visa fuerunt, quædam vero quæ facta probantur sub uno statui scribere, omissis pluribus quæ popularis rumor jactitat vera quidem esse, sed michi non omni ex parte comperta. Et quidem quod de comite

PROLOGUE TO THE DESCRIPTION OF SOME MIRACLES OF THE GLORIOUS FATHER ARCHBISHOP ANSELM

I HAD already finished the task of writing the life of the venerable Father Anselm, and had said that I would not set down therein any account of the visions which appeared to various people about the time of his death. I did this because I considered that it would be an endless business to write down everything worthy of notice which was revealed concerning him, nor did I wish to write of one incident and reject another, as if I judged one more worthy of credence or dignified by a more glorious revelation than another. But the just Judge weighing (to put it plainly) my folly in this matter condescended to give tokens not in dreams but in deeds done for our Father at the time of his death and afterwards, which both provided obvious material for writing and showed that those things which had been seen by sleepers as if in dreams were to be interpreted not as the illusions of dreams but as the portents of real events. Thus I was compelled to write down a few of the many things I had passed over previously—things so well known not only to myself but to many others that the whole world knows of them and I am considered a simpleton for having omitted them. I decided therefore to gather together and write down some of the things which had been seen and done, omitting many things which popular rumour asserted to be true but of which I was not altogether certain. And the reason why

Ærnulfo ejusque comitibus in mari factum miraculum retuli, quodque de fratre bonæ videlicet vitæ Roberto monacho in fine ipsius operis scripsi:' ea re contigit, quia mox post transitum ipsius facta fuerunt, et michi evestigio innotuerunt. Nunc autem quæ juvante gratia Dei scripturum me fore confido, licet aut prius, aut ferme per idem tempus gesta extiterint:' ideo tamen illis non continuavi, quia nonnisi post evolutum longi temporis spatium in notitiam nostram perlata sunt. Quoniam ergo liber vitæ illius jam a multis transcriptus, et per diversas æcclesias est dispertitus, nec facile est omnia volumina me habere, et eis demere quid vel augere:' iis quæ scribemus aliud exordium constituemus. Magno siquidem opere desideramus, ut qui qualem vitam vir Deo amabilis Anselmus duxerit:' ex scriptis vera fateor relatione compositis agnoverunt:' quam pretiosa quoque in conspectu Domini sit mors ipsius, non minus vera rerum descriptione cognoscant.

EXPLICIT PROLOGUS

I recounted the miracle concerning Earl Arnulf and his companions at sea, and told the story of the worthy monk, brother Robert, at the end of my earlier work was that they happened soon after Anselm's death and became known to me immediately. But those things which, with the help of God's grace, I trust I shall now write about, though they happened at about the same time or even earlier, yet they only came to my notice after a long interval of time; hence I have not added them to the others. For the book of the *Life* has now been transcribed by many and distributed to various churches, and it is not easy for me to gather the volumes together to add or subtract anything; so I shall make a new beginning for those things which I am going to write. For it is my great desire that those who have already learned from my writings, which (I declare) give a true account of the manner of life of Anselm, a man beloved of God, should also from a no less true account learn how precious is his death in the sight of the Lord.

HERE ENDS THE PROLOGUE

INCIPIT QUÆDAM PARVA DESCRIPTIO MIRACULORUM GLORIOSI PATRIS ANSELMI CANTUARIENSIS

HELIAS QUIDAM nomine monachus fuit æcclesiæ Cantuariensis, bonis quidem moribus, et simplicitate decoratus vitæ innocentis. Huic pene tribus mensibus ante obitum patris Anselmi quadam nocte visum fuit se in oratorio solum stare, et prout Deus dabat orationi intendere. Inter quæ aspexit, et ecce pater Anselmus ante sepulchrum beati Dunstani precibus incumbebat. Vidit igitur eo orante qua claudebatur sepulchrum superiorem partem moveri, et quasi loco paulatim cedere. Ad quem motum cum Anselmus ab oratione concitus surgeret, vidit beatum Dunstanum in sepulchro sese quasi ad sedendum sensim erigere, sed præpediebatur operimento sepulchri quod necdum suo recessu locum ei sedendi effecerat. Anselmus autem toto conamine nitebatur molem evellere, sed nequiquam. Innuit igitur nominato fratri eminus stanti propius accedere, et quod ipse nequibat solus, communicato labore secum perficere. Accessit, et quod unus non poterat, ambo pariter effecerunt. Amoto itaque obstaculo, erexit se sanctissimus pater, et sedens, verso vultu ad Anselmum dixit illi, 'Amice karissime, scias me preces tuas exaudisse.' Et extensa

A BRIEF DESCRIPTION OF THE MIRACLES OF THE GLORIOUS FATHER ANSELM OF CANTERBURY

(A vision in which Elias saw St Dunstan offer Anselm a ring; and a further vision of Anselm's reception in heaven)

There was a certain monk of the church of Canterbury, Elias by name, an upright man endowed with a simple innocency of life. To him there appeared a vision one night almost three months before the death of Father Anselm. He thought that he was standing alone in the church praying as God gave him utterance. While he was thus occupied he looked up, and behold Father Anselm was prostrate in prayer before the tomb of St Dunstan. He saw that, while Anselm was praying, the lid of the tomb began to move so that it was gradually withdrawn from its place. Anselm was disturbed by this movement and, rising from his prayers, he saw St Dunstan raising himself gradually in his tomb as if to sit up; but he was hindered by the lid of the tomb which had not yet withdrawn sufficiently to leave him room for sitting. Anselm tried with all his might to move the weight, but without success. He therefore beckoned to the aforesaid brother, who stood at a distance, to approach and to help him to achieve what he was unable to effect alone. He approached and together they succeeded in doing what one had been unable to do. The obstacle being thus removed, the most holy Father raised himself and sitting up he turned to Anselm and said 'My dearest friend; know that I have heard

dextera sua.' obtulit ei anulum aureum dicens, 'Hoc
habeas signum, memet tibi vera locutum.' Cumque
Anselmus ut anulum susciperet manum extenderet.' re-
traxit manum beatus Dunstanus, et dixit ei, 'Hac quidem
vice istum anulum non habebis, sed me servante quarta
feria ante Pascha de manu Domini illum recipies.' Hanc
visionem idem frater michi familiari affatu sequenti die
enarravit, sed ego vitam quam mortem patris et domini
mei plus desiderans.' eam non eo quo evenit modo tunc
quidem interpretari conatus sum. Verum cum ad diem
illum ventum fuisset.' re ipsa patuit quid visionis ipsius
figura prætenderit. Aurora siquidem illius diei illuce-
scente.' huic vitæ pater ipse sublatus, et sicut quam sub-
scribimus alia visio declarabit.' supernæ remunerationis
gloria donatus est.

Eadem quippe hora qua de hac erat vita exiturus.'
quidam monachus in vicina beatorum apostolorum Petri
et Pauli et Sancti Augustini abbatia de transitu patris
sollicitus.' subito ut fit præ eadem sollicitudine sopore
gravatus obdormivit. Visum ergo illi est se cameræ in
qua ipse Anselmus jacebat jam moriturus comminus
astare, et quendam pulcherrimum albatarum persona-
rum cuneum eandem cameram hinc inde miro decore
circumvallare, et quasi alicujus ad se cito transituri ad-
ventum præstolari. Quidam vero prægrandis excellentiæ
pontifex pontificalibus ornamentis insignitus.' hujus cunei
magisterio ac dispositione fungebatur, et nutum ejus
omnes pariter expectabant. Hic videbatur ingredi et
egredi, et eos qui foris erant ne tedio suæ expectationis
afficerentur, exhortari. Et jam Anselmo obeunte.' festi-
nus exivit, et ait, 'Ecce adest quem expectatis, suscipite

your prayers.' And stretching out his right hand he offered him a gold ring, saying 'Take this as a sign that I have spoken the truth to you.' But when Anselm put out his hand to receive the ring, St Dunstan drew back his hand and said, 'You will not have the ring this time, but I shall keep it and on the fourth day before Easter you will receive it from the hand of the Lord.' The brother described this vision to me next day in conversation, but I—being more eager that my Father and lord should live than that he should die—tried at that time to interpret it in a way different from what later fell out. But when it came to the day, it was then clear what the vision had foretold, for as dawn broke on that day the Father was taken from this life and received the glory of a heavenly reward, as another vision which I shall describe made clear. At that same hour when he was to take leave of this life, a certain monk of the neighbouring abbey of the blessed Apostles Peter and Paul and St Augustine, who was anxious about the Father's death, was suddenly overcome with sleep as often happens when we are weary with anxiety. As he slept it seemed to him that he stood near to Anselm in the room where he lay dying, and the room was filled with a host of people most wonderfully and beautifully arrayed in white apparel and seeming to await the arrival of someone who was swiftly to come to them. The company was under the authority and direction of a bishop of outstanding splendour dressed in full pontifical robes, and all awaited his signal. He appeared to go in and out, exhorting those who were outside to watch without fainting. And when Anselm was on the point of death, he went out in haste and said, 'Behold he whom you await is at hand. Receive him, and lead him

illum, et quo Dominus jussit efferte in voce laudis et exultationis.'[1] Quod dum fieret.' frater qui hæc videbat expergefactus a somno est.' et patrem Anselmum intellexit præsentem vitam vita mutasse perenni. Quis autem pontifex ipse qui præsidebat aliis fuerit.' ex figura et habitu ejus beatum Dunstanum fuisse apertissime patuit, qui promissum anulum sicut prædiximus ei cum honore et gloria reddidit.

Alius quidam frater patrem Anselmum affectu valde sereno[a] diligens, et ideo magnopere nosse desiderans.' in quam partem vocationis Dei translatus de hac vita sumptus fuisset.' oravit Deum quatinus rei hujus certitudinem sibi revelare dignaretur. Ecce autem fratri eidem corpore dormienti non spiritu.' ipse vir Domini astitit, pronuncians se velle illum omnibus modis certum esse, quia statim ut corporis onere fuit exutus.' gloriose susceptus, et stola fuerit jocunditatis indutus. Hæc interim de visis dicta sint. Ad ea quæ manifeste facta sunt hinc veniemus, nichil unde animum nostrum vel levis dubitatio mordeat, ulla ratione scripturi.

Erat igitur vir quidam divitiis mundi non adeo locuples, sed spiritu serviendi Christo non mediocriter pro suo captu abundans.' qui obeunte patre Anselmo.' gravi corporis infirmitate pressus.' Cantuariæ moriebatur. Et ecce dum jam putaretur a corpore solvi.' in hora qua

[a] sereno: sincero HK
[1] cf. Ps. xli.5 (Vulg.)

where the Lord has ordained, with the voice of joy and praise.'[1] While this was taking place, the brother was roused from sleep and knew that father Anselm had exchanged this present for eternal life. It was perfectly clear from his appearance and bearing that the bishop presiding over the others was St Dunstan, who with full honour and glory gave Anselm the ring, which had been promised as we have described.

(A vision in which a monk was assured of Anselm's beatification)

A certain other brother who loved Father Anselm with an unclouded affection greatly desired on this account to know whereunto God had called him in taking him from this life, and he prayed God to deign to reveal this to him with certainty. Now while he was asleep in the body, but awake in the spirit, the man of God stood before him telling him that he wished him to have complete assurance that he had been received into glory and had been robed in the garment of joy as soon as he had laid down the burden of the body. Let this suffice for the moment about visions. Now let us come to those things which have been done openly, concerning which I shall on no account write anything about which even the slightest doubt troubles my mind.

(A vision experienced by a sick man who recovered at the moment of Anselm's death)

There was, then, a certain man not rich in the riches of this world, but abounding, according to the measure of his capacity, in the spirit of service for Christ. While Anselm was dying, he also lay at Canterbury suffering from a grave infirmity of body, at death's door. And, behold, when he thought that he was about to be

gloriosus Domini servus huic vitæ decedebat.[1] juvenis
quidam ei speciosus apparuit, quid haberet inquisivit.
At ille, 'En morior[1] ut perspicis' inquit, 'et quæris quid
habeam?' Respondit, 'Pater civitatis istius et totius
patriæ hujus jam nunc ad Deum relicto seculo in æter-
num victurus properat.' et tu morereris? Nequaquam.
Immo surge sanus, et glorifica Deum Patrem hæc in te
operantem, et jam prædictum patrem vestrum pro meri-
tis suis perenniter glorificantem.' Stupentibus itaque
cunctis qui ad funus ejus convenerant homo convaluit,
et quonam modo tam subito sanitati restitutus sit per-
cunctantur. At ille quid viderit, quid audierit, quid de
patris Anselmi glorificatione didicerit clara voce cunctos
edocuit. Igitur eo relicto concite currunt ad æcclesiam
Domini Salvatoris, et inveniunt sicut audierant jam de hac
vita translatum fuisse prædictum Domini vas electionis.

Quidam est ex monachis Cantuariensibus, in Dei ser-
vitio strenuus. Hic in seculari habitu adhuc positus, et
gradu presbyterii functus.' gravi corporis infirmitate cor-
reptus est, ut mortis metum quam vitæ spem magis
haberet. Unicum igitur animæ suæ præsidium si mona-
chus fieret esse confidens.' rogavit se in æcclesia Christi
Cantuariæ monachum fieri, utpote cita inter fratres
morte vitam finiturus. Adquieverunt illi precibus ejus,
et religiosa veste indutum, in domum infirmorum sus-
ceperunt. Non ergo juxta quod putabatur cita morte

[1] Gen. xxv.32; l.5

separated from the body, in the same hour in which the glorious servant of God himself departed from this life, a young man, beautiful to look on, appeared to him and asked him how he was. To whom he replied: 'Lo. I die,[1] as you see, and you ask how I am.' He answered: 'The Father of this city and of this whole country hastens at this very moment to God to dwell with him in eternity, having left this world. And shall you die? Surely not. Rather, rise and be whole and glorify God the Father working these things in you, and glorifying your Father everlastingly for his merits.' He recovered; and all those who had come together for his funeral were astonished and asked him how it had come to pass that he was so suddenly restored to health. Then he told them in a clear voice both what he had seen and heard, and what he had learned of the glorifying of Father Anselm. They left him therefore and ran quickly to the church of our Saviour, and found there that it was as they had heard, that the chosen vessel of the Lord had been taken from this life.

(*How a priest at the point of death took the monastic habit at Canterbury and was cured at Anselm's tomb*)

There is a certain monk of Canterbury, a man active in the service of God. He, while he was yet in a secular habit and ministered in the office of priest, fell gravely ill so that he had more fear of dying than hope of living. Having assurance therefore that the sole protection for his soul lay in his becoming a monk, he asked leave to become a monk at Christ Church, Canterbury, as one who would finish his life among the brethren by a speedy death. They granted his prayer and received him into the infirmary clothed in the religious habit. But he was

præsenti vita subtractus est, sed qua gravabatur corporali molestia diutina vexatione detentus est. Per vices tamen nonnunquam melius habebat, sed in eo non diu consistebat. Igitur inter vitam et mortem medius, ignorabat quid certius sperare deberet. Oneri ergo non solum aliis, sed et sibimet ipsi erat. Concepit tandem apud se sibi forte non inutile consilium fore, auxilium super hac sua magna necessitate a reverendo patre Anselmo requirere. Ductus itaque a suo quodam familiari amico est ad tumbam illius. Ubi stratus humi, infortunii sui querimoniam lacrimabili voce deprompsit, ac ut suam æcclesiam ad quam moriturus magis quam victurus venerat de se liberaret, hoc est vitam sibi vel conferendo vel funditus auferendo supplici prece poposcit. Mira Dei bonitas, mira potestas.[a] Non longis et importunis precibus egrum fatigari passus est, quod sincera fide petivit, celeri effectu secus quam putabat illi largitus est. In brevi nanque convaluit, et ex eo usque huc in conventu fratrum sanus et alacer vivit.

Vir quidam nobilis, miles fortis, multis Angliæ partibus notus, Humfredus nomine, gravissimo morbo percussus,[*] eo scilicet quem quidam ydropim nominant, a medicis desperatus morti ut estimabatur propinquus jacebat. Hic olim Anselmo notus, sanctitatis ejus insignia multa cognoverat. Prædicta igitur molestia pressus, semper ipsum in ore habebat, ipsius meritis et precibus Deum sibi propitium fore plena fide postulabat.

[a] potestas: potentia HK

not taken from this life by a speedy death according to
their expectation; on the contrary he remained long
weighed down with the bodily infirmity from which he
suffered. At times his condition improved, but not for
long. So he hung between life and death uncertain
which to expect, a burden to himself as well as to others.
At last he conceived the idea that it might not be
unprofitable to him to seek help from the reverend
father Anselm in this his great necessity. So he was led
by one of his familiar friends to Anselm's tomb, and there,
stretched out on the ground, in a tearful voice he made
lamentation of his misfortune, humbly begging and
praying that the church to which he had come to die
rather than to live should be freed from him, either by
taking away his life or restoring him to health. O, the
wonderful goodness, the wonderful power, of God! He
did not allow the sick man to be worn out by long and
persistent prayers, but granted him, swiftly and far
otherwise than he expected, what he sought with sincere
faith. For he quickly recovered and from that day to
this has lived in health and cheerfulness in the com-
munity of the brethren.

(*How the knight Humphrey was cured of dropsy by Anselm's belt*)

A certain nobleman, a powerful knight well-known in
many parts of England, Humphrey by name, was stricken
with a serious illness, which some people call dropsy.
He was given over by the doctors and lay, as it was
thought, near to death. He had formerly been known
to Anselm and was acquainted with the many tokens of
his holiness. While he lay sick of this infirmity, he had
Anselm's name always in his mouth, and it was with full
confidence in his merits and prayers that he besought

z

Erat huic quidam ex antiqua amicitia notus.' Haimo
dictus, æcclesiæ domini Christi Cantuariensis monachus.
Hunc ergo missis nunciis ad priorem æcclesiæ,[a] rogans
fecit venire ad se, quoddam corporis et animæ suæ re-
medium autumans esse, si eo et fratre qui secum venturus
erat assistente, in extremis suis solatiaretur. Veniens ergo
illuc frater idem.' cingulum domini et patris Anselmi
secum detulit. Nepos etenim meus ex sorore natus erat,[1]
et ipsum cingulum a me sibi commendatum custodiebat.[2]
Qui videns hominem nimio languore toto corpore intu-
muisse, et in tantum ut jam rumpi ab omnibus qui eum
videbant putaretur.' tradidit illi cingulum, indicans ei
cujus fuerit, et a quo illud sibi commendatum acceperit.
Ingemuit ille, et sanctitate beati patris[b] ad mentem re-
ducta, ac ut sui pius Deus ad merita ejus misereretur
devota prece præmissa.' acceptum cingulum deosculatus
sibi circumposuit. Summitatibus autem ejus ob immo-
deratam viri distentionem sese vix contingentibus.' paulu-
lum ita sustinuit. Et ecce mirum in modum corpus sen-
sim cœpit detumescere, et parvissimo intervallo plene
longitudine virilis pedis quod appositum erat cingulum
sibi connexum est. Quod ipse sentiens.' ilico cingulum
illud per turgentia membra hinc inde deduxit, et omnis
tumor inordinatus qui ea invaserat, ad tactum illius
statim evanuit. Nec abundantia pravi liquoris unde
tumebat aliquo meatu effluxit, sed quod magis forte
stupeas, in nichilum redacta deperiit. Convaluit igitur
homo, et post dies Cantuariam veniens, et patris tumbæ

[a] ecclesiae Christi I
[b] patris Anselmi I
[1] Nothing more is known about this nephew of Eadmer, but since he
had a Norman name it seems likely that Eadmer's sister had married a
Norman.

God to have mercy upon him. He had been friendly from of old with a certain monk of Christ Church, Canterbury, Haimo by name, and he sent messengers to the prior of the church asking that this friend should come to him. For he thought that he would obtain some relief both for body and soul if he was solaced in his last moments by the presence of Haimo and the brother who would come with him. Haimo therefore came to him bringing with him the belt of our lord and Father Anselm, for he was my sister's son and my nephew,[1] and I had left the belt with him to be looked after.[2] When he saw the sick man with his whole body so blown out with this disease that all who saw him thought that he would burst, he gave him the belt, telling him whose it was and from whom he had received it for safe-keeping. The sick man groaned and, calling to mind the holiness of the saintly Father and relying on his merits, he prayed devoutly that God would mercifully take pity on him. Then he took the belt, kissed it and put it round his body. He held it so for a short time, though the ends would hardly meet because of his unnatural distension. And behold the swelling of his body began gradually and miraculously to subside, until presently the ends of the belt overlapped fully by the length of a man's foot. When he felt this he moved the belt up and down along his swollen limbs, and at its touch the inordinate swelling with which they were afflicted immediately vanished. Nor did the great quantity of foul liquid which had distended him flow out through any channel, but—what you may think still more wonderful—simply vanished into nothingness. So he recovered and after some days

[2] With the miracles performed by means of Anselm's girdle, compare Bede, *Vita S. Cuthberti*, ed. B. Colgrave, pp. 232-4.

gratiosus sese præsentans.ʲ in conventu fratrum hæc omnia retulit, ac ut pro se Deo et beato servo ejus gratias agerent rogavit et obtinuit. Ego autem his auditis.ʲ fateor gaudio gavisus sum vehementi. Et conversus ad hominem.ʲ 'Cingulum' dixi 'nostrum est.ʲ volo ᵃ restituas ut vos decet.' At ille, 'Scio scio ita sicut asseris esse. Verum sine dubio noveris, quoniam illud non tam cito recuperabis, si domum meam pro eo ipse non iveris.' Adquievi dicto. Post dies paucos aliis nichilominus quibusdam necessariis actus illo veni, et cingulum a viro recepi. Ad preces vero ejus dedi illi ex eo corrigiam unam admodum strictam.ᵛ sed ad mensuram ipsius cinguli longam, et divisi ab invicem sumus. Cum igitur de sanitate illius nos securitas quædam certa teneret.ʲ emenso non modici temporis intervallo.ᵛ relatum nobis Cantuariæ est.ᵛ eundem virum pristina invalitudine correptum, acri dolore vexari. Pro re itaque perrexi ad eum, sed qua ferebatur molestia non inveni oppressum. Miratus igitur, et cur venerim, et utrumnam infirmatus fuerit juxta quod audieramus.ʲ sciscitatus sum. At ipse vere quidem se infirmatum testatus est.ʲ et percunctanti mihi quali modo convaluerit.ᵛ confessus est. Dicebat igitur quod languore nimio pressus, quid dudum perpessus, qualiterve fuerit curatus ad mentem reducto.ʲ in spem sibi venerit, quoniam tametsi integrum cingulum per quod convaluit non haberet.ʲ parte tamen illius quam habebat illum cujus erat sicut toto si vellet sibi posse mederi. 'Qua spe' inquit 'fretus.ʲ quam dedisti mihi corrigiam circumposui, et ilico prout ecce vides sanitati sum restitutus.' Hæc ita de his.

ᵃ volo: ut *add.* HK

came to Canterbury and presented himself in thankfulness at the Father's tomb. He told the whole story to the assembled brethren and both asked and obtained that they would give thanks for him to God and His holy servant. I confess that I was overcome with joy at what I heard and I turned to him and said, 'The belt belongs to me, and I hope you will give it back to me as you ought.' 'I know,' he said, 'I know it is as you say. But you can be quite sure that you will not get it back very quickly if you do not come for it to my house.' I acquiesced in this, and after a few days, when other business took me thither, I went and received the belt from him. At his request however I gave him a strip of it, rather narrow but cut from the whole length of the belt. And so we parted. A considerable time passed during which we were little troubled by anxiety about his health; then it was reported to us at Canterbury that he was once more sick and in great pain with his former illness. Wherefore I went to him, but found him not at all labouring under the trouble which had been reported to us. He was surprised and asked why I had come, and I for my part asked whether he was ill as we had heard. He said that he had indeed been ill; and when I asked how he had recovered, he told me that while he lay sick he remembered what he had formerly suffered and called to mind how he had been cured. Although he had not the whole belt which had formerly cured him, he conceived the hope that he who had owned it could cure him as well with the part as with the whole, if he so wished. 'So,' said he, 'sustained by this hope, I put round my body the strip which you gave me and I was at once, as you see, restored to health.' So much for this incident.

Cum is qui patri Anselmo in pontificatum successerat Radulfus scilicet archiepiscopus Romam pergens Lugdunum venisset, ubi ipse pater Anselmus olim ab Anglia pro justitia pulsus, non sicut exul aut peregrinus, sed sicut incola et ipsius loci præsul et dominus ab omnibus fuerat habitus.' mansit ibi per aliquot dies, ratione qua ita fieri erat necesse detentus.[1] Una igitur horum dierum pro nota michi locorum et hominum familiaritate ad Sanctum Hireneum ascendens.'[2] diverti ad oratorium beatæ Mariæ Magdalenæ duabus ancillis Dei juxta idem templum pro Deo reclusis locuturus. Quarum una Athaleidis nomine familiari affatu michi innotuit, se post obitum prefati patris Anselmi quadam vice orationibus ac lacrimis intentam, subito velut in mentis excessum supra se raptam, et tribunali gloriosissimæ Reginæ cælorum a quibusdam reverendis personis adductam. Quam cum debita veneratione salutasset, et jussa ante pedes ejus consedisset.' post plurima quæ vidit et audivit[a] admiranda patriæ cælestis præconia, quasi quadam fiducia constantior effecta.' inter alia quæ a Domina rerum inquisivit.'· nec michi quæ illa fuerint patefacere ut fatebatur potuit.' de Hugone Lugdunensi pontifice sciscitata est, quomodo scilicet aut in qua sorte judicii Dei esset consti-

[a] audivit et vidit HK
[1] Eadmer's visit to Lyons with Archbishop Ralph took place at Christmas 1116. The incident which follows is related in almost the same words in *H.N.* pp. 240-1, with the additional information that the two recluses had enjoyed Anselm's friendship during his lifetime and, after his death had been induced to stop quarrelling by a vision of Anselm. Eadmer may have omitted this detail as unedifying and tending—with its mention of 'lites, improperia, et plurima quae earum proposito indecentia erant'— to lessen the authority of the testimony of the recluse.

(The vision of a recluse near Lyons in which she was assured of Anselm's blessedness)

When Archbishop Ralph, Anselm's successor as archbishop, was going to Rome, he came to Lyons and was detained there for several days by necessary business.[1] It was here that Father Anselm, during the time of his exile from England for the sake of justice, had formerly been treated by all men as if he was a native, and even bishop and lord of that place, rather than an exile or wanderer. I therefore, being well-known in those parts and among that people, went up on one of these days to St Irenaeus.[2] On the way I turned aside to the church of St Mary Magdalen to speak to two godly anchoresses who lived in the service of God near the church. One of them, Athaleidis by name, told me in the course of a friendly conversation that after the death of Father Anselm she was once praying earnestly and with tears, when she was suddenly transported above herself as if in an ecstasy and brought by some reverend persons into the court of the most glorious Queen of Heaven. She saluted her with due reverence and was ordered to sit down at her feet. In the many things which she saw and heard, she experienced a wonderful foretaste of the heavenly kingdom; and then, as if growing in confidence and assurance, she asked our Lady about various things. Among other things which she was not able, she said, to reveal to me, she asked about Hugh, archbishop of Lyons, and the fate he had met with in the Judgement

[2] The famous monastery of St Irenaeus was on a hill outside the walls of Lyons towards the south-west.

tutus.[1] At illa, 'Bene' inquit 'filia bene illi per Dei
gratiam erit.' 'Et de domino meo' ait 'Anselmo Can-
tuariorum archiepiscopo pia Domina quid sentiemus?'
Respondit, 'De illo certissima esto, quod sine dubio in
magna gloria Dei est.' Hæc illa michi tanta lacrimarum
inundatione perfusa narravit, ut fidem verbis ejus nolle
adhibere, perfidiæ videatur posse ascribi. Quid hic
dicemus? Quis de æterna beatitudine illius quæso am-
plius dubitabit, quam suo testimonio illa ipsius beati-
tudinis Mater sub tanta certitudine denunciavit?

Illud quoque quod cuidam qui ei viventi familiariter
adhærere consueverat, ut sibi quidem visum fuit, idem
pater per id ferme temporis dormienti dixit,' his sub-
jungere placuit. Videbatur itaque illi se patrem ipsum
alba candidissima indutum, et pontificali infula decora-
tum per dexteram sicut viventem solebat quasi missam
celebraturum ad æcclesiam ducere, et in eundo ipsum
de præsenti vita assumptum ut sepe contingit advertere.
Nichil igitur hesitans,' allocutus eum, 'Care' inquit 'pater
scio te mundo exemptum vitam præsentem vita mutasse
perenni. Quapropter oro te,' indica michi ubinam degas,
quomodo vivas, quidve agas.' Ait, 'Ibi vivo, ubi video,
lætor, perfungor.' Ad quod ipse mox expergefactus,'
quæ audierat ne memoria elaberentur secum volvere
cœpit. Et ecce dum in hoc totus esset,' unum e quatuor

[1] Hugh, archbishop of Lyons, died on 7 October 1106.

of God.[1] To this our Lady replied, 'It will be well with him, my daughter, by the grace of God.' 'And what, gracious Lady,' she said, 'are we to think about my lord Anselm, archbishop of Canterbury?' 'About him,' she replied, 'be well assured, that without doubt he is in the great glory of God.' She told me these things with such great shedding of tears that not to give credence to her words would seem an act of faithlessness. What shall we say therefore? Who, I ask, will any longer be in doubt about his eternal blessedness, which has been announced by her own lips and with such certainty by the Mother of blessedness herself?

(Two visions in which Anselm revealed to an old servant his state of blessedness)

It is fitting that I should here add what the Father at about this time said in a dream to a man who had been closely attached to him in his life-time. It seemed to this man that he was leading Anselm by the hand to Church to celebrate Mass, as he had been accustomed to do when he was alive. The Father was wearing an alb of purest white and was arrayed in his pontifical vestments, and it was only as they went along that the man became aware, as often happens, that his companion had been taken from this present life. So without hesitation he addressed him thus: 'Dear Father, I know that you have been taken from this world and have exchanged this life for eternal life. Wherefore I beseech you to tell me where you dwell, how you live and what you do.' He replied: 'There I live, where I see, rejoice and enjoy.' At this he presently awoke and began to turn over in his mind what he had heard, lest it should slip from his memory. And, behold, while he was giving his whole attention to

quæ sibi dicta recordabatur, animo suo elapsum egre
ferebat. Sollicitius ergo meditans, nec quid fuerit certo
apprehendere valens.' repente somno pressus parumper
oculos clausit, et ilico vocem sibi dicentem audivit,
'Lætor.' Hoc enim de quatuor quæ patrem sibi dixisse
tenebat, videlicet.' *vivo, video, lætor, perfungor*.' unum erat,
quodque memoriam suam fugisse dolebat. Verum ubi
id modo quo dixi recuperavit.' eo magis gavisus est, quo
se per hoc certiora vidisse cognovit.

Post hæc dum petente *a* Alexandro rege Scotorum ad
pontificatum Sancti Andreæ in Scotiam essem trans-
latus,[1] et ibi aliquantum temporis degens incolis regionis
illius notus fuissem et acceptus.' contigit quandam matro-
nam de nobili Anglorum prosapia ortam, et in Christiana
religione circumquaque probatam.' Eastrildem nomine
gravi corporis languore vexari, et in tantum ut nichil ei
præter mortem superesse quicunque accederet testaretur.
Hæc olim fama sanctitatis Anselmi patris audita, sed
tunc per me nam bonis aliorum magnifice delectabatur
plenius inde edocta.' cingulum ipsius patris quo de supra
nonnulla retulimus, sibi quamvis dissolvi et esse cum
Christo magis optaret[2] circumponi permisit. Quo facto.'

a petente: repente HK
[1] The invitation for Eadmer to become bishop of St Andrews must
have reached Canterbury about April 1120 (*H.N.* p. 279), and Henry I's
permission for acceptance was obtained before Eadmer left Canterbury,
probably early in June 1120. He was formally elected bishop at St Andrews
on 29 June, and he was installed about the beginning of August, taking his
episcopal ring from the king and his staff from the altar. He was soon
seeking permission to return to Canterbury for advice and he was back in
Canterbury early in the year 1121. These events are fully described in
H.N. pp. 282-8 and give a date—the second half of 1120—for the incident
described here.

this matter, he was troubled because one of the four things which he remembered to have been said to him had escaped his mind. He considered therefore even more anxiously, and still could not exactly remember what it was. Then suddenly he was overcome with sleep and closed his eyes for a while, and at once he heard the voice saying to him 'I rejoice'; for of the four things which he remembered the Father had said to him—namely 'I live, I see, I rejoice, I enjoy'—this was the one which to his grief had escaped his memory. When he had recovered this word in the way I have described, he rejoiced the more because he was thereby the more certain that what he had seen was true.

(Concerning the cure of a noble Englishwoman in Scotland by means of Anselm's belt)

After this I was transferred, at the request of Alexander king of Scots, to the bishopric of St Andrews in Scotland,[1] and during the short time I lived there I became well-known and acceptable to the inhabitants of that region. It happened that there was there a certain matron called Eastrilda, born of noble English stock and of approved soundness in the Christian religion, who was labouring under so serious a bodily ailment that whoever saw her reported that there was nothing left for her but to die. She had formerly heard of the fame of Father Anselm's sanctity, but it was only then that she was by me more fully informed of it, for she took great delight in hearing good things of others. Although she was desirous rather to depart and be with Christ,[2] yet she permitted the Father's belt, concerning which I have said something

[2] cf. Phil. 1.23

mox meliorari incipiens, post paucos dies integerrimæ
sanitati stupentibus cunctis restituta est. His affui, hæc
vidi, pro his tali ratione administratis non solus ego sed
et multi mecum plurimum exhilarati.ᶥ laudes Deo et
gratias egimus.

Dehinc cum me zelus timoris Dei et amor salutis
animæ meæ cogerent Scotiam ad horam linquere, et ad
totius Britanniæ ᵃ matrem æcclesiam dico Cantuariensem
quæ ab infantia me nutriverat quærendi de iis quæ me
valde gravabant consilii causa revolare.ᶥ illo veni, sed
eorum quæ me illuc egerant nichil inveni.¹ Radulfus si-
quidem archiepiscopus infirmabatur, nec ulla eum sani-
tas secuta est.ᶥ donec præsenti vitæ superfuit.² His diebus
quidam de fratribus acuta febre correptus.ᶥ plurimorum
corda magni doloris mucrone suo incommodo conster-
nebat. Juvenis enim erat, et bonorum in se morum
indicia præferens.ᶥ fructuosum se æcclesiæ Dei futurum
bonæ spei fiducia præsignabat. Is ergo crescente lan-
guore a semetipso pene et ab aliis desperatus.ᶥ ad Deum
modis omnibus conversus est, ac ut animæ suæ de cor-
pore migranti nil adversi obsisteret quanta potuit solli-
citudine operam dabat. Aderamus illi, vota ipsius pio
studio prosequentes. Interea occurrunt animo quæ vel
quanta beatus Anselmus suis ᵇ alumnis beneficia præ-
rogare consueverit. Inde ad verba prodimus, et quæ
etiam per cingulum suum mundo exemptus mira sit

ᵃ Angliae H
ᵇ suis *om.* HK
¹ For these events, see *St Anselm and his Biographer,* p. 236.
² Archbishop Ralph died on 20 October 1122. He had had a stroke
which made him an invalid during the last two years of his life and pre-
vented his taking a full part in the king's marriage on 6 January 1121. He

above, to be put round her. This was done, and she soon began to get better until after a few days, to the amazement of all, she was restored to perfect health. I was present and saw these things, and not only I, but many others with me, greatly rejoiced at what had been accomplished by this means, and gave praise and thanks to God.

(How Anselm's belt cured a monk of Christ Church, Canterbury)

After this, the zeal of the fear of God and the love of my soul's health forced me to leave Scotland for a time, and to return to the mother church of all Britain, the church of Canterbury I mean, which had nourished me from infancy, to seek counsel there concerning those things which so greatly oppressed me.[1] I came there but found none of the things that had brought me thither. Archbishop Ralph indeed was ill and never regained his health as long as his life lasted.[2] In those days one of the brethren was afflicted with a dangerous fever and his sufferings struck a sharp pang of grief into the hearts of many. For he was a young man who seemed to have laid the foundations of an upright life and gave good promise of being one day useful to the Church of God. So, as his sickness increased, he was almost given over both by himself and others, and he turned himself entirely to God, taking care with all diligence that no harm should come to his soul when it left his body. We were present, assisting his endeavours with pious zeal. While we were thus occupied I remembered the many and great benefits which St Anselm had wrought for his disciples. I spoke my thoughts aloud and recounted the

had evidently died before this passage was written: it must therefore be later, but probably not much later, than October 1122.

operatus retractamus. Nec mora, rogatus ab infirmo
et assistentibus cingulum attuli, et collo languentis ap-
pensum est. Eadem hora febris conquievit, nec ulterius
eum invasit. Convaluit ergo frater ille, et Salvatori
omnium Deo grates per fidelem famulum suum persol-
vimus inde.

Quid faciam? Si ea solum quæ per memoratum
cingulum mira facta sunt singulatim scribere voluero.'
procul dubio cunctis his intendere volentibus oneri ero.
Solenne etenim jam hominibus quaquaversum egrotanti-
bus extat, et maxime mulieribus in partu periclitantibus
ipsum cingulum devota mentis intentione expetere, firma
spe sibi pollicentibus indubiam sospitatem se consecutu-
ros, illius solummodo usu ad tempus potiri mereantur.
Nec aliquis sua spe in hac fraudatus hucusque nobis
nunciatus est.' ab iis scilicet quorum diligentiæ ipsum
cingulum pro remedio illud plena fide expetentium cre-
dere non dubitavimus.

Illud tamen prætermittere nulla ratione possum per-
suadere animo meo.' quod nuperrime quidam ex fratri-
bus æcclesiæ Cantuariensis, magno quodam tumore in
modum amplæ et teretis speræ sub umbilico ejus cres-
cente graviter afflictus.' mox ad tactum cinguli ipsius et
dolore sedato.' qui jam ad cor usque pertinxerat, et post
modicum tumore penitus detumescente.' pristinæ sanitati
redditus.' omnino convaluit. Nec alicui incredibile vi-
deri debere pronuncio.' tantum virum vultui Dei assis-
tentem talia facere posse, cum opus huic simile eo adhuc

wonders which he had performed also since his death by means of his belt. The sick man and those around him at once asked me to bring the belt, which I did, and it was hung round the sufferer's neck. In that same hour the fever left him and did not again return. So the brother recovered and we gave thanks to God the Saviour of all mankind for what he had done through his faithful servant.

(*The many cures wrought by Anselm's belt; and a miraculous cure in Anselm's lifetime recently recalled by Elias, abbot of Holy Trinity, Rouen*)

What shall I do? If I should describe one by one the marvels wrought by this single belt alone, I should without doubt become burdensome to all my audience. For it is a common practice for sick people on all sides and especially for women in the dangers of childbirth, to ask for the belt with pious intention and in the sure hope that they will regain their health if only they can have the use of it for the time-being. Nor, of all those to whose care we have seen fit to entrust the belt on their asking for it in firm faith of their recovery, have we to this day heard of one who has hoped in vain. But I cannot persuade myself to omit something which very recently happened to one of the brethren of the Church of Canterbury. He was suffering severely from a great tumour growing beneath his navel in the shape of a large, smooth ball, but at the touch of the belt the pain, which had spread as far as his heart, disappeared, and after a little while the tumour died down entirely so that he recovered and enjoyed his former good health. And I declare that no-one should think it incredible that such things can be done by so great a man standing in

inter undas vitæ labentis gemente divina majestas pro
designanda gratia ejus facere dignata sit, sicut ego per
id temporis quo hæc longe post obitum illius scripsi in-
dubia penitus relatione accepi, immo jam cognitum sed
a memoria oblivione deletum, in mentem lætus recipere
merui. Venerabilis siquidem abbas Montis Sanctæ Tri-
nitatis Rotomagi Helias nomine, his diebus Cantuariam
veniens,[1] cum me referente miraculum quod nuperrime
retuli audisset,' sciscitatus est utrumnam memoriæ meæ
inesset mirabile factum.'; in se tempore quo pater Ansel-
mus Rotomagi morabatur ob merita ipsius patris per-
petratum. Cui cum respondissem me nec quid animo
volveret aut quid dicere vellet quovis pacto animadver-
tere.' 'Mirabilis homo' ait.'; 'recordarisne saltem ipsum
beatum patrem cujus obsequio sedulus insistere solebas.';
sacros ordines Rotomagi aliquando administrasse?'
'Magis' inquam 'hoc firmissime scio quam recorder.'
'Qualiter' ait 'tunc elapsum a memoria tua est quod
michi ad sacrum ordinem suscipiendum inter alios præ
aliis gratia tua obsecutus fuisti, utpote quem gravissimo
dolore et ultra quam credi possit genu turgente afflictum
vidisti nonnisi a duobus fratribus sustentatum posse in
ordinis susceptione subsistere? Et utique tunc tibi in-
notuit quemadmodum mox ubi me manibus præsentis
antistitis sacrandus humiliavi, ac dominum Christum ut
ordini suscipiendo aptus existere, corporisque sanitatem
propter merita et intercessiones ipsius patris mererer adi-
pisci pro posse devotus oravi.' ilico sedato tumore, ac

[1] Elias was abbot of Holy Trinity Rouen from 1120-30. He witnessed
a charter in England in the spring of 1123 (*Regesta* no. 1400) and this would
fit very well with the probable date of his visit to Canterbury. From the
reference to *his diebus* it is clear that this passage was being written very
shortly afterwards.

the presence of God, for while he was yet groaning among the waves of this mortal life the divine majesty deigned to do something very like this to show His favour towards him. This is something I have heard on unimpeachable testimony while I have been engaged in writing these things, long after Anselm's death, though indeed I already knew it but had forgotten, and now rejoice to have it brought back to my mind. It was the venerable abbot of La Trinité-du-Mont at Rouen, Elias by name, who on a recent visit to Canterbury,[1] when he heard me recounting the miracle which I have just described, asked me if I remembered the remarkable thing which had happened to himself through the merits of Father Anselm, at the time when he was staying at Rouen. When I answered that I had no idea what he had in mind or what he was referring to, he said, 'You strange man! Do you not remember how the saintly Father, in whose service you were wont to be so diligent, once conferred holy orders at Rouen?' 'I know he did this,' I replied, 'but I can remember nothing of it.' 'How can you have forgotten,' he said, 'that when I was coming up to receive holy orders, you among others, and more than the others, helped me by your kindness; for you saw that I was afflicted with a terrible pain, more grievous than can be believed, from a swollen knee, and I could not stand to receive orders unless I was supported by two brethren? And at that time you were certainly aware that while I humbled myself to receive consecration at the hands of the archbishop, and while I prayed the Lord Christ with all possible devotion that I might be worthy of the orders I was about to receive and that I might be restored to health of body by the merits and intercession of Father Anselm, the swelling at once

2 A

fugato omni dolore·⁖ totus convalui.' Quæ ubi audivi·'
confestim agnovi. Et intelligens cuncta verissima esse·'
fateor erubui, meque ipsum valde repræhendi, eo quod
tam evidens et grande miraculum in ordine vitæ beati
viri locum suum desidia mea prævalente perdiderit. Hic
itaque licet sero dictum et creditum sit.

Inter hæc tanti viri insignia facta·' diebus ac noctibus
frequens ad sepulchrum ejus fratrum accessus erat, sin-
gulis dulce habentibus notæ pietati sui carissimi patris
suas siquæ emergebant necessitates animarum vel cor-
porum quasi vivo depromere, et inde pro modo causarum
ab eo consilium et auxilium implorare. Quæ unus ex iis
qui post obitum ipsius ad conversionem venerant fieri
cernens, et vitam viri non omni ex parte notissimam
habens·' cogitare cœpit intra se quidnam certi de sancti-
tate defuncti fratres acceperint, quorum devotionem circa
tumulum ejus cernebat ita assiduam esse. Cupiens ita-
que eorum ad quos relicto seculo venerat actus imitari·'
tumbæ patris more aliorum se prosternere gestiebat, sed
utrum pro eo, an ut ipse pro se Deo preces offerret pre-
caretur·' hæsitabat. Nullum igitur habens qui eum ab
hac sua hæsitatione ad plenum evolveret·' ad sinum
gratiæ Dei se convertit, obsecrans ut ipse cui omnes
hominum viæ patent, et qui secum gradientes sanctificat
sicut ipse sanctus est·' aliquo certo indicio sibi revelare

abated, the pain totally disappeared, and I was com-
pletely cured.' When I heard this, I immediately re-
membered; and knowing that what he had said was
quite true, I confess I blushed and blamed myself
severely for having failed through apathy to tell so great
and undoubted a miracle in its right place in my life of
the saintly man. But let it here, though late, be spoken
and believed.

*(The revelation of Anselm's beatitude to a monk of Christ
Church in a vision)*

While these outstanding deeds of the mighty man were
being performed, there was a constant stream of brethren
to his tomb by day and night, each holding it sweet to
carry whatever difficulties arose of body or soul before
the well-known kindness of their beloved Father, as if he
were still alive. Here they implored his counsel and aid
in their affairs. Now, when one of those who had
assumed the religious habit after the death of Anselm
saw this, he began—being not altogether familiar with
his life—to wonder within himself what certitude the
brethren, whom he saw to be so assiduous in their
devotion before his tomb, had of the sanctity of the dead
man. Wishing therefore to imitate the actions of those
among whom on leaving the world he had come to live,
he was anxious to prostrate himself before the Father's
tomb like the others, but was doubtful whether to pray
for Anselm or to beseech him to offer prayers to God
for the suppliant himself. Having no-one who could
entirely free him from this doubt, he turned to the bosom
of the divine grace, begging that he, to whom all the
ways of men are plain, and who makes holy as he him-
self is holy those who walk in his footsteps, would deign

2 A *

dignetur quid de Anselmo verius amodo sentiat, sanctus-
ne videlicet sit qui pro aliis ad Deum intercedere digne
possit, an adhuc talis pro quo potius intercedendum ab
aliis sit. Orat semel, orat secundo. O mira bonitas Dei,
mira benignitas, et vere clementia Domini mira. Non
passa est hominem diutius in hæsitatione sua languere,
sed quam pie petebat rei veritatem ne longiore ut fit
mora fatigatus cœpto desisteret.' dignata est certa reve-
latione mox iterata prece docere. Nam ubi precibus
secundo incubuit.' subito ut sepe contingere solet lenis
oculos ejus somnus oppressit. Et ecce ante illum volu-
men apertum, in quo deducto lumine vidit decentissime
scriptum SANCTUS ANSELMUS. Ilico expergefactus oculos
a somno levavit, et vere nomen patris Anselmi in libro
vitæ scriptum.' apposito quod nosse quærebat sanctitatis
prænomine intellexit.

Alia post hæc die cum idem frater illic missam cele-
braturus ante sepulchrum ipsius sancti patris pertrans-
iret.' tantam miri odoris et inestimabilis suavitatis fra-
grantiam sensit ex ipso manare,ᵃ ut nullis eam mundana-
rum specierum odoribus aut suavitatibus comparari posse
putares. Qua in re plane advertit, primæ visioni sine
omni dubitatione fidem habere, quam subsequens divi-
nus odor testatus est verissimam esse.

A quodam fratre mihi in fraterna dilectione dudum
familiariter juncto.' non multis evolutis diebus[1] accepi

ᵃ ex ipso (*erasure*) manare 𝖢: ex ipso sepulcro manare I
[1] cf. Gen. xxxviii.12

clearly to reveal to him what he ought henceforth to believe about Anselm: whether he was a saint who could worthily intercede for others before God, or whether he was as yet one for whom others ought rather to intercede. He prayed once, and yet again. O, the wonderful goodness, the wonderful kindness of God; the truly wonderful clemency of the Lord which did not allow him to languish in a state of doubt, but deigned to reveal to him at the second time of asking the certainty of the truth which he earnestly sought, lest—as might happen—wearied by a longer delay, he should abandon his quest. For while he put forward his prayer for the second time, suddenly a gentle sleep, as often happens, closed his eyes, and, behold, a book stood open before him on which he looked and saw written in handsome letters SAINT ANSELM. At once he awoke and opened his eyes, and knew that he had seen the name of Father Anselm written in the Book of Life with the prefix of sanctity about which he sought to know.

(*Concerning the fragrant odour at Anselm's tomb*)

On a later day when this same brother was passing before the tomb of the holy Father to celebrate mass, he was aware of an odour emanating from it, so fragrant and of so incomparable a sweetness that it could not be likened to any kind of earthly scent or sweetness. From this he plainly perceived that he could place full confidence in his first vision, which the heavenly fragrance later testified to have been most certainly true.

(*A miracle performed during the recent fire at Bury St Edmunds*)

What I now relate I heard not many days later[1] from a certain brother who had formerly been joined to me in

quod narro. Villa Sancti Eadmundi nuper ex insperato
igne succensa.' seviente incendio quaquaversum in des-
tructionem vertebatur.¹ Turbatum vulgus in ea con-
sistens.' turbatis discursibus suis rebus consulere labora-
bat, sed non multum proficiebat. Ventus enim vehemens
erat, et hinc inde longius ignem propellens.' priusquam
percipi posset.'· ædificia ab ardentibus domibus plurimum
distantia flamma volans occupabat. Juvit hoc infor-
tunium claritas solis, qui discurrentem flammam ne
videretur suis radiis obtenebrabat. Erat autem inter
alios ibi juvenis quidam, quem sua paupertas quam ex
obitu patris Anselmi pontificis Cantuariorum se incurrisse
gemebat.'· illuc a Cantia egerat. Solebat namque in fami-
lia ipsius venerandi antistitis pro suo officio ministrare,
et sibi quæque necessaria propagare. Quo defuncto.'
abbatem Sancti Eadmundi adiit, sperans suo commodo
conversationem illius magis profuturam quam quorum-
libet aliorum. Erat enim abbas idem nepos beati Anselmi
ex sorore natus, et ipse Anselmus nominatus. Juvenis
igitur ille tunc cum incendium eruperat.'· noviter sibi
domum satis accommodam fabricaverat, eamque tunc
primo consummaverat. Ecce autem vis incendii vento
impulsa domui incumbit, et in tantum ut postem portæ
consumptura flamma teneret. Aderat frater ille a quo
ista accepimus, qui hominis dolori compatiens, monuit

¹ The date of this incident cannot be exactly determined since there is
no other mention of this fire at Bury St Edmunds; but it almost certainly
took place in 1123-4, and was added to the collection of miracles as soon
as the information reached Canterbury. Anselm the younger was abbot
of St Edmunds from 1121-48, and the incident was clearly early in his
abbacy. The *iuvenis* of whom the story is told must have been a man of at
least 35 or thereabouts if he had served in the household of Archbishop
Anselm; but he would still qualify for the title of *iuvenis* in accordance with
the ancient and medieval practice of labelling *iuventus* the period of life
between 28 (or 21) and 50 (see A. Hofmeister, 'Puer, iuvenis, senex', in
Papsttum und Kaisertum: Festschrift P. Kehr, 1926, pp. 287-316).

brotherly love. A fire lately broke out by accident in
the town of St Edmunds and, raging in all directions,
was reducing it to ashes.[1] The frightened populace of
the place ran to and fro in agitation seeking to succour
their goods, though without much success. For the wind
was very strong and drove the fire far and wide, so that
the flying sparks seized on houses far distant from those
which were burning before they could be detected. The
sun helped on the disaster by concealing the spreading
flames with the brightness of its rays. Among the other
inhabitants was a certain man, who lamented the death
of Father Anselm, archbishop of Canterbury, as the
cause of the poverty which had driven him from Canter-
bury to this place. For he had been a member of the
household of the venerable archbishop and had gained
his livelihood in this employment. After his death, he
approached the abbot of St Edmunds hoping that this
connection would be more advantageous to him than
any other, for the abbot was the nephew of St Anselm,
the son of his sister, and was himself called Anselm.
Thus it came about that the man had recently built
himself a convenient house and had just finished it when
the fire broke out. The force of the fire, driven on by
the wind, was starting to threaten his house, and was
already so near that the flames were laying hold of the
door-post to consume it. The brother from whom we
heard this was present and, having compassion on the

On the strength of the following fifteenth century notice in an Ely
chronicle, Rule, p. ci, dated this incident in 1140 and consequently ascribed
the conclusion of the present work to this or the following year: 'Nota
quod a.d. 1140 factum est incendium apud Bury sci. Edmundi.' (The
next entry incidentally makes Henry II king in 1104; see Lambeth MS
448 f. 117). But, even if there were no other considerations, fires were too
common to allow much weight to be attached to this slender line of
argument.

eum*a* et diligenter hortatus est quatinus in mentem revocaret dominum suum Anselmum qui eum nutriverat, et dominicam orationem in memoriam nominis ejus decantaret, eique domum suam a præsenti periculo defendendam commendaret. Adquievit ille, et flexis genibus fecit quod monuit. O clementia Dei, o insigne meritum famuli Dei. Necdum precem ad plenum absolvit, et ecce totum incendium a domus lesione ventus ab alia parte surgens evolvit. Mirabile itaque factum ostendit ibi omnipotens Deus, cum ad invocationem fidelis famuli sui Anselmi domus sibi commendata in medio ignis stabat illesa, et cæteris omnibus eam circumcirca vallantibus in favillam cineremque redactis, manebat intacta.

Hæc pro designanda qualitate vitæ tuæ reverende pater Anselme qualicunque stilo digessi, ex industria multa preteriens quæ magnitudini gratiæ Dei quæ tecum operabatur sullimi preconio possent ascribi. Peperci enim incredulitati quorundam qui usque hodie tibi non sincero animo detrahunt, et quæ scripsi nimia esse contendunt. Jam cani capitis digitique trementes me a scribendo compescunt, et ut meritorum tuorum aliquam partem in vita perenni merear adipisci continua prece insistam, suadent atque compellunt. Quod utinam miseratio Dei michi concedat efficaciter exsequi. Amen. VALE igitur mi pater et advocate dulcissime,*b* et esto pro me, Edmero videlicet alumno tuo et donec pontificatui

a eum: illum HK
b dulcissime: pater Anselme *add.* I

man's grief, he advised and earnestly exhorted him to call to mind his lord Anselm, who had brought him up, and to recite the Lord's Prayer in memory of his name, commending to him the preservation of his house from the present danger. He was persuaded, and on bended knees did what was advised. O, the clemency of God! O, the abundant merit of the servant of God! He had not finished the prayer when behold the wind blew up from another quarter and drove away the fire altogether from damaging his house. Thus did God Almighty there show forth a wonder: the house committed to his care in the name of his faithful servant Anselm stood unharmed in the middle of the fire, and, while all the other houses round about it were reduced to dust and ashes, it remained untouched.

I have written these things as best I could, O reverend father Anselm, to show the quality of your life, and I have purposely omitted many things which might well with loud acclaim be ascribed to the greatness of God's working in you. But I have had regard to the unbelief of certain men who to this day with jaundiced minds are your detractors and assert that I have written too much. Now my white hairs and trembling fingers constrain me to lay down my pen, both persuading and compelling me to turn myself wholly to prayer so that I may be found worthy to obtain some share in your merits in eternal life. May the mercy of God grant that I may effectually attain this. Amen. FAREWELL therefore, my dearest Father and advocate; assist me, thy pupil Eadmer, thy assiduous and tireless servant while thou

Cantuariensi presedisti assiduo et indefesso ministro tuo. Si ad hæc quivis me defuncto aliqua quæ fortasse per te facturus est Deus scribendo adjecerit.ʲ illi non michi ascribatur qui hoc fecerit. Ego hic finem imposui.ᵃ

ᵃ Ego hic finem imposui: Ego Edmerus monachus ecclesiae Christi Cantuariae hic finem imposui istius operis ad laudem et honorem Dei et sancti Anselmi Cantuariensis archiepiscopi qui in Trinitate vivit et regnat per omnia secula seculorum. Amen. I

didst hold the archbishopric of Canterbury. If anyone after my death shall add to what I have written anything which God may do through thee, let it be ascribed to him who wrote it, not to me. I for my part have here made an end.

APPENDIX

The following passage is found only in the group of manuscripts VRP. Like the other addition in this group (see p. xiv) it is probably not by Eadmer but almost certainly a personal recollection of one of Anselm's friends at Bec, possibly Boso. In R and P it comes at the beginning of the *Life*, before the Prologue; but in V it is separated from the *Life* and preceded by this note:

f. 160. Ista pagina debet esse ante prologum Sancti Anselmi, sed scriptor oblitus est eam.

MS V is a Bec manuscript, and it is apparent from this note that the anecdote was on a loose leaf in the Bec exemplar of the *Vita Anselmi*.[1]

Vir Dei venerabilis Anselmus cum adhuc esset puerulus, ut ipse postmodum referre solitus erat, litteris imbui valde desiderabat, parentesque suos ut ad scolam mitteretur assidue*a* exorabat. Unde divina providentia disponente, ad hoc pervenit quod tanto mentis amore rogabat. Denique traditus est cuidam consanguineo suo, ut eum attentius doceret; qui eum in domo sua reclusit, ubi studiosius doceretur, et ne evagando*b* foras licentia a studio discendi præpediretur. Ubi dum diutius clausus haberetur pene in amentiam versus est. Post aliquantum vero temporis domum reducitur

[1] I have suggested above (p. xiii) that chapter 53 of Book ii was in a similar state in the Bec manuscript, and that it was dealt with in different ways in the existing descendants of this copy, ABMNVRP. The passage was first printed by M. Rule (see above p. xxv).

 a assiduus RP *b* evangando P

matrique redditur. Puer inexpertam sibi clientium videns frequentiam expavit et omnium consortia fugiebat, ac etiam aspectum declinabat atque interrogatus responsum non dabat. Videns hæc mater cum lacrimis exclamavit, 'Heu me miseram; filium meum amisi.' Pertractans autem et recogitans apud semetipsam quid facto opus esset, tandem salubre reperit consilium. Præcepit itaque omnibus domus suæ famulis et ancillis ut eum permitterent facere quicquid vellet, nullusque ei obsisteret; immo si cui aliquid imperaret, facere non differret; sicque*a* ad priorem, Deo volente, rediit sospitatem. Cum autem*b* ad virilem pervenisset ætatem et religionis habitum suscepisset tanta discretione erga omnes studuit se habere, et quos regendos susceperat, maxime juvenes, tanta lenitate in morum honestate informare sicut in se olim didicerat huic ætati convenire. Cui Dei gratia ita semper affuit ut nullus nostra ætate fuerit qui tam in hujusmodi*e* dispensatione profecerit. Nam vita ejus et conversatio disciplina morum aliis extitit, sicut in libro vitæ ejus plenius invenitur.

a sique R
b Cum autem: Cumque R
e huiusmodi: huius P

INDEX

Abbotsley, xxiv*n*
Adam, member of St Anselm's household, 124
Alcuin, xxxiii
Alexander, king of Scots, 163
Alexander, monk of Canterbury, member of Anselm's household, xiii-xiv, 131; his *Dicta Anselmi*, 74*n*, 95*n*, 120*n*
Alter orbis, 105
Anchin, abbey of, xvii, xviii
Anglo-Saxon Chronicle, 51*n*, 67*n*, 69*n*, 85*n*, 87*n*, 91*n*, 139*n*, 148*n*
Anselm, St: parentage and birthplace, 3, 7*n*1; leaves home, 7-8; arrives at Bec, 8; becomes a monk, 10; prior of Bec, 12; abbot of Bec, 44; visits Canterbury, 48-57; Archbishop of Canterbury, 64; consecration, 66; disputes with William Rufus, 67, 68, 85-9, 91-3; farewell address at Canterbury, 93-7; leaves England, 98; arrival at Lyons, 103; at Rome, 104; at Capua, 109-12; at Council of Bari, 112-13; returns to Rome, 113; at Vatican Council, 115; returns to Lyons, 116; returns to England, 127; dispute with Henry I and second exile, 127; in Rome, 128; in Florence, 129; stays in Lyons, 130-4; returns to Normandy, 134; settlement with Henry I, 137; returns to England, 138; at Bury St Edmunds, 139; final settlement at Westminster (Aug. 1107), 140; last illness and death, 141-3
— *characteristics*: abstemiousness, 14, 78-9; discretion, 33, 59-60; leans towards eremitical life, 10; hospitality, 46-8; mildness, 82-4, 111; hates private property, 40-1; hates secular business, 45-6, 69-71,

80-81; veneration for Blessed Sacrament, 141; cares for the sick, 22-5; his horror of sin, 84-5; sorrow for sin, 101-02; corrects manuscripts, 15; solves theological problems, 28-31, 60-1, 72-3, 113, 142; talks at meals, 73-8; visions, 35-6; cares for the young, 16, 20, 37-9
— *conversation and sermons*: 13-14, 20-1, 54-7, 70-1, 74-8, 80-1, 89-91, 93-7, 101*n*, 120*n*, 121, 123*n*, 133
— *miracles*: 26-8, 57-9, 61, 65-6, 67-8, 99-100, 107-09, 117-22, 129-30, 131-2, 137-8, 166-7; posthumous miracles, 143-8, 154-70
— *opinions*: on monastic life, 32-4, 35-6, 94-7; on love, 48-50; on St Elphege, 50-54; on obedience, 75-7; on saints' relics, 133-4; on education, 20-1, 37-9; on Cluny, 9; on secular ambition, 35, 80-1, 82-3; on hell, 84
— *personal relations*: with Alexander, 131; his nephew Anselm, 104*n*; Earl Arnulf, 146*n*; Baldwin, 65-6, 81, 87, 103-04; Boso, 60-1; Gilbert Crispin, 63*n*, 107*n*, 142*n*; Eadmer, 50, 133-4, 149-51; his mother Ermenberga, 3-4; his father Gundulf, 7; Henry I, 126-8, 130, 132, 134; Hugh, Earl of Chester, 63; Hugh, abbot of Cluny, 123-4; Hugh, archbishop of Lyons, 103, 116; John, abbot of Telese, 106; Archbishop Lanfranc, 8, 10-11, 29*n*, 48, 50-4; Lanzo, prior of Lewes, 32-4; Maurilius, archbishop of Rouen, 21-2; Osbern, monk of Bec, 16-20; Urban II, 72, 85-7, 103, 104-06, 110-13; William I, 56; William II, 63-5, 67, 68-9, 85-9, 91-3, 98, 113, 116, 122, 124, 126

Anselm, St—*Cont.*
— *his similes*: captive bird and sinner, 90; garden and monastery, 35-6; huntsman and devils, 89; matron and divine will, 77*n*; mill and human life, 74-7; river and world, 35; secular and divine service, 90; tree and youth, 37; owl's nest and cloister, 70; wax and youth, 20
— *unfavourable judgements on*: 15-16, 60*n*, 79, 130*n*, 136-7
— *uncertainty about his sanctity*, 167-8
— *Works*:
Cur Deus Homo, 63*n*, 88*n*, 107
De Casu Diaboli, 28, 66*n*
De Conceptu Virginali et Originali Peccato, 122
De Concordia Praescientiae et Prae-destinationis et Gratiae Dei cum Libero Arbitrio, 140
De Grammatico, 28, 29*n*
De Incarnatione Verbi, 63*n*, 72, 88*n*, 106*n*
De Libertate Arbitrii, 28, 140*n*
De Processione Spiritus Sancti, 113*n*
De Veritate, 28, 53*n*
Meditatio Redemptionis Humanae, 122
Monologion, 29
Prayers and Meditations, 14
Proslogion, xvi, 30-1
— *letters*: 2: 32*n*; 4, 5, 7: 16*n*, 20*n*; 37: 32*n*, 32-4; 49: 60*n*; 64: 8*n*; 70, 71: 125*n*; 72: 29*n*; 91: 49*n*; 97: 28*n*; 100: 29*n*, 31*n*; 107: 24*n*; 109: 28*n*, 29*n*, 31*n*; 112: 59*n*; 113: 34*n*; 125, 128, 129: 106*n*; 147: 72*n*; 148-166: 66*n*; 149: 65*n*; 156: 12*n*; 170-171: 67*n*; 176: 69*n*; 207: 72*n*, 73*n*; 212: 127*n*; 213: 106*n*; 239-240: 113*n*; 262: 104*n*; 272: 132*n*; 281: 127*n*; 303: 128*n*; 308, 310, 327: 130*n*; 328: 104*n*, 123*n*; 330: 130*n*; 335: 32*n*; 355, 366: 130*n*; 367-371: 135*n*; 426: 146*n*; 451: 134*n*; 473: 57*n*
— *Works containing reports of Anselm's talk and sermons*:
Dicta Anselmi: 74*n*, 95*n*, 120*n*, 131
De Similitudinibus: 13*n*, 19*n*, 21*n*, 33*n*, 36*n*, 38*n*, 50*n*, 55*n*, 71*n*,

74*n*, 77*n*, 84*n*, 85*n*, 90*n*, 91*n*, 95*n*, 101*n*
De Beatitudine caelestis patriae: 120*n*
— *Projected work*: De origine animae, 142
Anselm, nephew of St Anselm, 104*n*, 169
Aosta, 3
Aristotle, *Categories*, 29*n*
Arnulf of Montgomery, Earl (? of Pembroke), 146
Aspres-sur-Buech, 103*n*, 104*n*
Athaleidis, anchoress of Lyons, 161
Athanasius, *Vita S. Antonii*, 14*n*, 78*n*
Authie (Altya), river, 27*n*, 28
Averso, 111*n*
Avranches, xiv, 8*n*

Bacon, Roger, xxix, xxxi*n*
Baldwin, monk of Bec; comes from Tournai; head of Anselm's household, 63*n*, 81, 99, 143; suggests a miracle, 65; blames Anselm's mildness, 82; exiled, 87; witnesses a miracle, 99; Anselm's spokesman, 103-04; his directions at Anselm's funeral, 143; his vision after Anselm's death, 143*n*; gives Eadmer information on miracles, 149
Bari, Council of, 73, 105*n*, 112
Beauvais, 132*n*
Bec, abbey of, 8-62 *passim*, 137; foundation, 11*n*; poverty, 47; customs, 9*n*, 18-19; patrons, 27*n*; English possessions, 48; hospitality at, 46*n*; school at, 8; *Vita Anselmi* at, x, xiv-xv
See also Anselm, Baldwin, Boso, Herlwin, Lanfranc, Osbern, Ri-culfus
Bede, xxxii
Becket, Archbishop Thomas, 73*n*
Bellême, Robert of, 146*n*
Benedict, St, 54, 73*n*, 94*n*, 109*n*
Boethius, 29*n*, 30*n*
Boso, abbot of Bec, xiv, 60, 149, 172
Bury St Edmunds, 139-40, 168-9

Cadulus, knight, later monk at Marmoutier, 42-3
Calixtus II, *see* Guy, archbishop of Vienne

Canterbury: archbishops, *see* Anselm, Dunstan, Elphege, Lanfranc, Ralph; knights of, 88; lands of, 67, 87, 88*n*, 132, 134; rights of, 67, 139*n*; tenants of, 81-4 — Christ Church; Anselm's first visit to (1079), ix, 148; Anselm's address to monks of (1097), 93-7; Anselm at (1103), 127*n*; building at, 88*n*; customs of, 9*n*; sufferings during Anselm's exile, 100; consequent criticism of Anselm, 130*n*; Anselm's burial at, 143-5; Baldwin's vision at, 143*n*; cures at, 157, 160, 164; doubts of Anselm's sanctity at, xi, 167-8; visit of Elias, abbot of Holy Trinity Rouen to, 166; MSS of, xx, xxiii
— *Domesday Monachorum*, 27*n*, 88*n*
— monks of, *see* Eadmer, Ernulf, Haimo, Ordwy, Osbern
Capua, siege of (1098), 109-12
Cassian, *Collationes*, 74*n*
Cassiodorus, xxxiii
Chaise-Dieu, la, 125
Chiusa, abbey of, 7*n*, 104*n*, 123*n*
Cîteaux, xvi
Clairvaux, xviii
Clement III, (anti-pope), 115
Cluny, abbey of, xxvii, 9, 102*n*, 121, 123
Councils, Ecclesiastical: Bari (1098), 112-3; Vatican (1099), 115, 127
— Royal: Westminster (Christmas 1092), 64*n*; Gloucester (March 1093), 64-5; Gloucester (Christmas 1093), 67; Hastings (Feb.-March 1094), 68-9; Rockingham (1095), 85-7; Windsor (1097), 88-9; Winchester (1097), 91-3; Winchester (1103), 127*n*; Westminster (Easter 1107), 139; (August 1107), 139-40
Crispin, Gilbert, monk of Bec and abbot of Westminster, xix, 6*n*, 8*n*, 11*n*, 40*n*, 63*n*, 107*n*, 142*n*
Crispin, Milo, *Life of Lanfranc*, 8*n*, 15*n*, 60*n*

Damian, Peter, 91*n*
Delisle, L., 44*n*
Donatus, *Ars Grammatica*, xxxii

Dunstan, St, 109*n*, 154

Eadmer, monk of Christ Church, Canterbury: first meeting with Anselm, ix, 50; Anselm's companion, ix; with Anselm at Susa, 103; with Anselm at Lyons, 132-4; at Anselm's funeral, 144; he preserves Anselm's belt, 159-60, 164-5; last words on Anselm, 170-1; at Lyons with Archbishop Ralph, 161; Bishop of St Andrews, 163
— *Works*:
Historia Novorum, 1, 64-163 notes *passim*
Hymn on St Dunstan, 54*n*
Vita Anselmi: date and manner of composition, ix-x; completed despite Anselm's prohibition, x, 150-1; alterations, xi; and additions to, xi-xii; authorities for, 148-9; relation to *Historia Novorum*, 1-2; and to *Liber Miraculorum*, 152-3; MSS. of, x-xi, xiii-xxv
Eastrilda, 163
Elias, abbot of Holy Trinity, Rouen, 165, 166
Elias, monk of Canterbury, 154
Elphege, archbishop of Canterbury, 50-4
Ermenberga, mother of Anselm, 3, 4, 6
Ernulf, prior of Canterbury, 130*n*

Farfa, customs of, 9*n*
Fécamp, abbey of, 47*n*
Florence, xix, 129
Florence of Worcester, *Chronicon ex chronicis*, 91*n*, 113*n*, 122*n*

Gaunilo, monk of Marmoutier, 31*n*
Gilbert, count of Brionne, 27*n*
Gillingham, 85*n*
Glanvill on ecclesiastical homage, 140*n*
Glastonbury, x, xxi
Goscelin, xxvi
Gravius, J., first editor of *Vita Anselmi*, xxiv

Gundulf, bishop of Rochester, 49n, 66, 86
Gundulf, father of Anselm, 3-4, 7
Guy, archbishop of Vienne (later Calixtus II), 117

Haimo, monk of Canterbury, nephew of Eadmer, 159
Harrow, 67
Hayes, 89
Henry I, King, 97n, 126-30, 132, 134-5, 137-41, 163n
Henry IV, Emperor, 42n
Herewald, 22
Herlwin, abbot of Bec, 11, 40, 44
Hinton, Charterhouse of, xxi
Holm Cultram, Cistercian Abbey, xxi
Homage, ecclesiastical: Anselm does homage, 66n; Urban II forbids, 115n; and Anselm refuses homage to Henry I, 127n; Paschal II abandons his prohibition, 140n; Glanvill on, 140n
Hugh, abbot of Cluny, xix, 123, 143n, 144n
Hugh, archbishop of Lyons, 102n, 103, 116, 130, 161-2
Hugh, earl of Chester, 63
Hugh the Anchorite, 59n
Humbert, count of Savoy, 104n
Humphrey, a knight, 158

Investiture: lay, Anselm's attitude to, 65n; Urban II forbids, 115; and Anselm enforces prohibition, 127; Henry I abandons investitures, 140
Isidore, Etymologiae, 105n
Ivo, bishop of Chartres, 132n

John, abbot of Telese, 106
John the Baptist, St, 53
John of Salisbury: Policraticus, 73n; Vita Anselmi, xxiv, 126n
Jumièges, abbey of, xv
Justitia, 53

Kant, Immanuel, 31n

Lambert, abbot of Bertin, 101n

Lanfranc, archbishop of Canterbury: prior of Bec, 11; his correction of manuscripts, 15n; abbot of St Stephen, Caen, 12n; archbishop of Canterbury, 48; Liturgical innovations, 51; builds church at Harrow, 67; his knights, 88n; his death, 63; his burial place, 145n1; his prose style, xxxvi
— Anselm's master, 8-11; contrast with Anselm, xi; critic of Anselm, 29n; discussion with Anselm on St Elphege, 48-54
— Monastic Constitutions, ed. D. Knowles, 9n, 13n, 18n, 19n, 24n, 51n
Lanfranc (nephew of the archbishop), 16n, 77n
Lanzo, prior of Lewes, 32
Liberi (Sclavia), 106, 109n, 111n, 112
London, 67-8; bridge at, 148; Council at (1107), 139-40; St Paul's Cathedral, 68n

Mâcon, 121
Malaterra, Geoffrey, De rebus gestis Rogerii comitis, 109n, 110n, 111n
Malchus, bishop of Waterford, 72n, 73n, 101n
Malmesbury, abbey, x, see also William of Malmesbury
Marchiennes, abbey of, xviii
Marcigny, priory, 123
Marmoutier, abbey, 43; see also Gaunilo
Maurilius, archbishop of Rouen, 11, 12, 21-2, 45
Morgan, M., 48n
Murchertach, king of Ireland, 146n

Neot, St, relics of, 57n

Odo, abbot of Cluny, 30n
Ordericus Vitalis, Historia Ecclesiastica, 27n, 46n, 122n
Ordwy, monk of Canterbury, 130n
Osbern, monk of Bec, 16-20
Osbern, monk of Canterbury, xxvi, 52n, 65n; his Life of St Elphege, 54, 65n

Pallium, 85, 87

Paschal II, pope, 128
Peter, papal chamberlain, 134
Piacenza, 87n
Previté Orton, C. W., 3n
Prisca, St, 132
Punctuation, xxviii-xxxiv

Ralph, archbishop of Canterbury, 147, 161; abbot of Séez, xix, 136; at death and burial of Anselm, 142-5; orders addition to *Vita Anselmi*, xx, 150n; death, xxii, 164
Ralph de Diceto, 97n
Rectitudo, 53n
Regularis Concordia, 13n
Richeza, sister of Anselm, 123n
Riculfus, sacrist at Bec, 24-26; an authority for *Vita Anselmi*, xiv, 149
Robert, count of Meulan, 91n
Robert, duke of Normandy, 66n, 138
Robert, servant of Ralph, bishop of Rochester, 147-8
Rochester cathedral: *Vita Anselmi* at, x, xix
Rockingham, council at, 85
Roger, count of Sicily, 111
Roger, duke of Apulia, 109, 111
Rome, 87, 88, 91, 92; Anselm's reception at, 104-06, 113-15, 127; Vatican Council (1099) at, 115-16, 127; Church of St Prisca at, 132-4; mission to (1106), 134, 135n
Rouen, 11, 166; *see also* Elias, Maurilius
Round, J. H., 27n
Rule, M., xxv, 85n, 140n

St Andrews: *see* Eadmer
St Bertin, abbey, x, 100, 101n
St Edmund, abbey: *see* Bury St Edmunds
St Irenaeus, abbey, 161
St Mark, hospital at Bristol, xxi
St Omer, xvii, 101
St Werburgh's abbey, 63n
Salerno, 111n
Salisbury, 127
Savoy, counts of, 3n, 104n
Schmitt, F. S., on the chronology of Anselm's works, 28n
Schools, monastic, 8n

Scilla, 13
Sclavia, *see* Liberi
Scutarius, 42
Stationes at Rome, 114
Stone, Richard, monk of Canterbury, xxiii
Sulpicius Severus, *Vita S. Martini*, 14n
Susa, 103
Sutton, Oliver, bishop of Lincoln, 57n

Thérouanne, bishopric of, 101n
Thietmar of Merseburg, 51n
Tinchebrai, battle of, 138n
Tirel, Walter, 27, 126n
Tournai, monastery of St Martin at, xvii

Urban II, pope, 69n; receives *De Incarn. Verbi*, 73; sends pallium, 85; recognized by William II, 87; Anselm's visit to, 103, 105-06, 110-15; death, 122
Ursio (or Ursus), 34

Vatican Council (1099), 115
Veritas, 53
Vitae Patrum, 33n

Walchelin, bishop of Winchester, 91n
Walo, bishop of Paris, 132
Walter, cardinal-bishop of Albano, 87
William I, 56, 63
William II: accession, 63; first meeting with Anselm, 63-4; illness, 64; appoints Anselm as archbishop, 64-5; quarrels with Anselm, 67, 68-9, 85-9, 91-3, 98; negotiates with Urban II, 87n, 88n, 113; rumours of his death, 122-4; death, 126
William of Malmesbury, xxi, 32n, 165n, 113n, 123n, 140n
William of Warelwast, bishop of Exeter, 97, 113, 128, 130, 134-5
Winchester, 65, 91, 127n; *see* Walchelin
Wissant, 99, 100, 101n
Wohancus pictor, 139n
Writing tablets, 30n

Printed in Great Britain by
Thomas Nelson and Sons Ltd, Edinburgh